Cornelis Engebrechtsz. 's Leiden

J. D. Bangs

CORNELIS ENGEBRECHTSZ.'S LEIDEN

Studies in Cultural History

VAN GORCUM ASSEN 1979

The publication of this book was made possible through a grant from the Netherlands Organization for the Advancement of Pure Research (Z.W.O.)

ISBN 90 232 1630 X

Printed in The Netherlands by Van Gorcum, Assen

Contents

Foreword

Leiden art and crafts of the late fifteenth and pre-Reformation sixteenth centuries have usually been considered products of a provincial backwater. This point of view is seen as early as C. van Mander (1604), who found it necessary to imagine that Cornelis Engebrechtsz. had founded painting in Leiden. It is also seen in the widely accepted pronouncements of M. J. Friedländer and G. J. Hoogewerff; and it continues as recently as J. Bruyn's article on the relation of Lucas van Leyden and his Leiden contemporaries to the "Southern Netherlands" (1969), where Pieter Cornelisz. Kunst's "Leiden training and somewhat provincial self-consciousness" are considered sufficient reasons for his presumed independence from "Southern Netherlandish" exemplars. Another recent study in which Leiden's backwardness is presupposed is W. S. Gibson's Harvard Ph. D. dissertation (1969), which provided the framework for the historical remaks in J. R. J. van Asperen de Boer's and A. K. Wheelock, Jr.'s *Oud Holland* article on Cornelis Engebrechtsz. (1973).

Although R. van Luttervelt could rightly claim some awareness of the historical inaccuracy of an art historical approach based on present national boundaries (an incomplete awareness, nevertheless, of what was presupposed), this did not prevent him and the rest of the Amsterdam Rijksmuseum's exhibition committee in 1958 from mounting a codifying exhibition along the scheme worked out by Friedländer, where an intuitively identifiable art of the "Northern Netherlands" is supposed to exist for the period considered in the following studies of Leiden art. The 1958 exhibition led to the acrimonious exchange of remarks between P. Geyl and R. van Luttervelt together with K. Boon, cited below (in *Bijdragen voor de Geschiedenis der Nederlanden*, 1959 and 1960). Through this exchange, which contains a condensed statement of the art historical problems which have to be faced in any historical study of pre-Reformation art in Leiden and other cities, the reader can discover the depth of feeling associated with any revisionist approach to the art adopted by the art critics in the name of the present Dutch nation's pre-national history as its own.

Geyl had previously opposed Pirenne, Colenbrander, and Friedländer, among others. One of his points was that cultural unity was more evident along the western provinces (Flanders, Brabant, Holland and Zeeland, and Utrecht) than cultural disunity was evident along a division into north and south roughly corresponding to the present states Belgium and The Netherlands. Pirenne, however, made at least one accurate observation on the cultural situation of the time — that the person who writes in French will have a wider audience than the person who uses Dutch. The English translation of Geyl's work is eagerly awaited. Moreover, van Luttervelt and Boon

pointedly demanded that Geyl produce at least one northern city with a cultural life equal to his claims. It is my opinion that any of the cities of Holland would serve, if art historians were able to make use of the documents in the cities where they are preserved. Leiden in the time of Cornelis Engebrechtsz. is, therefore, presented in the following diverse aspects to support Geyl's view.

Leiden in Cornelis Engebrechtsz.'s time has been thought to have had but one industry, weaving. This is inaccurate. Leiden was also a major exporter of dairy products, parchment, fish, grain, bricks and oils. Because of the cloth trade and these other interests there was lively international contact in Leiden with the factors of mechants from England, Spain, the Hanseatic League, the German Rhineland, and even Italy, who were almost constantly in residence. But I have chosen not to study economic, political, or social history in this work, which does no more than provide a beginning for a revised view of Leiden's artistic climate.

The studies which follow cover topics which may be considered to have an immediate bearing on the question of determining cultural level in some broad sense. The genealogical appendix, which is not further elaborated, indicates the social connections of Cornelis Engebrechtsz. and his family; the names of many of these people will turn up in any study of economic, political, or social activity in the area. The main point, however, is made in the text, supported by the illustrations. A fairly simple exposition of the complexity of Leiden art in the time is found there. Secondarily, a variety of tangential polemic and discursive supporting argument is confined mostly to the notes. They are frequently long in relation to text, because Leiden topics raise basic issues regarding generally accepted style critical opinions. The notes, therefore, contain a running commentary on the secondary point of art historical method, in addition to the usual references to sources. Such commentary is required in a short attempt to show that a single case, Leiden, calls into doubt the approach followed by Friedländer and others in studying all of what is called "Early Netherlandish Painting." It follows that the polemic is not intended personally. It is aimed at reliance on a method which I consider a last resort, but which seems to have been used too soon by too many students. (One chapter departs from this principle and the polemic forms part of the text. In this instance I follow a sixteenth-century precedent and repay in kind.)

The sorts of primary and secondary sources used for Leiden can be used to good effect in new studies of the art of other cities. While this concept is certainly understood by numerous art historians, the practice is rare, if not absent. No simple bibliography is attached, because it is my opinion that the student who wants to learn about Netherlandish art would do well to read this book for an understanding of use of archival and other sources. Secondary sources I have chosen not to mention may prove useful for other purposes. (A good bibliography for Cornelis Engebrechtsz. is found in W. S. Gibson's dissertation, cited below.) My criteria for rejection have been repetitious acceptance of erroneous material, presentation of personal opinions as if valid without further evidence, and material not dealing with topics directly at hand, such as considerable portions of discussion of disputed attributions of anonymous works. Some topics that are discussed raise issues where a complete bibliography of sources consulted, not to mention those I omitted to consult, would be too long for

reasonable use. Examples are theories of language history, hieroglyphics, and church history. The student of these topics can easily find further bibliographical information through the works cited.

New content and supportive method are here presented, both to the well-read general reader (possibly a figment) happy to make another random choice between available secondary sources, whose number increases by one, and to the student who wants to test the method and perhaps correct or add to the content (who of course must have a reading knowledge of Dutch, written and printed, past and present).

Throughout my work I have received advice and help from the staff of the Leiden Municipal Archives, especially Mr. B. N. Leverland (who at the last moment tracked down the location of a lost commission document for Huych Jacopsz.) and Mr. C. Pelle, both of whon assisted me in learning to read. Recently Mr. P. de Baar has given useful tips on items and sources I had earlier overlooked or had noted and forgotten or might never have thought of consulting. The research and publication have been made possible by several grants from the Netherlands Organization for the Advancement of Pure Research Z.W.O. and by a one-year research fellowship from the Faculty of Letters of the Rijksuniversiteit Leiden.

Many people have contributed to my understanding of the subjects discussed in this book — through conversation, correspondence, or other means. My thanks are due to Professors I. Schöffer, S. Dresden, C. Gilbert, J. Duverger, H. Oberman, J. Pelikan, J. Godbey, E. G. Rupp, E. H. Gombrich, D. P. Walker, J. B. Trapp, J. C. Taylor, C. Sicking, A. E. Cohen, J. G. van Gelder, H. Boogman, C. Eisler, P. Reuterswärd, H. Berkhof; to the Archivists A. Versprille, W. Downer, and J. Fox; to P. Obbema, R. Breugelmans, T. Falk, J. Rowlands, J. Asselberghs, Y. Cazaux; Mmes, P. Junquera-da Vega, F. Garcia de Wattenberg, G. Andreé de Bosque; J. Garff, J. Lodewijks, J. van Asperen de Boer, J. Filedt-Kok, J. Leeuwenberg, W. Kloek, M. Wurfbain, C. Reedijk, M. Vente, H. Mühl; to the curators of the collections in numerous Dutch museums; to the staffs of the Rijksbureau voor Kunsthistorische Documentatie and of the Instituut voor het Kunstpatrimonium; and to the pastors of the parish churches of Aranda de Duero, Peñaranda de Duero, Baños de Valdarrados, the Chancellor of the diocese of Burgos, the provost of King's College Chapel, the costers of the Dutch Reformed churches of Leiden and Abcoude, and the pastors of the parish churches of Onse Lieve Vrouwe (Hartebrug) and St. Petrus in Leiden and of St. Willebrordus in Oegstgeest. I am grateful to the military authorities who granted me an unhurried personal tour of inspection of the tapestry collection of the Palacio de Oriente in Madrid. Notary C. de Loës provided a sense of historical continuity early in the research. He had official possesion of recent papers on a family studied of whom the first dated reference 575 years earlier was a deposition notarized by his direct ancestor C. de Loës. Family members who have aided in clarifying the period and its social structure include C. Bangs and M. Friesen (von Riesen) — Bangs (my parents), Mme. M. Waridel — Duperthuis, L. Dupertuis de Roget, Mlles. A. and M. Wackernagel, Mlle. S. Jouvenaz — du Lex, and Mrs. J. Løschbrandt who assited my access to material concerning T. Bang. My wife interrupted her own research to contribute laughter before toning down the footnotes.

Among the people whose scholarship has contributed to improving my conception

of the problems discussed, I remain indebted most to the late Professor H. van de Waal, whose knowledge of the existing literature was unrivalled and who had already been asking the questions which I try to answer to some extent here. Dr. J. J. Woltjer has read several parts in earlier versions and corrected some errors. This, however, is new; its errors are my own.

This book has not been written for art critics, but for two children. Their inspiration was essential in the last revision.

Leiden, October 3, 1976

1. Cornelis Engebrechtsz., a Documentary Study of the Man and his Artistic Environment: Biography

Cornelis Engebrechtsz. is the earliest Leiden painter any of whose works can be identified with certainty. Information about him, however, has been scanty and often unreliable. Van Mander has been the major biographical source, but, as W. S. Gibson has pointed out, the death date given by van Mander for Cornelis Engebrechtsz., 1533, is inaccurate.[1] The current view of Cornelis and his artistic environment, or more broadly put, the cultural context in which he worked, is in fact less dependent on van Mander than it is on the opinions of M. J. Friedländer.[2] Friedländer's general assumptions have been accepted with only minor modifications by most later writers, such as G. J. Hoogewerff, E. Pelinck, K. G. Boon, J. Bruyn, and Gibson. These general assumptions were attacked repeatedly by the eminent historian P. Geyl, whose criticism, however, was either ignored, not understood, or not accepted.[3] This study of Cornelis Engebrechtsz. and his artistic environment is based on new archival research, which tends to support the opinions of Geyl. Often contradicting Friedländer's general presuppositions, it sometimes requires explanatory material relating to relatively unexplored areas of Leiden's cultural history, a kind of history usually omitted by writers of the Friedländer School.

Birth and Death Dates, Family and Housing

Van Mander gives Cornelis Engebrechtsz.'s birth date as 1468.[4] Caution is suggested by the fact that only one of van Mander's biographical dates for sixteenth-century Leiden artists can be verified: that Lucas van Leyden died in 1533.[5] Nevertheless, 1468 might be correct for Cornelis' birth; and the necessary conditions for its being correct can be specified. The argument must begin with the marriage contract of Pieter, Cornelis Engebrechtsz.'s son, and Marytgen Gerytsdr. van Dam. The contract, to which Cornelis was a witness, can be dated at July 1, 1509.[6] It was Marytgen's second marriage.[7] If she was about twenty years old at her second marriage, which is possible; and if Pieter Cornelisz. Kunst was twenty or twenty-one, which is not impossible, although less likely,[8] then Pieter would have been born around 1489. He was legitimate.[9] Cornelis Engebrechtsz. was, therefore, married at least as early as ca. 1489. If Cornelis was himself twenty or so when his son Pieter was born, the birth date 1468 given by van Mander could be correct.

The date 1468 requires the unusual presumption that both father and son were about twenty years old at marriage. The preserved Leiden marriage contracts give the

impression that more commonly the man would be nearer the age of majority, twenty-five, or already have reached it, before marrying.[10] If either Cornelis or his son Pieter married at the more usual age of about twenty-five, the birth date 1468 is incorrect. If both did, then Pieter was born ca. 1485 and Cornelis was born ca. 1460. To summarize, van Mander's birth date for Cornelis Engebrechtsz. must be doubted and replaced with an earlier and vaguer suggestion of ca. 1460-1465.

Cornelis Engebrechtsz.'s death date, on the other hand, can be stated with some precision. He died between February 11, 1527 (the last reference to him during his life), and August 26, 1527 (six weeks before the first reference, on October 7, 1527, to his widow and his estate).[11] Cornelis, thus, died six years earlier than reported by van Mander (1533) and three years earlier than reported in Gibson's unpublished dissertation (1530) and repeated in a subsequent article by J. R. J. van Asperen de Boer and A. K. Wheelock, Jr.[12]

The correct name of Cornelis Engebrechtsz.'s wife, Elysabeth Pietersdr., was given first by Gibson.[13] The couple had six children, Pieter Cornelisz. (Kunst), Cornelis Cornelisz. (Kunst), Lucas Cornelisz. (Cock), Clemeynse Cornelisdr., Beatris Cornelisdr., and Lucie Cornelisdr.[14]

Where Cornelis and his family lived is first indicated by house registration connected with a tax levy in 1497-1498, also giving information on several other painters.[15] Cornelis owned a house in the neighborhood of the Schotsepoort,[16] and he is listed as living in his house in the Burchstrenge neighborhood, along with his wife's sister.[17] Repetition of the listing in 1501-1502, however, mentions "Cornelis Engebrechtsz., painter, with his sister."[18]

While no sister of Elysabeth Pietersdr. is known from other documents, Cornelis himself had a sister, Elysabeth Engebrechtsdr. She seems to have been his only sibling. They were joint heirs and probably the closest relatives of an Otto Dircxz. of Gouda.[19] Probably Otto Dircxz. was a brother of Cornelis Engebrechtsz.'s father or mother. If he was Cornelis' paternal uncle, Cornelis' father would have been named Engebrecht Dircxz.[20]

The St. Catherine's Hospital financial records for housing income list Cornelis Engebrechtsz. as owner of a house opposite the chapel of the fishermen in the years 1504, 1505, 1506, 1507, 1508, 1509, 1510, 1511, 1512, 1513, 1514, 1515, 1516, 1517 and 1518 (one volume), 1519, 1520, 1521 (1522's records are missing), 1523, 1524, 1525, and 1526.[21] The records for 1527, 1528, and 1529 are missing. In 1530-1533 (one volume) Cornelis' widow and children are listed as owners, and their house is described as next to Pieter van Noerde's. The 1539 records repeat the listing from 1530-1533, even though Elysabeth Pietersdr. had died in 1538.[22] Cornelis must have moved to this house in late 1503 or early 1504 and lived there until his death in 1527.[23] Gibson, with thanks to A. F. De Graaff, states merely that, "The rent records of the St. Catherine Hospital for 1509 and again for 1526 inform us that Engebrechtsz lived 'Opposite the Fish Chapel,' in a house which his wife had probably inherited from her parents."[24]

Training

Leiden had a painter's guild; and various painters were active in Leiden during Cornelis Engebrechtsz.'s youth.[25] These painters trained pupils. That Cornelis' parents might have sent him outside Leiden for his earliest training is unlikely, because of the extraordinary expense involved.[26]

Leiden's guild, however, was not the only place a local youth could conveniently learn to paint. Like Huych Jacopsz., Lucas van Leyden's father, Cornelis Engebrechtsz. may have been apprenticed to Brother Tymanus, the leading painter of the monastery Hieronymusdal (Lopsen), just outside Leiden's city walls. In 1482 the monastery made payments to both painters, Cornelis and Huych, but Cornelis' name does not appear in the records as an assistant. This contrasts with the example of Huych Jacopsz., who was Brother Tyman's assistant as early as 1469 and 1471. These Hieronymusdal connections are discussed in more detail below; here, however, it may be remarked that Cornelis' 1482 payment indicates a connection which could have brought him into contact with the young painter Jan Mostaert.

Jan Mostaert's father (Jan) held land in the Haarlem area from the Leiden monastery Hieronymusdal from at least as early as 1490[27] until 1499-1500.[28] The fee on this land had to be brought annually by the painter's father.[29] Easy transportation allows the suggestion, unprovable, that the painter Jan Mostaert could have come along to Leiden at some time and there have met various Leiden painters.[30]

Cornelis Engebrechtsz. is not called an assistant ("*knecht*") in 1482, which indicates a degree of independence by then.[31] Legal matters in 1487 mentioned in note 13 show that Cornelis was already married and in Leiden that year.[32]

Possible Travel

In the four years between 1482 and 1486-1487 (allowing for a period of courtship or marriage arrangements), Cornelis Engebrechtsz. hypothetically may have travelled, working as a temporary assistant to other painters. This hypothesis must be explored briefly, to do justice to the extensive literature proposing non-Leiden training or long-term trips of formative influence. Such temporary employment could not have been on a long-term basis, because to work for longer than some months in a town of which he was not a burgher was against standard guild regulations.[33] Cornelis did not become a burgher of any other town than Leiden.[34]

Throughout his career, however, Cornelis Engebrechtsz. could have been active for short periods in other towns, by paying a small daily fee to the local guild.[35] No long periods were spent away from Leiden after his marriage, however, because to be absent with wife and household for a year and a day amounted to moving. At that point a ten per-cent excise tax on personal possessions was due to the town a person had left.[36] Despite the possibility of short absences, Gibson's claim that, "There is stylistic evidence for an extended sojourn in Brussels shortly after 1500,"[37] can be rejected on the basis of the documentary evidence.[38]

No documentary evidence supports the suggestion of travel between 1482 and

1486-1487. This period, however, is all that is left for attempts to explain Cornelis' art by postulating necessary training in a studio in what is now Belgium. Pelinck has suggested that Cornelis must have been a trainee of Colyn de Coter in Brussels.[39] Pelinck compares several heads in paintings once attributed to de Coter with heads in Cornelis' triptychs in the Leiden Municipal Museum "De Lakenhal" and finds all so similar that in his opinion Cornelis must have done the first group under de Coter's tutelage. He also identifies a mood which is supposed to belong to Cornelis' works. Unfortunately he does not describe it, but rather gives as examples the soft sadness of the Mother and John, and the pious attention of Nicodemus.[40] It must be repeated that, although Cornelis certainly may have travelled at any time during his life, he also had access to new compositional ideas through prints,[41] and the documentary evidence at hand discourages belief in the necessity of non-Leiden training.

Militia Membership

Cornelis Engebrechtsz.'s archery guild membership has been known to art historians since the nineteenth century.[42] He belonged to the Longbow Archers ("*hantboog-schutters*") first, appearing in their lists of 1499[43] and 1506.[44] By 1514[45] he had become a member of the Crossbow Archers ("*voetboogschutters*"), and he appears in their lists also in 1515, 1519, 1518-1520, and 1522.[46] There are no lists for other years during his life except 1479 and 1494, where he is not named.[47] Ca. 1520 he was one of the neighborhood captains,[48] a rank filled by people of relative wealth and social importance.[49] That Cornelis belonged to this social group is confirmed by evidence of his wealth seen in estate litigation following his death.

The Longbow Archers were required to appear in uniform in the processions on Holy Sacrament Day (Thursday after Trinity Sunday) and on Lady Day (March 25).[50] The Crossbow Archers had to appear in uniform for mass in the Leiden Pieterskerk annually on St. George's Day (April 23).[51] Cornelis Engebrechtsz.'s presence on these dates is, nevertheless, not assured by the rules. He could afford the small fines which were imposed for inexcusable absence.

The militia members acted primarily as police patrols, not only as defenders of the town from possible outside attack. Cornelis may have travelled occasionally during his militia years, but he was probably in Leiden most of the time. He, too, was required to take his turns in the night police watch of the neighborhood.

While Cornelis was a member, other Leiden painters who were militia members were captain Huych Jacopsz., Florys Ghysbrechtsz., Phillips Claesz. van Zeyst, Lucas van Leyden, Willem Jansz., Robbrecht Robbrechtsz., Jeronimus (Cornelisz.), captain Pieter Jansz., Jan Jacopsz., Baernt (Claesz.), Harman (Jansz.), Huge (not identical with Huych Jacopsz.), Reyer Garbrantsz., and Cornelis Engebrechtsz.'s sons Cornelis Cornelisz. Kunst and Pieter Cornelisz. Kunst.[52] The militia membership of Cornelis' sons implies that they were born in Leiden.[53] The same is true for Cornelis Engebrechtsz. himself.[54]

Through militia and guild membership Cornelis took part in the celebrations surrounding the "Joyous Entry" into Leiden made in 1508 by Maximilian, and that

made by the future Charles V in 1515. The Leiden painters' guild performed a comedy as part of the 1515 festivities, which raises the possibility that Cornelis may have had more to do with the "Joyous Entry" than is indicated simply by his militia membership. Through membership Cornelis was among the groups organized to accompany Charles into town.

Payments and Lawsuits

Cornelis Engebrechtsz. received at least two commissions from the city government of Leiden. He collaborated with his son Pieter on a map used by the city as a legal document in defense of city privileges of fishing rights; they were paid for it on July 17, 1522.[55] The cartographic accuracy of the 1518 Brussels portraits is notable in conjunction with the map making activities of Cornelis and Pieter.[56]

In 1525 Cornelis was paid for painting the banners of the four city trumpetters.[57] Ill. 42 He wrote the payment receipt itself (it is countersigned by two city treasurers). His name in the text of the receipt is, thus, his signature.[58] The banners he painted replaced a set that had been made for the 1515 Joyous Entry. That set had been painted by Dirck Hugenz.[59]

The financial records of the wealthy Abbey of Rijnsburg consistently note the residence of artists and artisans employed there, unless they came from nearby Leiden.[60] Patronymics are almost always omitted in these references. It may be assumed, therefore, that payments to "Cornelis the painter" were payments to Cornelis Engebrechtsz. "Cornelis the painter" was paid for heraldic paintings on an ornate dresser or buffet in 1496-1497.[61] In 1505-1506 he was paid for painting what was evidently the coach used by abbey officials.[62] The next year, 1506-1507, he was paid for the design of "the coat of arms of St. Benedict," probably a design for carving; and for the designing of stained-glass roundels in the "Blue Room," part of the suite of the abbess.[63] The roundels were carried out by the glasspainters Ewout Vos and his two assistants.[64]

Another commission is mentioned in estate litigation in 1530.[65] Besides the recorded commissions, four lawsuits refer to Cornelis Engebrechtsz. during his life. In contrast to his militia membership, these commissions and lawsuits have not been known before.[66]

On June 10, 1513, the bookprinter Jan Zevertsz. sued "Cornelis the illustrator" for delivery of some illustrations or payment of 12 Ryns guldens.[67] Identifying "Cornelis the illustrator" as Cornelis Engebrechtsz. means rejecting three alternatives.

First, the reference may mention someone otherwise unrecorded, whose existence is unprovable. The term "the illustrator" does not, however, recur in the Leiden records. This suggests that it is used here in connection with the lawsuit's subject. The defendant's occupation is, then, specified as an identification bearing on the case.[68] That no one else is called an "illustrator" strongly weighs against the hypothesis of an otherwise unrecorded Cornelis in an otherwise unrecorded profession.

Second, "Cornelis the illustrator" might be proposed as Cornelis Hendricxz. Lettersnyder of Delft. The monogram *C H with a pot* which appears on the map in Jan

5

Zevertsz.'s *Cronycke van Hollandt 1517* (map dated 1514) has been tentatively proposed, admittedly without proof, as perhaps that of Cornelis Hendricxz. Lettersnyder (although it has nothing in common with colophons used by that family).[69] Cornelis Hendricxz. Lettersnyder is mentioned in the Leiden documents only on February 12, 1535, and October 16, 1536, when he and the Leiden printer Pieter Jansz. van Woerden (Huych Jansz. van Woerden's brother, evidently) sued a Leiden merchant.[70] Delft is given as his residence, which is consistent with other references to him. Because the case against "Cornelis the illustrator" was brought in Leiden and not Delft, he could not be identical with Cornelis Hendricxz. Lettersnyder.[71]

Third, "Cornelis the illustrator" might have been a painter resident in Leiden, named Cornelis Florysz. the Englishman. He is mentioned in 1498, 1531, 1536, and 1537.[72] He was brought to court on March 17, 1536, for delivery of a banner commissioned by the officers of the guild of St. Catherine, held in the Pieterskerk. This is the only reference to his work known. This Englishman remains an unknown figure, who might have been "the illustrator," although the peculiatity of his non-local origins would almost certainly have led to further identification in the legal notes, if that were so.[73]

Cornelis Engebrechtsz. remains the most likely person to have been described as "Cornelis the illustrator" in Jan Zevertsz.'s lawsuit of June 10, 1513. The connection with Hieronymusdal, residence of Cornelius Aurelius, author of the *Cronycke van Hollandt 1517*, may be significant.[74] A particular group of woodcuts appearing in Jan Zevertsz.'s publications from before 1509 onwards may have been the work of Cornelis Engebrechtsz. and the origin of the lawsuit. The group is discussed below together with other hypotheses.

Cornelis may be presumed to have been an official of the painters' guild, perhaps the dean, on the basis of a lawsuit brought on June 15, 1520, by the painter Dirck Mast.[75] Mast sued for recovery of apprenticeship fees from the father of an apprentice of Mast's.[76] He named Cornelis Engebrechtsz. as the man whose opinion of the correct fee should be considered valid by the court, if they did not rely on Mast's own testimony and demand for £ 3/—/—. The fee demanded by Mast was probably standard payment to the artist for taking on an apprentice; the artist also had to pay a fee to the guild for each apprentice he was training, with a maximum of two at any one time in effect, apparently.[77]

Financial arrangements between Cornelis Engebrechtsz. and Lucas van Leyden's brother, Dirck Hugenz., are suggested by a lawsuit of August 12, 1521.[78] Katryn Jansdr., almost certainly the litigious wife of Dirck, demanded that Cornelis sign a promisory note for £ 3/—/—, as she claimed he had verbally agreed to do. Other details are not given.

The last known reference to Cornelis Engebrechtsz. during his life is a lawsuit of February 11, 1527, when Matheeus van Berendrecht, an important pewtersmith belonging to one of Leiden's ruling families, summoned Cornelis Engebrechtsz. and Frans Pieter Mouwerynsz.'sz. (a business associate of Cornelis Cornelisz. Kunst) in a case whose nature is not described.[79] Estate litigation after Cornelis died began on October 7, 1527, and is summarized below. It continued beyond the death of his widow, which was between March 22, 1538, and May 17, 1538.

Notes

1. C. van Mander, *Het Schilder — Boek*, Haarlem, 1604 (reprint, Utrecht, 1969), folio 211. See W. S. Gibson, "The Paintings of Cornelis Engebrechtsz" (Ph. D. diss., Harvard University, 1969), 16.

2. Friedländer's work is still considered standard; and it is being reissued in English translation with better illustrations and with notes intended to bring it up to date. The project is supported by the Governments of Belgium, Germany, and The Netherlands. The original flavor of Friedländer's statements about the qualities he considered characteristic of the Dutch folk are more clearly seen in the German version. In placing Cornelis Engebrechtsz. in context, for example, Friedländer limited himself to brief, unsupported generalizations about the racially and spiritually determined inclinations of the folk of Holland to accept the Reformation when it finally did arrive, and their inclination to be moved by epic and dramatic illustrations of Bible stories painted by Cornelis Engebrechtsz., until it did. Friedländer thought, also, that the relatively poor community in which Cornelis lived supported artists badly, rarely commissioned portraits, and did not reflect the taste of the court, the Italians, or the rich merchants, in contrast to Brussels and Antwerp. (See Friedländer, *Die altniederländische Malerei*, X, *Lucas van Leyden und andere holländische Meister seiner Zeit*, Berlin, 1933, 75.) The new version is milder, but still peculiar as history: "His penchant for the epic and dramatic was reinforced by what the Dutch people were then looking for. Predisposed by tradition and cast of mind, they were about to accept the Reformation. They were deeply concerned with everything relating to Christ's sacrificial death. In Antwerp and Brussels the sophisticated standards of taste were set by the court, the Italians, the wealthy merchants; but Dutch society was far less affluent and demanded straightforward depiction of the gospels." Next it is announced that, "Holland must be viewed as basically Germanic." (See Friedländer, *Early Netherlandish Painting*, X, *Lucas van Leyden and Other Dutch Masters of his Time*, Leiden, 1973, 44.) G. J. Hoogewerff's equally standard work, *De Noord Nederlandsche Schilderkunst*, The Hague, 1939, approximately equal in reliability, but with better notes and more photographs for comparison, is unfortunately not being re-issued. A description of art history based, like Friedländer's, on the presuppositions of idealism is found in C. Gilbert (ed.), *Renaissance Art*, New York, 1970, xix-xx. Friedländer's Cornelis Engebrechtsz. study is one where "an attempt is made to present attributions as if they were incidental to an idealistic critical essay, which has higher prestige." The focus of the present study is the historical inaccuracy of the background presupposed for the idealistic, intuitive approach, coupled with new suggestions based on new historical research.

3. See P. Geyl, "De Hardleersheid der (of van sommige) Kunsthistorici," *Bijdragen voor de Geschiedenis der Nederlanden*, XIV, 1959, 217-226; see also Geyl's answer to the response by K. Boon and R. van Luttervelt, "Zijn de Kunsthistorici Hardleers?," *Bijdragen voor de Geschiedenis der Nederlanden*, XV, 1960, 103-111. The existence of the previously un-noticed Leiden documents (ca. 20.000 referring to artists and craftsmen or their works) suggests in any case that R.W. Scheller was premature in stating that, "Art historical research in the archives of The Netherlands is, . . . if not completed, then at least accomplished well enough to reduce the chance of the appearance of any previously overlooked documents to negligibility," (Scheller, "Nieuwe gegevens over het St. Lukasgilde te Delft in de zestiende eeuw," *Nederlands Kunsthistorisch Jaarboek*, XXIII, 1972, 41).

4. Van Mander, *Schilderboek*, folio 210.

5. Lucas van Leyden's name appears on an undated page of a fragmentarily preserved financial account book for the Leiden Pieterskerk listing his burial there. The page can be dated 1533 because adjoining numbered pages written in the same hand and continuing the same account categories have been preserved, split up in other archival collections. The date 1533 appears on these pages, which also list money left by will to the church that year. Lucas was not a donor. See Kerk, Arch. 323 (fragments); the other fragments of the 1533 records are to be bound together with these in the future. I found them in various places in the archives of the Hervormd Gemeente, Leiden, now preserved in the Leiden Municipal Archives. All the fragments can now be requested with the inventory number given above.

6. See appendix 2, no. 4. See also R. A. 42, January 7, 1510, two lawsuits; R. A. 42, February 4. 1510; February 11, 1510; February 18, 1510; February 25, 1510; March 11, 1510 (two cases); Further, R. A. 42, May 8, 1514, and May 15, 1514.

7. The marriage contract with her first husband, Cornelis Claesz., who had died before the second marriage, is not preserved. It was made at the house of Katryn Claesdr., Pieter Rembrandtsz.'s widow

(see R. A. 41, 1504-1521, folio 127, February 18, 1510) in the presence of Yssaack Claesz. and Claes Claesz. Because Pieter Rembrandtsz. was a very wealthy draper, the marriage of Marytgen van Dam to Pieter Cornelisz. Kunst had important financial aspects. The sum in dispute from the first marriage of Marytgen van Dam was 900 Ryns guldens, for which Pieter Cornelisz. Kunst had acted as bond for Claes Jacobsz. (father of Marytgen van Dam's first husband) and for one of his sons, who is unnamed. This transaction apparently took place before the second marriage. Also involved was land sale. See appendix 2, nos. 31, 36, 37, and 43.

8. That Pieter Cornelisz. Kunst could be bond for 900 Ryns guldens suggests that he had attained majority. He must have, if the unspecified son of Claes Jacopsz. was Marytgen van Dam's first husband and not one of her first husband's brothers. The marriage contract of Pieter Cornelisz. Kunst and Marytgen van Dam does not specify their ages, which was sometimes done in marriage contracts of minors. The omission does not prove minority. Not all marriage contracts are preserved, and there is no way to determine if listing of minority was legally standard. The idea that Pieter could act as bond for 900 guldens while a minor is untenable. The legal cases referred to in note 6 show antagonistic, not amicable, business relations with the relatives of Marytgen's first husband. This strongly supports the idea that Pieter was of age when he married in 1509.

9. Illegitimacy is excluded by the absence of reference to it in inheritance litigation after the death of Cornelis Engebrechtsz.

10. For preserved marriage contracts, see R. A. 76. The impression given by some lawsuits in R. A. 42 and R. A. 43, where witnesses were called to testify to the contents of marriage contracts, is that often marriages were closed with unwritten oral contracts in the presence of witnesses, as is the implication in the lawsuits concerned with Marytgen van Dam's first marriage. Other marriage contracts were made up in two copies, one given to each spouse (see, for example, R. A. 102, folio 47). There is, therefore, no basis for a statistical study on the average marriage age.

11. R. A. 42, February 11, 1527, and October 7, 1527. A widow could not be sued about the estate until at least six weeks after the death of her husband. Fot this legal point, see R. A. 42, August 12, 1538, mentioned in B. N. Leverland, research on Huych Jacopsz. in G. A. Leiden, archive correspondence, 1968, number 35, March 19, 1968.

12. Gibson, working from archival research done by A. F. De Graaff, gives as death date, 1530, "or earlier" (Gibson, diss., 16). Elsewhere, however, Gibson specifies 1530 ("1530, the year of Engebrechtsz' death," Gibson, diss., 209). The date 1530 is taken over by J. R. J. van Asperen de Boer and A. K. Wheelock, Jr., "Underdrawings in Some Paintings by Cornelis Engebrechtsz.," *Oud Holland*, LXXXVII, 1973, 61. They note that Gibson's dissertation established much of the framework for their own conclusions. A number of unchecked archival errors thereby enters the published literature on the painter.

13. Gibson, diss., 15, with thanks to De Graaff, whose documentary reference is W. A., Gr. Bew. B, p. 146, August 12, 1533. Cornelis Engebrechtsz.'s presence in Leiden in 1487 is indicated on October 16, 1487, first mentioned by Gibson (document: W. A., Gr. Bew. A. no. 445; Gibson, diss., 13, with thanks to De Graaff). Cornelis is named as a close relative of Jan Pietersz., minor son of Pieter Hugenz., baker, and his late wife, Berber Jansdr., although Cornelis' precise relationship is not specified. Cornelis was consulted together with a heer Jonius, priest, living in Delft, as close relatives, on the arrangements made by the *weesmeesteren* in securing the inheritance due to Jan Pietersz. on his reaching majority. (The *"weesmeesteren"* were the city officials in charge of the *"Weeskamer,"* literally, "orphan chamber." Although the word is usually translated "orphanage," it had a wider meaning. Besides being a commission regulating the appointment of guardians of all children, *both* of whose parents were dead (orphans), the commission also regulated the appointment of guardians of the interests of all minors having *one* deceased parent. The commission also exercised final trusteeship of all estates due to succeed to children under guardianship of persons appointed by the commission.) Cornelis did not appear before the commission as a witness, contrary to Gibson, diss., 15, based on information from De Graaff. This is significant regarding sealing rights, affecting another document discussed below. The witnesses were two magistrates, Bouwen Paidze (Paeds or Paedts) and Heynrick Gerytsz. van Alcmade. Cornelis Engebrechtsz. approved the arrangements, representing his family's interest in safeguarding the rights of Jan Pietersz. Nothing indicates a relation to Barbara Jansdr. The system of patronymics then used allows the inference that Jan Pietersz. was probably a brother of Elysabeth

Pietersdr., Cornelis' wife; and that Cornelis was consulted as her legal guardian representing her family interests. The 1487 document shows Cornelis' presence in Leiden. Combined with the information on Pieter Cornelisz. Kunst's age, it establishes reasonably certainly that Cornelis Engebrechtsz. was already married in 1487. An incorrect name for Cornelis' wife ("Fytgen") was given by W. J. C. Rammelman Elsevier in *De Navorscher*, VIII, 1858, 245. He presumably mistook references to "Fytgen Cornelis Engebrechtsz. weduwe" (Sophie, widow of Cornelis Engebrechtsz.) as referring to the widow of the painter. In fact, Fytgen lived in Delft and received an annuity from Leiden (see her receipt, signed with a mark, in S. A. 665 (Bijlagen Thesauriers Rekeningen, 1532), loose piece dated June 26, 1533; and the annual listings for Delft for payments of "*lyfrenten*" in the name of Marytgen Cornelisdr., in the treasury records. This annuity was bought in 1525.

14. Janlysbet Cornelisdr., who is mentioned as a daughter of Cornelis Engebrechtsz. in De Graaff, "Pieter Cornelis Engebrechtsz., Genaamd Kunst," *Jaarboekje voor Geschiedenis en Oudheidkunde van Leiden en Omstreken*, LIII, 1961, 64, was the daughter of Cornelis van Dam. See appendix 2, no. 51.

15. See S. A. 578 (Thesauriers Rekeningen 1497-1498). The other painters listed are Jan Jansz. (folio 58 verso), Hugo Jacopsz. (folio 62), Jan the painter (folio 67, reference is either to Jan Jansz. or Jan Jacopsz.), Pieter (Jansz.: folio 67 verso), and possibly the brother of Lucas van Leyden, Dirck Hugenz. (folio 91 verso, but without occupation listed, so the reference may be to his contemporary, Dirck Huych Alewynsz.'sz.). Occupations are noted in this tax list either at random or in cases where confusion might have arisen between people sharing the same name and patronymic. However, the example of Dirck Hugenz. shows that occupations were not always given even where such confusion was possible. The occupational statistics given in N. W. Posthumus, *De Geschiedenis van de Leidsche Lakenindustrie*, The Hague, 1908, I, appendix XII, and 400-403, are based on this tax list. Posthumus lists seven painters through failure to note the duplicate listing of Cornelis Engebrechtsz. Posthumus' statistics are incorrect, because of the randomness of the tax list's notation of occupations. By listing the painters together with masons, thatchers, tilers, roofers, and other construction workers, Posthumus inaccurately implies that the painters were house painters. The grouping is also inconsistent with guild membership. F. Dülberg uses the same statistic (Dülberg, "Die Persönlichkeit des Lucas van Leyden," *Oud-Holland*, XVII, 1899, 66, note 3), citing P. J. Blok, *Eene Hollandsche Stad onder de Bourgondisch Oostenrijksche Heerschappij*, The Hague, 1884, 329, who must have used the same tax lists. The few artists and craftsmen noted by Posthumus and others from this list give the incorrect impression that Leiden could not have been an important artistic center (in a quantitative sense) ca. 1500.

16. S. A. 578 (Thesauriers Rekeningen 1497-1498), folio 48. The Schotsepoort was an alley extending towards the Schotsetoren at the end of the Doelensteeg. The document is mentioned by Gibson, with thanks to De Graaff; citation details are omitted. See Gibson, diss., 14.

17. S. A. 578 (Thesauriers Rekeningen 1497-1498), folio 68. Cornelis Engebrechtsz.'s house can be located approximately by using this list and those of 1502 (see below), which follow a traditional registration pattern street by street. The house occupied by Cornelis in these years was in the Nieuwe Straat in the direction of the Hooygracht. The traditional order of registration (confirmed by the location on the list of some particular names, such as "*Nanne de hoeyckmakere*") ensures that names in the vicinity of that of Cornelis Engebrechtsz.'s were of people living in the Nieuwe Straat. The precise property location cannot be determined, because several inhabitants covered their shares of the tax levy by buying municipal debentures and do not appear on the list. It is certain that Cornelis did not live at the present address Nieuwe Rijn 4, contrary to De Graaff, "Pieter Cornelis Engebrechtsz," 63. Although no source is given for the assertion that the correct address is Nieuwe Rijn 4, presumably it is based on a misinterpretation of one of the 1502 lists, S. A. 945 (a document mentioned by Gibson, diss., 14, thus presumably known to De Graaff). Nieuwe Rijn 4 can be found by counting back from the end of that list, if it is forgotten that the neighborhood Burchstrenge contained not only the Burcht side of the Nieuwe Rijn but also the Hoochstraat, the Oude Rijn, the Hooglandse Kerkgracht, the Nieuwe Straat (Burcht end), the Hooglandse Kerkhof, and the Nieuwe Staat (Hooygracht end). Cornelis' house was somewhere approximately behind the house from which the Leiden city view of the Brussels 1518 portraits could be seen. Besides the likely misinterpretation of the 1502 list, De Graaff refers to the year 1544 in his assertions of the locations of the houses of Pieter Cornelisz. Kunst and Cornelis Engebrechtsz., whose house was supposedly occupied in 1544 by his daughter Beatris, widow of Jan van Schengen [*sic*] (she was actually the widow of Claes Jansz. van Schengen). See De Graaff, "Pieter

9

Cornelis Engebrechtsz," 64. This must be based on the Tenth Penny tax records of 1544 (A. R. A., The Hague, Staten van Holland vóór 1572, 275), although De Graaff gives no source. The neighborhood lists of 1544 are divided into groups of house owners and house renters. It is impossible from these lists to locate residences.

18. See S. A. 597 (Thesauriers Rekeningen 1498-1499), folio 45 verso, a repetition in a list of incomplete notations. The omission of the first house is explained by the fact that payment was made at Cornelis' residence. Also on the 1498-1499 list are Huge Jacopsz. (folio 41 verso) and Pieter Jansz. (folio 44 verso). For Cornelis' sister, see S. A. 581 (Thesauriers Rekeningen 1501-1502), folio 45. A final reference to the tax occurs in the neighborhood lists of 1502, S. A. 945, where Cornelis Engebrechtsz. is mentioned with his sister on folio 36 verso. This is mentioned by Gibson, diss., 14. That Cornelis' name appears there is noted in J. C. Overvoorde's and J. W. Verburcht's printed inventory (of the) *Archief der Secretarie van de Stad Leiden*, Leiden, 1937, 88. The correct dating of the document first appeared in D. Koning, "Het Geboortejaar, de Moeder en de Woning van Lucas van Leyden," *Jaarboekje voor Geschiedenis en Oudheidkunde van Leiden en Omstreken*, LI. 1959, 86. Comparison of the lists in S. A. 945 and S. A. 581 confirms the dating. In particular may be noted the listing of "*Nanne de Hoeyck- makere*" in both lists. He died in 1502, as is indicated by a note on death duties (S. A. 581, folio 3). Also mentioned in the tax lists of 1501-1502 (S. A. 581) are the painters Jan Jansz. (folio 40 verso), Huge Jacopsz. (folio 41 verso), Pieter Jansz. (folio 44), and Willem Jansz. (folio 53).

19. See R. A. 42, October 13, 1536. The absence of other heirs indicates that the artist was not the brother of other people with the patronymic Engebrechtsz., alive in Leiden at the same time, such as Dirck Engebrechtsz. of Oegstgeest and Mathys Engebrechtsz., pewtersmith.

20. The family relationship must have been fairly close, because of the absence of any complicated specification of the relation in the joint inheritance lawsuit. From Otto Dircxz.'s widow's inheritance of half the house, it follows that the usual reversion clauses were in effect, namely, that if there were no children from the marriage family property reverted to next of kin and that increment was to be divided half and half between the surviving spouse and next of kin of deceased. C. E. Taurel's assertion, based on information from Rammelman Elsevier, that Cornelis Engebrechtsz.'s father was "*Engebrecht de Timmerman*" is not proven (Taurel, *De Christelijke Kunst in Holland en Vlaanderen*, Amsterdam, 1881, I, 190). Taurel's argument, that making woodcuts implied adeptness at carpentry to the minds of Leiden's city officials, is implausible. Evidently it is based on the presupposition that Leiden was ruled by people so unfamiliar with art that they regarded anyone who claimed to be an artist as more likely to be a carpenter, a known job. Also unlikely as a candidate for father of Cornelis Engebrechtsz. is the "Meester Engebrechtsz." [*sic*] mentioned by Dülberg, *Die Leydener Malerschule*, Berlin, 1899, 41. Meester Engebrecht (Ysbrantsz.) was a priest. See Kl. Arch. 349; see also Leverland, "De Pastoors van de Parochie van O. L. Vrouw te Leiden," (ms., typed, 1959), G. A. Leiden, Bibl. no. 65045 ʄ. Further, see C. Reedijk, *The Poems of Desiderius Erasmus*, Leiden, 1956, 156, no. 11, A Complimentary Poem for Engelbertus Schut (= Engebrecht Ysbrantsz.), introductory note on Me- ester Engebrecht and Erasmus' contact with him. The opinion here that he was Cornelis' father is based on sources susceptible to schematic presentation of their inter-dependence, including Friedländer.

21. Gasthuis Archieven 303, the *Maenboeken* of the Catherina Gasthuis. The *Maenboeken* are annual records of collection from properties on which the hospital held (feudal) obligation papers. The records are not foliated, but they are arranged by streets in a recurrent order which facilitates location of entries from one year to the next. Absence in these records of any annotation that Cornelis had rented the house to someone else proves his own residence there. That he was one of the Overseers of the Fishmarket and its chapel in 1517 confirms his association with the place (see Gast. Arch. 1011 cited in C. Dozy et al., "Miscellanea," assorted notations made in the archive before inventarization). This document conflicts with the official list for 1517 in S. A. 74. See further, note 49 below.

22. The intervening years are not recorded. The death date of Cornelis' widow is mentioned in estate litigation.

23. A further indication of Cornelis Engebrechtsz.'s presence in Leiden in 1504 is found in R. A. 50, 1494-1509, folio 92, March 18, 1504, where he is mentioned already living in the house connected with the St. Catherine's Hospital.

24. Gibson, diss., 14-15. In the 1504 *Maenboek* the name of the previous owner, Lucie Pieter Woutersz.'s

10

widow, is crossed out and a correction is made, *"huys Cornelis Engebrechtsz."* The previous owner could have been the mother of Cornelis' wife, Elysabeth Pietersdr., but there is no proof that this was so, although it would seem to have been De Graaff's assumption. Cornelis might also have bought the house, rather than acquiring it through his wife's inheriting it.

25. R. E. O. Ekkart's statement that there was no guild in the time is incorrect; see his "Leidse Schilders, Tekenaars en Graveurs uit de Tweede Helft van de 16de en het Begin van de 17de Eeuw," *Jaarboekje voor Geschiedenis en Oudheidkunde van Leiden en Omstreken,* LXVI, 1974, 193 (the footnote supporting the opinion was unfortunately not printed). See also the brief reference to the Leiden guild in this period in Hoogewerff, *De Geschiedenis van de St. Lucasgilden in Nederland,* Amsterdam, 1947, 58-59, citing Blok's history of Leiden, second edition.

26. The additional expenses would have included travel and room rent. Apprenticeship took place during minority; lawsuits about apprenticeship, therefore, invariably were brought by or against the parent or legal guardian of the apprentice. Such lawsuits are found in R. A. 42 and R. A. 43. For examples concerning painters, see R. A. 42, June 2, 1488, painter Jan Jacopsz.; September 2, 1513, painter Jeronimus Cornelisz.; September 6, 1532, painter "Jan Jacopsz." (actually Jan Jansz., as shown by R. A. 42, August 16, 1529; May 16, 1530; June 13, 1530). For Cornelis Engebrechtsz., see R. A. 42, June 15, 1520, discussed below.

27. See Kl. Arch. 119 [1490], folio 93.

28. Kl. Arch. 123, 1499-1500, (unfoliated, headed:) *"Buyten Haerlem"* (outside Haarlem); compare the record for the following years under the same heading; the land was bought by Andries Ropier. For the connection of Ropier with Mostaert, see M. Thierry de Bye Dólleman, "Jan Jansz. Mostaert, Schilder, een beroemd Haarlemmer (ca. 1473- ca. 1555)," *Jaarboek van het Centraal Bureau voor Genealogie,* XVII, 1963, 123-136.

29. The use of the land by millers implies that the Jan Mostaert named was the painter's father, a miller, as does the early date 1490.

30. Transport was usually by scow, to judge from the comparative number of lawsuits involving freight charges and bargemen and freight charges and waggoners in R. A. 42 and R. A. 43. Faster travel, however, was by horse or horse and wagon (although this would not apply to Haarlem); see the annual lists of the burgomasters' travel expenses in the Thesauriers Rekeningen. That Jan Mostaert might have studied in Leiden, at Hieronymusdal for example, should be considered, since van Mander's informant about Mostaert, Claes Suycker, was inaccurate (see de Bye Dólleman's article mentioned in note 28).

31.' De Bye Dólleman assumes that the identification of Jan Mostaert as a *"schilder"* in 1498 implies that he was already accepted as a master in the guild at Haarlem (De Bye Dólleman, "Jan Jansz. Mostaert," 127). If this applies to the Latin word is not clear; perhaps Cornelis was a "journeyman" (although this term had no exact equivalent in the guild structure) and had not yet produced his entrance masterpiece and set up his own studio.

32. See note 13. This is consistent with ca. 1489 as the latest reasonably acceptable birth date for Pieter Cornelisz. Kunst.

33. It is impossible to determine which small towns, if they had guilds, strictly enforced such a general rule between 1482 and 1486-1487. Cities may be presumed to have enforced it, as did Leiden.

34. This is indicated by the clear absence of legal precedent in the litigation about the estate of Jan Zevertsz., arising from his simultaneously having been a burgher of Leiden and Antwerp (R. A. 41, 1533-1542, folios 57 and 57 verso, October 29, 1534; document mentioned in M. E. Kronenberg, "Lotgevallen van Jan Severz., boekdrukker te Leiden (c. 1502-1524) en te Antwerpen (c. 1527-c. 1530)," *Het Boek,* XIII, 1924, 34).

35. Lawsuits about such fees from Leiden guilds are found in R. A. 42 and R. A. 43; for example, see R. A. 42, April 12, 1538, where the guild of the *"Vier Gecroende"* and St. Quyryn (guild of bricklayers, stonemasons, and sculptors) demanded one blanck per week from a non-Leiden mason who had worked in Leiden for thirty weeks. Other cases refer to day fees. See also R. A. 42, March 21, 1544, for a lawsuit brought by the St. Joseph's guild against a cabinetmaker, Gabriel van der Goude (that is, from Gouda), who had not paid his fees for working in Leiden. The limit on such work was a year and a day, as noted below. That painters did travel for work outside their own towns is well known. Jan van Scorel travelled extensively, including to Leiden, although he enjoyed exemption from guild regu-

lations and civil court proceedings as a canon. His visit to Leiden in 1541 or 1542 is mentioned in connection with the Pieterskerk organ. In 1520 Jan Gossaert *dit* Mabuse travelled to Utrecht for a commission (see W. H. Vroom, "Jan Gossaert van Mabuse als ontwerper van koorbanken in de Dom van Utrecht," *Oud Holland*, LXXIX, 1964, 172-175; this appears to differ from the dates given in H. Pauwels, H. R. Hoetinck, S. Herzog, *Jan Gossaert genaamd Mabuse*, exhibition catalog, Rotterdam, Museum Boymans-van Beuningen, and Bruges, Groeningemuseum, 1965, 376). Leiden was visited briefly in 1520 by an Antwerp sculptor (? or goldsmith) named "Meester Jaquet van Antwerpen"; see R. A. 42, February 26, 1520, a demand from Meester Jaquet for proper payment for work he had done on the ostensory of the church "of Katwijk." (Which of the two Katwijk villages is not stated.)

36. See R. A. 42, November 16, 1534, for an attempt by the city to collect on this excise, from the bookseller and printer Bartelmees Jacopsz., who had moved to Amsterdam after living in Leiden since at least before April 29, 1521 (R. A. 42). The collection of this excise is also recorded annually in the city treasury records. That such an excise was not limited to Leiden is shown by Jan Mostaert's petition to the burgomasters of Haarlem for an excise-free leave of absence of more than a year in order to paint the altarpiece for a church in Hoorn. See A. van der Willigen, *Geschiedkundige aanteekeningen over Haarlemsche Schilders*, Haarlem, 1866, 166. The burgomasters granted the petition, stipulating that if the absence exceeded eighteen months, they would proceed with the usual excise litigation and collection. J. Snyder states that because Mostaert's name "does not appear" in the Haarlem archives between 1550 and 1554, Mostaert probably intended to settle permanently in Hoorn, citing van der Willigen's publication of the petition and answer (Snyder, "The Early Haarlem School of Painting, Part III: The Problem of Geertgen tot Sint Jans and Jan Mostaert," *The Art Bulletin*, LIII, 1971, 451). Evidently Snyder misunderstood the document published by van der Willigen and explained by Hoogewerff, *Noord Nederlandsche Schilderkunst*, II, 501.

37. Gibson, diss., 78.

38. The documents connected with Cornelis' house contradict the statement that he is not recorded in Leiden between 1502 and 1506.

39. Pelinck, "Cornelis Engebrechtsz, De Herkomst van zijn Kunst," *Nederlandsch Kunsthistorisch Jaarboek*, II, 1948-1949, 40-74 and 376-378.

40. Pelinck, "Cornelis Engebrechtsz," 42. Further proof that the anonymous paintings should be ascribed to Cornelis is seen in their display of what are supposed to be characteristics of painting in Holland. These characteristics are a soft lighting that is very finely accented and the rounding of forms, which is considered less hard and angular than in the works which Pelinck thinks may be properly attributed to de Coter. J. Bruyn thinks that the Brussels 1518 portraits are not by Cornelis Engebrechtsz. precisely because they lack what is considered by Bruyn to be Cornelis' characteristic angularity of form. Gibson says that the "Colynesque" paintings discussed by Pelinck display hard draughtmanship and a treatment of anatomy that are just not the way Cornelis did it (Gibson, diss., 77).

41. Lucas van Leyden's acquaintance with the engravings and woodcuts of Dürer is indisputable. The woodcuts appearing in books printed in Leiden had diverse origins. Some were copies of blocks from other books, some were re-used blocks from books originally published elsewhere, and some were new. Books printed elsewhere were clearly available in Leiden. For example, Jan Pietersz. van Dam, the sculptor, demanded the return of a "*Duytsche Bibel*" (Bible in Dutch or German) on October 14, 1519 (R. A. 42). Cornelius Aurelius' acquaintance with illustrations from non-local books is shown by the map in the *Cronycke van Hollandt 1517* (see C. P. Burger, "De Oudste Hollandsche Wereldkaart, een werk van Cornelius Aurelius," *Het Boek*, V, 1916, 57). And Jan Zevertsz. brought suit on August 8, 1511 (R. A. 42), for damages connected with a pattern boek ("*een vedemus boek*"), as well as to ensure that the defendant, Pieter Jansz. keep to their mutually arranged contract. The reference to a joint contract suggests that the printer Pieter Jansz. van Woerden was meant, not the painter Pieter Jansz.; the printer is known to have worked closely enough with Jan Zevertsz. to have issued later editions of his publications.

42. See Taurel, *Christelijke Kunst*, I, 190.

43. S. A. 84, folio 183 verso.

44. S. A. 84, folio 187.

45. S. A. 84, folio 195. The term used in 1514 is "Old Archers" ("*Oude Scutten*"). Hoogewerff pointed out that the term refers to the seniority of foundation of the guild and does not indicate rank or age of the

members (Hoogewerff, *Noord Nederlandsche Schilderkunst*, III, 145). The reorganization he mentions may be irrelevant; the division had existed for some time. Compare Friedländer, *Lucas van Leyden and Other Dutch Masters*, 34 and 97, note 14 (for "Haarlem" read "Leiden").

46. For 1515, 1519, and 1522, see S. A. 84, folios 198, 201 verso, and 203. For 1518-1520, see S. A. 1176, folio 5.

47. This does not indicate absence from Leiden.

48. The list in S. A. 1176, folio 5, of the company led by Cornelis Engebrechtsz. is as follows: Pieter Cornelisz., Joest Willemsz., Meester Jan Meester Heynricx knecht, Pieter Pietersz., Claes Pietersz. zijn zoon, Geryt Woutersz., Willem Jacopsz., Heynrick Pietersz. van Benthuysen, Capiteijn Cornelis Engebrechtsz., Cornelis Cornelisz., Jan Jansz. van Middelburch, Geryt Dircxz. coman. The third person listed was probably van Benthuysen's assistant and, as mentioned below in connection with the Stoop family, the assistant or servant could have been related to his master.

49. That Cornelis Engebrechtsz. was relatively wealthy is confirmed by his having been a warden of the "Vischcapelle" together with Jan Mathysz., Meester Wouter Heynricxz. surgeon, and Cornelis Jansz. *vischcoper* (Gast. Arch. 1011, February 11, 1517; mentioned without citation in Dozy's miscellaneous notes, Leiden Municipal Archives). The opinion is consistent with that of Dülberg, *Leydener Maler-schule*, 40; N. Beets, *Lucas de Leyde*, Brussels, 1913, 9; and Friedländer, *Lucas van Leyden and Other Dutch Masters*, 34. Captains for companies of two neighborhoods, for example, were Jan van Honthorst, captain-general of "T wanthuys," under whom were captains Jacop Deyman, Claes Claesz., Yssaack Claesz., Jan Bouwensz. Paedze (Paeds, Paedts), Dirck Comen Jansz., Jan Cornelisz. Cuyper, Jan de Cock (cook and innkeeper, not painter), and Pieter Hoechstraat; and Geryt van Lochorst, captain-general of "Overthoff," under whom were captains Cornelis Heerman, Geryt Roest, Tyman Dircxz., Jan van Noerde, Jan van Bosschuysen, Henric van Alcmade, and Phillips Nachtegael (See S. A. 1176, folios 1-2 verso). Gibson's opinion that the captains were not wealthy and in high social positions is incorrect (Gibson, diss., 16, with thanks to De Graaff.) For a geographical and functional idea of the neighborhoods, see H. A. van Oerle, *Leiden binnen en buiten de stadsvesten; de geschiedenis van de stedebouwkundige ontwikkeling binnen het Leidse rechtsgebied tot aan het einde van de gouden eeuw*, Leiden, 1975, 81-84.

50. S. A. 84, folio 189 (guild rules). Presumably there was also an annual mass at the guild altar of St. Sebastian in the Pancraeskerk (see R. A. 42, August 25, 1511) on St. Sebastian's Day, January 20.

51. S. A. 84, folio 189 (guild rules). This was followed by a guild hall banquet.

52. See S. A. 1176, folios 2, 5, 7, 8, 18 verso, 22 verso (the reference on folio 7 to the painter Huge is unique, so that the occupation may be incorrectly noted; see also S. A. 84, folio 186. Cornelis Cornelisz. Kunst is named in 1519, 1518-1520, and 1522 (see S. A. 84, folios 202 verso and 205; and S. A. 1176, folio 5). Pieter Cornelisz. Kunst is named in 1514, 1519, and 1518-1520 (see S. A. 84, folios 196 and 203; and S. A. 1176, folio 5).

53. The implication of Leiden birth is contained in the requirement that militia members be Leiden burghers, either by birth or by having been made burghers through an official act, to which a fee was attached. (The sixteenth-century phrase "or burgher's son" is intended to include the minors of burghers made by official act, who at majority did not have to repeat the legal procedures done by their fathers. There is no indication that the phrase is meant to take care of the unlikely chance of birth during a trip away from one's official residence.) The lists of burghers made by official act are preserved for the relevant years and neither Pieter Cornelisz. Kunst nor his brother appears on them.

54. Some people, however, were made burghers without charge, a categorical example being surgeons; their names are listed, as having paid nothing, in the treasury accounting of new burghers. These accounts appear in the first few pages of each year's accounts. The alternative checklist is the record of special acts by which people were made burghers, the "*Poorterboeken*" (S. A. 21, 22), for which an alphabetical index has been made. Cornelis Engebrechtsz. and his sons do not appear on any list of immigrant burghers. Cornelis' militia membership totally excludes the possibility of an extended stay in Antwerp after 1510, suggested by Gibson, diss., 129-130.

55. S. A. 602 (Thesauriers Rekeningen 1521-1522), folio 102.

56. The 1518 portraits are discussed below. Pieter Cornelisz. Kunst was paid by the city for other maps in 1540 and in 1540-1541. See S. A. 622 (Thesauriers Rekeningen 1539-1540), folio 54, March 5, 1540; S. A. 623 (Thesauriers Rekeningen 1540-1541), folios 64 and 65 verso (three separate payments in fiscal 1540-1541).

57. S. A. 663 (Bijlagen Thesauriers Rekeningen 1525), loose piece.
58. He spelled the patronymic "Enghebrechtsz." on this occasion, although other contemporary references to him give the usual "Engebrechtsz." He may have varied the spelling on different documents, a common practice when name spelling was not standardized.
59. S. A. 594 (Thesauriers Rekeningen 1514-1515), folio 87.
60. See J. D. Bangs, "Rijnsburg Abbey: Additional documentation on Furniture, Artists, Musicians, and Buildings, 1500-1570," *Bulletin van de Koninklijke Nederlandse Oudheidkundige Bond*, LXXIV, 1975, 182-190 (also contained in Bangs, *Documentary Studies in Leiden Art and Crafts 1475-1575*, Leiden, 1976, 182-190 (dissertation, Rijksuniversiteit Leiden, privately printed)).
61. See Bangs, "Rijnsburg Abbey," note 61.
62. See Bangs, "Rijnsburg Abbey," notes 65 and 66.
63. See Bangs, "Rijnsburg Abbey," notes 63 and 64.
64. See Bangs, "Rijnsburg Abbey," note 68.
65. The 1530 lawsuit is included with estate litigation, discussed below. Gibson mentions another document as possibly referring to the painter Cornelis Engebrechtsz. (Gibson, diss., 15): Kl. Arch. 442, December 1, 1512 (summarized in Overvoorde, *Archieven der Kloosters*, II, reg. 2152). It is a land sale document sealed by a Cornelis Engebrechtsz. and Claes Vrankensz. This Cornelis Engebrechtsz.'s seal is preserved fragmentarily. The land was in Zoeterwoude, outside Leiden. The presence of two seals indicates some sort of attestation. Probably the document is a "*bezegeld schepenbrief*" (sealed magistrates' attestation) or other document requiring two witnesses with sealing power. The seal of this Cornelis Engebrechtsz., although partial, matches part of another partially preserved seal of the Delft magistrate Cornelis Engebrechtsz. (A. R. A., The Hague, *Delftsche Statenklooster Archieven*, indexed alphabetically by name). The land sale involved orphans under the guardianship of the *weesmeesteren* of Delft, as is stated in the other document connected with the land sale, also registered under the same inventory number but not summarized by Overvoorde. The painter Cornelis Engebrechtsz. was not a magistrate or other official with sealing power. For the Delft magistrate Cornelis Engebrechtsz. Vosmaer inde Croon, see D. P. Oosterbaan, *De Oude Kerk te Delft gedurende de Middeleeuwen*, The Hague, 1973, 96-97, note 94.
66. The Rijnsburg Abbey payment of 1496-1497, although published, had not been connected with Cornelis Engebrechtsz. and the published abbey records from before 1500 where the reference to "Cornelis the painter" is indexed do not seem to have been used by students of Cornelis Engebrechtsz.
67. R. A. 42. "Zevertsz." is the most commonly found spelling of the name in documents, although he is usually called "Jan Seversz." in studies (perhaps as a falsely rationaliszed way to keep his name unconfused with that of Jan Zevertsz. the crippled printer in Amsterdam). The amount demanded may represent an approximation of the commission with an unknown additional amount of claimed punitive damages.
68. People with more than one occupation, and occupations with various facets, are often described in litigation by the term applicable to the case. For example, Cornelis Cornelisz. Kunst, painter and draper, is described as a painter in painting lawsuits and as a draper in cloth trade lawsuits; Willem Nicasiusz. van Flory, goldsmith and innkeeper, is described as a goldsmith in commission and guild lawsuits and as an innkeeper in lawsuits for the recovery of beer debts; Willem Andriesz. de Raet, tapestry weaver and draper, is described as a tapestry weaver in tapestry lawsuits and as a draper in cloth trade lawsuits. This practice is not absolute; and in cases unrelated to the occupations the term seems to be randomly chosen.
69. See Burger's article cited in note 41.
70. R. A. 42; R. A. 50, 1536-1546, loose piece dated October 16, 1536, inserted between folios 5 and 6. The second document is only a continuation of the same litigation. Pieter Jansz. van Woerden had bought a print shop from Jan Lucasz. van Delft in 1526, and that may have brought him into contact with Cornelis Hendrixz. Lettersnyder. The print shop could be the same as what Pieter Jansz. van Woerden sold the same year to heer Foye van Zyl (priest and printer); alternatively, Pieter Jansz. van Woerden may have been replacing his equipment. See R. A. 42, January 12, 1526; May 18, 1526 (twice); June 4, 1526; June 22, 1526; July 9, 1526; August 27, 1526; R. A. 41, 1520-1529, folio 325 verso (January 24, 1526); folio 345 verso and 347 verso (May 28, 1526). More complete information about Leiden printers like Huych and Pieter Jansz. van Woerden will appear in *Quaerendo*. For the present it may be

14

remarked that Huych Jansz. van Woerden was active as a printer in Leiden until 1515, having sold one house in June, 1511, but living at another address until 1515. See R. A. 50, 1509-1536, folio 18, after May 26, 1511, and before June 30, 1511; see also R. A. 42, March 5, 1515. In the intervening years he was associated with Jan Zevertsz. The foregoing information about Huych Jansz. van Woerden's residence contradicts opinions in E. W. Moes, "Hugo Jansz. van Woerden," *De Amsterdamsche Boekdrukkers en Uitgevers in de Zestiende Eeuw*, Amsterdam, 1896, I, 30; and *De Vijfhonderdste Verjaring van de Boekdrukkunst in de Nederlanden* (catalog, Koninklijke Bibliotheek Albert I), Brussels, 1973, 488; and F. J. Dubiez, *Op de Grens van Humanisme en Hervorming, De Betekenis van de Boekdrukkunst te Amsterdam in een bewogen Tijd*, Nieuwkoop, 1962.

71. Mutual agreements among the cities of Holland allowed litigation to be carried on in the city of residence of the defendent according to the local charters in the city of residence of the plaintiff, where the contract in question was drawn up.

72. R. A. 2, 1435-1500, folio 230 verso, August 6, 1498; R. A. 2, 1435-1500. folio 231, August 27, 1498; R. A. 42, April 17, 1531; R. A. 42, March 27, 1536; R. A. 42, March 16, 1537; R. A. 42, July 6, 1537; see also R. A. 4, 1528-1548, folio 32 verso, September 3, 1530; R. A. 6, folio 12, July 20, 1507; futher possible references are R. A. 42, December 16, 1513, and R. A. 42, December 23, 1513. In the last two cases, brought by the painter Phillips Claesz. van Zeyst, the defendent "Cornelis the Englishman" was temporarily in Naeldwijk. No other Englishman named Cornelis but with a different patronymic has been found in R. A. 42. In connection with the issue of Leiden's previously presumed cultural isolation I have noted the names of everyone in R. A. 42 and R. A. 43, as well as a few other important documentary series, identified as coming from an area not in what has become the present nation The Netherlands.

73. The only references to an unspecified "Cornelis the painter" in this period are those from Rijnsburg Abbey.

74. The lawsuit is too early to refer to Cornelis Cornelisz. Kunst, so far as can be determined from documents now known. Definite acquaintance of Jan Zevertsz. with Pieter Cornelisz. Kunst is proven on August 19, 1521, when Jan Zevertsz. subpoenaed Pieter together with various other people for testimony about unspecified matters (R. A. 42). Jan Zevertsz.'s publication of Aurelius' *Cronycke van Hollandt 1517* shows connection with the monastery, to which he later sold a book, *Speculum Confessorum* (see Kl. Arch. 125, unfoliated, verso of the twenty-third folio, counting an uncut page as two folios, dated 1518).

75. Dirck Adriaensz. Mast, active until 1565, was a painter, innkeeper, and lawyer. As lawyer to Johanna van Swieten, Vrouwe tot Upmeer, he may have been the painter responsible for the renovation of the van Swieten memorial painting (Leiden Municipal Museum "De Lakenhal"). His brother was the Leiden bookprinter Claes Adriaensz. Mast. Both are mentioned briefly in L. Knappert, *De Opkomst van het Protestantisme in eene Noord-Nederlandsche Stad, Geschiedenis van de Hervorming binnen Leiden van den Aanvang tot op het Beleg*, Leiden, 1908, 78 and 109. The Matheus van Berendrecht who was visiting Dirck Mast, mentioned by Knappert, is identical with the pewtersmith mentioned in the last lawsuit naming Cornelis Engebrechtsz. during his life. For some of the necessary corrections to Knappert, see A. F. M. Mellink, *De Wederdopers in de Noordelijke Nederlanden 1531-1544*, Groningen, 1953, 186-207.

76. R. A. 42. The father's name was Cornelis Ghysbrechtsz.

77. The practice was found in several guilds. Lawsuits about guild fees for apprenticeship of members of the St. Lucas guild are recorded in R. A. 42, October 7, 1541, among other places. Lawsuits implying a maximum of two apprentices at any one time are recorded in R. A. 42, October 7, 1541, and June 15, 1554, and in R. A. 43, February 4, 1566. The period of apprenticeship was two or three years, of which the first two were considered the period in which the apprentice learned the trade mostly at the expense of the master and the third year was a year in which the work of the apprentice, by now up to reasonable standards, was for the profit of the master. The arrangements seem to have been contracted individually, rather than being specified by guild regulations (see R. A. 42, September 6, 1536). Two-year contracts may have been prevalent, because they are mentioned relatively frequently in apprenticeship litigation (for example, R. A. 42, February 16, 1543; March 2, 1543; September 10, 1546; and R. A. 43, September 24, 1566). A case mentioning the third year as profit for the master occurred on March 22, 1555 (R. A. 42). It is possible that a former apprentice could be hired with a

similar contract to stay as an assistant (an escape clause in the event of non-salable production after two years, perhaps). Besides the case of Huych Jacopsz., "*knecht*" of Brother Tyman, only one other reference to a painter's "*knecht*" has been found in the Leiden documents (see Bangs, "Rijnsburg Abbey," 189, note 117). The word could mean apprentice, assistant, servant, or foreman, depending on context. In the Rijnsburg reference, the painter's "*knecht*" could very easily have been that particular painter's brother, since they collaborated. Cabinetmakers, however, did employ such assistants, and their guild sued some of its wealthier members on June 15, 1554 (R. A. 42), for employing more than the guild's statutory number of assistants.

78. R. A. 42. The frequency of Dirck Hugenz.'s wife's court appearences makes it unlikely that another person of the same name is noted in the lawsuit against Cornelis Engebrechtsz., whom she must have known through guild contacts. She divorced Dirck Hugenz. in 1535 (see R. A. 42, January 29, 1535, two cases).

79. R. A. 42, Although Cornelis' occupation is not given in this one case, the connection with the painter's son's business associate is sufficient grounds for identifying this as Cornelis Engebrechtsz. the painter. *No other person with the same name and patronymic has been found as a Leiden resident in the Leiden documents of this period.* The subpoenaes probably had to do with a contract dispute between Matheeus van Berendrecht and Roeloff Gerytsz. (R. A. 42, February 8, 1527), on which a decision of February 15, 1527, was in van Berendrecht's favor, based on the testimony heard by the magistrates.

2. The Marienpoel Convent and Cornelis Engebrechtsz.

Two of Cornelis Engebrechtsz.'s most important works came originally from the Augustinian convent of Marienpoel in Oegstgeest, just outside Leiden.[1] Both are triptychs, *The Crucifixion*, and *The Lamentation* (or: *The Seven Sorrows of Mary*, as the center panel contains the other six sorrows in small scenes at the sides). Both are now in the Leiden Municipal Museum "De Lakenhal."[2] To determine where the triptychs hung in the convent has been considered impossible.[3] Documentary evidence enables a suggestion to be made that they were, on the contrary, located at identifiable places within the convent chapel.

Ill. 1,2,3,4

The Chapel and its Contents

An idea of the chapel itself must first be formed. The convent was founded by Boudewyn van Swieten in 1428 and the chapel was consecrated in 1430. It underwent various alterations, but in the course of war it was deserted and in ruins by 1573.[4] No descriptions of the chapel as such are preserved and there are no reliable depictions of it. The following remarks are based on preserved convent documents.

The chapel was a hall church without aisles, seven bays long. Each bay was provided with an elaborately carved vaulting boss donated by area nobles in 1522.[5] The apse could have been square or polygonal. Seven bays indicates the presence of twelve buttresses (outside) and pilasters (inside), besides buttresses at the apse and west end corners.[6] The pilasters were provided with statues of the apostles, donated in 1497.[7] There was also a statue of Mary, evidently within a suspended *Marianum* in front of the high altar.[8] The priests' choir occupied the easternmost three bays, with the high altar probably in the easternmost bay.[9] A choir screen separated these from the other four, although as a "closed" convent, the "nave" was not open to the public.[10] The "nave" was covered by an upper choir (or balcony) extending to the parapet or balcony rail of the choir screen.[11] This was the nuns' choir.[12] It contained facing choir stalls and a lectern.[13] The nuns' choir was reached by a circular stair, whose ground floor door opened into the lower choir.[14]

Ill. 9,10,11

The chapel in this form had a ground plan and section like those of the Utrecht convent chapel incorporated in the Aartsbisschoppelijk Museum; and like the former arrangement of the chapel which has been rebuilt to serve as the *Academie Gebouw* of the University of Leiden.[15]

Marienpoel had four altars. The high altar was dedicated to the Virgin Mary, SS.

Jerome and Augustine, SS. Katharine and Ursula with her accompaniment, and All Saints.[16] The three other altars were located against the choir screen.[17] The "Sacraments Altar" (Altar of the Holy Sacrament) was dedicated to SS. Stephan Martyr, Agnes, Elysabeth, and All Saints.[18] It supported the "*Sacramentshuis*" (ostensory, in which the cibory with consecrated host was displayed).[19] Such a "*Sacramentshuis*" was usually an elaborately carved item of stone, decorated with miniature architecture-like tracery; thus it is unlikely that there was a painted triptych as an altarpiece for this altar.[20] The middle altar of the three in front of the choir screen was first dedicated to SS. Andrew, John the Evangelist, and Mary Magdalene;[21] however, at "reconsecration"[22] in 1571, the altar was dedicated to God, the Virgin Mary, the apostles Andrew, Thomas, and John the Evangelist, as well as all the other apostles, furthermore, to SS. Nicolas, Willebrord, Adelbert, Mary Magdalene, Mary of Egypt, All Saints, and the Holy Cross.[23] For short, it was called the St. Andrew's Altar.[24] The high altar, the Sacraments Altar, and St. Andrew's altar were donated by Adriaen van Swieten and dedicated in 1457.[25] The last of the group of three altars at the choir screen was dedicated in 1457 also, a donation of Vranc van der Bouchorst.[26] Known as the St. Barbara Altar, it was dedicated to SS. Barbara and Dorothy, and the Ten Thousand Martyrs, and to all virgins.[27]

The 1457 dedication of the four altars presumably indicates alterations to the church made in memory of the founder Boudewyn van Swieten (d. 1454), Adriaen's father. The church consecrated in 1430 must have been simpler, having one altar, whose altarpiece was probably the carved wooden triptych received in 1420, the year the convent moved to Oegstgeest.[28]

The crucifix used in the Holy Week processions was displayed during the year in a stand of some sort.[29] This may have been in the "Holy Cross Chapel," which had no separate altar and which was apparently located in the choir.[30] A sculpture of the Holy Sepulchre (*Entombment*), dating from 1497, was also located in the chapel.[31] The Holy Cross chapel may have been identical with the sculptured *Entombment*, as was the case in the Leiden Jerusalems Chapel.[32] The date of the Marienpoel Holy Sepulchre suggests a combined commission with the apostle statues of the same year. Three paintings assumed to have come from Marienpoel because their donors are Augustinian nuns accompanied by St. Augustine depict *Christ Crowned with Thorns*,[33] *Christ Nailed to the Cross*,[34] and *The Lamentation*.[35] A typical location for the Holy Sepulchre would be behind or to the right of the high altar, where the grave of the prioresses was. These three paintings have been discussed in connection with the work of Cornelis Engebrechtsz. in the past, sometimes attributed to him on stylistic grounds.[36] They may be considered as a group, and it may be postulated that they were associated with the special devotional services held daily by the nuns, Tuesdays and Thursdays excepted, at the Holy Sepulchre, for which a forty day indulgence was granted in 1497.[37]

In 1486 Adriaen van Swieten[38] left the convent various legacies including 38 Rijns guldens for the middle panel of the triptych of the St. Andrew Chapel.[39] The side panels had been painted at his expense (£ 3/—/— Flemish) during his life.[40] He also willed money for the canopy to be built to house the triptych and for a lectern at this altar.[41]

18

The Sacraments Altar almost certainly had no triptych on it, because of its Ill. 12 *Sacramentshuis*. The St. Andrew's altar was provided with the triptych of 1486. The van Swieten Memorial Painting (Leiden Municipal Museum "De Lakenhal") has been considered to represent the altarpiece of the high altar, but this cannot be accurate, because no reconstruction of the "renewed" painting (renewed in 1552) can be proposed in the form of a triptych, as would be necessary from its size. The arrangement remains unsymmetrical, with those memorialized facing a Madonna and Child not in the center. Any proposal for a triptych would cut through one or more portraits, since the number of figures is uneven, consisting of married couples and one nun (the first prioress, Katherina van Swieten). The memorial painting was probably located as was customary in the neighborhood of the van Swieten family tomb. This would make placement on either wall of the priests' choir or on the choir side of the choir screen a likely position instead of the high altar. The van Swieten tomb was in the center of the priests' choir.[42]

The high altar and the St. Barbara altar, thus, remain as possible locations for Ill. 1,2 Cornelis Engebrechtsz.'s two triptychs. The *Crucifixion* triptych is larger, and its function as an altarpiece is indicated by a predella which springs out from what must have been the width of the altar itself.[43] It is my opinion that this was the altarpiece of Marienpoel's high altar. The commission, in this hypothesis, can be seen in the context of a gradual enrichment of the high altar which took place in 1496 (the *Marianum*), continuing in the painting of the statue of Mary in 1497, as noted above, and continued further in 1499 and 1500, when sums of money were spent for the high altar itself.[44] The *Lamentation* or *Seven Sorrows of Mary* triptych, then, remains as the altarpiece of the St. Barbara altar, which was dedicated also to all virgins.[45]

The Donor

Dating these two triptychs has issued in controversy among students of Cornelis Ill. 3 Engebrechtsz.[46] C. E. Taurel's identification of the donor of both altarpieces as the Marienpoel regent Jacop Maertensz. provides a *datum post quem*.[47] Jacop Maertensz. arrived at Marienpoel in 1508 (*not* 1504); he died, however, in 1526, which leaves a long time open for the commissions.[48] Pelinck has argued from the *Necrologium* entry for Jacop Maertensz. that he arrived in Marienpoel in 1504 as auxiliary chaplain and became regent in 1508.[49] Because Pelinck thinks it "hardly probable" that Jacop Maertensz.'s chaplaincy of four years followed retirement as regent, Pelinck assumes that the four years preceded the regency. The *Necrologium* states: Anniversarius venerabilis patris nostri Jacobi Martini Canonici regularis de Heyloe octavi rectoris nostri qui laudabiliter rexit quatuordeci annis et fuit quatuor annis fidelis socius Obyt anno domini MCCCCCXXVI Etatis vero sue quinquegesimo.[50] Pelinck reverses the order stated.

It is Pelinck's opinion that Jacob Maertensz. succeeded Jacop Schout as regent in 1508.[51] Jacop Schout is mentioned on May 6, 1508, as *"broeder Jacob Schout pater ende confessoir van die nonnen tot Poel buyten Leyden."*[52] (*"Pater ende confessoir"* is, incidentally, synonymous with "regent" and "rector" in the *Necrologium*.) Pelinck

19

cites this as if it implied that Jacop Schout had died in or before 1508, which this document does not. *Another* Jacop Schout had died in or before 1508. Sixteen of his heirs and their representatives, his grandchildren and his children or their spouses, gave full power of attorney to the husband of one of the heirs, Katryn Michielsdr., whose husband Vrydach Gerytsz. was empowered to represent them before the Court of Holland in estate litigation against a Jacop Adriaensz.[53] Vrydach's wife Katryn, who was one of this Jacop Schout's heirs, was also a donor of one of the Marienpoel vaulting bosses; and their daughter, also an heir of this Jacop Schout, was a Marienpoel nun, Marytgen Vrydachsdr.[54] Gibson notes that the year 1507 is given for the death of rector Sebastian Francxz. by R.H.C. Römer;[55] and Gibson correctly suggests that Jacop Maertensz. may have succeeded Sebastian Francxz., contradicting Pelinck.[56]

There were certainly two Jacop Schouts, the first of whom died in 1508 and had many legitimate descendents, and who was almost certainly related to the other, Jacop Maertensz. Schout, who was Marienpoel's eighth rector, and who died in 1526. The conflation of the two appears first in H. F. van Heussen.[57] The continuous list of rectors derived from the *Necrologium* (see note 48) and additional family connections discussed below indicate that the surname of the regent Jacop Maertensz. was Schout, and that he was not from Amsterdam, contrary to Taurel, who suggests that he was born there and, presumably having no coat of arms, used not a "housemark" but that of the town of Amsterdam (to honor his birthplace) on the *Lamentation* triptych.[58] Ill. 17 Cornelis Engebrechtsz.'s triptych has the coat of arms in grisaille. Its connection with Leiden families including van der Bouchorst, van Swieten, and especially van Dorp, is discussed in notes below.[59]

Unlikely as it may seem, Jacop Maertensz. Schout did retire as regent, while remaining as a priest in the convent (*socius*). His retirement can be understood in terms of financial mismanagement, which is clearly recorded in the convent's account books.[60]

Jacop Maertensz. Schout's Art Acquisitions on Credit

Notable improvements were made in the rector's living quarters before Jacop Maertensz.'s retirement. A small amount was paid in 1518-1519 to the cabinetmaker Claes Oliviersz., £ −/14/6.[61] In 1519-1520 £ 10/−/− payment for woodwork in the regent's room was made to the same man.[62] In 1521-1522 he was paid 24 stuvers for a writing desk in the rector's smaller room; the stained-glass painter Cleophas Anthonisz. of Delft was paid £ 6/−/− for two stained-glass panels in the same room; and 4 stuvers freight cost was paid for transporting the windows from Delft.[63] In 1522-1523 a tapestry was bought from heer Willem van Alckemade, knight.[64] This was used in the large priests' hall. Further, £ 27/−/− was donated to the Prior of 's Gravenzande for a choir stall to be built in his priory, as thanks for hearing confession at Marienpoel.[65] 6 stuvers were given to the assistants of Cleophas Anthonisz. for installing the two stained-glass windows in the regent's smaller room.[66] Claes Oliviersz. recieved 38 stuvers.[67] 8 stuvers and 2 pence were spent for drinking glasses, thirteen of which were

20

bought at Delft.[68] Cleophas Anthonisz, received an additional £ 2/10/— for remaking the two top panes of the window, for which he had been given incorrect measurements at first.[69]

These pages precede the famous list of commissions for the regent's house, which have been incorrectly ascribed to Brother Lambrecht Jansz., who is said by Jacop Maertensz. to have shared the administration with him sometimes. One of two references confirming this is the often cited document in which he is called "regent."[70] This document was written by the sheriff of the manor of Noordwijk, who may not have known at that point, April 11, 1523, who the regent actually was. Lambrecht Jansz. was never regent and does not appear among them in the *Necrologium*, although he may have expected to succeed Jacop Maertensz. Schout and was being trained in the job.

In fact, the famous commission came from Jacop Maertensz. himself. They include *"een Marienbeelt hangende in paters boven camer gecoft van Jan van der Bouchorst ende Meester Hughe Jacopsz. tot Leyden"* for £ 6/—/— (Flemish); a *"tafereel met deuren"* hanging in the rector's dining room, costing £ 3/21/— [*sic*]; a wood crucifix in the rector's lower room, with a *"camelooten"* skirt, costing £ 2/10/—; a pewter candlestick, bought together with a statue of St. Paul for £ 4/10/—; repainting a birdcage in the dining room at a cost of £ 1/17/—; a slate in a frame for keeping records (a good idea, but a little late) bought for 13 stuvers; *"een figuer"* bought from *"Meester Lucas tot Leyden"* depicting *The Flight to Egypt* for £ 2/5/—; an oiled and varnished cloth to protect the large painting in the upper room of the rector (this was evidently the painting by Huych Jacopsz.) costing 17 stuvers; a small stained-glass panel bought from Pieter Cornelisz. Kunst depicting, according to previous references to these commissions, a drinking scene (perhaps, on the other hand, its subject is in fact not specified, since the payment records the potation, *"wijngelach"*, which normally accompanied completion of a window, depending on the interpretation of the word *"met"* (with)). The payment to Pieter Cornelisz. Kunst is described as: *Peter Cornelisz. tot Leyden voir een clein glaesken gescreven staende inden neder camer met wyngelach ende anders —— XII st."*

There are several attempts in the records to ascribe the financial problems to Lambrecht Jansz., who is not referred to as the *"pater"* ("rector" or "regent"), but as *"brueder"* ("brother"). The next folio after the records of the art commissions describes the records as the recollection of what the rector had done and whereupon he called for correction on the basis of better proofs if anyone had them, placing himself entirely in justice in the presence of God, who will judge both those who do misdeeds and those (worthy of praise, presumably) who must suffer injustice under pressure.[71] At the bottom of the next folio is the statement that the rector owed the convent an approximate total of £ 89/10/6; at the bottom of the following folio, the last of the book, it is declared that the rector's debts total £ 160/5/—. In this context it is not so surprising that Jacop Maertensz. Schout retired from the regency early.

The records for the following year, 1523-1524, are carefully signed by Jacop Maertensz.'s successor as regent, Mathias Willemsz., together with the prioress, the procuratrix, another nun, and the accountant. The same is true for the 1524-1525 records. In 1525-1526 the next rector, Servatius Rogerii the early friend of Erasmus,

signed with the other people, as he did in later years also. (Mathias Willemsz. had resigned to become prior of the monastery of Polris.) The financial problems in the later years of Jacop Maertensz.'s regency explain the total of fourteen years' regency and four years' assistant chaplaincy as beginning in 1508, which is consistent with the order of the *Necrologium*.

The triptych in the 1522-1523 records cannot be identified as one of Cornelis Engebrechtsz.'s Marienpoel altarpieces, even though bought by Jacop Maertensz. and not Lambrecht Jansz. Its price is not high enough to be consistent with the prices paid for other works of art or for the amounts donated as parts of the St. Andrew's altar triptych, the doors alone of which cost £ 3/—/— (Flemish) before 1496, as mentioned above. Although £ 6/—/— had been paid for Huych Jacopsz. painting of Mary, if Friedländer is to be believed that "The mere sight of the Mother of God did not satisfy Dutch devotional needs — that required a story-telling sermon, dramatized with incident,"[72] Huych's painting must have been unsatisfactory. This could have been the reason for Jacop Maertensz.'s acquisition of other art, such as the smaller triptych. Alternatively it could be hypothesized that Jacop Maertensz. was not essentially Dutch, or that he was not devout. The documents suggest an art lover with a budget too small for his wishes.

The Date of Cornelis Engebrechtsz.'s Marienpoel Altarpieces

Ill. 1,7,8 Van Asperen de Boer and Wheelock discovered that the predella of the Crucifixion triptych contains two anomalous underdrawings for donors which were never painted, and which do not correspond with the portrait of Jacop Maertensz. Schout painted on the predella.[73] I should like to propose the following hypothetical explanation.[74] Conceivably the two donor figures in the underdrawing were intended to be portraits of two regents.[75] Two had died in 1496, Johannis Chrispiani of Heilo and Ghysbert N. of Donck; two others died within a short time of each other, Gerard Dircxz. in 1504 and Sebastian Francxz. in 1507. As an altarpiece for the renovated high altar, the triptych could have been planned as a memorial for either pair of regents, although preference would go to the idea of a memorial to the two who died the same year. Their portraits could have been replaced by that of Jacop Maertenz. Schout. The memorialization of the four deceased rectors preceding him is, I think, quite likely seen in the *Spes Nostra* painting, discussed below.

Ill. 3,4 The architectural ornament on the outsides of the wings of both triptychs is practically identical, suggesting closeness to each other in date, if they were not simultaneously commissioned. The absence of "Antique" ("Renaissance") ornament[76] in the Marienpoel triptychs compared with the ornament on the wings of the *van der Does- van Poelgeest* triptych and the Brussels 1518 portraits suggests on the basis of architectural detail[77] that the Marienpoel triptychs are earlier. This comparison has been used before by Friedländer and I think it valid. Gibson, however, thinks that the *Crucifixion* triptych must be dated ca. 1517-1522, supposing it to display strong Antwerp influence, seen in composition, poses, and clothing.[78] In fact, the composition and clothing are derived from three of Albrecht Dürer's woodcuts of the

22

Crucifixion, all dated before 1500-1502.[79] No Antwerp influence is necessary.[80] It is my opinion (together with other writers)[81] that the Marienpoel triptychs were commissioned ca. 1508 and completed within the next two or three years.[82] Pelinck's idea that a 1508 commission could have marked Jacop Maertensz.'s accession to the regency is quite likely correct, and it gains support in the parallel donation from Gerard Dircxz. in 1496, the year he became rector, by which the *Sacramentshuis* was paid for.[83]

On Related Paintings

A painting clearly derivative of the Cornelis Engebrechtsz. *Crucifixion* triptych, and perhaps indicating his own later development of the theme, is the Philadelphia *Crucifixion* (from its original shape, certainly the central panel of a triptych), attributed by Friedländer and Hoogewerff to Jan Mostaert and dated by them at ca. 1530.[84]

The Marienpoel *Lamentation* triptych is closely associated with five other versions of the same subject.[85] Which ones, if any, Cornelis may have painted himself is disputed.[86] The Munich version is closest to the presumed prototype, Geertgen tot Sint Jans' *Lamentation* (Vienna).[87] Geertgen's painting was the basis for a closer variation, attributed to Mostaert.[88] The Marienpoel *Lamentation* and one of the associated paintings[89] include an addition to the general type, the pose of John, who with one hand wipes away a tear,[90] while with the other he supports the Virgin's right shoulder. Not a novel pose,[91] it does, however, call attention to the similarity between Cornelis Engebrechtsz.'s Marienpoel *Lamentation* and a *Pietà* attributed to Gerard David,[92] as well as to the carved wooden triptych of Valladolid, whose central scene of the *Lamentation* is a close parallel to the Marienpoel painting.[93] Unfortunately neither work is signed or dated; and they merely remind the viewer of the common stock of devices whose inventor(s) cannot be located any more, especially not on the basis of present national boundaries.

Spes Nostra, A Memorial

An anonymous painting[94] which I think probably came from Marienpoel (and could Ill. 8 be by Cornelis Engebrechtsz., Huych Jacopsz. or some other Leiden painter, like Jan Jansz.) is now called *Allegory on the Vanity of Life* (Rijksmuseum, Amsterdam).[95] A decayed corpse lies in a half-open grave in the center foreground. The stone has on it the words: *Requiescant in pace.*[96] On the left of the grave two Augustinian monks kneel, accompanied by St. Jerome; on the right two Augustinian monks kneel, accompanied by St. Augustine.[97] The Visitation occupies the central middleground (center) of the painting. The background contains a scene of the childhood of Jesus, set apparently in a convent or monastery courtyard.[98] The high altar of Marienpoel, as already observed, was dedicated to the Virgin Mary, SS. Jerome and Augustine, SS. Katherine and Ursula with her accompaniment, and All Saints. In front of the high

altar was the family grave of the van Swietens;[99] to the high altar's left was the grave of the priests of the convent.[100] This peculiar painting can be considered a possible memorial to the four rectors who died in 1496, 1504, and 1507, together with their predecessors. As such it would have hung above their communal grave beside Marienpoel's high altar. The painting would thus also be dated as finished ca. 1508; and it invites comparison with the portrait of Jacop Maertensz. Schout on Cornelis Engebrechtsz.'s *Lamentation* triptych. This hypothesis would account for the fact that the monk farthest right was painted over the completed extended robes of the monk second from right and over the completed figure of St. Augustine.[101] The monk at the left edge may be a similar addition, although traces of the figure underneath (if any) are lacking. The two monks facing each other second from right and left would in this way be identifiable as the two rectors who died in 1496 (Johannes Chrispiani and Ghysbert N.). In any case the monk farthest right appears more recent than the other three and very likely represents the rector who died in 1507 (Sebastian Francxz.), while the remaining monk would be the rector who died in 1504 (Gerard Dircxz.). These identifications, however, depend on the unproven hypothesis that the painting was in Marienpoel. The painting can be associated with more elaborate contemporary memorial iconography,[102] as well as with the patron saints of the high altar of Marienpoel. A hypothetical connection with Marienpoel can, therefore, be accepted more readily than the hypothesis proposed by H. Schulte Nordholt connecting the painting with the Augustinian monastery of Sion naer Delft, and considering it an early "allegory."[103] The monastery Sion burned to the ground in 1544 with its contents,[104] in itself a reason to doubt that the painting came from there. Further, the "Altar of the Dead" postulated as the painting's location within that monastery is a concept for memorial services which has no parallel in preserved Leiden monastic records.

An Open Question

The so-called Paedts-van Raephorst or Paedts-Pynssen triptych, whose central panel depicted the *Feeding of the Five Thousand* (formerly in Berlin; destroyed)[105] is another painting ascribed to Cornelis Engebrechtsz.,[106] which may have tenuous connections with Marienpoel. The right wing included an Augustinian nun among the group of six women accompanied by St. Barbara.[107] It has been noted that no Paedts-van Raephorst or Paedts-Pynssen family has been discovered among Leiden records.[108] The Paedts coat of arms, however, is the same as that of Heerman of Oegstgeest (modified here by the addition of the coat of arms of the donor's mother in the center); moreover, the Paedts family was a branch of the Heerman family. Other branches of the Heerman family used the same coat of arms, for example, the families van Ryswyck, van Zonnevelt, and Spruyt, and that of the mother of Boudewyn van Swieten, the founder of Marienpoel.[109] Alternatives exist also for the coat of arms identified as van Raephorst or Pynssen, chiefly appearing in the Leiden family Gorter van Reygersberch.[110] This multiple use of the same heraldry, together with variable surname usage,[111] raises the possibility that the triptych was commissioned by one of

24

the families closely connected with Marienpoel.[112] That the prioresses and nuns of Marienpoel were often relatives or descendents of families of principal donors of the convent complicates the question of identifying the families of the donor(s) of the *Feeding of the Five Thousand* triptych, a question which must remain open until systematic genealogical and heraldic research has been undertaken for the area.[113]

Notes

1. Van Mander, *Schilderboek*, folio 210 verso. For Marienpoel, see Overvoorde, *Archieven van de Kloosters*, Leiden, 1917, I, 120-121; and W. J. J. C. Bijleveld, "Het nonnenklooster Mariënpoel en de stichter Boudewyn van Swieten," *Jaarboekje voor Geschiedenis en Oudheidkunde van Leiden en Rijnland*, II, 1905, 138-178.

2. Pelinck, *Stedelijk Museum "De Lakenhal" Leiden Beschrijvende Catalogus van de Schilderijen en Tekeningen*, Leiden, 1949, 57-70 (including information about the *van der Does- van Poelgeest* panels, discussed below), nos. 93 and 94, as well as no. 622; further 97-100, no. 250, for the van Swieten Memorial painting, also from Marienpoel and discussed below. Pelinck provides additional bibliographical references for the paintings and for Marienpoel.

3. Bijleveld, "Het nonnenklooster Mariënpoel," 163. The plan and section of the chapel of Marienpoel proposed below disregard Gibson's generalizations about medieval churches and the "Mass of the Dead" (Gibson, diss., 119). Various locations were used for memorial services for donors, and the specific instructions for them are given in the service book of Marienpoel (Kl. Arch. 882). Moreover, unspecified memorials were held on the associated Saint's Day, and the names of the people to be remembered were inserted in the proper prayers in the services of the day, which were usually said at the high altar but sometimes at other altars for reasons unrelated to the person remembered. If a "Mass of the Dead" means a requiem mass preceding burial, then it is clear from instructions in Kl. Arch. 882, Kl. Arch. 883, and Kl. Arch. 884 that the high altar was used.

4. See R. A. 43, May 8, 1573; see also R. A. 43, April 10, 1573, and April 17, 1573, for the sale of the woodwork, ironwork, windows, and everything else that could be removed from the convents Roomburch and Engelendal. Additional references on Marienpoel are given in Overvoorde's introduction to the convent archives (see note 1 above). Particularly interesting in the context of prevailing notions of the extent of iconoclastic destruction is that the contents of these convents were sold, not merely destroyed. The excavations described in G. P. Roodenburg and H. H. Vos, "Onderzoek op het kloosterterrein Mariënpoel naar het burggrafelijk kasteel Paddenpoel," *Jaarboekje voor Geschiedenis en Oudheidkunde van Leiden en Omstreken*, LVIII, 1966, 65-66, were not carried out on the convent location indicated on the tapestry map of Leiden and surrounding areas (Leiden Municipal Museum "De Lakenhal") by Lankaert. This may explain the absence of any convent remains in the excavated location.

5. Kl. Arch. 883 (a clearer copy is found in Kl. Arch. 884), unfoliated, noted after notes on memorials to be held in various months: Int iaer ons heer: MCCCCC ende XXII doe sijn die roosen int priesters choer ghegeven Die eerste roos heeft ghegeven die edel. Vrou van Wassenair, Josina van Egmondt, heer Jan van Wassenaers huusvrou Die anderde roos Meester Jacop van Lichtenberch Die derde roos Gielis van Vlaeminckspoerte, suster Agniet van Vlaeminckspoorte hair vader Item op onse choer boven heeft die vierde roes ghegeven heer Willem van Alckemade Die vijfte roos heeft ghegeven heer Gerrit van Lochorst Die seste roos heeft ghegeven Jan van Vlaeminckspoorte suster Agniet van Vlaeminckspoorte hair broeder Die sevende roos heeft ghegeven suster Marritgen Vrydachs hair moeder.

6. The west corners presumably had outside buttresses and inside quarter pilasters, as a square east end would have had. A polygonal apse would have had several outside buttresses and segmental pilasters inside, although in a polygonal apse the inside pilasters could have been omitted in favor of corbels with narrower attached pillars, or in favor of corbels with supportive vertical wood beams.

7. Kl. Arch. 889, folio 12 verso: Item Adriaen van der Boeckorst gaf Sinte Peter Item Florijs van

Wingaerden gaf Sinte Bartholomeus Item Jan van Boeckorst gaf Sinte Jacob Item Ian van de Werf gaf Sint Ian Ewangelist Item Willem van Remerswael gaf Sinte Pouwels Item myn Vrouwe van Kats gaf Sinte Philps Item Ian die Bastert van Duvoerde die gaf Sinte Symon ende Sinte Iudas ende hi was die eerste Item Ian Meynertsz. gaf Sinte Andreas Item Iacob Symonsz. gaf Sinte Matheus Item heer Ghijsbert onse pater heer Gherijts broeder gaf Sinte Thomas. The Judas included is Judas son of James (Acts 2: 13). Paul, then, must have replaced Thadeeus, unless the gift of his statue is merely unrecorded. The statement that these statues were on the Holy Sacrament Altar is incorrect and does not account for the intervening gifts registered in Kl. Arch. 889 (See Bijleveld, "Het nonnenklooster Mariënpoel," 163).

8. Kl. Arch. 889, folio 12 verso, preceding the statue donations: Item Saerles [Charles] van Penen gaf sijn suster vijf £ groot [Flemish] ende daer vort Onse Vrouwe of ghestofeert opgaende het coste XIX Rijns guldens. The *Marianum* is mentioned on folio 12: Die crens voer dat hoech outaer heeft ghecoft XXII Ryns guldens. This is mentioned with a large donation in 1496 from Pater Gherijt Dirck Jansz.'sz. (for his father's name, see folio 11 verso) and various items bought from convent funds, which were obtained through conversion of existing objects like coral rosaries, silver spoons and cups, etc. These funds were spent for a new cibory, which cost 100 Ryns guldens. This was probably the cibory used on the Sacraments Altar, which received its new ostensory in the same year (see note 19), and for which 27 Ryns guldens of "decorations" were bought from convent funds. These payments are followed immediately by the note about the *Marianum* for the high altar. On folio 12 verso the first note is of a gift of £ 3 /—/— (Flemish) from the will of heer Jan van Wassenair, who is said to have died in 1497. The gift's use is not specified. Payment for painting the statue of Mary follows it immediately.

9. See note 5. The remaining two bays contained a lectern (see Kl. Arch. 882, references to services for Easter Even, "De Vigilia Pasche"). These two bays were probably also the location of the choir stalls in the priests' choir donated in 1557 in memory of Prioress Gerritgen van Rietwyck by her uncle, Cornelis van Rietwyck, her cousin or nephew Florys Maertensz., and Wouter Cornelisz., (her sister's husband), which cost 30 Ryns guldens (Kl. Arch. 883 and 884, unfoliated).

10. The existence of this screen is a conclusion drawn from references in various places in Kl. Arch. 882 to the doors of the choir, to being "in the choir and outside the choir" (service for "*Onser Vrouwen Lichtmisse*" February 2) and during the same procession, references to the "farthest corners of the nave" ("*die veerste hocken van den pande*"); as well as to the grave of Jacop Tollenair *alias* Asselyns, "in the rear of the church" ("*in die after kerk*"), in Kl. Arch. 884. For the correct translation of "*pande*" as "nave" (and not as "cloister-walk," in contrast to the standard *Middelnederlands* dictionary), see Overvoorde, "Rekeningen uit de Bouwperiode van de St. Pieterskerk te Leiden," *Bijdragen voor de Geschiedenis van het Bisdom Haarlem*, XXX, 1906, 139-143: comparison of various descriptions of the locations of altars in the Pieterskerk, some of which were located in the nave, as is clearly indicated by documents describing them in relation to known locations there or using the term "middle church" ("*middenkerk*"), and as is also indicated by documents where the location is called the "*pand.*" I have checked the relevant documents: KB 900, 901, 902 = 73 E 39, 40, 41. Overvoorde's readings are correct. The Pieterskerk, a parish church, never had a cloister-walk. That "*pand*" can mean "nave" requires a revision of numerous archeological and other studies, where cloister-walks' remains have been hypothetically reconstructed using recorded donations for items such as stained-glass windows in the "*pand*" as if relevant. The inference about the Marienpoel choir screen is supported by the information in note 5. The nave was not the parish church of Oegstgeest, which was completely separate, as indicated by various legal concessions and confirmations made during the founding of the convent, recorded in Kl. Arch. 858. The descendents of people for whom memorial services were held presumably attended the services sometimes, which accounts for some of the visits from wealthy people, recorded among the wine expenses in the annual account books (Kl. Arch. 901). The lay servants of the convent also attended at least some of the services in the chapel and were thus in the nave.

11. The upper church must have rested on the "*pilaeren van de kerck*" ("Pillars of the church"), which were evidently wood (see R. A. 43, May 8, 1573). The choir screen was, therefore, probably also wood, although stone cannot be totally excluded as a possibility.

12. See note 5.

13. See Kl. Arch. 882. The lectern was used, among other things, for singing, which was restricted to simple chants without contrapuntal elaboration. Further, to prevent individual distinction and elaboration of the service, no organ was allowed in the church (*"Daer om mede so ordelen wi dat men in gheenre manieren orghelen en besighe of henghe inden dienst gods/"*). This contradicts Bijleveld, "Het nonnenklooster Mariënpoel," 156-157.

14. Kl. Arch. 884. References to the stair and its position are in the notes about the location of the graves of Ghijsbrecht Dirrickz. and Michiel Michielsz. van Helmondt, where the stair is described as a circular stair.

15. That the University of Leiden's Academie Gebouw, a former convent chapel, once had a similar plan and elevation (excepting the additional presence of a side aisle) is seen on the outside by the evidence of the limestone bases of the former tall windows of the priests' choir (now interrupted by modern windows on the ground floor at the southern bays, and confused by renovations in the northern bays). The former window bases form part of a continuous plinth seen intact on the buttresses next to them. The lower nave is now occupied by what is called the Vaulted Room, and internal dimensions, including those of the vaulting, indicate that the former choir secreen probably included small vaulting over choir screen altars. One bay with a bricked up window gives the dimensions of the original windows of the priests' choir. The present entrance hall was part of the chapel and shows on the Liefrinck map of 1578. From this side aisle the upper choir could be reached by the exceptionally broad circular stair. Its width can be explained in terms of the instructions for processions at Mariënpoel, where the facing choirs of nuns entered and left their choir two by two. The floor level of the old nuns' choir shows in an exterior plinth on the north wall. The continuation of the Leiden stair to ground level suggests that the turret originally had a door at ground level, opening on the convent grounds, a few steps below the chapel's original floor level. The floor level was lowered in this century. For an architectural history of the Leiden convent chapel, based on interpretation of the same visible structural changes, but differing from the foregoing at several important points (inserting, for example, a gratuitous change of placement of the high altar from one end to the other), see H. van Oerle, "Het Academiegebouw te Leiden, Geschiedenis der verandering van de oude kloosterkerk tot het universiteitsgebouw," *Bulletin van den Nederlandschen Oudheidkundigen Bond*, XXXVIII, 1937, 77-96. No documents referring to the necessary visits for consecration by the bishop are known, nor does anything in the documents support the presumed move of the high altar.

16. Kl. Arch. 884.

17. This is induced from the fact that the three were together and the St. Andrew's altar is described as the middle one in Kl. Arch. 889, folio 11. References in Kl. Arch. 882 to the services connected with Easter Even mention the high altar in the choir and the altars outside the choir. Arrangement against the choir screen was common. An example is seen in the St. Joriskerk, Amersfoort, from which, however, the altars have been removed. See further, J. K. Steppe, *Het Koordoksaal in de Nederlanden*, Brussels, 1952 (= *Verhandelingen van de Koninklijke Vlaamse Academie voor Wetenschappen, Letteren en Schone Kunsten van België, Klasse der Schone Kunsten, Verhandeling Nr. 7*).

18. Kl. Arch. 884.

19. See note 8; further, see Kl. Arch. 897 (Overvoorde, *Archieven van de kloosters*, II, reg. 1922). The impression given by Overvoorde in his introductory description of the convent in the archive inventory is that the *Sacramentshuis* was separate from the altars. While true for some other churches, at Marienpoel the *Sacramentshuis* was definitely on the St. Stephan's altar (see Overvoorde, *Archieven van de Kloosters*, 1, 120).

20. An example is in the Aartsbisschoppelijk Museum, Utrecht. Others are found *in situ* in various churches where the pre-Reformation furniture is partially intact, such as St. Pieters, Leuven, and the St. Bartholomeuskerk, Meersen.

21. Kl. Arch. 884; Kl. Arch. 889, folio 11.

22. Probably the correct word should be "reconciliation" but the word *"gewijt"* ("consecrated" or "dedicated") is used for the occasion in 1571 in Kl. Arch. 883 and 884. Perhaps the addition of more patron saints explains the use of the word. Possibly the altar was desecrated in the unruly times after 1566, since several altars in Leiden were reconciled in 1571. The altar is incorrectly described as a "new altar" by Overvoorde, *Archieven van de Kloosters*, I, 121.

23. Kl. Arch. 884.

24. Kl. Arch. 884, references to the altar in 1457 and 1571.

25. Kl. Arch. 884.

26. Kl. Arch. 884. Vranc van der Bouchorst was married to Katherine van Bakenes (Kl. Arch. 888, January 23).

27. Kl. Arch. 884.

28. See Kl. Arch. 889, folio 2 verso. The convent had been established earlier on land donated by the noble family van Vliet near Oudewater. When the convent moved in 1420 (several years passed before details of the new foundation were completed), it received the altarpiece just mentioned from the "Oude Vrou van Vliet."

29. See notes for the Easter Week services (Kl. Arch. 882, "*Van den Sonnendach van Palm*," etc.).

30. Kl. Arch. 884, references to the graves of Ghysbrecht van Swieten and Bouwen van der Bouchorst, buried in a single grave in front of the Holy Cross Chapel ("*voirt Heilich Cruus Capelle*"). The instructions for replacement of the cross in its usual position during services connected with Easter do not state that the cross was to be taken out of the choir, although whenever that was done in other parts of the service, it is specified (see Kl. Arch. 884).

31. Kl. Arch. 878.

32. See Ned. Herv. Diaconie, Leiden, Cat. no. A. 1. ("Register van de Huiszitten van St. Pieter, van 1428-1556"), folio 35 verso: ". . .maeche ic daer een coppelle ende dat sel hieten die cruis cappelle ende men sel die laten wien ende dat heilige graf daer in setten. . ." This refers to the *Entombment* in the choir of the Jerusalems Chapel on the Cellebroedersgracht, now called the Kaiserstraat.

33. Friedländer, *Lucas van Leyden and Other Dutch Masters*, no. 85, plate 70.

34. Friedländer, *Lucas van Leyden and Other Dutch Masters*, no. 87, plate 71.

35. For the painting of *The Lamentation*, see Hoogewerff, *Noord Nederlandsche Schilderkunst*, III, 151, and V, 131, no. 3.

36. Attribution is uncertain. See Kl. Arch. 884 for the location of graves ("*soessen*" = "*susteren*" and may also be a pun referring to the old age reached by some prioresses).

37. Special devotional services were associated with the sculpture in accordance with the indulgence granted on April 20, 1497, by Frederick van Baden, Bishop of Utrecht (Kl. Arch. 878; summarized in Overvoorde, *Archieven van de Kloosters*, II, reg. no. 1927).

38. Adriaen Jansz. van Swieten is the eighth figure left of the Madonna and Child depicted in the van Swieten Memorial painting. His wife Otte van Egmont is also depicted, but his first wife is not.

39. Kl. Arch. 889, folio 11.

40. This commission arrangement strikes me as rather strange. It may represent the construction over several years of a carved altarpiece with painted doors, the peculiarity being that the carving would then have had to fit the completed doors. The word "*ghestoveert*" does not exclude the commission of a painted center, however (see text in note 41 below).

41 Kl. Arch. 889, folio 11: Item ontfangen in testament van heer Adriaen van Zwieten ridder sijn soen [probably a clerical error for *Jans soen*] een £ groet iaers waer voir wi ten ewighe daghe alle weect een misse sullen doen lesen voir syn ziel ende synre beyder wijfven zielen Ende noch XXXVIII Ryns guldens dair die tafel in die middelste capelle binnen mede ghestoveert is ende dat latryn mit syn bescot ende Sinte Andries tabernakel om ghemaect syn behalven die doren van die tafel die hi bi syn leven het verven si costen III £ groet; hi starf int iaer ons heren MCCCC ende LXXXVI den laesten dach in augusto.

42. The painting is described as the high altar's altarpiece by Bijleveld, "Het nonnenklooster Mariën-poel," 159. He dates it ca. 1457. Pelinck dates it shortly after 1454 (Pelinck, *Lakenhal Painting Catalog*, no. 150, 99). The painting was "renewed" in 1552 according to the inscription under the portrait of Johanna van Swieten, Vrouwe van Upmeer, who commissioned the renovation. The present painting is on vertical strips of canvas. The left strip contains her portrait and that of Jan van Swieten, heer van Upmeer (d. 1510); since this is to Johanna's left it may be an addition. Alternatively it may be a copy of an earlier portrait that had been next to the portrait of Otte van Egmont before renovation. The death dates of the people depicted give no clue as to commission date, nor is there any indication that the painting was ever an altarpiece. Most likely the original donor (before renovation) is Jan van Swieten, heer van Upmeer, because the heraldry above his portrait is far more complete than that above the portraits of his relatives. The painting could well have been on canvas

from its origin and in 1552 simply have been "renewed" (touched up) instead of being entirely copied. The left strip of canvas would have been the only addition, replacing one containing only a portrait of Jan van Swieten, heer van Upmeer.

43. The springing out of the predella does not imply later addition of the predella: see J. R. J. van Asperen de Boer, "Technical Examination of the Frame of Engebrechtsz.' *Crucifixion* and some other Sixteenth-Century Frames," *Nederlands Kunsthistorisch Jaarboek*, XXVI, 1975, 73-87.

44. Kl. Arch. 889, folio 12 verso. The church as it was in 1457 was decoratively enriched about a generation later, just as the 1457 situation had apparently been an alteration of the chapel as it was in 1430.

45. See note 44. See also Kl. Arch. 882, processions for the sorrows of Mary. Van Mander describes both paintings as altarpieces (van Mander, *Schilderboek*, folio 210).

46. See Friedländer, *Lucas van Leyden and Other Dutch Masters*, 92 (editor's note on Cornelis Engebrechtsz.).

47. Taurel, *Christelijke Kunst*, I, 188.

48. Because the discovery (discussed below) of two underdrawings which were not painted but were replaced by the present donor's portrait raises the issue of the regents (rectors) of Marienpoel, I have compiled the following sequence from the Marienpoel *Necrologium* (Kl. Arch. 888). (1) Baldewyn Pietersz., d. June 6, 1461; (2) Vopponis Johannis, d. September 25, 1476; (3) Symon Nicolai, d. March 24, 1477; (4) Johannis Chrispiani, d. August 8, 1496; (5) Ghysbert N., d. March 7, 1496; (6) Gerard Dircxz., d. March 28, 1504; (7) Sebastian Francxz., d. August 25, 1507; (8) Jacop Maertensz. Schout, d. March 14, 1526; (9) Mathias Willemsz., d. September 11, 1532; (10) Servatius Rogerii, d. January 3, 1540; (11) Pieter Anthonisz., d. November 15, 1547; (12) Matheeus Jordansz., d. February 27, 1556. See below for information about a later rector (?) of the van Rietwijk family. For the number 7 in the year of the death of Sebastian Francxz., compare Kl. Arch. 888, March 28, the 4 in 1504; and June 2, the X in anno XVcV.

49. Pelinck, "Cornelis Engebrechtsz," 51.

50. See note 48.

51. Pelinck, "Cornelis Engebrechtsz," 51.

52. Kl. Arch. 911, folio 77 verso.

53. Kl. Arch. 1094, August 1, 1508; mentioned but evidently not read by Pelinck and Gibson.

54. See Kl. Arch. 901, 1519-1520, folio 20 verso; see also note 5.

55. R. H. C. Römer, *Geschiedkundig Overzigt van de Kloosters en Abdijen in de voormalige Graafschappen Holland en Zeeland*, Leiden, 1854, II, 216. (Römer, however, does not note the similarity of the 4 and the 7 in the dates of Sebastian Francxz. and Gerard Dircxz., although giving them in correct order; see note 48).

56. Gibson, diss., 34.

57. H. F. van Heussen, *Oudheden en Gestichten van Rynland*, Leiden, 1719, 451.

58. Taurel, *Christelijke Kunst*, I, 188.

59. See note 109; see also the discussion of the tombslab of Ghysbrecht van der Bouchorst and his wife Marghritte, below.

60. The financial records are found in Kl. Arch. 901, especially for 1522-1523.

61. Kl. Arch. 901, 1518-1519, folio 23 verso.

62. Kl. Arch. 901, 1519-1520, folio 33 verso.

63. Kl. Arch. 901, 1521-1522, folios for "*reparacie.*"

64. Kl. Arch. 901, 1522-1523, folio 26.

65. Kl. Arch. 901, 1522-1523, folio 30 verso.

66. Kl. Arch. 901, 1522-1523, folio 32.

67. Kl. Arch. 901, 1522-1523, folio 35.

68. Kl. Arch. 901, 1522-1523, folio 36.

69. Kl. Arch. 901, 1522-1523, folio 36 verso.

70. Kl. Arch. 1018; see Pelinck, "Cornelis Engebrechtsz," 51; Pelinck, *Lakenhal Painting Catalog*, 61; Gibson, diss., 34. See also the bijlagen to the treasury records of 1522-1523.

71. "Recollectie vanden voirgaende Rekeninge bewysende wat den pater mach eyschen godlicken up correctien van beter bewys dat hy gaerne wil van guede redelecke persoene hoeren stellende hem

selven ganselick in iusticie in presentie van God die der oirdelen sal den ghenen die der ongelyck doen ende die bedruct ongelyck moeten Lyden."

72. Friedländer, *Lucas van Leyden and Other Dutch Masters*, 26.

73. Van Asperen de Boer and Wheelock, "Underdrawings," 82-83. The denial that the second newly discovered head is a portrait because it is described as "anguished" in contrast to surrounding figures, described as having, "sad, meditative countenances," is tendentious.

74. Mr. van Asperen de Boer kindly informed me that later laboratory research disproved the two-dates theory proposed in the article on underdrawings. I had, thus, the advantage of knowing that unpublished research did not contradict my hypothesis. Further, see note 43.

75. An alternative and less satisfactory hypothesis could be built on six inconclusive lawsuits involving a priest of Heilo and his brother, who was a Leiden resident in possession of a painting and other things owned by Heilo, after his brother the priest had died, and also involving Marienpoel. See R. A. 42, June 28 (two cases), August 13, August 23, August 28 (two cases), all in 1512.

76. See J. Duverger, "Vlaamsche Beeldhouwers te Brou," *Oud-Holland*, XLVII, 1930, 1-27. The work at Brou is a mixture of "gothic" (or "modern") and "Renaissance" (or "Antique").

77. The appearance of architectural motifs is considered here to be a verifiable occurence, in contrast to gradual changes of manual technique or of conception within the work of a single artist. "Doric" pillars are seen in the left background of Lucas van Leyden's engraving *Ecce Homo* dated on the plate 1510 (B. VII. 378. 71), which was copied in a painting ascribed by Friedländer to the "Master of Alkmaar" (Friedländer, *Lucas van Leyden and Other Dutch Masters*, no. 58, plate 37), and in another anonymous painting, which has no additional scene in the foreground, now part of an altarpiece in Baños de Valdarrados, near Aranda de Duero, diocese of Burgos, Spain. Similar capitals also appear in the *Nativity* painting ascribed by Friedländer to Cornelis Engebrechtsz. (Friedländer, *Lucas van Leyden and Other Dutch Masters*, no. 68, plate 58) which is provided with an inscription described by Friedländer as "half-obliterated." The inscription reads: (hie)r leyt begrave(n) vrou Margriete va(n) Naelwyck en(de) starf anno domini (?) M cccc en VII opten (. . . ?) dach van (. . . ?). It is a pity that there is no historical evidence that Cornelis Engebrechtsz. painted this dated picture, assuming that it was painted shortly after the death date. The introduction of "Antique" ornament into Leiden publications such as the engravings of Lucas van Leyden and the blocks used by Jan Zevertsz. increases steadily after ca. 1510 and was commonplace by 1515. The architecture in both triptychs from Marienpoel has much in common with the architecture in the portrait of Henrick Willemsz. van Naeldwyck (Friedländer, *Lucas van Leyden and Other Dutch Masters*, no. 59 I, no. 2 of the series, plate 40), discussed below in connection with Huych Jacopsz. and his teacher. The connection of the two Marienpoel triptychs with a date sometime up to ca. 1510 on the basis of commonly used ornament supports the hypothesis that their commission was connected with the renovations at Marienpoel including the high altar by 1500. The architectural ornament provides no tight proof for dating the paintings, but it is more consistent with placing them together ca. 1508-1510 than it is with any theory of stylistic development within the composition and brushwork and coloring, etc., that would separate the triptychs by several years.

78. Gibson, diss., 128. That ". . . the dainty little caps worn by the holy women reflect a fashion much in vogue in Antwerp" may be true, but such caps appear also in the illustrations to the Gouda (?) edition ca. 1488 of Olivier de la Marche's *Le Chevalier Délibéré* (see H. van de Waal, *Drie Eeuwen Vader-landsche Geschied-Uitbeelding*, The Hague, 1952, I, 132: II, ill. 49). (See also the unnumbered illustration from *Le Chevalier Délibéré* in A. J. J. Delen, *Oude Vlaamsche Graphiek*, Antwerp, 1943; and in the same work, note 19, p. 153-154.)

79. See W. Kurth, *The Complete Woodcuts of Albrecht Dürer*, New York, 1963, nos. 88, and 192, and p. 27 (commentary on no. 192). See also, J. Held, *Dürers Wirkung auf die niederländische Kunst seiner Zeit*, The Hague, 1931, 19-21.

80. The entire concept of the "Antwerp Mannerists" is a construction unsupported by historical evidence. The evidence necessary for supporting this particular abstraction would be proof that what occurred in Antwerp was significantly different from what occurred elsewhere, that the Antwerp painters were not so much individual in their paintings as they were communal in using elements which can be identified as not present in the work produced in other towns, where, as in Leiden, the oeuvre of most artists remains totally unknown and at the same time may be assumed to have undergone the heavy

inspiration of the prints of Dürer. An interesting example of a painting by an "Antwerp Mannerist," the "Master of 1518," depicts *The Last Supper* with a donor (see *Anonieme Vlaamse Primitieven, Zuidnederlandse Meesters met Noodnamen van de 15de en het Begin van de 16de Eeuw* (catalog, Groeningemuseum), Bruges, 1969, cat. no. 97; from the Koninklijke Musea voor Schone Kunsten van België, inv. no. 3242). The donor's coat of arms is supposed by the catalog's compilers (in particular H. Pauwels) to be that of a Norwegian family, which supported the maintenance of Roman Catholicism in Norway in the sixteenth century. Presumably part of their support was ordering this portrait to be painted in Antwerp. Without denying that such a Norwegian family may have used that coat of arms, it is also evidently that of a bastard of the Leiden family van Bosch, members of the governing oligarchy. This family was acquainted with Leiden artists of more than one generation. Lucas van Leyden's step-mother was the bastard daughter of a priest, heer Dirck Florysz. van Bosch, who was himself a bastard. (The documentation for this is cited in the discussion below of Lucas van Leyden's birth date.) Which bastard van Bosch might be represented in the "Antwerp Mannerist" painting has, however, not been studied. For the moment it is sufficient to indicate the possibility that a painting supposed to have come from Antwerp might easily portray someone whose choice of painter would be more likely to fall in Leiden. Books published in Antwerp during the period of the "Antwerp Mannerists" fail to differ significantly in their illustration from books published in other Netherlandish cities. Compare the various illustrations in *NAT*. See also note 109.

81. For example, Dülberg, *Leydener Malerschule*, 46; and Pelinck, "Cornelis Engebrechtsz," 58.

82. That such commissions probably took about a year or slightly longer is implied by the document mentioned above about the altarpiece in Hoorn painted by Jan Mostaert; see chapter 1, note 36.

83. Kl. Arch. 897, donation of 33 guldens from pater Gherijt Dircxz., June 13, 1496, half of which was to be used for the *Sacramentshuis*.

84. That the painting is connected with Cornelis Engebrechtsz.'s triptych is seen in several figures, such as the woman standing at the left in the Philadelphia painting, similar to the second figure from the left in Cornelis' *Crucifixion*. See also M. Lehrs, *Late Gothic Engravings of Germany and the Netherlands*, New York, 1969, no. 454, engraving of the *Crucifixion* by the Master W with the sign ⚒. Of course, Jan Mostaert may have travelled to Leiden to see the painting and have been permitted to see it within the convent. That copying other works already on display was a normal practice is discussed below in connection with the van der Stijpen van Duivelant family triptych by Jan van Scorel (copied in the background of the portrait of Cornelis Willemsz., chaplain of the Leiden St. Anna Hof on the Hooygracht) and in connection with the pulpit and the organ of the Leiden Pieterskerk. A lawsuit about copying a painting already hanging in a church is recorded in R. A. 42, July 28, 1536 (as a contracted specification, not as a copyright infringement). Such copying, including travelling around to do it, greatly confuses the concept of local schools. Furthermore, it raises questions about the inference of "studio copies" drawn from the present existence of several versions of a single composition, which differ greatly in quality.

85. Four of these associations seem reasonable: Friedländer, *Lucas van Leyden and Other Dutch Masters*, no. 94 (Munich), plate 74; no. 96 (Ghent), plate 75; no. 74 A (Vienna), plate 64; Gibson, diss., no. 53 (Liège), ill. 49; the fifth is connected by Friedländer for no apparent reason: Friedländer, *Lucas van Leyden and Other Dutch Masters*, no. 95 (Aachen), plate 74.

86. For example, Friedländer ascribes his no. 74 A, plate 64 (see note 85) to "J. de Cock." Gibson, in discussing the painting attributed by Friedländer to J. de Cock, calls the painter the "Lamentation Master" and without documentation assumes that he came from Antwerp to Leiden perhaps as early as 1512-1514; that he collaborated with Cornelis Engebrechtsz. on an undocumented and unsigned triptych now in Basel; that this painter's presence in Leiden establishes a "definite link between Engebrechtsz and the Antwerp Mannerists" (Gibson, diss., 248); but that this artist's work was so inferior that the Antwerp contribution to Cornelis Engebrechtsz.'s own style must have come through access to hypothetical pattern books brought along from Antwerp by the "Lamentation Master."

87. Friedländer, *Early Netherlandish Painting*, V, *Geertgen tot Sint Jans and Jerome Bosch*, Leiden, 1969, no. 6 A, plate 8.

88. Friedländer, *Lucas van Leyden and Other Dutch Masters*, no. 2, plate 4. Friedländer thought that Mostaert did not do the central panel but only the wings depicting the donors. Presumably for this reason the wings were exhibited alone for many years, although according to Friedländer, *Lucas van*

31

Leyden and Other Dutch Masters, 98, note 30, the panels have now been reunited. (The panels have been re-separated, with the wings on view in the main halls of the Rijksmuseum, perhaps temporarily.) This occurence gives hope that the central panel of the *van der Does-van Poelgeest* triptych, described by van Mander as Cornelis Engebrechtsz.'s best work, will someday be rediscovered. Perhaps the central panel was not destroyed through a desire to preserve only the family portraits, as suggested by Overvoorde and contradicting the seventeenth-century description of the major family portraits as having been in the central panel, as described below. The central panel, it can be hoped, could have been put into storage on the advice of an art critic who disagreed with van Mander.

89. The closest copy of the pose discussed is in the painting ascribed by Friedländer to J. de Cock and by Gibson to the "Lamentation Master" (see notes 85 and 86). The face and hand of John in Cornelis Engebrechtsz's *Lamentation* combined with the the hand supporting the head of Christ are items seen also in the painting ascribed to Gerard David (see note 92), which is both undated and unsigned.

90. Gibson mentions earlier examples of this gesture in connection with Cornelis' painting; see Gibson, diss., 95, note 37.

91. The pose appears in several other places, for example, Israhel van Meckenem's engraving *The Deposition* (Lehrs IX, 162. 151) and van Meckenem's engraving *Christ in the Tomb supported by an Angel* (B. VI. 153. 138). The pose also appears in two paintings by the "Master of the Figdor Collection" (Friedländer, *Geerten tot Sint Jans and Jerome Bosch*, nos. 28 and 29, plate 22). The pose appears further in Lucas van Leyden's engraving *The Crucifixion* of 1515 (B. VII, 380. 74[11]).

92. See E. Bermejo, "Primitivos flamencos (2)," *Reales Sitios*, IX, 1972, fold-out color plate. The only connection of this painting with Bruges is the repetition of a figure of Mary Magdalene somewhat similar to that from the painting in the Church of Our Lady, Bruges, ascribed to Adriaen Ysenbrandt, *The Seven Sorrows of Mary*, although the pose is reversed.

93. Because of the common features in paintings mentioned above, also found in engravings and in other painted or carved altarpieces, it is impossible without documentation to connect this unmarked triptych with Leiden or Haarlem or any other particular place of origin. It is said to have been acquired for a convent in Valladolid during the fifteenth century (see F. Garcia de Wattenberg, *Museo Nacional de Escultura, Guia Breva*, Valladolid, 1974, no. 10). See also A. L. Mayer, *El Estilo Gótico en España*, Madrid, 1960 (3d edition, first published 1928), plate 82. Leiden had a resident factor for merchants from Valladolid (for example, see R. A. 41, 1486-1492, folio 38 verso, June 2, 1487), but it may be assumed that other towns also had such merchants in their midsts. Compare further the central scene of the Valladolid triptych with the carving in the Haarlem Bisschoppelijk Museum, *The Lamentation*, illustrated in D. P. R. A. Bouvy, *Middeleeuwsche Beeldhouwkunst in de Noordelijke Nederlanden*, Amsterdam, 1947, ill. 106, described as Utrecht work ca. 1460-1470 on p. 98. An excellent comparison photograph of the sculpture *Lamentation* (Rijksmuseum) attributed to the Master of Joachim and Anna is in J. J. M. Timmers, *De Schoonheid van ons Land, Beeldhouwkunst, Houten Beelden*, Amsterdam and Antwerp, 1949, ill. 108.

94. The painting is attributed by Friedländer to the "Master of Delft" in *Lucas van Leyden and Other Dutch Masters*, no. 66[l], plate 52, Hoogewerff made the painting the origin of another nameless painter, the "Master of the *Spes Nostra*" (in other words, the painter of the painting in question). See Hoogewerff, *Noord Nederlandsche Schilderkunst*, II, 279. Who painted the picture remains unknown.

95. *Catalogue of Paintings, Rijksmuseum, Amsterdam*, 1960, 199, cat. no. 1538 TI.

96. On the ground in front of the grave are the words: Si quis eris qui transieris hoc respice plora/ Sum quod eris es ipse fui pro me pecor ora. (For an English translation, see E. Panofsky, *Tomb Sculpture, Its Changing Aspects from Ancient Egypt to Bernini*, London, 1964, ill. 166b (within the banderol).) The plural form "requiescant" on the tomb indicates a grave for more than one person, as was then usual. See also K. Cohen, *Metamorphosis of a Death Symbol*, Berkeley, California, 1973, 76.

97. That their habits are the same is noted by H. Schulte Nordholt, "Meester van Spes Nostra, Allegorie op de vergankelijkheid," *Openbaar Kunstbezit*, VII, 1963, no. 35.

98. Schulte Nordholt points out the chapel on the left and the conventual building and gatehouse on the right. It is hard to believe that a single grave could contain all the monks of the monastery of Sion naer Delft, as suggested by Schulte Nordholt (see note 97), who refers to the *algemene graf van kloosterlingen* ("common grave of confraters").

99. Kl. Arch. 884.

100. Kl. Arch. 884.
101. This is visible on unaided inspection of the painting and was futher confirmed during recent restoration in the Rijksmuseum.
102. See Panofsky, *Tomb Sculpture*, 64, ill. 259, 260.
103. To call the painting an "allegory" is incorrect in the absence of any allegorical figure or allegorical story. Moreover, it denies the memorial function probably attached to the four portraits. The "Altar of the Dead" ("het dodenaltaar") may be a concept related to the "Mass of the Dead" (see note 3).
104. P. M. Bots, *De Oude Kloosters en Abdijen van het tegenwoordige Bisdom Haarlem*, Rijsenburg, 1882, 110. Contrary to the impression given by Schulte Nordholt, St. Jerome was not a patron saint of the monastery of Sion (see note 97).
105. While this is generally described as destroyed, the catalog to Friedländer, *Lucas van Leyden and Other Dutch Masters*, 77, describes it as "Lost in 1945".
106. Friedländer, *Lucas van Leyden and Other Dutch Masters*, no. 69, plates 56 and 57.
107. See Kl. Arch 350 (will of Mr. Jan Gherijtsz.) for a Leiden commission from a cleric who would not necessarily seem the main portrait in a family memorial painting.
108. Attempts to locate such families have almost certainly been limited to records indexed by surname; such marriage connections may have existed. No thorough search has been carried out, taking into account the dominant habit of omitting surnames in most records. For references to previous notes calling attention to the absence of such a combination of families in Leiden, see Gibson, diss., 201, note 51.
109. This can be seen on the coat of arms above his portrait in the van Swieten Memorial painting. See also Bijleveld, "Het nonnenklooster Marienpoel," 240. Multiple heraldic use is found in all sources based on original fifteenth and sixteenth-century material; an example is the *Wapenkaart* of Ghysbrecht van Ryckhuysen (engraving, Leiden, 1758). This is the least complex of sources. A brief glance shows that in the seventeenth-century city councils members of the Leiden family van Dorp (itself a branch of other families in the prevalent way) used a coat of arms with a diagonal band on which were three Greek crosses, a coat of arms which would be like that of Amsterdam if the arrangement were vertical. Some members of the same family, however, used a different coat of arms (based on other family connections) in the early sixteenth century (three erased eagles' heads, two and one) found on their preserved seals.
110. Various family members used one or the other or both of the surnames. Different members of this family used different metals between the bars in the coat of arms.
111. One Marienpoel prioress is called van Rietwyck, van Ryck, and van Ry(s)wyck or van Ry(c)wyck in various years, all correctly. See Kl. Arch. 901, payments from Alkmaar 1524-1525 on, preceded by one payment from her mother, Grietgen Florysdr. (in 1523-1524, folio 13 verso). Gerritgen Ysbrantsdr. van Rietwyck was the prioress in whose memory the stalls of 1557 were given by various relatives including her uncle Cornelis van Rietwyck (see note 9). Her brother was the cleric, probably rector, who wrote Kl. Arch. 883 and 884, the two books of memorial notes. Another brother was a priest, heer Willem Ysbrantsz. van Rietwyck; and they had two sisters, Anna and Katheryn. Their father Ysbrant van Rietwyck married Margriet Florysdr., probably daughter of Florys Adriaensz., their grandfather (it is not stated that he was their maternal grandfather). Florys Adriaensz.'s sister was the prioress Geertruyt Adriaensdr., who died March 10, 1538, at age eighty-four, having been prioress for forty-two years (Necrologium), during which the Cornelis Engebrechtsz. triptychs were painted. Besides Cornelis van Rietwyck, Gerritgen Ysbrantsdr. van Rietwyck had another uncle, Aelbrecht van Rietwyck (Kl. Arch. 889, folio 15) and financial arrangements made with the convent were resolved from some difficulties by the intervention of her mother, Margriete Florysdr., who secured help from two other uncles of Gerritgen. Their names were Meester Willem van Ryck and Cornelis van Ryck, which suggests that van Ryck was that of the maternal side, and, thus, also the surname of Florys Adriaensz. and his sister. (It is evident that Gerritgen van Rietwyck's brother also wrote the memorial book Kl. Arch. 889 from references to "*Katharijne IJsbrantsdr., van Ryck myn suster*" and "*Anna van Ryck myn suster*" on folio 15, and from the stricken-out word "*myn*" instead of "*die*" ("the") before the phrase "uncle of Sister Gerritgen IJsbrantsdr." in a reference to the memorial stalls.) Cousins of the writer and the prioress were Florys Maertensz. and the nun Margriete Maertensdr., who is listed in the *Necrologium* on July 5, without year. Margriete Maertensdr. has

33

been thought hypothetically to have been rector Jacop Maertensz. Schout's sister (which remains hypothetically possible). Sister Margriete Maertensdr. was probably the daughter of Meester Maerten Florysz., which would indicate that she died before 1519-1520 (see Kl. Arch. 901, 1519-1520, folio 13 verso). Another cousin was the nun Focula Pietersdr. (*Necrologium*, March 15, 1502). Other unnamed members of the family (families) were buried in the convent chapel and were remembered in August during the service for the writer's mother and his sister Anna. If this included Jacop Maertensz. Schout, who as rector had a separate memorial (also?), his debts contrast memorably with Gerritgen Ysbrantsdr. van Rietwyck's gift of 550 Ryns guldens (Kl. Arch. 889, folio 15). Unless otherwise noted, see Kl. Arch. 883 for the foregoing information.

112. A comparison of the names of donors in Kl. Arch. 889 and Kl. Arch. 858 (*Cartularium*) with the names of nuns receiving annuities or other payments in Kl. Arch. 901 bears out this statement; see also the names of donors listed in the *Necrologium*, Kl. Arch. 888. The high connections of some of the nuns receiving annuities are not immediately clear from the notes for any one year; subsequent years sometimes clarify the relations. The Marytgen Willemsdr. (Kl. Arch. 901, 1518-1519, folio 18 verso), whose father was Willem Willemsz., a brewer, was probably a daughter of Willem Willemsz. van Thorenvliet (see appendix 2, no. 102), whose existence was forgotten by later genealogists of the inheriting descendents of the founders of the St. Anna Hof. Nuns in Marienpoel were related to various families of importance in the Low Countries, including Asselyns, van Duvoirde (= van Duivenvoirde), van der Bouchorst, van Bosschuysen, Nys, van Teylingen, van Lichtenberg, van Mathenes, Goudt, van Honstert, van Wilbergeen, Coeganck, van Vlaemincxpoirt, van Wassenair, van Schengen, van Scagen, van Coirtgeen, van Buytewech, van Hoochtwoude, van Coulster, van Alckemade, van Helewyn (= Alewyns), van Remmerswael, de Luu, Velleman, van Vliet, van Lindt, van Airdenburch, van Dale, besides the van Swietens, the van Rietwycks, and others.

113. No such study has yet been made; nor has a collection of basic heraldic material been gathered for such a study, despite the extensive random collections available. Until thorough heraldic research is undertaken in connection with paintings now arranged by style little can be said about correct identification of donors except where documented exactness has been discovered. The complexity of the so-called Paedts-van Raephorst or Paedts-Pynssen triptych's donor identification is a problem running through works in all volumes of standard books purporting to sort out Southern from Nothern Netherlandish art in this period.

3. The *van der Does-van Poelgeest Panels*

A discussion of the *van der Does-van Poelgeest Panels* must begin with a reminder that here the main part, which van Mander praised as Cornelis Engebrechtsz.'s best work, is missing.[1] Van Mander described the central subject as *The Opening of the Seventh Seal* (Rev. 5: 6) and said the composition was filled with many figures.[2] Overvoorde performed one of style criticism's most daring leaps by comparing the lost central panel with other paintings in his attempt to date it at 1509.[3] His comparison, moreover, was with several undated pictures. While agreeing here with Friedländer's proposed date of ca. 1515,[4] it is obligatory to focus attention once again on the biographies of the people portrayed especially in the preserved wings, in support of the otherwise oracular proposition. The date ca. 1515 is suggested on the one hand by the repetition of architectural ornament in the 1518 Brussels portraits and on the other hand by a complicated legal development in 1515 affecting all the van der Does-van Poelgeest heirs. It will be seen, contrary to Friedländer[5] and van Asperen de Boer and Wheelock[6] that Overvoorde did not tell enough, nor even a good deal, about the families involved. In fact, Overvoorde's 1911 publication has had the misfortune of being misunderstood with a resulting jumble of names and persons uncorrected in the new English Friedländer. Van Asperen de Boer and Wheelock are correct in calling the biographical information available "complex" but it is certainly not "sparce." There is far more available than required for discussing the painting or indicating general social characteristics of the sitters.

 What follows is for that reason very incomplete as biography. Details of the lives of the sitters have been selected to illumine the painting's probable date, to correct some published biographical errors, and to emphasize specifically the complexity of the connections affecting Leiden's ruling class as expressed by the family relations of these sitters. The last aspect continues the observations made about art commissions for Marienpoel, but adds a factor of multiplicity that in the end leaves one reeling when faced with the potential problems of unidentified sitters, as in *The Feeding of the Five Thousand.*[7]

 The *van der Does-van Poelgeest* triptych memorialized Willem van der Does (last mentioned alive in a lawsuit of May 5, 1507, when he was represented by his grandson, Geryt van Lochorst)[8] and his wife Henrica van Poelgeest, who had died as early as 1484.[9] Their relation to Adriaen van Poelgeest, knight, sheriff of Leiden, who died on August 10, 1507,[10] might explain van Mander's statement that the painting had hung in the chapel of the Lords of Lochorst in the Pieterskerk and that *among* the praying figures were the donors.[11]

Adriaen van Poelgeest's sister was Henrica van Poelgeest, who married Willem van der Does. Adriaen van Poelgeest's wife was Machtelt van der Does. who was Willem van der Does' sister. Machtelt van der Does died on September 21, 1507.[12] The heirs of Adriaen van Poelgeest and Machtelt van der Does were the three daughters of Willem van der Does and Henrica van Poelgeest, who are portrayed with their husbands (except in one case, where a widow is portrayed with her son and legal guardian) on the remaining wings of the *van der Does-van Poelgeest* triptych. "House Lochorst" (opposite the Pieterskerk's north transept) passed into possession of Geryt Jansz. van Lochorst, son of Jan Gerytsz. van Lochorst and Adriaena van der Does. (Willem's daughter), through the inheritance from Adriaen van Poelgeest.[13] Because Adriaen van Poelgeest and his widow and Willem van der Does all died within a fairly short period, the memorial painting may have been connected with the complicated relation and inheritance and have been commissioned primarily by Geryt van Lochorst and his mother. This hypothesis would explain van Mander's statement about the donors. It would also explain why the triptych was inherited by Geryt van Lochorst's heirs and not by those of Heerman or Stoop. Alternatively, van Mander may simply have included the saints in his group of "praying figures," leaving the three pairs as possible joint donors. Further, Willem van der Does and his wife are said in a seventeenth-century description[14] to have been portrayed in the central panel. If true, they could have been the donors (by last will of Willem van der Does, not preserved), or they could have been the non-donors in the group, with the heirs as joint donors. Van Mander does not mention portraits in the central panel, but he does not specifically mention the wings and he does not identify the portraits.

Ill. 14,18 The arms of van der Does and of van der Does dimidiated with van Poelgeest appear on the outside of the panels (when closed).[15] Cornelis Engebrechtsz.'s banners must have looked something like these heraldic paintings. Their fresh color and high technical quality provide a startlingly refined contrast, despite damage, to the restored portrait sides. The achievement on the left, van der Does, is closely similar to that in the lower left corner of the tomb of Emperor Frederick III in Vienna, by Nicolaus Gerritsz. van Leyden.[16] The griffon supporting the van der Does-van Poelgeest arms is similar to that supporting the van Poelgeest-van der Does arms on the tombslab of Adriaen van Poelgeest and Machtelt van der Does in the Leiden Pieterskerk.[17]

Willem van der Does and Henrica van Poelgeest had three daughters. Adriaena van der Does[18] married Jan Gerritsz. van Lochorst. Henrica van der Does married Jacop Gerritsz. Heerman.[19] Margaretha van der Does married Willem Jan Kerstantsz.'sz. Stoop. The marriage contracts are not preserved.

Ill. 15,16 Overvoorde, discussing the painting, misleadingly implied that almost no information could be found about the people portrayed (although the Leiden archives contain extensive documentation on every high municipal government official in this period).[20] Overvoorde's impression has been repeated by subsequent writers.[21] There exist, nonetheless, countless references to Geryt Jansz. van Lochorst, Jacop Gerritsz. Heerman, and Willem Jan Kerstantsz.'sz. Stoop.[22] The 1514 burgomasters, for example, included Geryt van Lochorst and Willem Jan Kerstantsz.'sz. Stoop, besides Cornelis Heerman (a relative of Jacop) and Meester Willem Symonsz. van Oy.[23] There are also many references to Geryt van Lochorst's father, Jan. Because the *van*

der Does- van Poelgeest Panels were certainly painted after the death of Willem van der Does (1507-1508), and Jan van Lochorst had already died (1495), it is assumed here that the van Lochorst portrayed in the wings is Jan's son Geryt Jansz. van Lochorst. Geryt acted as legal guardian of his mother in inheritance cases where the other joint heirs were Heerman and his wife and Stoop and his wife.[24] Nothing indicates that the van Lochorst portrayed was deceased; further, nothing indicates that the painting memorialized anyone depicted on its wings.

Geryt van Lochorst was one of the burgomasters again in 1515 and 1518; he was sheriff from 1527 to 1536.[25] He is often mentioned in these functions, as well as in the less important offices he held, in documents of the time.

Jacop Heerman was one of the burgomasters in 1502 and 1503,[26] and Keeper of the city's water privileges ("*Vroon Meester*") in 1515.[27] He travelled to Jerusalem in 1491,[28] a trip commemorated in Cornelis Engebrechtsz.'s portrait, where Heerman holds a palm branch in the customary way.[29] Heerman seems to have commissioned a stained-glass window in 1509, possibly in one of the Leiden churches.[30] He was an advisor for the financial guaranties of the inheritance due to the children of his late illegitimate son, Jacop Jacopsz. Heerman, in 1530.[31] He died ca. 1535, as his daughter, "Jonnfrou Heynrick van Kennenburch, widow of the late Adriaen van Egmont," was sued by the city in 1536 to pay death duties on the estates of her father and her brother, Geryt Jacopsz. Heerman.[32] It is apparent that Overvoorde's claim that Heerman had no children is inaccurate.[33] His and later explanations of how the painting was inherited by the van Lochorsts are based on this inaccurate supposition.

Willem Jan Kerstantsz.'sz. Stoop was a magistrate in 1505,[34] 1506,[35] and 1515.[36] He was one of the burgomasters in 1514, 1517, and 1518.[37] He was evidently involved in a lawsuit about a silver Agnus Dei and a silver lavabo or water pitcher, on March 23, 1515.[38] He died in 1519, the last year in which Margaretha van der Does is noted as his wife in the annual lists of the female regents of the St. Catherine's Hospital, a position she held until 1534.[39] In 1520 she was identified as "Joncfr. Margriete Mr. Clements wyf," because she had remarried with Meester Clement Jansz. van Amsterdam, a Leiden surgeon. Gibson's presumption that Margaretha van der Does and her husband lived in Amsterdam is incorrect. It is a result of sloppy reporting by Overvoorde, who refers to Clement Jansz. as a surgeon at Amsterdam, not from Amsterdam.[40]

Gibson surmises that Margaretha van der Does might have desired to be depicted as married to Stoop, even after her remarriage, because Gibson dates the painting after Stoop's death on the basis of "the new physiognomical type employed for Mary Magdalene on the right wing."[41] Gibson evidently assumes that marriage to Stoop was somewhat more noteworthy socially, but this cannot be taken seriously.[42] That Margaretha might capriciously have preferred to be portrayed with her first husband after remarriage does not seem likely, and it would have required her second husband's consent.[43] In addition, the triptych's memorial function did not of necessity include memorialization of Willem Jan Kerstantsz.'sz. Stoop. A portrait of her first husband could have been changed to account for the remarriage, without altering the memorial to her parents. It has been observed above that the van Swieten Memorial painting includes one married couple where a man is shown with his second wife, but not with a portrait of his first. Alterations in the underdrawing of Stoop's portrait,

discovered by van Asperen de Boer and Wheelock, however, are only changes of placement, the kind of unexceptional compositional alteration conceivable in the preparation of the portrait during Stoop's life.[44] To summarize, it is clear that the panels can be dated before 1519-1520, the date of Margaretha van der Does' remarriage.[45]

Since Overvoorde,[46] it has been usual to suppose that the compositional arrangement of two people in front and one in back was to be explained by a difference in social rank. Van Lochorst and Heerman are depicted in armor; Stoop is depicted in velvet, damask, and fur (described by Gibson as a simple costume).[47] Since every militia member was required to possess armor, all three did; and it is not clear why a fur-lined cloak should be considered less impressive.[48] No social significance can be attached to the differences between the kinds of clothing in the depictions of the three men. As seen below, they were relatives of each other. The "sober middle-class dress of the Paeds family" (in the *Feeding of the Five Thousand* triptych) described by Gibson in contrast to that of van Lochorst and Heerman, their relatives, is also a misconception.[49] Gibson was evidently unaware of the relation when making the comparison.

Dating the *van der Does-van Poelgeest Panels* at ca. 1515 has not been recently questioned before Gibson. Van Asperen de Boer and Wheelock follow Gibson in placing execution after Stoop's death.[50] They imply incorrectly that Gibson places the commission definitely before 1521, while in fact he suggests that it could also have taken place after 1521.[51] Combining Gibson's dating with his mistaken idea that Margaretha van der Does moved to Amsterdam after remarriage, van Asperen de Boer and Wheelock arrive at a mistaken explanation of stylistic differences between the drawing technique used in the portrait of Margaretha van der Does and in the portraits of her sisters. The drawing is thought to have been made first as an idealized female head *because* of Margaretha van der Does' supposed unavailability for portrait sittings, then altered in the direction of more accuracy, presumably at a last moment sitting.[52] What the correct explanation might be for the technical differences discovered by van Asperen de Boer and Wheelock is unknown. It is conceivable that Margaretha van der Does looked more like Cornelis' habitual generalized idea of a female head than did her sisters. In any case, she was not out of town.

Ill. 13, 40,41 The stone architectural ornament at the tops of the panels contains shell and panel designs together with putti, seen also in the 1518 Brussels portraits, as wood. This suggests that the 1515 inheritance lawsuits involving the three pairs of people depicted jointly defending their inheritance of the estate of Adriaen van Poelgeest through Willem van der Does[53] may have led to the commission at about the time of the lawsuits. The commission, although a bit late, could then be seen as conspicuous piety from the true heirs. Adriaen van Poelgeest and his wife's gravestone must have been commissioned while they were still alive or shortly after their deaths in 1507. It was left unfinished.[54] It has connections with the heraldic and symbolic designs on the closed *van der Does- van Poelgeest Panels*.[55] The gravestone, however, has no "Antique" ornament[56] in contrast to the *van der Does-van Poelgeest Panels*.

The *Crucifixion* triptych (Wallraf-Richartz-Museum, Cologne), attributed by Friedländer to the workshop of the so-called Master of Delft, is a painting whose

wings seem to be based on the *van der Does-van Poelgeest Panels*.[57] Of course, it could also be the other way around.

It is possible at this point to digress and examine briefly the complex family relationships represented by the three couples on the *van der Does-van Poelgeest Panels*.

Henrica van Poelgeest's parents were Jan Gerytsz. van Poelgeest and Margriete van Swieten, daughter of Boudewyn van Swieten and Lutgard van Nijenrode. Margriete van Swieten and her husband are depicted on the van Swieten Memorial painting from Marienpoel. Also depicted are Margriete van Swieten's brothers and sisters and their spouses, and a nephew and his wife, and their daughter. The families to which these relatives were connected by marriage were van Leyenborch, van Diemen, van den Abeele, van Egmont, and van Hoochtwoude.[58] Ill. 12

Another van Swieten relative, Hugo van Swieten, married Luytgairt Claesdr. van Bosschuysen, and their daughter Katryn married Adriaen van der Bouchorst, while their other daughter, Adriaena van Swieten, married Ghysbrecht van Ysselsteyn.[59] Their sons were Willem Hugenz. van Swieten and Pieter Hugenz. van Swieten. The children and heirs (for example, the children of Pieter and a granddaughter of Adriaena, who was married to Jacop (Oom) van Wyngaerden) were involved in an inheritance lawsuit with other relatives, who included the heirs of Geryt Pietersz. (van) Ryswyck, and Katryn Jacopsdr. (van) Ryswyck, who had married Geryt van Lochorst. A son of this last marriage was Jan Gerytsz. van Lochorst, who married Adriaena van der Does, who is portrayed on the *van der Does- van Poelgeest Panels* of Cornelis Engebrechtsz.[60]

Geryt (van) Ryswyck's mother was Lysbeth Heynricxdr. van der Does, who married Aernt Heerman (an instance of surname choice), grandfather of Florys Heerman.[61] Florys Heerman was related to Willem Heerman and Cornelis Heerman, who was in possession of the estate of Lysbet Jan Heermansdr., widow of Adriaen van der Mye, and must therefore have been related to her.[62] They were also related to Jacop Gerritsz. Heerman, who married Henrica van der Does and is portrayed on the *van der Does- van Poelgeest Panels* of Cornelis Engebrechtsz. An inheritance suit of August 9, 1529,[63] lists some relatives of Cornelie, daughter of Cornelis Heerman. On the side of her mother Katryn (daughter of Bouwen Fyck) she was related to Jan van Berendrecht, Adriaen van Zonnevelt, (another) Bouwen Fyck, Adriaen Fyck, and Aernt van Diemen. On her father's side she was related to Jacop Heerman, Geryt Heerman, Geryt van Lochorst (son of Jan Gerritsz. van Lochorst and Adriaena van der Does), Coen van Bosschuysen, and Jan van Bosschuysen. In other words, Geryt van Lochorst and Jacop Heerman were related to each other.

The Fycks were heirs of Clemeynse Dircxdr. van Zyl, as were Cornelis Willemz. van Montfoirde and Jacop van der Does, who had married Alydt Florysdr. van Zyl.[64] Pieter van Zyl was an hier of Adriaen van der Mye and was involved in an inheritance dispute with Geryt Jan Kerstantsz.'sz., a first cousin of Willem Jan Kerstantsz.'sz. Stoop, who married Margaretha van der Does and is depicted on the *van der Does-van Poelgeest Panels* of Cornelis Engebrechtsz.[65]

Among the other heirs of Adriaen van der Mye were Bruyninck Heerman and Willem Heerman (relatives of Jacop Gerritsz. Heerman), and Canon Pieter Duyst.[66]

Through connections with Adriaen van der Mye and his wife, Lysbet Jan Heermansdr., the three husbands of the daughters of Willem van der Does and Henrica van Poelgeest were related, or connected by marriage, to each other, disregarding the immediate connection of their marriages to sisters.

Jacop Gerritsz. Heerman was a distant relative of Geryt (van) Ryswyck, the relative of Jan Gerytsz. van Lochorst's mother.[67] Coen van Bosschuysen, relative of Jacop Gerritsz. Heerman and Geryt van Lochorst, as already seen, was also a distant relative of the Stoops.[68]

A relative of Coen van Bosschuysen's, Jacop van Bosschuysen, married Alyt Jan Heermansdr., sister of Lysbet, the wife of Adriaen van der Mye.[69] Elysabeth van Bosschuysen, daughter of Jacop van Bosschuysen and Alyt Jan Heermansdr., was married to (1) Jan van Wena, (2) Lucas van Leyden, and (3) Jan van Ryswyck.[70] Elysabeth van Bosschuysen was related to Jacop van der Does, relative of Willem van der Does.[71]

The relatives of Willem Jan Kerstantsz.'sz. Stoop are interesting in connection with the idea that he was socially inferior to van Lochorst and Heerman, as proposed by Overvoorde. That he was indirectly connected with them has just been demonstrated. His closer relations are also worth noting. His grandfather was Kerstant Boeyensz. Kerstant Boeyensz. had four sons, Jan Kerstantsz., Jan Kerstantsz. Stoop, Willem Kerstantsz., and Geryt Kerstantsz.[72] Jan Kerstantsz. Stoop married twice. His first wife, Alyt, bore him two sons, Willem Jan Kerstantsz.'sz. Stoop (who married Margaretha van der Does) and Heynrick van Leeuwen (unless a previous marriage is implied for Alyt by the name of this "brother" of Willem Jan Kerstantsz.'sz. Stoop). Possibly Alyt's surname was van Leeuwen, or more fully, van Leyden van Leeuwen.[73]

Jan Kerstantsz.'sz. Stoop's second wife was Clara Pieter Jansz'sdr., whose first husband had been Jacop Dirck Aelbrechtsz.'sz. Erkenraet Dirck Aelbrechtsz.'sdr., Jacop's sister, married Jan Paeds.[74] Paeds, as observed above, was a branch of the Heerman family (deriving its surname from what had been the first name of a certain Paeds Heerman). Jan Kerstantsz. Stoop's brother, Jan Kerstantsz. (also known as Jan Kerstant Boeyenz.'sz.), married Sophie Willemsdr., daughter of Willem Claesz. van Thorenvliet and Hillegont Willemsdr. de Bruyn, the founders of the St. Anna Hof on the Hooygracht in Leiden. Jan Kerstant Boeyenz.'sz's wife's sister was Clemeynse Willemsdr., who married Jan Nannenz. Paeds. Jan Kerstant Boeyenz.'sz's wife's brother was Willem Willemsz., one of whose daughters married Claes van Zyl.

This Willem Willemsz. had a son Willem, whose son Pouwels Willemsz. van Thorenvliet[75] married Marytgen Pietersdr. Marytgen was Pieter Cornelisz. Kunst's daughter and Cornelis Engebrechtsz.'s granddaughter. Thus Cornelis Engebrechtsz.'s granddaughter was a distant connection of the people portrayed on the *van der Does-van Poelgeest Panels*.

Jan Kerstantsz. Stoop and his son Willem were both members of the local government. Jan Kerstantsz. Stoop was a magistrate in 1507, 1511, 1512, 1513, 1518, 1519, 1520, and 1521.[76] He was one of the burgomasters in 1515.[77] Willem Jan Kerstantsz.'sz. Stoop's offices are mentioned above.

The exact relation of various other members of the Stoop family in Leiden to each other is not clear, but one branch had a manor house outside Leiden. Confusing the

documents which refer to Willem Jan Kerstantsz.'sz. Stoop (who is also called Willem Stoop, Willem Jansz., Willem Jan Kerstantsz.'sz., and Willem Jansz. Stoop) are documents which refer to other relatives named Willem Stoop. These include his uncle, Willem Kerstantsz. Stoop;[78] Willem Symonsz. Stoop, who was also active in the city government and is not to be confused with Willem Symonsz. (van Oy) also in the government at about the same time;[79] and Willem Willemsz. Stoop.[80]

In addition to Jan Kerstantsz. and his brother Jan Kerstantsz. Stoop, there were Jan Reynersz. Stoop[81] and Jan Willemsz. Stoop, who married Alyt Willemsdr. van Leeuwen.[82] Also active in Leiden in this period were Roelof Pietersz. Stoop; his brother Meester Zeger Pietersz. Stoop; and his sister Cornelie Pietersdr. Stoop, who married Claes van Leeuwen; and his daughter Haes Roelofsdr. Stoop;[83] and his sons Jan Roelofsz. Stoop[84] and Daniel Roelofsz. Stoop.[85] Daniel Roelofsz. Stoop's daughter Katryn married Willem Boelinck.[86] Also mentioned are Pieter Stoop, a cousin of Jan Kerstantsz. Stoop who worked for him and evidently lived in Jan Kerstantsz. Stoop's house;[87] and Adriaen Stoop.[88]

Economically interesting is that Jan Kerstantsz. Stoop, Dien Aliwen, Niclaes Reynier (Stoop?) and others claimed family relationship to Claes Aelwynsz. and refer to Aelwyn Claes Aelwynsz.'sz. (whose gravestone in the Pieterskerk has been mentioned in a note above because of connection with the van Persijn family) as their brother.[89] According to a later complaint[90] Aelwyn Claesz. died of the plague while in the Antwerp inn where he lodged with his associates doing a great amount of wholesale trade in wood, cooper's wares, oils, and vinegar. The illness is called a gift of God ("*Aelwyn Claesz. voirs. die welcke van God almachtich beghaeft Is geweest mit der siecte der pestilentien*").

In many documents referring to the people just named the surname or the patronymic is omitted. This could cause confusion to someone unfamiliar with the specified family relations and connections.

The foregoing inter-relations seem to some extent comical. They deserve serious emphasis, however, because they affect government, social, and artistic concerns. And without a knowledge of the specific relationships, recorded historical events can appear vastly simplified, inexplicable, or even without any evident background on what may be considered a broadly local level. Thus, city government actions on a political or religious point may be inaccurately thought to be mere responses to a largely distant set of governmental decrees formulated by unknown officials elsewhere. However, in showing some forms of broadly local inter-relationship as represented in the couples on the *van der Does-van Poelgeest Panels*, no attention has been focussed on the geographically more distant relations which the same people had on a similar, close family level. That such relations extended from Leiden to Mechelen is seen, for example, in the discussion of the Leiden sheriff Nicholas van Berendrecht in my dissertation. In the context of the general political and cultural history of the period it is these very complicated family ties that clarify certain events, and that further militate against accepting any idea of cultural backwardness in Leiden. An example of the mixture of politics, religion, and art is seen in the role played by Pouwels Willemsz. van Thorenvliet in the preservation of art works of the St. Anna Hof in Leiden (founded by his ancestors) during the Reformation.

Having begun the examination of Cornelis Engebrechtsz.'s best work (in van Mander's opinion) with the reminder that the main part is missing, it is fitting to close this brief study of the biographical details of the sitters with a reminder that at the moment there does not exist a sufficient basis of study of the inter-related landed nobility and oligarchies of the various cities in the Low Countries in the fifteenth and sixteenth centuries to make possible a thorough study of anonymous but heraldically decorated art works. Prior attribution by style to some localized painter or "school" restricts heraldic identification study to the point of becoming a significant block to art historical research. It remains impossible to know even where to begin research on identifying sitters if an anonymous painting has been assigned by style critics to the wrong town or area. The art historian is thus deprived of an important avenue for approaching the identification of commissions and artists and for understanding what characterized local artistic differences, if they existed on more than economic bases. Without the study of family connections, of donations of lost or destroyed art works to demolished or emptied churches, and of the biographies of forgotten artists and craftsmen, the art historian may scarcely notice what is missing from the neatly arranged systems within which preserved works are now displayed.

Notes

1. See Pelinck, *Lakenhal Painting Catalog*, 66-70, no. 622. Pelinck relates the date 1837 as both approximate and uncertain, for the destruction of the central panel. The painting is recorded in van Mander, *Schilderboek*, folio 210 verso.
2. Hoogewerff's statement that the central panel depicted the *Last Judgement* is an error (see his *Noord Nederlandsche Schilderkunst*, III, 159). The error was noted by H. van de Waal (marginal notation in library copy, Rijksuniversiteit Leiden). Hoogewerff's error could have originated in a misreading of Dülberg, "Das Jungste Gericht der Lucas van Leyden," *Repertorium für Kunstwissenschaft*, XXII, 1899, 32. The note on the "centre" in Friedländer, *Lucas van Leyden and Other Dutch Masters*, 78, no. 75, does not refer to the central panel but to the middle portrait of the men depicted.
3. Overvoorde, "Een Weinig Bekend Altaarstuk van Cornelis Engebrechtsz.," *Bulletin van de Nederlandschen Oudheidkundigen Bond*, XII, 1911, 308.
4. Friedländer, *Lucas van Leyden and Other Dutch Masters*, 39. Friedländer gives 1515 as the earliest possible date likely, in contradicting Overvoorde; but he leaves open what the latest possible date might be.
5. Friedländer, *Lucas van Leyden and Other Dutch Masters*, 39.
6. Van Asperen de Boer and Wheelock, "Underdrawings," 85.
7. See above, chapter two, note 105, and subsequent material.
8. R. A. 42.
9. See R. A. 41, December 14, 1484.
10. See R. A. 41, September 14, 1515, a reference to a year's income due to the estate in the year after death.
11. Van Mander, *Schilderboek*, folio 210 verso.
12. See S. A. 588 (Thesauriers Rekeningen 1507-1508), folios 90 verso and 91. See also C. Hoek, "Grafschriften te Leiden en Rotterdam," *Ons Voorgeslacht*, XVI, 1961, 11, where the reading for Adriaen van Poelgeest is erroneous.
13. See R. A. 42, November 23, 1508; September 19, 1511; January 26, 1515; and March 30, 1515; see also R. A. 41, February 5, 1515; September 24, 1515. See also the gravestone of Adriaen van Poelgeest and Machtelt van der Does, against the east wall of the north transept of the Pieterskerk, Leiden. Also granted a legacy by Adriaen van Poelgeest's will were the children of Cornelis van Hoichtwoude, who

had been married to a van der Does. This legacy resulted in the sequence of lawsuits in 1515. See further, R. A. 42, January 31, 1533, for a reference to Geryt van Hoochtwoude, married to a Machtelt van der Does, whose daughter married Anthonis Carlier, Master of the Mint at Dordrecht (R. A. 42, October 20, 1536). Also note payments in 1507 for memorial masses for Adriaen van Poelgeest and in 1508 for Willem van der Does, from the heirs (Kerk. Arch. 18, unfoliated). For House Lochorst, particularly, see R. A. 41, December 14, 1484, lawsuits brought by Willem van der Does against Adriaen van Poelgeest and his father Jan van Poelgeest. The house had come into possession of Adriaen van Poelgeest through his mother, Margriete van Swieten, daughter of Boudewyn van Swieten (founder of Marienpoel). The inheritance was to have been equally divided among the three children of Jan van Poelgeest and Margriete van Swieten, Adriaen, Willem, and Henrica van Poelgeest, but Willem van der Does' lawsuit claiming equal inheritance in the name of his wife's claim (she had already died) was rejected on a technicality, apparently having been instigated after the expiration of a statutory time limit. In the absence of other heirs, it follows that the three daughters of Willem van der Does and Henrica van Poelgeest were equal heirs of the house at the death of Machtelt van der Does, widow of Adriaen van Poelgeest, unless Adriaen van Poelgeest's will (not preserved) contained special limitations about the division of that part of his estate. The shares which came to Heerman and Stoop, if inheritance was equal, could have been handled by an annual payment. A settlement of this sort had been demanded by Willem van der Does in the interests of his wife's heirs (literally in the interest of his wife's inheritance, which may have been a legal error, also) in the lawsuit of December 14, 1484 (R. A. 41).

14. See Friedländer, "Das Inventar der Sammlung Wttenhorst," *Oud-Holland*, XXIII, 1905, 65.

15. The arms of van der Does are a red field with nine gold lozenges, placed 5 and 4. Those of van Poelgeest are a blue field with a gold horizontal bar and three silver eagles, displayed, placed 2 and 1. The dimidiation of the arms ensures that Willem van der Does and his wife are memorialized, not Adriaen van Poelgeest and his wife.

16. Nicolas Gerritsz. van Leyden is not known to have been connected with Leiden except through his own seal, which he used at Strassbourg, where his arms are three posthorns and he uses the name "van Leyden." Another person using the name van Leyden is known to have used the same arms in the sixteenth century (see C. Bangs, *Arminius*, Nashville, 1971, 27-29). The tomb of Frederick III is, of course, reproduced in numerous places; a clear photograph of the entire slab is found in C. Gilbert, *History of Renaissance Art, Painting, Sculpture, Architecture, throughout Europe*, New York, 1973, 326, fig. 407.

17. Although the tomb is nearly obliterated by wear, the upper part of the griffon is visible (the lowest part of the slab was left unfinished). The griffon's head is practically identical with that on the *van der Does-van Poelgeest Panels*; and it is at points like ears and beaks that other griffons in heraldry of the same time show great variation. Cornelis Engebrechtsz. may have been commissioned to make a drawing for the sculptor of the tomb, but no documents confirm the hypothesis. The design may also conform to a local type of griffon. The design of the van Poelgeest- van der Does tombslab is related in its border decoration to the tomb of Floris van der Bouchorst (d. 1509) now in the parish church of Noordwyck. In the same church is the earlier slab of Vranc van der Bouchorst, who donated one of the Marienpoel altars consecrated in 1457, described above.

18. Her name is given incorrectly as Adriaena van Poelgeest in Gibson, diss., 172.

19. After one reference in a sixteenth-century form (given name, surname, patronymic) to "Jacop Heerman Gerritsz," Gibson omits the surname (Gibson, diss., 173 f.). Van Asperen de Boer and Wheelock omit the surname entirely (van Asperen de Boer and Wheelock, "Underdrawings," 85). Overvoorde gives the fullest form of the surname, "Heerman van Oestgeest" (Overvoorde, "Altaarstuk van Cornelis Engebrechtsz.," 304). Overvoorde's form, accurate for the family, does not appear in most documentary references to Jacop Gerritsz. Heerman (van Oestgeest). Friedländer, *Lucas van Leyden and Other Dutch Masters*, 39 and 78, has "Jacob Heermans van Oegstgeest."

20. Overvoorde, "Altaarstuk van Cornelis Engebrechtsz.," 308.

21. Most recently: van Asperen de Boer and Wheelock, "Underdrawings," 85.

22. Willem Jan Kerstantsz.'sz. Stoop has sometimes been confused with his father in references to the portrait. For example, see Hoogewerff, *Noord Nederlandsche Schilderkunst*, III, 158; Friedländer, *Lucas van Leyden and Other Dutch Masters*, 39 and 78; Gibson, diss., 174; van Asperen de Boer and

Wheelock, "Underdrawings," 85-87. Van Asperen de Boer and Wheelock list the father consistently, without the correct name once.

23. S. A. 73, folio 16.

24. See note 13.

25. S. A. 73, folios 1, 17, and 20.

26. S. A. 73, folios 4 and 5.

27. S. A. 74, folio 3. This contradicts Pelinck's date, 1516, which must be a misprint or misreading (Pelinck, *Lakenhal Painting Catalog*, 69).

28. For the Jerusalem trip, see S. A. 562 (Burgomeesters Rekeningen 1490-1491), folio 180 verso.

29. Overvoorde suggested that because Heerman is depicted holding the palm branch in his arm, not in his hands, the branch was added after the rest of the painting was completed, commemorating a later trip (Overvoorde, "Altaarstuk van Cornelis Engebrechtsz.," 306). Pelinck described the branch as probably not painted in later (Pelinck, *Lakenhal Painting Catalog*, 69). Compare with portraits of Jerusalem Brothers by Jan van Scorel for the customary palm branch pose.

30. R. A. 42, December 3, 1509.

31. W. A. Gr. Bew. B, folios 102 verso and 103. This contradicts Gibson's statement that the latest reference to Heerman is in 1520 (Gibson, diss., 198).

32. R. A. 42, September 15, 1536; see also R. A. 42, September 27, 1540. He is mentioned by name.

33. Overvoorde, "Altaarstuk van Cornelis Engebrechtsz.," 310.

34. S. A. 73, folio 7.

35. R. A. 42, folio 77, June 10, 1510; see also the sessions for 1506.

36. S. A. 73, folio 17.

37. S. A. 73, folios 16, 19, and 20.

38. R. A. 42, March 23, 1515. The defendant, "Mr. Willem Stoop," seems to have been Willem Symonsz. Stoop; and in this year the only other candidate for the second "Willem Stoop" in the case is Willem Jan Kerstantsz.'sz. Stoop.

39. S. A. 74, annual lists. In 1515, the first preserved list, the other two regents were "Joncfrou Janna Willems weduwe van Bosschuysen" and Clara, the second wife of Jan Kerstantsz. Stoop. The group remained the same until 1522, when Janna van Bosschuysen was replaced by Claertgen van Lodensteyn. Clara Jan Kerstantsz. Stoop's wife was replaced in 1524 by Marytgen Claes Claesz.'s wife, after which the group remained the same until the replacement of Margaretha van der Does in 1534 by Claesgen Gerytsdr. Joncfr. Margaretha van der Does is mentioned as late as June 31, 1533 (R. A. 42). The exact date of the death of Willem Jan Kerstantsz.'sz. Stoop seems to be June 25, 1519 (see Kl. Arch. 1243, Necrologium Marienhaven, folio 30).

40. Gibson, diss., 175; see also Overvoorde, "Altaarstuk van Cornelis Engebrechtsz.," 310.

41. Gibson, diss., 175.

42. That Leiden's surgeons were wealthy and enjoyed high social prestige is clear from lawsuits in R. A. 42 and R. A. 43. Marriage with patrician families was not exceptional. An example is Meester Jan Claesz. van Zeyst (brother of the painter Phillips Claesz. van Zeyst), surgeon and official in the city government (see S. A. 73 and S. A. 74), who was married to Joncfr. Russent Michielsdr. (see, for example, R. A. 42, November 27, 1536; July 26, 1537). The form of address used for Margaretha van der Does in her later years indicates no loss of social prominence. See R. A. 42, November 27, 1531, where she is mentioned as *"Jonffrou Margriete van der Does Willems dochter wedue wylen Meester Clement Jansz. doctoer In medicinen."* For Gibson's implication of loss of social prestige, see Gibson, diss., 175.

43. If the commission was paid by the heirs, he would have had to consent to the painting of the previous husband's portrait alone instead of his own or instead of portraits of both her husbands. The admittedly slight amount of information available regarding sixteenth-century Netherlandish portrait commissions yields no examples of such behavior.

44. See van Asperen de Boer and Wheelock, "Underdrawings," 86.

45. The Willem Stoop who died in 1518 (mentioned in Overvoorde, "Altaarstuk van Cornelis Engebrechtsz.," 310) was apparently Willem Kerstantsz. Stoop, uncle of Willem Jan Kerstantsz.'sz. Stoop. See R. A. 42, February 7, 1519.

46. Overvoorde, "Altaarstuk van Cornelis Engebrechtsz.," 306.

47. Gibson, diss., 173.

48. See S. A. 84 for the various membership lists of the archery guilds; particularly, S. A. 84, folio 201 verso, 1519, in which Willem Jan Kerstantsz.'sz. Stoop is listed in the year of his death.
49. Gibson, diss., 185.
50. Van Asperen de Boer and Wheelock, "Underdrawings," 85-88.
51. Gibson, diss., 175.
52. Van Asperen de Boer and Wheelock, "Underdrawings," 87.
53. See note 13.
54. The bases of the armorial panels are only begun, where the cords and the lower parts of the griffon should be visible. Otherwise the gravestone is completely carved but very worn, and slightly damaged. Other graves on the church floor indicate that the present effect is probably one of wear on a nearly completed stone.
55. The designs are discussed below; for other connections see note 17.
56. Antique ornament is also missing from the 1509 van der Bouchorst tomb in Noordwyck. Material for comparison is found in J. Belonje, *Steenen Charters, (Oude Grafsteenen)*, Amsterdam, 1943 (3d edition), where, however, the slabs here discussed are omitted. The Leiden and Noordwyck slabs are depicted in E. H. ter Kuile, *Leiden en Westelijk Rijnland*, (= *De Nederlandsche Monumenten van Geschiedenis en Kunst*, VII, *De Provincie Zuidholland, eerste stuk*), The Hague, 1944, pl. XLVIII and pl. CL.
57. Friedländer, *Lucas van Leyden and Other Dutch Masters*, no. 61, plate 45. The central panel of this triptych seems to combine acquaintance with the Marienpoel *Crucifixion* triptych and Dürer's woodcut of ca. 1500 (Kurth, *Dürer Woodcuts*, no. 88). The triptych displays the arms of van Persijn and another family, which I have not attempted to identify. Van Persijn is a family appearing in the quarters of Anna van der Hooge, wife of Claes Aelewyn Claesz. (verHooch) on their tombstone against the north wall of the outside nave aisle of the Leiden Pieterskerk, from the third quarter of the sixteenth century. For other relatives and connections of Claes Aelewyn Claesz.'sz., see below. Van Persijn is the final part of the surname of the Leiden regent family de Grebber van Persijn (see R. A. 42, May 9, 1530). For an iconographical note on the central panel of the triptych, see E. Kai Sass, "Pilate and the Title for Christ's Cross in Medieval Representations of Golgotha," *Hafnia, Copenhagen Papers in the History of Art*, 1972, 4-67, especially 23.
58. For the descendency of Henrica van Poelgeest from Boudewyn van Swieten, see R. A. 41, December 12, 1484.
59. See R. A. 42, November 3, 1483.
60. See. R. A. 41, February 1, 1490.
61. See R. A. 41, July 23, 1483.
62. See R. A. 41, September 3, 1501.
63. R. A. 42.
64. See R. A. 41, August 6, 1485, and August 8, 1485.
65. See R. A. 41, May 7, 1501.
66. See R. A. 41, June 8, 1501.
67. See R. A. 42, October 26, 1490.
68. See R. A. 42, November 15, 1546.
69. See R. A. 41, February 13, 1514.
70. See R. A. 42, June 11, 1526; May 29, 1534; and September 4, 1536 (among other places).
71. See R. A. 42, October 11, 1535.
72. See R. A. 41, August 30, 1499.
73. See R. A. 41, December 17, 1512, and June 22, 1515.
74. See R. A. 41, October 21, 1494.
75. See Archieven der Hofjes, 131 and 132; see also Gasthuis Archieven, 303, the entry after Cornelis Engebrechtsz.'s house, which is the house of Jan Kerstant Boeyenz.'sz.
76. See R. A. 42, August 9, 1507; S. A. 73, folios 14, 15, 20, 21, 22, and 23.
77. S. A. 73, folio 17.
78. See R. A. 41, September 28, 1506.
79. See S. A. 73, folio 6; for Willem Symonsz. van Oy, see S. A. 73, folio 16.
80. See R. A. 42, July 9, 1526, and May 29, 1528.

81. See R. A. 41, July 16, 1483.
82. See R. A. 41, August 13, 1484.
83. See R. A. 41, D, folio 221, undated, ca. January 12, 1485.
84. See R. A. 42, June 21, 1508.
85. See R. A. 41, September 4, 1498.
86. See R. A. 42, June 21, 1508.
87. See R. A. 42, July 11, 1487.
88. See R. A. 2, January 26, 1476.
89. See R. A. 42, insertion between April 30, 1509, and May 4, 1509, but dated April 12, 1521. This must be connected with Aelwyn Claesz.'s death in 1520.
90. R. A. 42, January 10, 1539.

4. Notes and Some Unverified Hypotheses

The Brussels Portraits of 1518

G. Ring first published an attribution of the Brussels 1518 portraits to Cornelis Ill. 40,41
Engebrechtsz., surmising that the landscape behind the sitters might be in Leiden.[1]
Pelinck correctly identified the place depicted as a view of the Nieuwe Rijn and the
Gangetje in Leiden.[2] Key to the location is the confluence of the two canels and the
presence of the bridge, just visible at the right, the Karnemelcxbrug. A building he
could not identify is the small tower beyond the Hogewoerdsbrug (in the woman's
portrait).[3] The tower is depicted on a map from 1578 by Hans Liefrinck.[4] It was at the
Oosterlingplaats, formerly known as the Raemplaats (now called the Garenmarkt).[5]
The tower's real location shows that the city view is not drawn with a systematized
triangulation or perspective measurement — the space beyond the Hogewoerdsbrug is
unclearly defined in the painting. The houses there, however, show the correct
number of alleys and streets off to the left to corroborate the identification of the
tower's location. That this escaped Pelinck's notice may be a result of reliance on early
maps like Liefrinck's. All are distorted at just this place, extending the distance and
enlarging the curve so that the tower does not look like a possibility, being too far
away. Disregarding these distorted maps and standing at the place with the view it is
possible to obtain a direct line of sight to the former location of the tower. This is also
seen on any modern map. Liefrinck's map shows that the only houses which might
have obstructed the view at all were one-story cottages with narrow gables, and they
could not have blocked sight of the tower. The identification of this tower confirms
Pelinck's important discovery of the location of the view.

Although Pelinck is correct about the view, he is incorrect in identifying the sitters
as Dirck Ottenz. van Meerburch and his wife Cornelie Pietersdr. van Leyden van
Leeuwen; and he provides proof of the incorrectness in the same article.[6] The
portraits are dated 1518 on the panels. The man's age is given as forty-two; his wife's
as forty. Pelinck's research proved that Dirck Ottenz. van Meerburch was born in
1478.[7] According to the painting's inscription the man portrayed must have been born
in 1476 or 1475, bacause he was forty-two in 1518.[8] The portraits, therefore, cannot be
of Dirck Ottenz. and his wife.

The Leiden 1502 tax records suggest that the man portrayed may have belonged to
the van Zyl family, whose house was located at the end of the Karnemelcxbrug, and
from whose house the view could be seen.[9]

Hoogewerff sneered at the niches which form the|background of the sitters, im-

plying that such fine woodcarving could not have existed in simple, backward Leiden.[10] Hoogewerff interprets the presence of ornate carvings as an attempt by the practical and meditative, patiently enduring (all praiseworthy qualities, to be sure) Northerners to cheer their boring lot through imaginary finery which would allow them the illusion of surroundings like those they could have had, had they only been living in Belgium instead. Hoogewerff's attitude deserves mention because it expresses the presupposition that dominates past literature on Leiden art — that the

Ill. 49,50, place was an isolated backwater, in need of artistic inspiration from outside in-
56,57 fluences. The depicted woodwork is, nonetheless, quite restrained in comparison to the pulpit of the Leiden Pieterskerk, designed in 1532 by Pieter Cornelisz. Kunst.[11] As remarked above, decoration identical to that in the 1518 portraits is seen in the *van der Does-van Poelgeest Panels* by Cornelis Engebrechtsz. (except for a change of depicted materials). Such niches could have been more than mere fantasy.[12]

The Vienna Healing of Naaman Triptych

The *Healing of Naaman* triptych has outer wings on which are depicted SS. Cosmas and Damian. Above them is a banderol with the inscription: *T COMT* [followed by a small decoration, followed by the space of the frames of the closed panels, and the letter:] *D.* The last letter had been mistaken for a *P* by Gibson,[13] although the vertical does not extend beyond the curved stroke of the *D.* According to Gibson the inscription should be read as, "*T COMT*[*O*]*P* ('It comes up'), most probably referring to the precipitation in the urine flask examined by the saint on the right."[14]

Instead of supposing that the picture includes evidence of early scientific interest in precipitates, it is more likely that the inscription should be read: "*T COMT v*[*an*] [*GO*]*D*." The *v* is partially present in the decoration after *COMT*, and there is enough space for the remaining letters before *D*, assuming that the banderol continued across the frames of the panels. The translation is "It comes from God." This slogan refers to both illness and health.

The suggestion is supported by various documents. Almost all lawsuits brought by sixteenth-century Leiden surgeons for the recovery of fees, for example, describe successful cures as the joint work of the surgeon and God.[15] The guild regulated surgical activity according to astrologically approved days.[16] God was considered to regulate the heavens, which affected different parts of the body, so adherence to astrologically correct days for surgery gave evidence of the belief that health and healing came from God. That illness was also considered to come from God is illustrated by the sixteenth-century name for the plague, used in Leiden, "*De Gave Goids*" ("The Gift of God").[17]

The slogan "It comes from God" connects also with the story of Naaman (II Kings 5), depicted on the inside of the triptych. The healing of Naaman is considered a gift of God; therefore, payment is refused by Elisha. Gahazi's leprosy is considered punishment given by God.

Gibson is presumably correct in thinking that the Vienna triptych was an altarpiece for a surgeons' guild, although no documents are preserved to connect it with

48

Leiden.[18] Hoogewerff, however, thought that the painting must have been commissioned after someone had been healed of a disease, in fulfillment of a vow. He gives no source to support this pious assertion.[19]

Some Unverified Hypotheses

A fascination of the stylistic approach to attributions is the absence of verifiability at one of the points of most interest, separation of the work of a master from that of pupils and followers. Friedländer said that "Cornelis ran an art school."[20] Gibson has stressed the idea, claiming that Cornelis Engebrechtsz. had a large atelier with specialized assistants carrying out particular areas of artistic activity; this atelier is supposed to have dominated Leiden's artistic life before 1520.[21] Considering the hundreds of documentary references to Leiden artists and craftsmen before 1520, the existence of such a studio ought to be verifiable.[22] The Leiden problem, however, is complicated by the families of Cornelis Engebrechtsz. and Huych Jacopsz., containing eight painters (including Dammas Claesz.).

To distinguish between the styles of people trained constantly within their own families seems rather difficult, which may be why no one has bothered to ascribe anything to Dirck Hugenz. His works may look very much like those of his brother; and he received preference over Lucas in the commission for banners noted above. Similarly, as an older painter than Lucas, his works may look more like those of his father's early period (whatever that may have been). Huych Jacopsz., however, survived his son Lucas. He may, therefore, have developed along similar lines and painted pictures scarcely differing from those of his son Lucas or his son Dirck. Dirck, on the other hand, continued to paint into the 1540's.[23] The neglect of Dirck Hugenz. is surprising in the context of the numerous attributions to the sons of Cornelis Engebrechtsz., all made without historical evidence (except for the pulpit noted above). It may be added that Dammas Claesz., son-in-law of Lucas van Leyden, probably also imitated Lucas' painting and drawing style (but maybe not). He derived income from the sale of later impressions he made from the plates engraved by Lucas van Leyden.[24]

Except for family possibilities, no evidence has been found to support the idea that any Leiden painter between 1475 and 1575 had a large atelier with numerous assistants simultaneously in his employment. Closest to the idea is the activity of Hieronymusdal, but there the work of painters and illuminators was in later years separate, and there is no evidence of collaboration. Moreover, Hieronymusdal seems to have had no particular artistic overseer. Cornelius Aurelius does not seem to have influenced the choice of illustrations to his *Cronycke van Hollandt 1517*, so he may be discounted as artistic overseer.[25] Brother Tymanus seems to have had nothing to say about what the other painters produced. And the illuminators are not described in a way to suggest that they might have received directions from the painters. The sculptors were also apparently independent of directions from painters or illuminators. Guild regulations indicate that it must have been rare for a painter to have more than one or two apprentices at the same time. A large number of independent

painters, who at the most collaborated occasionally on isolated commissions, is a more accurate view of the situation. The reliability of van Mander's report that Lucas van Leyden and Aert Claesz. (Aertgen van Leyden) studied under Cornelis Engebrechtsz. is doubtful. Van Mander may merely have been attempting to explain their competence in oil painting, which he supposed was introduced to Leiden by Cornelis Engebrechtsz. Van Mander had only the sketchiest idea of art activity in Leiden during the first third of the sixteenth century, and he could say nothing about what occurred in the fifteenth century.

Cornelis must have had pupils, since he was consulted about the proper fees in the 1520 lawsuit. But it is not proven that the distinguishing characteristic of his own work contrasted with that of his students is that theirs is "often much coarser in quality."[26] Further, no "period of dissolution" in Cornelis' studio during the last decade of his life has been documented, despite Gibson's statement that evidence of one exists.[27] And, real iconoclasm notwithstanding, no evidence confirms that "many of his altarpieces were dismantled or destroyed in the religious troubles of the sixteenth century."[28]

Another unverified hypothesis is that it might be possible to identify which woodcuts appearing in Jan Zevertsz.'s publications were designed by Cornelis Engebrechtsz., by looking at the illustrations in these books, sorting out a few for ascription to Lucas van Leyden because of similarity to his known works, dividing the rest into internally related groups (style criticism), and deciding which look most like Cornelis Engebrechtsz.'s known works, the three Lakenhal triptychs. That Cornelis' woodcuts might resemble those of Lucas van Leyden is more or less obvious. He might even be the "old fashioned draughtsman, who was influenced by Lucas van Leyden around 1511," a description devised by R. Kahn[29] and used by H. van de Waal for an anonymous artist responsible, in his opinion, for a group of woodcuts used by Jan Zevertsz. from ca. 1509 on.[30]

Ill. 33,34, The works so grouped first appear in *Legende van S. Katherina van der Seyn*, 35,36,37, presumably published before 1509, because by 1509 the illustrations already show 38,39 signs of wear.[31] The book contains six illustrations.[32] One was re-used in the *Cronycke van Hollandt 1517* to represent *Suster Gheertruyt van Oesten*, which gave van de Waal the opportunity to group it with five other illustrations from Jan Zevertsz.'s books, as being from the same designer.[33] There is no documentary evidence supporting this grouping, which contradicts other equally unsupported groupings. The other illustrations were the *Mirakel van Ste. Barbara, Phillips van Bourgondie, Phillips de Schoone* (from the *Cronycke*), besides a *Gathering with an Enthroned King* and a *Sermon on the Mount*.[34] The version of the illustration of the kneeling St. Catherine of Sienna appearing in the *Cronycke* is cut down or blocked out from the original.[35]

The *Sermon on the Mount* appears on the title page of *Der Byen Boeck* (1515), together with another woodcut of three beehives, a decorated capital *H*, and two blocks of "Antique" ornament used to fill the bottom of the page.[36] Van de Waal does not explain the omission of the beehive woodcut from his group.[37]

The *Gathering with an Enthroned King* appears in a form with three blocks on the title page of *De Reipublica Cura* by Phillips van Leyden, published by Jan Zevertsz. in 1516.[38] The two side panels, depicting additional figures apparently desiring

audience, were added to the center block for this book. The center block had already appeared as the title page illustration to *Spiegel van Sassen* (1512).[39] The colophon of the *Spiegel van Sassen* depicts an elephant together with the letters *G D*, which have been identified as signifying "*Gode Dank*" (or: Gratia Dei [*sic*], "Thanks be to God").[40] This woodcut has not been grouped stylistically with the others, presumably because of the technical crudeness of the elephant, although it is scarcely cruder than the portrait of *Phillips van Bourgondie*. Moreover, this is an instance of alteration and re-use of a block. The elephant's oddness is explained by its dependence on Alart du Hamel's engraving *The War Elephant*.[41] The woodcut shows an attempt to follow the engraver's marks, which depend on engraving technique, as if the marks were essential to the proper depiction of an elephant.[42] The connection of the colophon with Cornelis Engebrechtsz. is the close similarity between the letters *G D* in the colophon and the same letters as they appear on the closed panels of the *van der Does- van Poelgeest* triptych.[43]

The problem is thereby returned to the point that there is no certainly that any of these particular woodcuts was designed by Cornelis Engebrechtsz. There is equally no proof concerning the supposed woodcuts of Lucas van Leyden.

Notes

1. G. Ring, *Beiträge zur Geschichte der niederländischer Bildnismalerei im 15. und 16. Jahrhundert*, Leipzig, 1913, 30. Bruyn disputes the attribution on stylistic grounds and considers the portraits to be a key to the early work of Cornelis Cornelisz. Kunst. (See J. Bruyn, "Lucas van Leyden en zijn Leidse tijdgenoten in hun relatie tot Zuid-Nederland," *Miscellanea I. Q. van Regteren Altena*, Amsterdam, 1969, 49. Bruyn's article presupposes that Leiden was more or less isolated from the culture of the "Southern Netherlands" and open to tracible "influences" linked to more or less isolated events.

2. Pelinck, "Twee Leidsche Portretten en een Stadsgezicht," *Jaarboekje voor Geschiedenis en Oudheidkunde van Leiden en Rijnland*, XXXII, 1940, 178-182. In Cornelis Engebrechtsz.'s time and into the seventeenth century the Oude Singel (the location suggested by Ring) was still the town's moat ("*singel*") and, thus, outside the town walls.

3. Pelinck, "Twee Leidsche Portretten," 180. The tower he describes is admittedly *not* what is depicted.

4. The original of this map is missing. A copy of 1744 is in the Leiden Municipal Museum "De Lakenhal." See van Oerle, "Waarachtige Afcunterfeitinge der Stad en Universiteit Leiden in Holland," *Jaarboekje voor Geschiedenis en Oudheidkunde van Leiden en Omstreken,* LXVI, 1974, 155-157.

5. The Raemplaats was also known as the Raemclocxgraft because the tower contained a bell ("*clock*") used to regulate work hours for the fullers. It began to be called the Oosterlingplaats ca. 1490 (see R. A. 50, folio 76 verso, September 30, 1493). The name change probably indicates that the representatives of the Hanseatic league in Leiden resided there. In the 1490's the representative was the merchant Koert Indeman (see, for example, R. A. 41, 1486-1492, folio 145 verso), while ca. 1502 the representative was Govert Engel, "*stede coopman van den Hanse*" (R. A. 50, 1494-1509, folio 73 verso).

6. Pelinck's identification seems to be an attempt to unify two eighteenth-century documentary references to portraits of Dirck Ottenz. van Meerburch and his wife, with existing paintings. Presumably through the cross-reference under "Lucas van Leyden" in the contemporary alphabetical index to the volume, Pelinck discovered a reference to a pair of portraits of Dirck Ottenz. van Meerburch and his wife in van Rijkhuysen's *Copey-brieven*, VI, folio 119. The portraits are described as dated 1518, round at the top, and painted by Lucas van Leyden. The age of the sitters in 1518 is not given. The reference incorrectly gives Dirck's birthdate as 1476. A second reference to these paintings, also cited by Pelinck, is found in van Rijkhuysen's *Geslacht en Wapenboek*, D. folio 28 verso. Here the portraits are said to depict Adriaen van Meerburch and his wife Josina Fransdr. van Leeuwen. The paintings

were dated 1518, when, it says, he was forty and she was forty-two. This chronology makes the identification impossible if painted in 1518. The confusion could have arisen from the identical coat of arms for both generations, Adriaen being Dirck's son. The description says that the paintings *included* the coats of arms of van Meerburch and of van Leyden van Leeuwen. It is followed by a reference to a double portrait explicitly described as without arms ("*zonder wapens*"), although the families were the patricians de Bije and Hopcoper. This implies that the description specifying the presence of heraldry in the paintings is reliable, especially because heraldry was van Rijkhuysen's interest, not paintings. Coats of arms are not found on the 1518 Brussels portraits. It may be concluded that more than one pair of rounded portraits were painted in 1518, and that people of approximately the same age appeared in them. The connection of the eighteenth-century documents, mutually contradictory, with the Brussels paintings fails. Van Rijkhuysen's manuscript volumes, 1749-1757, are on loan in the Leiden Municipal Archives. They belong to the library of the Rijksuniversiteit Leiden. Pelinck describes them as not entirely trustworthy (Pelinck, "Twee Leidsche Portretten," 178-179). Because Pelinck lists merely sources, not connecting them explicitly with the content of his article, it is not clear from the article where exactly van Rijkhuysen's information is essential to the argument (which ignores the particular discrepancies in van Rijkhuysen's descriptions).

7. Pelinck, "Twee Leidsche Portretten," 179. See S. A. 976, loose sealed statement under oath, dated December 5, 1543, noting the deposition given by Dirck Ottenz. van Meerburch and stating his age.

8. This seems to have been missed by Pelinck. Further confusion is caused by the transposition of photograph captions, so that the age 40 appears in a detail photograph of the city view whose caption states incorrectly that it is the city view in the man's portrait. The brewery mentioned by Pelinck is one of several houses whose backs are seen in the Brussels paintings. The brewery was owned by Dirck Ottenz., whose house in front of it, not visible in the painting, had an impressive façade on the Hogewoerd side.

9. S. A. 945, folio 34 verso (Burchstrenge). The seventh name in this neighborhood is Pieter van Zyl, an exceptionally wealthy man whose household included the minor children of Jan van Zyl. The Liefrinck 1578 map indicates that the house would be correctly located in connection with van Zyl's place on the list. While probable, it is not certain that a van Zyl owned the house sixteen years later.

10. Hoogewerff, *Noord Nederlandsche Schilderkunst*, III, 183-184: "Voorgesteld is een burgerlijk echtpaar, dat niet door uitdossing doch door rederijkende renaissance-entourage, zich een allure van voornaamheid zocht te geven. De versiering van de nissen, waarvoor deze "hij" van 42 en deze "zij" van 40 jaar zijn neergezeten, is al even kenmerkend voor het woekerend misverstand van stijl als de beide 'kaboutergens': hier geen 'putti', maar aap-aachtige monstertjes, die als houders der festoenen op de pronkerige kapiteelen zijn aangebracht. In aardig contrast met dit onwezenlijk décor is het stille grachtje, dat naar de simpele werkelijkheid op beide de paneelen is weergegeven. Het uitzicht voelt men als even echt van gelijkenis als de geportretteerde wezenstrekken van hem, met zijn practischen blik en van haar, met de nadenkende, wat lijdende uitdrukking in de oogen. De tinten zijn schuchter en lichtelijk vaal, zoals het leven aan zulk een weinig tierig kade, naar ons begrip, tamelijk vaal moet zijn geweeest. Dan is de verbeelding van Meester Cornelis [Engebrechtsz.] welkom, die op gepast wijze de woning wat komt opluisteren met zuidlandschen tooi en zwier van gebootste guirlanden. Men voelt er zich temet een eêlman bij worden!" It is difficult to find a more thorough-going example of the presupposition that in the early sixteenth century the cultural level of Leiden was lower than that found in the present Southern Netherlands (Belgium).

11. The pulpit is Pieter Cornelisz. Kunst's only documented work. It is discussed below.

12. Alternatively, the niche may have been taken over from the composition of some other artistic work, like the *Madonna and Child* attributed to Quentin Massys in the Mauritshuis, The Hague, on loan from the Rijksmuseum, Amsterdam (see Friedländer, *Early Netherlandish Painting*, VII, Leiden, 1971, plate 62). A chair with a canopy like the depicted niches is in the chapter house of the cathedral in Toledo, Spain, which confirms the actual existence of such furniture (see *All Toledo*, Barcelona, 1974, 35).

13. Gibson, diss., 162.

14. Gibson thanks J. G. van Gelder for the information, although van Gelder does not seem to have published this interpretation.

15. There are many such lawsuits in R. A. 42 and R. A. 43.

16. See Gilde Archieven 305 (guild charter of August 2, 1466); see also Gilde Archieven 306 (guild charter of November 29, 1553).

17. One of several references mentions the plague as having been present in 1530 and 1531 in Delft, Haarlem, and Hoorn. The statement was that death occurred "*deur zyecte van de gave goids*" (R. A. 41, 1533-1542, folio 180 verso, February 25, 1541). See also chapter 3, note 90.

18. Gibson, diss., 164.

19. Hoogewerff, *Noord Nederlandsche Schilderkunst*, III, 151-152.

20. Friedländer, *Lucas van Leyden and Other Dutch Masters*, 34.

21. Gibson, diss., 8, 17, 18, 20, and 205. These references progress from "immediate workshop" and "workshop" through an admission that it is difficult to determine precisely how many pupils and assistants there were working with Cornelis Engebrechtsz., although van Mander mentions five (mentioned by van Mander only as students, however), to the statement, "The collaboration of other artists with Engebrechtsz. particularly during the last decade of his life, will come as no surprise when we remember that he had a fairly large number of assistants, including his three sons, Lucas van Leyden, and Aert Claesz." Gibson's modest recollection has been summarized by van Asperen de Boer and Wheelock, who say that Cornelis "headed a vast workshop that dominated the Leyden school during the first third of the sixteenth century." (See van Asperen de Boer and Wheelock, "Underdrawings," 65.) Pelinck added to the discussion the idea that Dirck Hugenz. may have worked for Cornelis (Pelinck, "Cornelis Engebrechtsz.," 68).

22. The existence of enterprises employing relatively large numbers of people simultaneously can be documented. These include cloth dyeing establishments, breweries, oil mills, parchment manufactories, ship building wharves, and some other things. Painters' studios are not included. Among the more or less art-directed crafts forming the basis of this study, such relatively large operations have been found only in the group of cabinetmakers.

23. See Bangs, "Rijnsburg Abbey," note 89.

24. See R. A. 42, October 18, 1538.

25. See van de Waal, *Drie Eeuwen Vaderlandsche Geschied-Uitbeelding*, I, 127 and f.

26. Gibson, diss., 6. Certainly it may be assumed that a beginner did not equal the work of his master while just beginning, but it is not certain that pupils were doomed forever to paint works of coarser quality, a point raised by the supposition that Lucas van Leyden studied under Cornelis Engebrechtsz., if by nothing else.

27. Gibson, diss., 18.

28. Gibson, diss., 2. There is no evidence presently known that Cornelis Engebrechtsz. received any other commissions for altarpieces than for what is preserved. Of course it may be true that he painted other unknown altarpieces. What happened to most of Leiden's altarpieces is also unknown. The preservation of a rather large number of works of art from Marienpoel in the time of war and iconoclasm can be attributed to the fact that the person appointed to be official receiver of the goods of Marienpoel, as well as Leiderdorp and Zoeterwoude, at the Reformation was a descendent or collateral relative of the founders, Jonckheer Adriaen van Swieten, Treasurer General of Holland and Governor of Gouda (see R. A. 43, May 8, 1573).

29. R. Kahn, *Die Graphik des Lucas van Leyden*, Strassbourg, 1918, 77. Lucas might have influenced other Leiden artists, also, since his engravings were imitated as far away as Italy.

30. Van de Waal, *Drie Eeuwen Vaderlandsche Geschied-Uitbeelding*, I, 146-147.

31. NK, no. 1338.

32. See *NAT*, I, Leiden, Jan Seversz. XI., 32-37.

33. See van de Waal, *Drie Eeuwen Vaderlandsche Gescheid-Uitbeelding*, II, 79, notes to I, 147.

34. See note 30.

35. The alteration is not remarked upon by van de Waal, but see *Drie Eeuwen Vaderlandsche Geschied-Uitbeelding*, II, 79, note 2 from I, 146, for relevant literature.

36. NK, no. 2009; *NAT*, I, Jan Severz. IV., 9.

37. Because of the book's title the beehive woodcut must be a new design. The design is discussed by Kronenberg, "Lotgevallen van Jan Severz.," 10. The blocks used at the bottom as filler contain Antique ornament. The right block is cut off or blocked out and is not symmetrical, although its right half is a mirror image of the left, as far as it goes. These were not newly designed blocks made for the title page.

38. NK, no. 1720.

39. NK, no. 1934.
40. This is discussed below.
41. Lehrs, *Late Gothic Engravings*, no. 492.
42. See *De Vijfhonderdste Verjaring van de Boekdrukkunst in de Nederlanden*, 290, no. 138 (page 307), ill. 62 (page 289).
43. The disparity between the letters and the elephant is striking; but most artists could provide decorative capitals. Since the elephant block is reused, Leiden's arms replacing those of Gouda, the question of who altered the block may at least be raised.

5. Lawsuits about Cornelis Engebrechtsz.'s Estate

On October 7, 1527, Cornelis Engebrechtsz.'s widow, Elysabeth Pietersdr., was sued by Jacop Jansz. Cock, who demanded the share of her father's estate due to his wife, Clemeynse, or payment of £ 10/−/− (Flemish) instead (see appendix 1, no. 8). If the usual arrangement was followed, each of the children was supposed to inherit the same amount (equivalent to £ 60/−/− Hollands); and half the estate was to remain in possession of the widow. Cornelis Engebrechtsz., therefore, may have left an estate of ca. £ 720/−/− Hollands, plus property mentioned in a later lawsuit (appendix 1, no. 13), in which the children inherited an interest. Alternatively, the sum may have been purposely set high in expectation of court discounting. Extremely high overestimation would, however, have had little or no legal sense. A renewal of Jacop Jansz. Cock's lawsuit on November 15, 1527, states that division of the estate had been arranged in the presence of Lysbet Pietersdr. and all her children (appendix 1, no. 9). The presence of all three sons in Leiden in 1527 is thereby indicated.

Elysabeth Pietersdr. was sued three years later, on September 19, 1530, by Lieven Jacopsz. of Sassenheim, a village near Leiden (appendix 1, no. 10). He demanded payment of 2 Ryns guldens on grounds that Cornelis Engebrechtsz. had not finished a commission given to him before he died, by Lieven Jacopsz. Lieven Jacopsz. was not a regular advocate in Leiden, thus the possible connection with Lieven van Bosschuysen, whose guardian he was, is likely but not certain in this case. The court's decision was that the claim had not been proven satisfactorily. Elysabeth Pietersdr. was not required to pay. Whether the legal problem was proof of the actual existence of a commission or determination of its completion (since it was presumably a painting) is not clear.

Two lawsuits of November 17, 1533, connected with the death of Cornelis Engebrechtsz.'s daughter Lucie, help give an idea of his wealth (appendix 1, no. 11 and no. 12). Elysabeth Pietersdr., acting as possessor of the estate of Cornelis Engebrechtsz., sued Claes Cornelisz., who had been Lucie's husband, and demanded that he return to the estate all goods whose use had been enjoyed by the married couple during Lucie's life. The goods were to be divided equally among the heirs of Cornelis Engebrechtsz. The alternative sum of 100 Karolus guldens gives an approximate upward valuation of the worth of the goods, whatever they were. (100 Karolus guldens is a sum frequently appearing after 50 and 75 in generalized demands; this is particularly common in demands for remuneration for loss of honor, where the court often decided that it had been over-valued.) Theoretically, each child of Cornelis Engebrechtsz. had received an approximately equivalent value (estimated in 1533) of

100 Karolus guldens at majority or marriage. This was their mother's evaluation in the demand. The sum was also evidently bound to return to the family in the event of no issue. It may be inferred that Lucie had no surviving children. An estimated 600 Karolus guldens was apparently thought to have been divided among Cornelis Engebrechtsz.'s children at the proper times during his life. In addition there remained the part not heritable until after his death and the part of the estate retained in use by his widow.

Also on November 17, 1533, Claes Cornelisz. sued his former mother-in-law demanding a complete inventory of Cornelis Engebrechtsz.'s estate, or, in default, 100 Ryns guldens. He seems to have thought that something of the estate had been omitted from the previous inventory. The court tended to believe the original inventory, but the final decision is not recorded. The case was continued on December 12, 1533, until the first session after Christmas; but it does not appear then. The inventory is not preserved.

However imprecise the evaluations may be, it was a well-to-do family. One source of Cornelis Engebrechtsz.'s income is noted in a lawsuit of October 13, 1536, brought by his sister, Elysabeth Engebrechtsdr., against his widow, Elysabeth Pietersdr., with Jacop Jansz. Cock as husband of Clemeynse Cornelisdr., Pieter Cornelisz. Kunst with his legal guardians (Cornelis Cornelisz. Kunst and Jan Gerritsz. Smaling), and Beatris Cornelisdr., all as heirs of Cornelis Engebrechtsz. (appendix 1, no. 13). Cornelis Engebrechtsz. and his sister had been joint heirs of half a house in Gouda, which had belonged to an Otto Dircxz., whose widow (not named) inherited the other half-house. According to the lawsuit, Elysabeth Pietersdr., or her children, having one-fourth interest in the house, had sold the half-house without consulting Elysabeth Engebrechtsdr. She demanded that they renounce the sale to enable her to sell her own interest in the house. (She did not live there; it had probably been rented to someone.) The value of her fourth part of the house can be estimated as the sum of the legal alternative in the case, a fine of £ 3/−/− (Flemish) per defendent. The total would be £ 15/−/− (Flemish), because Lucie had died and Lucas is not named as a defendent. He was either still a minor or he had not received a share in the sale proceeds. His omission was not a result of departure from Leiden (see appendix 2, no. 9). The court's decision on this case was postponed and not recorded. Pieter Cornelisz. Kunst and his guardians, however, were declared not subject to the proceedings.

On March 28, 1528, Elysabeth Pietersdr. had sold part of her late husband's estate — land (an area of three "*morgen*") lying unsurveyed and common within eight "*morgen*" of land owned by the St. Anthonis Hospital outside Leiden. The new owner, Cornelis Woutersz. of Zoeterwoude, sued her ten years later, on March 15, 1538, demanding that she provide indemnity against a claim made by the hospital regents that they owned six and a half "*morgen*" of the land, not just five. Cornelis Woutersz. demanded a clear title or payment of 300 Karolus guldens, plus additional costs for legal expenses, damages, and interest. On March 22, 1538, the court postponed the case for two weeks (appendix 1, no. 14).

Elysabeth Pietersdr., Cornelis Engebrechtsz.'s widow, died between March 22, 1538, and May 17, 1538, probably within the two weeks' postponement of the lawsuit. (1539 is, thus, an incorrect death date. See Gibson, diss., 16.) The case did not come up

56

in the court session for which it had been scheduled. Approximately six weeks later the same case was resumed by "the joint heirs of the widow of Cornelis Engebrechtsz." The new lawsuit, dated May 17, 1538 (R. A. 42), was the first of a series that continued several months, then reappeared once ten years later. (See R. A. 42, June 17, 1538; July 26, 1538; September 27, 1538; and May 18, 1548.)

6. The Focus of Popular Piety:
Semi-literate and Illiterate Leiden Religion
in the Time of Cornelis Engebrechtsz.

Ill. 19 A lot has already been written about the Brothers of the Common Life and the Windesheimer Congregation.[1] While intensified popular piety is usually mentioned as the goal or purpose of this movement in general remarks,[2] insufficient, if any, attention has been given by art historians to the formal aspects of the practice of popular religion in the Low Countries between ca. 1490 and 1540. As mentioned above, Friedländer stated that, "The mere sight of the Mother of God did not satisfy Dutch devotional needs — that required a story-telling sermon, dramatized with incident," and that Cornelis Engebrechtsz.'s "penchant for the epic and the dramatic was reinforced by what the Dutch people were then looking for. Predisposed by tradition and cast of mind, they were about to accept the Reformation. They were deeply concerned with everything relating to Christ's sacrificial death. In Antwerp and Brussels the sophisticated standards of taste were set by the court, the Italians, the wealthy merchants; but Dutch society was far less affluent and demanded straightforward depiction of the gospels."[3] A little further, Friedländer remarks, "This merely serves to confirm as specifically Dutch the 'sense of history' that stirred in devotional painting, in protest against ecclesiastical convention."[4]

Friedländer lets it rest there. This does not provide a satisfactory explanation for the presence of Huych Jacopsz.'s mere painting of Mary, non-narrative, in the upper chamber of Marienpoel's rector's quarters, a painting costing about fifty percent more than a triptych of unspecified subject in the rector's dining room and nearly three times as much as a (narrative) painting by Lucas van Leyden, *The Flight to Egypt*. To put it in relative terms, Huych Jacopsz.'s painting cost a bit more than six or seven houses considered fit for artisans and their families.[5] Friedländer's opinion cannot, however, simply be replaced with its converse. For the focus of popular piety was not Mary in any exact sense. The specific focus was Rome itself.

The rosary of course was a vehicle of devotion, and this devotion emphasized Mary as mother of Christ providing constant reminder of Jesus' humanity, together with the recitation of the Lord's Prayer, not to be forgotten in the midst of the Ave Marias.[6] The rosary was not used for unregulated prayer. The prayers were organized according to granted indulgences. Rome was the location of the greatest number of obtainable indulgences. Not everyone could afford the trip to Rome, however, and by 1500 various alternatives had been instituted by which everyone, rich or poor, could obtain the indulgences of Rome by the simple practice of prayers. The prayers were arranged in numerical combinations of fifty or one hundred fifty, called in Dutch "*Souters*," and these are described in numerous books for the instruction of non-

58

Latin-reading clergy, non-Latin-reading laymen, and through them, the numerous illiterate members of the church.[7] The form of recitation is given in these books, together with instructions for the proper use for obtaining the indulgences of Rome. Invariably the *Souter* was to be recited most effectively in combination with meditation on one or another of the seven major churches of Rome, according to the feast days (Stations) on which the indulgences of all subordinate churches in and around Rome could be obtained in the superior church.

The focus of prayer, both in a meditative and a geographical sense, was thus Rome. Ill. 20 In meditation the person obtaining indulgences was exhorted to consider himself as if among the faithful throng in Rome on the day concerned. Geographically, the pious were expected to know Rome well enough to remember the seven major churches and their chief relics, as well as the chronology of prayer. The seven major churches are (A) St. John Lateran, (B) St. Peter's, (C) St. Paul's without the Walls, (D) St. Mary Maior, (E) St. Lawrence, (F) SS. Sebastian and Fabian, and (G) the Church of the Holy Cross of Jerusalem. The relics referred the faithful in meditation to the events of the histories and miracles of the New Testament, the early church, and later saints, and the meditation was supposed to take the form of inner imitation, meaning trying to imagine oneself there at the event sharing in the responses of faithful onlookers.

The chronology of prayer was determined by the calendar of Roman festival or major indulgence days associated with the seven major churches. To obtain the Roman indulgences, the correct church and relics had to be meditated on at the proper time and days. The year was arranged for other purposes according to various local calendars, such as that of the diocese of Utrecht, that of Leiden, the court of Holland in The Hague, or the Grand Council in Mechelen. For piety the year was arranged within the ecclesiastical seasons according to the major Roman feast days.

Taking one of the more popular works of this nature, *Van die seuen kercken vā Romen ēn vandē aflaten diemē daer in v'dienen mach,*[8] it is possible to give a general idea of the characteristics of the contents of such guides to prayer. The example chosen was published on February 20, 1521, by Willem Vorsterman, an Antwerp printer. It was owned by a convent in 's Hertogenbosch, where in 1530 it was in the keeping of a nun from Delft. It thus provides a kind of indication of the generalness of Netherlandish piety, underscored by the publication in Leiden of books of the *Souter* by Jan Zevertsz. and Huych Jansz. van Woerden.[9] Friedländer's northern piety as distinct from the religion of the south is belied by these books.

"Here begin[10] several articles about Holy Indulgence which all Christians must know who want to earn them. That one is obliged to believe in indulgence: Considering that simple unlettered Christians are only obliged for the salvation of their souls to know the 10 commandments of God, and because that first commandment of our belief is That a person shall believe in one God and pray to him alone, thus they are further obliged to know the 12 articles of the holy Christian faith contained in the Credo, together with the Pater Noster and Ave Maria. But there are many other points which follow from the 12 articles of our faith or which depend on them that they are not obliged to know, unless it is a matter which our holy father the pope, who is Christ Jesus' Stadholder on earth, together with the cardinals, patriarchs, bishops, doctors, and theologians, who are commanded to govern over the simple people ["*simple*

59

volck" = ordinary, illiterate people] to protect them from heresy and other deviations, or for other useful reasons through the inspiration of the Holy Spirit, have publicly declared and had preached and announced to the simple people. The people are obliged to know all such points and articles, which must nevertheless be based on one or more of the 12 principal articles. For example, it is necessary for every Christian who has reached the age of understanding that he must confess his sins. And for that reason, the holy church, that is our holy father the pope with the other prelates and theologians and superiors, ordered and announced every year that everyone must confess at least once a year to his superior, who is the pope, or the bishop, or the pastor, or someone appointed by one of those three to act as chaplain. While this does not appear publicly among the 12 articles of faith, it derives from that article of the Credo 'I believe in the forgiveness of sins.' That is to be understood as [meaning] in so far as a person confesses his sins, professes, and heartily repents, through that sorrow and the fact that he intends to avoid sin and do penance for it. Similarly are the seven sacraments of the holy church [obligatory items of belief], which our Lord Jesus himself instituted, and everything that is found in the holy Gospel, because that follows from the article of the Credo 'And I believe in the Lord Jesus Christ, etc.' In the same way all Christians are obliged to believe in holy indulgence — that is, that the holy father the pope has been made worthy stadholder of our Lord Christ Jesus, when he made St. Peter pope, saying, 'Pasce oves meas, Peter protect my sheep.' And thus He made him plenipotentiary before His death and after His resurrection, saying, 'Tu es pastor ovium. Tu es princeps apostelorum, etc., that is to say, You are the shepherd of the sheep, you are the prince of the apostles. I shall give you the keys of the kingdom of heaven,' which He gave him when He spoke, 'Quodcunque ligaverit super terram, etc., that is, I give you my power. Thus what you bind through the bond or the commands of the holy church while you are on the earth, that will be bound in heaven, that is before God. And what you here unbind through absolution, through indulgence, and remission of pains, which we are bound to suffer here or in the world to come, that will be unbound.' And our Lord Christ Jesus also taught St. Peter and the other apostles through examples and deeds how people shall unbind through indulgence; and through them all bishops and spiritual prelates and rulers of Christians, because He often granted indulgence himself on earth." (Examples of this are (1) the command to Peter to forgive 77 times, (2) forgiveness of Mary Magdalene, and (3) the woman found in adultery.)

After the introduction, there is a short explanation of indulgence, equating it with forgiveness, absolution, and penance, all under condition of being in the right mood. Then comes a list of the seven churches of Rome and their chief relics and assorted histories, all with the numerical totals of indulgence periods written off in purgatory for the practices of piety possible in each church. After each of the seven superior churches the attached inferior churches are listed with their relics, histories, and indulgences. The end of this section is formed by a statement that the Cardinal Legate Raymundus had all the preceding information verified before being sent to announce the Golden Year in Germany.[11]

Among the pious works mentioned as suitable acts of penance, donations for building churches or for other charitable activities are found. Nevertheless, the

doctrine of indulgence is described in these books as clearly distinct from financial imperatives. Grace was free, although it was complicated by an orderly system of illogicality whose effects on listeners can scarcely be guessed. Confusion may have been the general intellectual attitude of the time, while action following the more clearly defined pious regimen was undoubtedly prevalent.

Eight pages describe the activities open to members of the monastic orders who could not make it to Rome, but who desired Roman indulgences. Concerning the "*Reguliers Orden*" it is said:[12] "All priests, clerks, lay brothers, and all women who belong to the chapter of Windesheim by Zwolle, in whatever cloister or land they live, can earn all the indulgences in Rome's churches, chapels, on altars, or other holy places, not only on the Stations but also every day in their churches. Priests, clerks, and nuns who can read must visit five altars or other places ordained for the purpose (like Marienpoel's *Entombment*) and before each altar or place, read the psalm Miserere mei deus (Ps. 51). The lay brothers and women who cannot read shall read (= recite) before five altars or five places five Pater Nosters and five Ave Marias. In the same way they may also have indulgences if they are outside their cloister with permission of their superior, in whatever church they happen to enter." The Benedictines have the same privileges. The Dominicans ("*Prekers*") read one of the Seven Penitential Psalms before the seven pictures of the seven chief churches of Rome, or, if illiterate, one Pater Noster and ten Ave Marias, or a rosary of Maria before one, two, or three altars in whatever churches they enter. There are similar grants including five Pater Nosters and five Ave Marias, five psalms at five different altars, five times one psalm (or a psalm) at one altar, and five Pater Nosters and five Ave Marias before a high altar. Preachers going out to preach on feast days have a diminished requirement of three of each in the church they may enter. Like the Dominicans are the Minorites (Franciscan), and the "Brothers and Sisters of the Third Rule of St. Dominic and of St. Francis." The members of the Guild of Our Lady, otherwise known as the Guild of the worthy mother St. Anne, at Haarlem in the Dominican church were granted the possibility of earning the indulgences of Rome on feast days by saying one of the seven psalms or three Pater Nosters and three Ave Marias, before each of seven altars or other appointed places. This brotherhood enjoyed participation in the good works (indulgence earning) of the entire Dominican order. As at the beginning of the book, there is a calendar, of the Roman Stations, followed by an exhortation to think oneself a part of the devout Roman crowds on these days. After the long description of the indulgences of Rome, and alternatives for obtaining them, including the points where it was possible to earn all the indulgences of Jerusalem and the Holy Land and of Santiago de Campostella, there is a description for meditative purposes of a trip through the Holy Land with a specification of the associated indulgences.[13]

Next comes a description of "Dr. St. Bonaventura's" version of the rosary, a division of one hundred fifty greetings, ten of roses, ten of lilies, ten of violets, ten of wildflowers, and ten of sweet-smelling jugs of paradise. This is called the small *Souter*, and it led to the possibility of independent invention of prefatory adjectives in the Aves, to which indulgences were attached.

Various rosary groups are described, including one of the Seven Sorrows of Mary, said to be in "Walsland" (Wallonia) and other countries. Its members receive "great

graces and indulgences" (but these are not numerically specified) for saying seven Pater Nosters and Ave Marias in honor of the seven sorrows of Mary, twice a week. Nothing else is necessary for joining. A description of the Guild of the Sweet Name of Jesus ("*Broederscap des Rosencrans van den Soeten naem Ihesus*") follows.[14] This particular group merits citation, because in Leiden it shared its altar with the trade guild of St. Luke in the center of the nave side of the choir screen of the Pieterskerk.

"There is another brotherhood, of the Sweet Name of Jesus or the Rosary of our Lord Jesus Christ. This Rosary is short but very sweet and most pleasing to our dear Lord Jesus. And it is read like the rosary of Mary, but before the Pater Noster, one reads this little prayer: Hail most good Jesus full of mercy, mercifulness is with thee. Blessed be thy passion, thy death, thy tears, and thy wounds as thou art a savior of the world, Jesus Christ. Amen. Also before this Ave Maria people read ten times: Hail sweet Jesus, receive my [soul]. Also as often as one reads this rosary, out of thankfulness and in honor of the passion and bitter suffering of our dear Lord Jesus Christ, one earns fifteen thousand years and fifty years thousand years forty days [*sic*], because as often as one reads the greeting, Hail most good etc., one earns three thousand years of indulgence. And as frequently as one bows one's head or genuflects when naming the sweet name of Jesus, one earns twenty days, granted by Pope John XXII. Also Petrus de Palude, a doctor of the Dominicans, recounts of the "*Meester van den hooghen sin*" (= the Seraphic?), that he saw a Bull which contained a grant of one year and forty days' indulgence to all Christians who genuflect to the sweet name of Jesus. Further, this rosary is to be closed with the following small prayer: Blessed be the sweet name of Jesus our Lord Jesus Christ. And blessed be the name of the glorious virgin Mary his dear mother, now and in eternity. Amen. Pope Clement IV granted three years' indulgence as often as anyone says this prayer. Whoever wants to join this guild is not required to do anything more than to undertake to read this rosary."

The book continues with some words about the indulgences associated with holy water and with the devout attitude one should have (derived from the doctrine of transubstantiation) when hearing mass.[15] "So when we go to mass, we in fact go with the friends of our Lord and with the Lord Jesus himself to the hill of Calvary . . ."

To summarize, this and many other contemporary guides to popular (illiterate or semi-literate) devotion provide several forms of the rosary, whose use enabled a person to belong to a guild with no very clearly defined membership but which included the gain of indulgences. The maximum number of indulgences could be gained by saying one or another of the forms of the rosary in conjunction with contemplation of the seven major churches of Rome and the associated histories and relics on the correct feast days in the correct state of mind. Some of the books provide a set of schematized depictions of the seven churches, each given a letter to identify its Roman counterpart, as an aid to contemplation. The letters were printed in the margins for quick use of the calendar for Roman feast days also included. Other books use the letter system in the calendar without illustration. Devotion to Mary was a large part of pious activity, but only a part. Through contemplation, a fairly extensive body of knowledge about Rome was made a piece of general learning. The pious were expected to know as much as they could about the lives of the saints and the stories of the miracles associated with the seven superior Roman churches, and

also their subordinate churches, chapels, altars, and holy places. In this way, belief in indulgences and the use of the rosary contributed to widespread awareness of numerous aspects of Roman ecclesiastical history, legend, and buildings.

The pious practices here described lead to several additional observations. One is that Leiden's churches and chapels probably had a relatively intense use throughout the week by laymen and clerics engaged in prayers said at several places or altars. A second is that it is difficult to be certain what indulgences meant to people at this time – the concept was in any case not directly connected with money and must have had chiefly the purpose of shortening the uncountable years of purgatory awaiting almost every Christian. Indulgence was explained as forgiveness of sins. That indulgences could also help the souls of deceased Christians led to the possibility of posthumous inscription in rosary guilds by descendents who were members.[16] The relatively high frequency of deaths meant that few people did not have some near relative recently deceased, to be remembered in prayer. The rosary formalities could serve to give order to grief and to give a sense of doing the utmost possible to help the dead family member. It may be noted that many children are shown as members of crowds in early sixteenth-century Netherlandish paintings and that their proportion outweighs that of older children or youths. This presumably reflects a high death rate in infancy and early childhood, which could have reinforced the meditation on Mary as mother. (At least one devotional manual published in Leiden provides variations and expansions of the rosary aimed specifically at women readers.)[17] The pious activities were conceived as additions to the simplified requirements of faith for most of the illiterate population.

Regulated piety as described could take place at home, or without much observation, in a private or isolated way. Five or seven places could replace the altars of a church. These might be paintings or sculptures (an image of Mary is commended in the book for women noted above), or, as in some devotional manuals, book illustrations. It follows from this that the number of communicants in a city does not indicate the precise number of practicing Catholics, which means that surveys of city parishes give no secure base for population estimates. A parish priest in a city presumably answered such surveys with as much certainty as he could give, without necessarily having a clear idea of the number of people residing in his parish. Moreover, the privacy of devotion means that there was no obvious lack of devotion in people not *seen* practicing piety. That provides the background against which Anabaptists could grow numerically in secret.[18]

The theological rationale in the book considered here deserves some comment. The introduction derives an obligation to believe the Gospels (not to mention indulgences) from an article in the Credo. This is the opposite of deriving the Credo from the Bible and of declaring an obligation to believe first in the Gospels. Methodically it is the converse of Luther's derivation of the sacraments from the Gospels. The doctrine of indulgences is obligatory for belief because it is proclaimed by the church in a conciliar action. This might contain reference to the declaration on the immortality of the soul as dogma in 1513. The book (1521) contains an admonition not to doubt the doctrine of indulgences and not to meddle in the affairs of popes.[19] The warning is brief and does not mention Luther or Leo X's Bull "Exsurge Domine"

(June 15, 1520). There is a wealth of references to Rome and to the recent popes including Leo X, but not at this point. Finally, it may be remarked that the book and others like it are concerned with the distribution of grace and forgiveness of sins, and that this involved the pious in intense connection with Rome's relics in a mystical sense, because these relics were a direct connection with apostles, saints, and Christ himself. The position had long historical precedent dating back to the period of burial in graves near relics, or saints' graves, in the catacombs outside Rome.

Having seen that pious attention was focussed on Rome while the people expressed devotion to Mary in their meditation on salvation through Christ, with at least one Leiden book recommending meditation in front of an image of Mary, Friedländer's opinion that a picture of Mary did not satisfy Dutch devotional needs may be dismissed. What, however, of the religious turmoil supposed to have engaged the minds of Leiden's populace at this time? L. Silver makes much of this in his attempt to see Lucas van Leyden's *Moses Striking the Rock* as a comment on Lutheran or Sacramentarian issues.[20] Silver refers to L. Knappert's history of the rise of Protestantism in Leiden to support the idea of significantly wide-spread local turbulence. Both Silver and Knappert emphasize the large stock of Lutheran books thought to have been for sale in Jan Zevertsz.' shop.[21] The list was reascribed in 1925 by Kronenberg as being the records (1514 to after 1526) of Pieter Claesz. van Balen, a Leiden printer active after Jan Zevertsz.'s death.[22] Two items of additional evidence can be given. First is a case, reported accurately by Knappert, of a roofer who interrupted a meal-time discussion at a monastery in Warmond (near Leiden) with remarks showing disbelief in the value of the eucharist.[23] He was considered by the court to have been giving opinions about issues above his head, and his sentence belongs in the category of slander punishment (slander against the host). Transubstantion transferred the case from canon to civil law. Contrary to Knappert, it was not a relatively heavy punishment. Second is the attribution of six anonymously printed books by Luther to Jan Zevertsz. on the basis of type faces used.[24] Present research[25] has shown that type faces of exactly the same form were also used by other contemporary printers in Leiden and elsewhere and that Jan Zevertsz.'s printing equipment was used by his heirs after his death, so that the books could have been printed later (post 1534). Rather than being confronted with large groups of the population deeply concerned with Wittenberg, the foregoing material on piety indicates a population deeply interested in Rome. The interest could be stimulated by surrogates in the form of artworks. With small groups, the Anabaptists and the educated laymen and clerics, theological discussion and questioning was, in contrast, involved and lively.

Notes

1. See R. R. Post, *The Modern Devotion, Confrontation with Reformation and Humanism*, Leiden, 1968 (= *Studies in Medieval and Reformation Thought*, III), particularly chapter 15, "The Windesheimers after c. 1485. Confrontation with the Reformation and Humanism;" see also Post, *Kerkgeschiedenis van Nederland in de Middeleeuwen*, Utrecht, 1957.
2. For example, H. P. H. Jansen, *Middeleeuwse Geschiedenis der Nederlanden*, Utrecht, 1972, 203-204. For

general information on popular piety, see Post, *Kerkelijke Verhoudingen in Nederland vóór de Reformatie van ± 1500 tot ± 1580*, Utrecht, 1964, chapters 7 and 8.

3. Friedländer, *Lucas van Leyden and Other Dutch Masters*, 26 and 44; see above, chapter one, note 2, and chapter two, note 72.

4. Friedländer, *Lucas van Leyden and Other Dutch Masters*, 44-45.

5. See chapter two above.

6. See *The Pursuit of Holiness in Late Medieval and Renaissance Religion* (ed. C. Trinkaus and H. Oberman), Leiden, 1974 (= *Studies in Medieval and Reformation Thought*, X): A. N. Galpern, "Late Medieval Piety in Sixteenth-Century Champagne," 141-176; and N. Z. Davis, "Some Tasks and Themes in the Study of Popular Religion," 307-336. Neither article deals with the formal aspects of rosary recitation, nor is popular concentration on indulgences earned through piety studied. Galpern describes locally focussed activity of various sorts, like pilgrimages in the area. These also existed in Leiden. Popular seems to be equated with lay, by Galpern. Davis suggests among other things that more attention be given to women. A book addressed to pious women is cited below, but it obviously represents religious activity prescribed by clerical superiors, not any form of inventiveness or originality among lay women. That a place for such inventiviness was provided is mentioned below, where confusion of arrangements of Aves with arrangements of the psalter is explicit in the attempt to provide alternatives for the illiterate. For popular devotion focussed on saints, see J. J. Mak, "Middeleeuwse heiligenverering. De opvatting van de heilige," *Nederlands Archief voor Kerkgeschiedenis*, XXXVIII, 1951, 142-163.

7. For examples of the *Souter*, see NK, nos. 1910, 1911, 1912, 1913, 1914, 3808, 3820, 3888, 3889, 3976; see also the NK entries for the seven churches of Rome, below; see also M. F. A. G. Campbell, *Annales de la Typographie Néerlandaise au XVe Siècle*, The Hague, 1874, no. 763 (a Leiden *Rosencrans en souter van onze Lieve Vrouwe*, 1500). The foregoing numbers do not represent a complete list of Netherlandish editions of the *Souter*, but the titles given under these numbers together with authors and printers, provide orientation in the NK index for further entries there. See further, W. H. Kent, "Indulgences," *The Catholic Encyclopedia, an International work of reference on the Constitution, Doctrine, Discipline, and History of the Catholic Church*, New York, 1910, VII, 783-789; and A. J. Shipman, "The Rosary," in the same work, XIII, 184-188; and H. Thurston, "Confraternity of the Holy Rosary," in the same work, XIII, 188-189. Kent continues some of the logic of the sixteenth century requirement for believing in the doctrine of indulgences quoted below; however, he adds several distinctions, for the benefit of "anyone who forms a correct idea of what the Catholic Church really teaches on this subject," which are not made in the early-sixteenth century expositions of the requirement for belief and the definition. The remarks in W. M. Conway, *The Woodcutters of the Netherlands in the Fifteenth Century*, Cambridge, 1884 (reprint Nieuwkoop, 1970), 81, indicate the focus on Rome through depictions of Mary.

8. G. A. Leiden, Bibl. no. 72045 (= NK 1280, or 1279 where this copy is listed — the final page is missing). For other editions, see NK, nos. 1281, 1282, 1283, and 1284, as well as 3313. The Leiden copy is bound together with Vorsterman's edition of *Dit sijn die gracien ēn aflaten vā sinte Franciscus drien ordenen* (NK, no. 1020), and with a ms. of the same topic, the indulgences obtainable as if at Rome. The ms. contains evidence that the books came from 's Hertogenbosch (folios 48 verso — 49 and 76). It also gives information about travel to Rome. There is also a short printed rule of the Dominicans of 's Hertogenbosch bound in. The first book is ascribed to Jan Zevertsz. said to have been printed in Leiden ca. 1510, in Overvoorde, *Catalogus van Voorwerpen in het Stedelijk Museum "De Lakenhal" te Leiden*, Leiden, 1914, 149, no. 1621. The correct identification seems to have been made by B. Kruitwagen, to judge from inserted slips of paper with notes.

9. NK, nos. 1910, 1911, 3976, and 489 (= G. A. Leiden, Bibl. no. 72001: *Een suuerlic boecxken van onser lieuer vrouwen croon*).

10. G. A. Leiden, Bibl. no. 72045, folio 17, which is preceded by a calendar.

11. Bibl. no. 72045, folios 28-51 and on folio 55 a reference to the indulgences granted in 1517 for building the new St. Peter's in Rome. The book also refers to Meester Alan (de Rupe) when describing indulgences associated with the rosary, discussed below. The indisputable practice of sale of indulgences is conceded even in Kent's article on "Indulgences" of 1910 (see note 7). As far as preserved records show for the Leiden area, however, financial transactions connected with the granting of

indulgences occurred exclusively or almost exclusively in connection with the services of a bishop in consecration of churches, altars, and so forth, and there receipt of money was not directly connected with the grant. There is then no grounds for an image of indulgence hawkers, although Leiden's archives are incomplete especially for the ecclesiastical institutions which might contain references to irregular indulgence peddling (such as records of canon law trials). The pious practices for gaining indulgences cost nothing in theory. The Leiden government took measures from time to time preventing preaching by non-local clerics and even preventing giving them alms. There had been a large financial drain in 1488 and a repetition in 1517-1519 was feared. A locally focussed indulgence after confession followed by alms for restoration of the Pieterskerk tower was granted in 1513 (see Knappert, *Opkomst*, 28); the indulgence was permission to eat dairy products in Lent until Palm Sunday. The local financial problems associated with indulgence peddling indicate that measures aimed at preventing preaching by non-local clerics cannot in themselves be taken as attempts to guard against nascent Protestantism spread by the clergy. In Leiden what was required as charitable acts after confession is naturally unrecorded, but it cannot have been connected with indulgence peddling. The absence of records from the brotherhoods makes it impossible to look for patterns of donations. For the legal basis of indulgence peddling, largely referring to display of healing relics, in the diocese, see A. Eekhof, *De Questierders van den Aflaat in de Noordelijke Nederlanden*, The Hague, 1909, where Leiden is, however, not treated.

12. Bibl. no. 72045, folio 52 and f.
13. Bibl. no. 72045, folios 75-82.
14. Bibl. no. 72045, folios 85 and f. Further, see Kruitwagen, "De Vereering van den Zoeten Naam Jesus in de Nederlanden (I)," and "*Den Wijngaert van Sinte Franciscus* (Antwerpen H. Eckert van Homberch, 1518, 12 Dec.)," *Neerlandia Franciscana*, I, 1914, 329-357; and 43-72, 135-155. Since 1914 various examples of pre-Jesuit use of a cross combined in the monogram have been published. An unusually explicit version is seen in Lehrs, *Late Gothic Engravings*, no. 60 "St. Bernardino of Sienna," from the third quarter of the fifteenth century. See also, E. Ph. Goldschmidt, *Gothic & Renaissance Bookbindings Exemplified and Illustrated from the Author's Collection*, London, 1928, II, no. 192, pl. LXVIII (Venice, ca. 1530-40).
15. Bibl. no. 72045, folio 89.
16. This recalls the Mormon practice of baptism in the name of ancestors, who become partakers of benefits without right of refusal.
17. G. A. Leiden, Bibl. no. 72001 (see note 9). The book directs meditation on the various parts of Mary's body, from head to toes, on the subject of their connection with the infant Jesus. A prayer at the end of the book uses the feminine form of the word 'friend' as the reader's self-identification in addressing Mary with the Aves. The beginning of the book, however, says that every devout person will offer these prayers or greetings frequently, especially on Saturday and on Mary's other special feasts.
18. The number of Leiden comunicants given in a survey of 1514 was 9550. That Jan Beuckelsz. of Leiden, King of Münster, carried out unremarkable business activities without attracting any city attention until he left Leiden for Münster is seen from the documents cited in my article, 'The Last Years of Jan Beuckelsz. in Leiden, "*Jaarboekje voor Geschiedenis en Oudheidkunde van Leiden en Omstreken*, LXIV, 1972, 59-61 (in addition, see R. A. 53, 1558-1572, folio 3, between November 11, 1558, and March 7, 1559, a reference to Grietgen, daughter of Jan Beuckelsz. and Marie Ysbrantsdr.).
19. Bibl. no. 72045, folio 75.
20. L. Silver, "The *Sin of Moses*: Comments on the Early Reformation in a Late Painting by Lucas van Leyden," *The Art Bulletin*, LV, 1973, 401-409; see also correspondence in *The Art Bulletin*, LVI, 1974, and LVII, 1975.
21. See L. Knappert, *Opkomst*, 73-75. The book of the seven churches of Rome mentioned on page 73 by Knappert is Bibl. no. 72045. The "Leiden keys" presumably represent the Keys of Peter and have no direct connection with Leiden.
22. Kronenberg, "Het zoogenaamde winkelkasboek van Jan Seversz.," *Het Boek*, XIV, 1925, 334-338. An article of mine, "The so-called "Winkelkasboek" of Pieter Claesz. van Balen," will appear in *Quaerendo*.
23. R. A. 4, 1519-1528, folios 143 verso-145, June 23, 1526; reported in Knappert, *Opkomst*, 100-103; for the anti-transubstantiation papers of 1526, see the discussion of the Pieterskerk pulpit below.

24. Kronenberg, "Bij een onbekend Luther-druk van Jan Seversz. te Leiden (met datum V Augustus 1520)," *Het Boek*, XXXVIII, 1964-1966, 73-76, listing NK, nos. 3463, 4261, 3451, 263, 2116, besides the subject of the article.

25. In addition to the recently published information on type used in various places in The Netherlands, I have studied this particular point in connection with biographies of Leiden printers before 1575.

7. Leiden's Lettered Orthodoxy:
Cornelis Engebrechtsz., The Egyptian Tradition, and *The Babylonian Captivity of the Church*

Poor and busy people who could not afford to go to Rome to earn Rome's great indulgences, including those of the Holy Land and of Santiago de Campostella, had been granted alternative devotional exercises to be practised locally. An elite was consequently formed by people who freely chose to go on pilgrimages to these places. Those who returned formed the Brotherhood of Jerusalem Pilgrims, the Brotherhood of Pilgrims of St. Jacob, and the Roman Brotherhood (which in Leiden had its altar in the Pieterskerk). When travel to Jerusalem included real danger of enslavement, a pilgrimage there must have represented more than mere spending. What, exactly, is hard to tell. To this elite belonged Jacop Gerritsz. Heerman, portrayed as a returned Jerusalem traveller in Cornelis Engebrechtsz.'s *van der Does- van Poelgeest Panels*. This socially elite group also included educated clerics (together with the uneducated monks who took advantage of free travel). Their meditation and imitation was more sophisticated than in the popular devotion just described, while sharing many points, Here, too, the major focus was Rome, although among the clergy awareness of Wittenberg can also be found.[1]

An example of devotional literature for the study of the better educated is seen in Lucas van der Heij's translation (with editorial comparison of texts) of Bonaventura's *Stimuli Divini Amoris*, called *Dye Prickel der Minnen*. The preparation of the translation was completed in 1508; the book was published by Jan Zevertsz. in Leiden on August 25, 1511.[2] Meditations on the Ave Maria (book III, chapter 16) and the Pater Noster (book III, chapter 17) provide material for direct comparison with the simpler books just discussed. The Ave is handled at length emphasizing the humanity of Christ and the unworthiness of the meditator, who moves into increasing assertions of the correctness of various terms for references to Mary. These include many connected with the sea. Here the translation takes on a local pointedness, giving a vivid image of the precariousness of one of the major Netherlandish activities. (This material provides useful background for contemplation of St. Paul's sinking ship off Malta on the closed doors of Lucas van Leyden's *Last Judgement* triptych, in the Leiden Municipal Museum "De Lakenhal.") The Pater Noster is handled phrase by phrase, with explanations. For "daily bread" the explanation says that not only ordinary bread is meant, and not only ordinary bread and spiritual nourishment, but also a third meaning, sacramental bread. The third meaning is justified with the declaration, "And as I have said, there is a hidden meaning in our Lord's word."[3] This long book of meditations clearly represents commonly accepted truisms, expressed at a length evidently also readily accepted.

This learned group, whether pondering in vernacular or Latin, considered it normal for things to have multiple significance, to be understood perhaps in meditation, in meditations which did not differ very much from those advocated for the simple people. The distinctions between simple and learned piety are difficult to make with precision.

The closed *van der Does- van Poelgeest Panels* each show, besides the coats of arms already mentioned, a pair of handcuffs suspended on a cord held by a hand emerging from clouds, with the letters *G D* on alternate sides of the cord. These symbols have defied explanation.[4] The following can be suggested for the handcuffs. Willem van der Does, a judge, could bind and free from bondage in civil law.[5] He presumably also knew (from Acts 26:29) that St. Paul hoped that all would become like him except for his chains. The symbols of bondage could thereby be transformed into symbols of a neo-platonic conception of death. This point precedes the argument below that Leiden was aware of neo-platonic thought at this time. On that supposition, however, it is clear that death could be considered a spiritual release from physical bondage, allowing ascension, perhaps through a variety of realms of angels. Such a position is not far from the statements on the unworthiness of the meditator, who is often described in terms of his stinking flesh, in Bonaventura's *Prickel der Minnen*. It approaches Manicheism, as could be expected from a neo-platonic outlook as described below, where the ancient knowledge of the Persians had a place.[6]

The stars similarly suspended on a cord held by a hand emerging from clouds on the two sides of the van Poelgeest- van der Does tomb are Egyptian symbols of God and of Man's soul, of twilight, night, and time, according to Horapollo.[7] They, too, fit into neo-platonic death imagery. (And again the point precedes the argument below, that Horapollo was known then in Leiden.)

The letters *G D* on the closed *van der Does- van Poelgeest Panels* have another source, a customary abbreviation for *Gode Dank, Gratia Dei, Deo Gratias*, all of which are sentiments appearing on printers' colophons.[8] Variations on the sentiment appear elsewhere,[9] including the tombslab for Ghysbrecht van der Bouchorst and his wife Marghritte.[10] On this Leiden slab the letters *G A* appear entwined in a "knot of love" held by a hand emerging from clouds, on both sides of the slab, above the demidiated arms of the couple in the center. Presumably this represents the love of God.[11] The letters *G A* may be assumed to abbreviate *Gratiam Age* or *Gratiam Agimus*, through analogy with the colophons; an alternative would be a variant on the funeral prayer "O Alleghiheyligen Gods, coempt te hulpen, ende alle ghi enghelen. . ."[12]

Jan Zevertsz.'s 1512 colophon for the *Spiegel van Sassen* gives the letters *G D* accompanied by an elephant bearing a tower.[13] The significance of the elephant has not been explained in the search for the meaning of the letters *G D* (which were long thought to be the initials of the fifteenth-century printer who first used the block).[14] According to the "*Syll. Men.*," (= *Syllabus Menander*, presumably) cited by J. Boschio in *De Arte Symbolico* (1701),[15] a slogan accompanying an elephant and castle is "*Nec Me Labor iste Gravabit.*"[16] How such an appropriate slogan, punning on engraving in Dutch and Latin, could have been known in Holland two hundred years before Boschio must depend on the unspecified "*Syll. Men.*" Menander's comments are cited by Erasmus in the *Adages*, but he knew them only through "a collection of pithy sayings."[17]

Ill. 14

Ill. 18

Ill. 32

Ill. 36

Ill. 1,21 Support for the proposition that neo-platonic philosophical and theological ideas
22,23,24 were known in Leiden is found in connection with deciphering the inscription on the
back of Eleazar's robe in the scene of *The Brazen Serpent* on the right wing of Cornelis
Engebrechtsz.'s Marienpoel triptych *The Crucifixion*. Legible inscriptions on clothing
had appeared much earlier in Netherlandish art, of course, with the van Eyck Ghent
altarpiece providing what is probably the most famous example, and van der Goes'
Portinari altarpiece coming in as a close second.[18] Painting ascribed to Jacob Cor-
nelisz. van Amsterdam have legible inscriptions in Latin, and the *Feeding of the Five
Thousand* triptych ascribed to Cornelis Engebrechtsz. has the Dutch "NV EENS TE
DRIN(KEN)."[19] Eleazar's robe in *The Brazen Serpent* presents a different problem.

The inscription on the back of Eleazar's robe consists of embroidered letters on the
lower border and a vertical center band on the back. The robe recalls the form of a
chasuble in accordance with the priesthood of Eleazar, son of Aaron. The letters have
been described by Pelinck as "illegible."[20] Despite the horns in the hair of Moses,
Pelinck is unsure whether Moses or Aaron is depicted although Aaron had died
before the story of the Brazen Serpent (Num. 21: 49). Eleazar had inherited Aaron's
vestments, whose girdle is described specifically as embroidered in Ex. 28: 39 and Ex.
39: 29. The letters do not in any case correspond with ordinary letters.[21]

Ill. 22 A mixture of three basic letter forms is present. A sixteenth-century standard
Roman alphabet is used in the word at the left of the lower border, giving the word
alpha. What may be called pseudo-Egyptian (thought at the time to be real) is mixed
with real Greek and Hebrew letters in the center word of the lower border, giving the
Ill. 23 word *omega*. A form of Hebrew gives the word *Emeth* (meaning "truth") at the right
Ill. 24 of the lower border. And a form of Hebrew gives the alphabet up the center band of
the robe.[22]

The word "Emeth" ("truth"), Aleph, Mem, Taw, (read right to left) is used for the
first time as an attribute of God when God passed before Moses on Mount Sinai (Ex.
24: 6). Because the word begins with the first letter of the Hebrew alphabet and ends
with the last, the word was considered to have mystical meaning, lost in a literal
translation into Greek, where "omega" is not the last letter of the word "truth," as in
John 1: 14; Rev. 21: 6; and Rev. 22: 13. The mystical meaning was the expression of
the immediate presence of God in fullness and as absolute truth (see also Is. 41: 4 and
Is. 44: 6).[23] The expression of the immediate presence of God in fullness and absolute
truth at the event of the Brazen Serpent, considered a prefiguration of the Crucifixion,
is given prominence in the painting by the use of the words "Alpha" and "Omega"
and "Emeth." The appearance of the complete Hebrew alphabet in this context
represents an expansion of the beginning, mid, and end letters, which Reuchlin and
others also interpreted as synonymous with a particular form of praise of God.[24] The
typological connection of the Crucifixion with the Brazen Serpent is stated explicitly
in John 3: 14-15. The typological significance of Jesus Christ Crucified as God in a
trinitarian sense is also underscored by the presence of these words, in conformance
with the double use in Revelation, cited above, and by the presence of the complete
alphabet in Hebrew.[25]

Ill. 27,28 The forms of Hebrew used, especially in the vertical band, are related to pseudo-
Egyptian alphabets; their use can be connected with a renewed interest in the learning

70

of the Ancients, the more ancient the better. The precedence of more ancient over classical antiquity caused Cosimo de' Medici to order Marsilio Ficino to interrupt the translation of Plato so that Hermes Trismegistus could be finished first.[26]

Various pseudo-Egyptian alphabets from the sixteenth century are reproduced by T. Bang in his treatment of the origin of language in *Caelum Orientis et Prisci Mundi* (1657).[27] They come in sequence along with the "ancient Hebrew alphabet" and that used by Adam himself (two variants). That the form of Hebrew used by the Israelites in this depiction would be closer to pseudo-Egyptian letters rather than to the letter forms in the supposedly earlier alphabets of Adam and Seth, for example, is consistent with their sojourn in Egypt just before the events including the Brazen Serpent.[28]

Ill. 25,26, 29,30,31

Flavius Josephus told of Adam and Seth having written all antediluvian knowledge on two stones which were later discovered and deciphered by the Egyptians, who transmitted this knowledge to the Greeks, thus putting the origins of the rediscovered "pre-platonic" knowledge as early as the earliest stories in the Bible.[29] This was tradition from the very Beginning.

The significance of "Emeth" translated with the Greek "I am the Alpha and the Omega, the first and the last, the beginning and the end" (Rev. 22: 13), connected with the version in Is. 41: 4, ". . .I, the Lord, the first and with the last, I am He," gives "truth" as a name for God, in further connection with Ex. 4: 14, where God said to Moses at the burning bush, "I am who I am." Thus, truth was revealed at the beginning of all things as it would be revealed again at the end (see Rev. 21: 6). The concept of Logos (John 1: 1) could be used to justify the concept of a celestial alphabet existing before the Creation.[30]

This, then, is a mixture of Hermetic tradition with cabalistic tradition, the latter being the belief in an oral tradition starting with Moses and carried on by cabalists. Because Egyptian hieroglyphs were given a place in the supposed development of the Hebrew alphabet, the mixture was not thought contradictory or incapable of Christian use.[31] J. L. Blau comments on Pico's opinion about the revealed Scriptures as seen by cabalists, "Every letter in the Scriptures contains a revelation beyond its literal significance." This is a short step from Bonaventura. Pico merely supplied a guide for reaching the hidden meanings. The Hermetic tradition allowed for neo-platonic equation of the immediacy of revelation through hieroglyphs, the less immediate moralistic and theological knowledge of the pagans — Chaldeans, Persians, Greeks, and Romans, and the (perhaps inferior) Bible.

To see mystically immediate revelation in hieroglyphs was not far from the traditional medieval opinion that obelisks in Rome were witnesses to events in the lives of the saints.[32] That the hieroglyphs or the significance of obelisks might be intuitively revealed to the neo-platonist meant that the possibility existed for learning the alternative tradition, the unwritten revelation. Presumably the use of modern forms of language including current Hebrew in the Old Testament seemed to the neo-platonist to be inferior to the direct revelation contained in what the Egyptians wrote in the older hieroglyphic form of (Hebrew) language. The parables used by Jesus gave support for hieroglyphic apologies, besides for non-hieroglyphic assertions that the Bible contained hidden meaning. At the same time they were a constant reminder that to each person revelation was still incomplete. Hence the attempts of magicians to ascend, described by F. Yates and D. P. Walker.

Put simply, meditation on hieroglyphs was just as important as pondering the Bible for hidden meaning, for the deepest and true meaning.

It is uncertain that Cornelis Engebrechtsz. (or Jacop Maertenz. Schout) had access to Josephus. The relevant passage, however, was taken over in Petrus Comestor's *Scolastica Historia*,[33] a copy of which was found in the library of Hieronymusdal.[34]

The presence of a mixed alphabetic word (*omega*), of mixed languages (on the robe's lower border), and of a Hebrew form close to pseudo-Egyptian alphabets, on Eleazar's robe in the Marienpoel triptych connects the painting with recent humanist study and the realm of hieroglyphs and emblems. The same may be said, perhaps, of the use of the Hebrew word *Emeth*, although alternative sources may have informed Cornelis Engebrechtsz. or local scholars, for example, the Jews of Leiden[35] or visiting refugees from Constantinople.[36]

A direct connection with sources for hieroglyphic interest can be sought in Erasmus, whose acquaintances included Meester Engebrecht Ysbrantsz. Schut of Leiden, Cornelius Aurelius of Hieronymusdal and Servatius Rogerii of Marienpoel, and evidently also Canon Jan van der Haer of Gorkum who was a friend of Cornelius Aurelius.[37] Erasmus was firmly connected with the hieroglyphic interest, and he was certainly aware of the two famous products of the Aldine press of Venice, *Hieroglyphica Horapollo*[38] and the *Hypnerotomachia* of Francesco Colonna.[39] Although he later rejected Colonna's work as an idle falsification,[40] Erasmus supported "hieroglyphic" ideas with his *Adages* (1508), also published by Aldus.[41]

While it is certain that Cornelius Aurelius possessed his own books in addition to those found in the library of Hieronymusdal, it is the personal library of Jan Dircxz. van der Haer which is of greatest interest, partly because its inventory is preserved.[42] According to Kronenberg, van der Haer owned "ca." three thousand eight hundred and forty-nine books. These became the property of the Emperor and were deposited in a building in the Court of Holland in The Hague, where van der Haer was given a house next to his books and a pension in exchange for the library. It was packed in 1531 and unpacked in 1534, when it was made available for a sort of public use. Van der Haer's library included numerous works by Erasmus, including five editions of the *Adagia*, one in manuscript.[43] Van der Haer had seventy-one Luther publications, fifty-three anti-Luther works, and sixteen pro-Luther works by other authors.[44] He also owned nineteen works by Cornelius Aurelius, some in manuscript.[45] Besides these, and excluding the category "theology," his wide-ranging library contained multi-lingual dictionaries and grammars for Latin, Greek, Hebrew, and Chaldean; the magic of Raymon Lull (called in the inventory "traditional knowledge");[46] books on cabala by Reuchlin and others; the works of Flavius Josephus; *Isagogicon Joannis Celarii Gnostopolite...* ; Iamblichus *De Mysteriis Aegiptiorum, Chaldeorum, Assiriorum*; "Mercury Trismegistri" *Liber de Sapientia et Potestate Dei, Pimander, Asclepius* (et al.); "Oris Apollonis Niliari" *Hieroglyphica* (two editions); Pomponii Guarici Neapolitani *De Sculptura seu Statuaris* "libellus sculptoribus statuariis nuce utilis aegloge lepidessiem due catalogus videatur in exordio"; Vitruvius *De Architectura* libri decem; Alciatus *Emblematum Liber*.[47] Possession of Alciatus *Emblemata* in the year of its first edition is noteworthy as an indication of the speed of distribution to the backward north.

The connection of Cornelius Aurelius, Servatius Rogerii, Jan van der Haer, and Erasmus with each other suggests that knowledge of these matters was not out of reach for Leiden's literate minority, some of whom had been taught by Meester Engebrecht, friend of Wessel Gansfort and an acquaintance also of Cornelius Aurelius.[48]

Marienpoel received new ceiling bosses in 1522, as mentioned above.[49] A drawing which looks like a design for one is preserved on a sheet of parchment, which has been used as a book binding twice since the drawing was made.[50] The page contains some unrelated notes (and some I cannot read) together with a poem, written out twice next to the drawing. The right edge of the poem was sliced off in the most recent use as binding material (ca. 1580?). The poem seems to refer to the possible boss design, because it is a Christmas reference to the Christ Child, Savior of the world, seated with the father, "born a star in heaven,"[51] with reference further to the three kings from the East and their adoration of God. The possible boss design is, on the one hand, similar to preserved bosses;[52] on the other, it is similar to an illustration in Colonna's *Hypnerotomachia*.[53] That, in turn, is related to ceiling paintings of foliate stars in the *Domus Aurea*,[54] which look somewhat more like the preserved bosses than does the drawing. I cannot explain the coincidental similarities. The library list of Marienpoel is gone,[55] so the *Hypnerotomachia*'s presence there cannot be verified.[56]

Interest in hieroglyphs and cabala existed throughout Europe in the beginning of the sixteenth century.[57] The emphatic concentration on traditional knowledge, in the sense of truth revealed through ancient (traditional and unchanging) signs, is most striking in the veneration of hieroglyphs and obelisks, which even led Bramante to propose changing the axis of St. Peter's and moving the tombs of the Apostles to align the church with the Vatican Obelisk.[58] The obelisks of Rome were mute witnesses to truth.

Conceivably Eck's first attack on Luther referred also to this current interest, through its title *Obelisci*.[59] The connection with the correspondence of Origen (taken up explicitly by Luther in his reply called *Asterisci*) in no way removes the contemporary significance of the word "obelisk" and points to the conflict among the Early Fathers about Hermes Trismegistus, Luther's position being like that of Augustine.

While it is certain that people in Leiden could easily have been aware of hieroglyphic interests, through connections with Erasmus and van der Haer, there is some question as to whether such knowledge was also possessed by Luther. Did he know that hieroglyphic gnosticism gave Roman obelisks a sanctity recognized by humanists? Did he notice hieroglyphs and ask his recurrent question, "What does this mean?" Had he even seen a Roman obelisk? Answers can be found in his trip to Rome, in 1510-1511.[60] O. Scheel considered it difficult to determine what Roman sights (if any) Luther may have seen during his four week business trip in Rome. Agreeing with the position that the complete tour will never be known, it is possible to stop at two points. Luther said mass at St. Sebastian's and he saw the church of Ara Celi.

St. Sebastian's, as noted above, was one of the seven major churches to be visited in the search for indulgence. There is no doubt that Luther's dissatisfaction about

summary confession had to do with achieving the correct feeling for obtaining indulgence, a consciousness of absolution. He visited the seven churches, climbed the steps of St. John Lateran, said to have come from Pilate's palace in Jerusalem, and so forth.[61] To make these pilgrimages he had to pass numerous obelisks. But, while all artists had to keep an eye out for theology, not all theologians had to notice art. The supposition that Luther noticed obelisks assumes that he did so because they were objects of piety, not objects of art. Obelisks were connected with the piety recommended in the simplest works for popular religious practice: the reader was to try to imagine himself present in the crowds at Rome, better still, to imagine himself present at the holy event on which he was meditating. The pilgrim in Rome had the great advantage of meditation on the spot, and Luther took his time about it. In this meditation, the obelisks, witnesses to the events, marking the places or so it was thought, had to have made an impression.

At this point the theories of the humanists about the origin of language and the normal stories of the churches of Rome meet. An obelisk stood in front of the church of St. Maria in Ara Celi.[62] Octavius was said to have been buried in it. Octavius was the Roman emperor who consulted the Tiburtine sibyl and received a vision of Mary in the Sun, holding the Baby Jesus, on the day of Jesus' birth. This prophetic vision occurred at the place where Octavius subsequently erected the church of St. Maria in Ara Celi.[63] The story is reported by Augustine and must have been known by Luther. In his earnestness Luther could not have missed the obelisk.

Luther also visited some catacombs.[64] The grotesque decorations and the decorative carvings accompanying inscriptions on sarcophagi were thought at the time to be hieroglyphic.[65] To summarize, Luther saw obelisks and hieroglyphs as they were then understood, and piety was sufficient for considering them to contain hidden meanings of the same sort stressed by humanists in their elaborations of gnostic language theory. From a strictly medieval point of view obelisks received attention because of their contact with holy events; they were for that reason objects of meditation. From the point of view of neo-platonic language theory, they were witnesses not only of the holy events but also of a traditional revelation from God, a revelation which was complementary to that in Christ and recorded in the Bible. To suppose that Luther found out about the second view of obelisks requires the unprovable assumption that he was, while in Rome, interested in contemporary theology of the previous twenty years.

The new neo-platonism made use of Aquinas to support its claims for an equivalence between the kind of traditional revelation described above and biblical revelation. In Aquinas a system of natural theology could be found corresponding to the idea of mystical if not magical meaning connected with the ordinary objects of the world.[66] Against this, Luther developed a theological program of studies based on the Bible and Augustine, who alone seems to have opposed Hermes Trismegistus strongly.[67] Luther called his theology a "Theology of the Cross," while attempting to have Aquinas removed from university curricula.[68] The new gnosticism, however, had received papal approval in 1493, when Alexander VI absolved Giovanni Pico della Mirandola from charges of heresy. The decoration of the Appartamenta Borgia in the Vatican with Egyptian Isis bulls facing the cross was a clear sign of approval of

hieroglyphic revelation. It was combined with depictions of the Sibyls, representing further pagan revelation. The construction of the Vatican Belvedere, containing the "idols of the ancients" (as the Netherlandish pope Adriaen VI later called them)[69] had been going on some time when Luther arrived in Rome. In the shadow of the Vatican it was sometimes open to public visit.

This context of multiple gnostic language speculation and veneration of Egyptian obelisks in Rome, considered to contain traditional knowledge of a revelation equal to that in Christ, gives some of the background for Luther's *De Captivitate Babylonica Ecclesiae Praeludium* of 1520. The title is an expansion of Luther's preface to S. Prierias' anti-Lutheran *Epitoma responsionis ad Martinum Luther,* 1520,[70] which Luther had had republished with an introduction and some commentary. The introduction contained the real break with Rome, and its language points to familiarity with Roman syncretic revelation ideas: Eant nunc qui gloriantur, Romanum Ecclesiam nunquam fuisse haeresi contaminatam: unus hic Sylvester Arrium, Manicheum, Pelagium et omnes alios incomperabiliter superat. Si sic Roma credit, Beata Graecia, beata Boemia, beati omnes, qui sese ab ea separaverunt et de medio istius Babylonis exierunt, Damnati vero omnes, qui ei communicaverint. Et ego quoqui, si Pontifex et Cardinales hoc os Satanae non compescuerint et ad palinodiam adegerint, his testibus confiteor, me dissentire Romanae Ecclesiae et negare eam cum Papa et Cardinalibus tamquam abominationem stantem in loco sancto. Extincta est in ea iam dudem fides, proscriptum Euangelium, exul Christus, Mores plusquam barbarici. Una erat reliqua spes, scripturae sanctae illibata autoritas et eiusdem recta saltem opinio, si nulla intelligentia: iam et hanc Satan occupat, arcem Zion et turrim David hactenus inexpugnabilem. Nunc vale, infoelix, perdita et blasphema Roma: pervenit ira dei super te, sicut meruisti in finem, nec tot orationibus, quae pro te fiunt, nisi indies peior fieri voluisti. Curavimus enim Babylonem, et non est sanata: relinquamus ergo eam, ut sit habitatio draconum, lemurum, larvarum, lamiarum, et iuxta nomen suum confusio sempiterna, idolis avaritiae, perfidis, apostatis, cynaedis, Priapis, latronibus, Simonibus et infinitis aliis monstris ad os plena et novum quoddam pantheon impietatis. Vale, mi lector, et dolori meo ignosce et compatere.[71]

The reference to (Babylonian?) gardens in Rome must have recalled the Vatican Belvedere to the imaginations of most readers. ("Priapis" refers to gardens containing statues, especially with one of Priapus or a herm.)

De Captivitate Babylonica Ecclesiae Praeludium followed this in the same year, and its readers must have known the earlier publication. The later work is a discussion of the sacraments, in which three (Baptism, Penance, Eucharist) are retained as instituted by Christ and containing signs of his promises; and in which the other four (Confirmation, Matrimony, Ordination, Extreme Unction) are rejected as being human traditions.[72] References to paganism for these traditions are unclear compared to the earlier attack on Babylonian Rome; nevertheless, they are present. For example, "Even if an angel from heaven should teach otherwise, we shall not allow anything to prevail against these words."[73] Because the angel described may come from heaven, this is no reference to a fallen angel, but rather to angels in gnostic (and Aquinan) hierarchies, as well as to Luther's opposant Gabriel.[74] At the beginning the true "tradition" (translated: I Cor. 23: For I received from the Lord what I

also *delivered* to you. . .) from Christ to the Corinthians through Paul is established as a criterion for what follows.[75] The word "tradition" is used in rejecting Matrimony (as a sacrament).[76] It has negative connotations in the phrase "per impiorum hominum opiniones et traditiones. . ."[77]

However, in deriving the sacraments from the works of Christ as witnessed by the Bible, Luther was rejecting a church tradition of deriving them from the Credo, as mentioned above. Luther, thus, turned against all the traditions of man accepted by the church of his time, Roman, Greek, Chaldean, Persian, Egyptian, Cabalist, or anything else, including recent ordinary piety. (It may be remarked that the rejection of Cabalist exegesis was, however, gradual and later.)

De Captivitate Babylonica Ecclesiae Praeludium cannot be read without the earlier description of Babylon in mind. The conclusion must be drawn that Luther was rejecting the papacy of the Room of the Sibyls, the Room of the Saints, and the Vatican Obelisk and Belvedere,[78] together with the alternative revelations supported by the use of Aquinas. Confirmation for this contention can be found in the woodcut broadside *Aussfürung der Christglaubigen auss Egyptischer finsterniss*, by "Master H" dated 1524 on the block, depicting "Luther Leading the Faithful Out of the Darkness." "Master H" worked in Wittenberg, ca. 1522-1525; at Leipzig, 1526-1531; and at Magdeburg after 1532. He illustrated the Apocalypse in Luther's *New Testament* published by Melchior Sachse at Erfurt in 1527-1528.[79] Close connection with contemporary understanding of Luther's significance may be assumed, so the peculiar use of the word "Egyptian" takes on importance. The word could refer to the ninth plague (Ex. 10: 21-23), which would be an unusual choice (not the last of the plagues, and not a more generalized term like "Egyptian bondage"). Or it could refer to the Gypsies, who had usually been called simply "heathens" until they became considered a continuation of old Egypt in the fifteenth and early sixteenth centuries. Either way, the word calls attention to the alternative revelations favored in Rome and considered to have been transmitted by the Egyptians.

Luther, in the midst of a new and pagan "traditionalism" called contemporary Rome pagan, with a certain literal precision. He had no great objection to the preservation of medieval and recent art which lacked the *new* "traditional" gnosticism, and which as in earlier times might support the faith of Christians.[80] Here he and the writer of the Augsburg Confession (Melancthon) contrast with reformers whose program required a radically different ecclesiastical polity, new politics, and the expulsion of images and music from the liturgy.

Cornelius Aurelius of Hieronymusdal, poet laureate in 1508, could very well be bothered when asked point blank what he thought of "our Martin" while dining in a group with his Augustinian superiors.[81] In becoming familiar with Luther's work, his erudite orthodoxy compatible with syncretist humanism may have been a system he saw in need of reappraisal. (In my opinion Luther's assumption of a cabalist derived eschatalogical time for the world and his own marginal annotations to his copy of Reuchlin's *De Arte Cabalistica*, reported by F. Secret, do not in themselves necessarily prove that he was aware while in Rome of the pervasive acceptable gnosticism.[82] Important for consideration of *De Captivitate Babylonica*, they do not guarantee his interests in Rome or before his certain acquaintance with Reuchlin's work (1517)).[83]

Notes

1. See chapter 6, note 23, for references to a discussion of theological developments in Germany, at Warmond. Cornelius Aurelius and Jan van der Haer knew works by Luther. Mellink, *Wederdopers*, 328-334, summarizes current opinion on early Lutheranism in the Low Countries.

2. G. A. Leiden, Bibl. no. 72046 (= NK, no. 468). On Bonaventura's popularity in this period, see L. J. Mees, "*Het boec vanden vier inwendige oefeningen*, a widely read incunabulum and post-incunabulum," *Quaerendo, A Quarterly Journal from the Low Countries devoted to Manuscripts and Printed Books*, IV, 1974, 180-213.

3. "En also ic geseit hebbe so is in ons herē woert een verborgen ordinancie."

4. The letters have been misread as "T en S?" (Overvoorde, "Altaarstuk van Cornelis Engebrechtsz.," 307) and as "c en d" (Pelinck, *Lakenhal Painting Catalog*, 68). The *D* is clear on both panels. The *G* is damaged on one, but complete on the other, showing the necessary stroke back and downwards to form an elaborate *G* as found in archival records of the period which have decorated initials. Compare also the *G* on the colophon of the *Spiegel van Sassen*, 1512.

5. It does not seem likely that Willem van der Does would equate his powers as magistrate with the statement to the apostle Peter (see Matt. 16: 19) and the other apostles (see Matt. 18: 18). An unrecorded alternative source for a "hieroglyph" referring to an incorrupt judge is suggested by the hieroglyph cited by K. Giehlow, "Die Hieroglyphenkunde des humanismus in der Allegorie der Renaissance, besonders der Ehrenpforte Kaisers Maximilien I," *Jahrbuch der Kunsthistorischen Sammlung des Allerhöchsten Kaiserhauses*, XXXII, 1915, 1-232, particularly see 169, (w): "Imaginibus quibus recisae manus, judices incorruptos, et quae inter eos oculis conniverit (!) [Giehlow], principem judicem significabat." Giehlow's unsurpassed study is essential to the hypotheses briefly presented in this chapter.

6. See D. P. Walker, *The Ancient Theology, Studies in Christian Platonism. . .*, Ithaca, 1972, 20. A neo-platonic outlook on the traditional source of knowledge could have been based on the *Spieghel Historiael* written in rhymed Dutch in the last years of the life of Jacob van Maerlant (ca. 1283-1288), at the request of Count Floris V, which was a translation of Vincent of Beauvais' *Speculum Historiale*. For the Chaldean Oracles, see W. Kroll, *De Oraculis Chaldaicis*, Breslau, 1894 (= *Breslauer Philologische Abhandlungen*, VII, 1-72).

7. G. Boas, *The Hieroglyphs of Horapollo*, New York, 1950, 66 (Book I, no. 13); 87 (Book II, no. 1). See further P. O. Kristeller, *Die Tarocchi, Zwei Italienische Kupferstichfolgen aus dem XV Jahrhundert* (= *Graphische Gesellschaft II, Ausserordentliche Veröffentlichung*), Berlin, 1910, no. 48 *Octava Spera* ("der Fixsternhimmel").

8. See *De Vijfhonderdste Verjaring van de Boekdrukkunst in de Nederlanden*, 447-448, cat. no. 205, discussion of the first known use of this printer's mark, in *Die historie van hertoghe Godevaert van Boloen* (ca. 1486-1489); see also ill. no. 62, pp. 289-290, cat. no. 138 (p. 307) for the use of the tower alone, reworked as the arms of Antwerp; see further *NAT*, II, Anvers, Theodoricus Martinus Alostensis, II, no. 11 (ca. 1502, = NK, no. 1862). For sources on the history of the block used in the *Spiegel van Sassen*, 1512, see Kronenberg, review of P. Baush, "De Portretten der graven en gravinnen van Holland in Jan Seversz.' Divisiekroniek 1517," in *Het Boek*, XIV, 1925, 315-320. In addition to books ending with "Deo Gracias" (such as *NAT*, I, Gouda, Allard Gauter, I, no. 3, and II, no. 5; *NAT*, II, Adriaen van Bergen, IV, no. 10), see *NAT*, I, Amsterdam, Doen Pietersoen, V, no. 19, which ends "Gratia Dei." This makes a translation into "Gode Dank" unnecessary, despite the translations of "Laus Deo" into "Lof God" or, as in the book printed by Jan Zevertsz. (who also used the Latin form), *NAT*, I, Leiden, Jan Seversz., VII, no. 16, "Lof God van al." Another slogan is *NAT*, I, Leiden, Pieter Janszoon, I, no. 2, "In God Ist Al."

9. The *G D* on the closed *van der Does-van Poelgeest Panels* appears both above the arms of the man and (repeated) above the arms of his wife. An interpretation as initials is, therefore, impossible. Similar considerations rule out the interpretation of the *G A* appearing above the votive figure of William of Orange and also repeated above the figure of his wife Anna of Saxony, as being intended as initials (for "Guillaume d'Aurange") in their proposed complete Gouda St. Janskerk window. See A. C. M. Mensing, "Het Raadsel van Raam 22 te Gouda," *Oud Holland*, LV, 1938, 106.

10. This slab is now in the forecourt of the Leiden Municipal Museum "De Lakenhal" on the left side of

the entrance. The quarters of Ghysbrecht van der Bouchorst show his father to have married a woman whose arms were three Greek crosses on a bend (this, if the bend were a vertical bar, would be the arms which appear on the Marienpoel *Lamentation* triptych). Further, Ghysbrecht van der Bouchorst was descended from a van Swieten and a van Diemen. These relations provide further support for regarding the arms on the triptych as belonging to a local family and not as being the arms of the city of Amsterdam.

11. See. however, F. Yates, *Giordano Bruno and the Hermetic Tradition,* London, 1964, 35. The implication could be that the "knots of love" were required for a combination of unrecognized Manicheism with a doctrine of resurrection of the body. According to Yates, the Hermetic concept is that man is united with God through man's intellect, shared with the divine; other creatures are "bound to the celestial plan" by "knots of love." In dualism dividing mind from body, the second being considered created, the orthodox doctrine of the resurrection of the body could make such knots comforting.

12. NK, no. 593.

13. NK, no. 1934: the tower has been redesigned and is a copy, not a re-use, of the tower as appearing in the arms of Antwerp. The figures are apparently derived from du Hamel's print, mentioned above. For a cruder version of the elephant, with a tower not derived from du Hamel or the arms of Antwerp, see *NAT,* II, Anvers, Nicolas de Grave, IX, no. 19, dated 1515.

14. The explanation of *G D* posed a problem to bibliophiles as long as it was thought to be a clue to the name of the Gouda printer or to the person who commissioned the printing of the book. Colophons themselves do not appear to have received sufficient special attention. A comparison of the heraldic devices used in the colophons of the Delft printers known by the sobriquet "Lettersnyder" shows, for example, that they were probably related to the van der Meer family, one of whose members was also a printer in Delft (see *NAT,* I, Delft; further, see Friedländer, *Lucas van Leyden and Other Dutch Masters,* no. 37, plate 23, and page 98, note 46, for a member of the family). This argues against the suggestion that the monogram *C H with a pot* on the map in the *Cronycke van Hollandt 1517* has anything to do with Cornelis Hendricxz. Lettersnyder (see chapter one, notes 69 and 41).

15. J. Boschio, *De Arte Symbolico. . .,* Augsburg and Dillingen, 1701 (reprinted Graz, 1972), Class II, p. 16, no. 194, ill. p. 10.

16. "It is no work to carry this." The explanation given by Erasmus for adage no. DCCCLXIII (D. Erasmus, *Adagiorum Chiliades Tres,* Venice, 1508, 99: "Elephantis noncapit murem") seems less appropriate as a source for the colophon. See M. M. Philips, *The 'Adages' of Erasmus,* Cambridge, 1964, 263.

17. Phillips, *The 'Adages' of Erasmus,* 48.

18. The word *SABAWT* appears on the robes of God, with other legible texts on the hem, in van Eyck's altarpiece. The word *SANCTVS* is repeated on the edge of the cope of the foremost angel kneeling in the van der Goes triptych.

19. For the latter, see Friedländer, *Lucas van Leyden and Other Dutch Masters,* no. 69, plate 57.

20. Pelinck, *Lakenhal Painting Catalog,* 60.

21. See F. L. Moriarity, "Alphabet," *New Catholic Encyclopedia,* New York, 1967, I, 334-336. The closest of the alphabets in the comparative charts to that on the vertical band in the painting is the Hebrew cursive of ca. 600 B. C.

22. The word *alpha* is clearly written in mixed Roman majuscules and miniscules of decorated sixteenth-century form at the left on the lower border, although intersected by a scabbard. A more decorated variation of the same letters gives Moses' name and patronymic on the hem of his robe. The word *Emeth* is found at the right edge of the lower border of Eleazar's robe, written in a form of Hebrew close to that mentioned in note 21: Aleph, Mem, Tāw. Slight variation is found in the *aleph,* which is set vertically, as in Greek and Roman letters, and which therefore looks more like the majuscule *aleph* given in the Hebrew alphabet in J. Cellarius, *Opuscula Quatuor,* 1517 (*NAT,* I, Deventer, Theodoricus de Borne, VI, no. 28). The *mem* is also similar to the majuscule given by Cellarius; but the *taw* takes the older *X* form. The word *omega* is between the other words, read left to right: *omicron* (or possibly a "Chaldean" or "Syriac" variant), *mem* in the Hebrew form used in the word *Emeth,* a vowel equivalent to *epsilon* is omitted (implying Hebrew), *gamma* or *gimel* is reversed from the usual *gamma* and from the *gimel* in the vertical alphabet but similar to the majuscule *gimel* given by Cellarius, *aleph* in the same form of Hebrew used in the word *Emeth.* For a discussion of cabalistic mixtures of letters from

different alphabets within one word to add power to that word (mixtures including Hebrew, Syrian, and Chaldean or Abyssinian), see T. Bang, *Caelum Orientis et Prisci Mundi*, Copenhagen, 1657, 135 and f., especially 137-138, including references to previously published explanations of cabalistic alphabets based on celestial alphabets. Celestial alphabets were the Hebrew alphabet as found in the stars, as on pages 135 and 136 of Bang, where supposed later derivatives are shown. The mixture of alphabets seems a logical development of Pico's mixture of truths; it is evidently part of what J. L. Blau identifies as the Christian interpretation of the Cabala (see below). See also H. C. Agrippa de Nettesheym, *De Occulta Philosophia*, Antwerp, 1531 (*NAT*, II, Anvers, Johannes Grapheus, VI, no. 26); the comparative alphabet magic of this book is mentioned cursorily in Yates, *Giordano Bruno*, 133-134, in a chapter devoted to the contents of Agrippa de Nettesheym's complete book, considered a survey of Renaissance magic. (I take the publication date of *De Occulta Philosophia* from *NAT*; the date 1533 is given by Walker, *Spiritual and Demonic Magic from Ficino to Campanella*, London, 1958, 90.)

23. See further, *The Catholic Encyclopedia*, New York, 1907, I, 332-333, articles on "Alpha and Omega-Scriptural," "Alpha and Omega – in Jewish Theology," [*sic*] and "Alphabet, Christian use of." For an exposition of late-fifteenth and early sixteenth-century Christian understanding of this and other simple forms of Hebrew letter mysticism (together with more complicated aspects of cabala than can be found in Leiden), see J. L. Blau, *The Christian Interpretation of the Cabala in the Renaissance*, New York, 1944.

24. See Blau, *Christian Interpretation of the Cabala*, 59.

25. The form used is practically identical with that given by Cellarius, but the robe's alphabet mixes majuscule and miniscule letters. The miniscules of Cellarius may be attempts at rendering contemporary script, but in illustration they take on the appearance of Hebrew miniscules (!). On the robe *iod* takes an enlarged form of Cellarius' majuscule, looking like a form of *heth* in other Hebrew alphabets. *Nün* is omitted (*mem* is followed by *samech*). *Ain* is omitted. *Pe* is present, as is *zade*. *Küff* is omitted. *Zes*, *schin*, and *taü* (miniscule) are present. Except for the omission of three letters, the order is correct. A depiction of the high-priest's robes including the alpha-omega motif is seen as a Bible illustration, where the inscription ALFHAO (= Alpha O) occurs on the crescent of the high-priest's turban; see Prince d'Essling, *Études sur l'art de la gravure sur bois à Vénise, les Livres à Figures Vénitiens de la fin du XVe Siècle et du Commencement du XVIe*, Florence and Paris, 1907, illustration from no. 132, Latin Bible published (Venice) by Octavianus Scotus, August 8, 1489.

26. See Yates, *Giordano Bruno*, 12-14. For Ficino, see P. O. Kristeller, *The Philosophy of Marsilio Ficino*, New York, 1943; Kristeller, *Renaissance Thought, The Classic, Scholastic, and Humanist Strains*, New York, 1961, 52-53; Kristeller, *Renaissance Thought, II, Papers on Humanism and the Arts*, New York, 1965, 98-99 and 106; Kristeller, *Renaissance Philosophy and the Mediaeval Tradition (Wimmer Lecture XV)*, Latrobe, 1966, 76-77; and Walker, *Spiritual and Demonic Magic*. See also A. J. Festugière, *La révélation d'Hermès Trismégiste*, Paris, 1950; and C. Trinkaus, *In Our Image and Likeness, Humanity and Divinity in Italian Humanist Thought*, London, 1970, where the influence of the Hermetic tradition is considered over-emphasized by other writers, because (although Hermetism was admittedly present) the derivative notions could have been easily derived from non-Hermetic sources in humanist thought before Ficino.

27. For pseudo-Egyptian alphabets, see Bang, *Caelum Orientis*, 111, 112, 114, 115, 116. The alphabet on Eleazar's robe is related to the double set of alphabets on p. 114, with variant letters, some found in other pseudo-Egyptian alphabets or in the "ancient Hebrew" alphabet (p. 101) or that of Adam (two sets, on p. 100).

28. Presumably Cornelis Engebrechtsz. worked with similar concepts of language development, with minor letter variations. Similar letters are seen in works by Konrad Witz, Hans Holbein the Elder, Mair von Landshut, Ambrosius Holbein, and Pieter Bruegel, among others. Hans Holbein the Elder's *Madonna and Child* (see *Hans Holbein der Ältere und die Kunst der Spätgotik*, Augsburg, 1965, exhibition catalog, ill. 11, cat. no. 11) is similar to Mair's engraving *The Madonna, half-length on the Crescent Moon, Carried by two Angels* (Lehrs, *Late Gothic Engravings*, no. 582). The shoulder inscription differs. Holbein's is more complete, but is is certainly not written in the clear Hebrew of his painting *Joachim's Offering* (*Augsburg Catalog*, 1965, ill. no. 7, cat. no. 7). What forms were used by Holbein and Mair is not known. Both apparently reflect another painting, whose inscription may have

been illegible to them (or lost in transmission). Holbein's version uses letters similar to those in the alphabet of Enoch in Bang, *Caelum Orientis*, 104. Witz's painting *The Synagogue* (Basel) combines forms which appear in Cellarius with letters in the alphabet of Noah and the pseudo-Egyptian alphabet in Bang, *Caelum Orientis*, 105 and 115. A drawing of an unknown young man by Ambrosius Holbein (Basel, Öffentliche Kunstsammlung, K. – K. U. II. 31. a, *Brustbild eines bartlosen jungen Mannes*) has undeciphered inscription in an alphabet similar to those of Adam and Noah in Bang, *Caelum Orientis*, 100 and 105; Pieter Bruegel's drawing for the engraving *Fortitudo* (Museum Boymans- van Beuningen, Rotterdam, drawing M. 147) has an inscription with letters similar to the alphabet of Enoch in Bang, *Caelum Orientis*, 104 (although there are other possibilities for Bruegel's alphabet). The existence of manuscript sources for the intelligible organization of these various alphabets and the possibility of reading the inscriptions eventually may be hypothesized in opposition to the continuation of the presupposition that they were vague imitations of Hebrew by uninformed artists. Some help may be found in the directions (related to cabalistic magic squares and notation) indicated in K. A Nowotny, "The Construction of Certain Seals and Characters in the Work of Agrippa of Nettesheim," *Journal of the Warburg and Courtauld Institutes*, XII, 1949, 46-57. Compare these directions particularly with the "celestial" Hebrew alphabets in Bang, *Caelum Orientis*, 135-136. In Basel, the inscription on Ambrosius Holbein's drawing was described in terms of not yet having been deciphered, implying the hope of doing so in the future (1972 museum label). In Leiden, however, not having been considered as culturally advanced as Basel, illegibility was expected for the inscriptions on Eleazar's robe. That the alphabets were wide-spread is shown by the appearance of such letters on a painting at Osek, Csechoslovakia (see J. Pešina, *Painting of the Gothic and Renaissance Periods, 1450-1550*, Prague, n. d., ill. 275, cat. no. 365, Master I. W. and assistant: *Brass Serpent*).

29. See E. H. Gombrich, *Symbolic Images, Studies in the Art of the Renaissance*, London, 1972, 149. Gombrich's idea that there was a single position which can be called "The Christian Interpretation" of the hieroglyphic problems is an oversimplification missing the issues here discussed briefly. The admittedly simplified division into liberal and illiberal views is also inadequate (see Walker, *Ancient Theology*, 123). The genealogy of Hermes Trismegistus was important in the establishment of the priority of the revelations. See Yates, *Giordano Bruno*, 11, 14, 15, 17-19; Walker, *Ancient Theology*, 17, 20-21.

30. Examples of the alphabet are found in Bang, *Caelum Orientis*, 135-136. The unification of the Greek concept of Logos with hierarchies of angels may have contributed to the early disputes about the Trinity, where Christ's names as Logos and angel were discussed (see J. Pelikan, *The Christian Tradition, A History of the Development of Doctrine, I, The Emergence of the Catholic Tradition (100-600)*, Chicago, 1971, 182-184 and indexed references to Christ defined as Logos. See also Blau, *The Christian Interpretation of the Cabala*, first chapter and 48.

31. Blau, *The Christian Interpretation of the Cabala*, 21 and 28. On Erasmus, see W. L. Gundersheimer, "Erasmus, Humanism, and the Christian Cabala," *Journal of the Warburg and Courtauld Institutes*, XXVI, 1963, 38-52, especially 50. I disagree with Gundersheimer's opinion that the "Lutheran schism" was a different controversy from the cabala-associated controversy by 1520 (Gundersheimer, 50). See also, E. F. Rice, "Erasmus and the Religious Tradition, 1495-1499," *Journal of the History of Ideas*, XI, 1950, 387-411 (an attempted analysis of Erasmus' developing attitudes towards aspects of traditional religion, lacking useful distinctions). For the wide-spread knowledge of hieroglyphic and related subjects in Germany in the three decades immediately preceding Luther's controversial beginnings, see P. du Columbier, "Les Triomphes en Images de l'Empereur Maximilien Ier," *Les fêtes de la Renaissance, II, Fêtes et Cérémonies au Temps de Charles Quint*, Paris, 1969, 108-112.

32. See J. Capgrave, *Ye Solace of Pilgrimes, A Description of Rome, circa A. D. 1450, by John Capgrave, an Austin Friar of King's Lynn* (ed. C. A. Mills), Oxford, 1911. The editorial notes provide comparative selections from roughly contemporary guides to Rome in other languages, to around 1500.

33. See Gombrich, *Symbolic Images*, 150, note 66.

34. See P. F. J. Obbema, "A Dutch monastery library of c. 1495, Leiden, Lopsen?," *Quaerendo, A Quarterly Journal from the Low Countries devoted to Manuscripts and Printed Books*, IV, 1974, 234, no. 167. Obbema notes the publication of a partial edition containing only the New Testament history as early as 1473, but it is not clear whether the monastery owned a complete manuscript, a complete printed book, or an example of such a published abridgement. Hieronymusdal was not the only source

of books in Leiden and the area, of course. It is most likely that a copy of the Dutch *Bijbel* printed in Delft by Jacob Jacobsz. van der Meer and Mauricius Yemantsz. van Middelborch in 1477 was available. This, however, did not contain Comestor's additions, although they were well-known from Dutch manuscript Bibles, and the *Bijbel* would have grown in exegesis. (See S. Hindman, "Fifteenth-Century Dutch Bible Illustrations and the Historia Scholastica," *Journal of the Warburg & Courtauld Institutes*, XXXVII, 1974, 131-144.) The collection of Philips van Leyden had been under the control of the Pieterskerk or the Pancraeskerk since his death in 1382, and donated accessions may have occurred as well as recurrent failures to return books to the lending library. See B N. Leverland, "Philips van Leyden, ca. 1328-1382, Kannunik van St. Pancras, zijn verwanten — zijn stichtingen," *Jaarboekje voor Gescheidenis en Oudheidkunde van Leiden en Omstreken*, LVII, 1965, 83.

35. That there were Jews in Leiden in the fifteenth and sixteenth centuries is contrary to presently published opinion. An article of mine on a notable rabbi of the mid-sixteenth century will appear in *Jewish Social Studies*. The scanty references to people identified with the words "the Jew" or "the Jew's son" (*"die Joode"* or *"die Juedenz."*) do not indicate whether or not they were religiously active, nor is the religion of their mothers specified, nor any other aspect except that their neighbors identified them with words inseparable from Judaism. Their names indicate that they were probably Ashkenazim; they may not have known Hebrew even if religiously active.

36. Payments to refugees from lands conquered by the Turks are found in various years after the fall of Constantinople (1453), registered in the Burgemeesters Rekeningen. For examples, see S. A. 525 (Burgemeesters Rekeningen 1460-1461), folio 112, a reference to two noblemen from Constantinople with letters from the Pope and the Duke of Burgundy asking permission to solicit alms in the churches and houses and from the city government. Alms were granted by the city, in exclusion of the other requests and with the stipulation that they leave; see also S. A. 528 (Burgemeesters Rekeningen 1462-1463), folio 144 verso, — two knights with retainers, claiming to have letters from the Patriarch of Constantinople and the Kaiser; and folio 115, — two Greek priests driven from their monastery by the Turks. Other years contain similar alms payments, continuing over a fairly long period. See S. A. 551 (Burgemeesters Rekeningen 1474-1475), folio 142. On May 25, 1475, two noblemen and a priest from Constantinople came with letters from the Duke of Burgundy asking permission to beg. They were told it was against Leiden's city charter to allow begging, besides being against common law, but they were given alms "for the sake of God." The next reference on the same page is of another recurrent sort — payment of money to "heathens," sometimes called "Egyptians" (= Gypsies). On June 7, 1475, "Joncheer Pieter van Cliene Egipten" (Sir Peter of Little Egypt) arrived with a group of heathens with letters of permission to pass unhindered, from the Duke and the Court of Holland, together with instructions from both sources to give them alms. The nearly annual visits of "Egyptians" to Leiden continued with diminishing frequency into the third quarter of the sixteenth century, when George Congre (or "Conget"), chief of some "Egiptenaers," was condemned to six years' galley slavery (R. A. 3, 1533-1584, July 15, 1562). For Leiden visits of Gypsies in 1430, 1466, and 1467, see Overvoorde, "Bladvulling," *Jaarboekje voor Geschiedenis en Oudheidkunde van Leiden en Rijnland*, XV, 1918, 35.

37. For Erasmus' acquaintances, see the introduction and prefatory notes in Reedijk, *Poems of Erasmus*. See also Kronenberg, "Werken van Cornelius Aurelius (Donckanus) in de bibliotheek van Kanunnik Mr. Jan Dircsz. van der Haer," *Het Boek*, XXXVI, 1963-1964, 69-79.

38. First published in 1505 by Aldus. See Gielow, "Hieroglyphenkunde des Humanismus," 107; Walker, *Ancient Theology*, 100-104; Boas, *Hieroglyphs of Horapollo*.

39. Written 1479 or, at least partially, earlier; published by Aldus in 1499. See Gielow, "Hieroglyphenkunde des Humanismus;" J. W. Appell, *The Dream of Poliphilus*, London, 1889 (facsimiles of 168 woodcuts, with some parts left out); Colonna, *Hypnerotomachia Poliphili*, ed. G. Pozzi and L. Ciaponni, Padua, 1964; further, *Discours du Songe de Poliphile*, ed. B. Guégin, reprint of the Kerver edition with French translation of the text, Paris, 1926; Colonna, *Hypnerotomachia (The Strife of Love in a Dreame)*, London, 1592 (reprint, Amsterdam, 1969, not a complete translation). The major study is that of Pozzi and Ciaponni, including an extensive bibliography and indices. See also N. Dacos, *La Découverte de la Domus Aurea et La Formation des Grotesques à la Renaissance*, London, 1969, 57 (I disagree with Dacos' opinion that the *Hypnerotomachia* was an independent development; nevertheless, Pozzi and Ciaponni see no connection with the *Domus Aurea*, which they also do not consider in referring to the sights available in fifteenth-century Rome; see Pozzi and Ciaponni, *Hypnerotomachia*,

II, 10). That the works derivative of the *Domus Aurea* indicated by Dacos might have contributed inspiration as being equally valid examples of antique design is not considered by Pozzi and Ciaponni. See further *Le Studiolo d'Isabelle d'Este, Les dossiers du département des peintures 10,* Louvre exhibition catalog, Paris, 1975.

40. Yates, *Giordano Bruno,* 165, clearly misinterprets a slighting remark about Colonna made by Erasmus as being a remark against Hermes Trismegistus; this seems to imply to Yates an unsubstantiated division of "secular humanism" from "religious humanism" in her discussion of reactions to Hermes Trismegistus. Walker seems to have been misled by Yates in his interpretation of the same passage of Erasmus (see Walker, *Ancient Theology,* 126). The combination of religious thought and secularity through neo-platonic allegorization seems to be visually represented in some of Dürer's work, discussed by Giehlow. It is further evident in the compositional derivation of the title page illustration to the 1511 edition of Dürer's *Apocalypse* (Kurth, *Dürer Woodcuts,* no. 213), which is in the *Hypnerotomachia,* third illustration from the end (= Appell, *The Dream of Poliphilus,* ill. 166) so that the nature of the revelation of John can be connected with Venus confronting the soul of Poliphilus, and Venus crowned as the pagan goddess of love can be connected with the crowned Mary holding Jesus ("Love Incarnate") as equivalent to the pagan Cupid, who has been compositionally replaced by John's attributive eagle. A further modification is seen in the painting by Ambrosius Holbein *Christus vor Gottvater* (see *Die Malerfamilie Holbein in Basel,* Kunstmuseum Basel, exhibition catalog, 1960, ill. 35, cat. no. 80), where the composition is reversed, John is replaced by Christ (copied from Dürer's woodcut, Kurth, *Dürer's Woodcuts,* no. 214); Mary is replaced by God the Father; and Cupid is replaced through multiplication into many angels as putti. Another version is Lucas Cranach the Elder's *Der heilige Bartholomäus, von Friedrich dem Weisen verehrt,* an undated engraving which shows the *Hypnerotomachia* and Dürer compositions reversed (see W. Schade, *Die Malerfamilie Cranach,* Dresden, 1974, ill. 68).

41. Giehlow, "Hieroglyphenkunde des Humanismus," 107-108.

42. A. R. A., The Hague, Inv. Derde Afdeling, old inventory, Hof van Holland, R. A. 10.

43. Kronenberg, "Erasmus-Uitgaven A°. 1531 in het Bezit van Kanunnik Mr. Jan Dircsz. van der Haer te Gorkum," *Opstellen door vrienden en Collega's aangeboden aan Dr. F. K. H. Kossmann,* The Hague, 1958, 99-117, especially 109.

44. Kronenberg, "Luther-Uitgaven A°. 1531 in het Bezit van Kanunnik Mr. Jan Dircsz. van der Haer te Gorkum," *Het Boek,* XXXVI, 1963-1964, 1-23.

45. See note 37.

46. See Blau, *The Christian Interpretation of the Cabala,* 17, 117-118.

47. A. R. A., The Hague, Inv. Derde Afdeling, old inventory Hof van Holland, R. A. 10, folios 55 verso, 122, 122 verso, 123, 128, 132, 133, 135, 143 verso, 145, 168, 169 verso, 171 verso, 172 verso, 173 verso, 174 verso, 176 verso, 186, 194 verso, 201 verso, 202, 208 verso, 216 verso, 219 verso; further, in the appendix of books acquired after 1531, fifth and sixth unnumbered folios: Albertus Dureri pictoris et architecti *De Urbibus Artibus Castellis Rondenis ac Numendis Rationes* ex Germanica lingua in linguam Latinam traducte; *Imago et representatio antiChristi apocalipsis. ca. XIII.*

48. See Reedijk, *Poems of Erasmus,* 157-158.

49. See chapter two, note 5.

50. Kl. Arch. 901 (Marienpoel Rekeningen, 1536), inside of the binding. That the binding was not originally intended for this book is evident from the fact that it extends only halfway across the size of the pages, at most. The holes from the previous sewing run horizontally across the parchment, indicating an earlier book with at least four quires, now missing. Many of Leiden's ecclesiastical and other records were bound shortly after the Reformation, which explains the appearance in some of them of unrelated earlier material. It also explains the use of the catalog of a library disbanded in 1526 (whose catalog was drawn up in 1495, according to recent accessions) for binding a volume of legal records covering the period between 1497 and 1505 (R. A. 41, Kenningboek G). See Obbema, "A Dutch monastery library of c. 1495," 220.

51. Arianism seems to have slipped into the poetry via the Star from the East (see Pelikan, *The Emergence of the Catholic Tradition (100-600),* 191 and f; see also Blau, *The Christian Interpretation of the Cabala,* 14-16).

52. In addition to one in private psssession, see the bosses of the (restored) Laurenskerk, Rotterdam;

Jacobskerk, The Hague; and the Onze Lieve Vrouwe Kerk, Dordrecht.

53. See Pozzi and Ciaponni, *Hypnerotomachia*, I, 312; Appell, *The Dream of Poliphilus*, no. 124. The design is supposed to represent a garden plan, as are the illustrations nos. 123, 126, 128, and 129. The perspective distortions, explained as marvelously inventive in the text of Colonna, would more appropriately be seen in drawings made from below or from a distance, of designs above the draughtsman.

54. See Dacos, *Domus Aurea*, fig. 33. Notable in many *Domus Aurea* illustrations or murals are the garden effects, with vines and trees branching over barrel vaults or growing up walls. Similar but lusher vegetation dominates some of the *Hypnerotomachia* illustrations. This is ascribed by Pozzi and Ciaponni to an acquaintance with a specific garden (or herbalist) literature. See Pozzi and Ciaponni, *Hypnerotomachia*, II, 14. Both may be correct as sources, one for visual ideas, the other for the plant nomenclature.

55. One of Marienpoel's annual record books is horizontally bound (across half the size of the pages) with a piece of parchment inscribed "Register Librorum."

56. It does not appear in van der Haer's non-theological works (according to his own division of topics). I have not read the lists of theological works (the first 122 folios of the inventory) to check there for it. Van der Haer, as already mentioned, was not the only book owner in the area, although he may have been the most spectacular collector.

57. See note 31. Further, see Blau, *The Christian Interpretation of the Cabala*, 34-36, for Erasmus and Colet, among similar connections cited by Blau.

58. See Gombrich, *Symbolic Images*, 103; see also Giehlow, "Hieroglyphenkunde des Humanismus," 29-30.

59. For the Eck and Luther exhange, see Luther's Works, Weimar edition, 1888, I, 278-f. *Asterisci*, especially the third statement and reply. A famous study of tradition within the church preceding the period of Luther and the translation and publication of *Horapollo* is H. A. Oberman, *The Harvest of Medieval Theology, Gabriel Biel and Late Medieval Nominalism*, Cambridge, Mass., 1963. Oberman distinguishes between two traditions within the church. The tradition at issue in the hieroglyphic problems was not a third of the same category, because it concerned revelation outside the church, bypassing biblical revelation. See further, J. N. Bakhuizen van den Brinck, "Erasme: Humanisme et 'philosophia christiana'," *Mededelingen van het Nederlands Instituut te Rome*, XXVI (new series I), 1974, 89-100, especially 92-94. In my opinion, the word "traditional" had acquired an additional, special significance which referred distinctly to the non-biblical alternative sources of ancient knowledge and combined the meanings "tradition" and "translation" or "explanation." This new meaning had just recently been accepted within the church at Rome, and thus it had become a recent part of church tradition. See Walker, *Ancient Theology*, 1-21; Gombrich, *Symbolic Images*, 147; Yates, *Giordano Bruno*, 165, citing Erasmus, *Paraclesis*, 1519, in *Opera Omnia*, Leiden, 1703-1706, col. 139; Giehlow, "Hieroglyphenkunde des Humanismus," 169 ("Haec ab Horo mutati, si Horo libellus, qui circumfertur, neutiquam tanto dignus nomine. Ceterum ex aliorum traditionibus."); Giehlow, "Hieroglyphenkunde des Humanismus," 102, note 1, reference to Erasmus' Froben 1513 edition of the *Adagiorum Chiliades*, 112 ("Etiam Horus Aegyptius, cujus extant duo super hujus modi symbolis libri, serpentis sculptura non annum, sed aevum representari tradit, annum autem tum Isidis, tum Phoenicis imagine."); Erasmus, *Adagiorum Chiliades Tres*, 1508, p. 239, no. XMXCI (for use of the verb form in reference to classical antiquity, rather than to ecclesiastical tradition); Boas, *Horapollo*, 23-27. Compare Bakhuizen van den Brink, *Traditio in de Reformatie en het Katholicisme in de Zestiende Eeuw*, Amsterdam, 1952 (= *Mededelingen der Koninklijke Nederlandse Akademie van Wetenschappen, Afd. Letterkunde*, Nieuwe Reeks, XV, no. 2).

60. For an account of this trip, with citations of sources, see O. Scheel, *Martin Luther, II, Im Klooster*, Tübingen, 1917, 248-297.

61. Scheel, *Martin Luther*, 286-287.

62. See Capgrave, *Solace of Pilgrimes*, 42.

63. Capgrave, *Solace of Pilgrimes*, 39-42 and 158-159; compare G. A. Leiden, Bibl. no. 72045, folio 39 verso — 40: Tot sctā Maria gheheetē in ara celi/ dit is die ierste kerke onser lieuer vrouwe vā de ganse werelt Dit plach te zijn dat paleys des keysers Octauianus hier sach hi een ionfer met een kindekē in /d sonnē eñ hi aen bedense op zȳ knien.

64. Scheel, *Martin Luther*, 287. This differs from the date 1578 usually given for the rediscovery of the Roman catacombs. However, G. A. Leiden, Bibl. no. 72045, contains a manuscript addition relating details from a trip to Rome, evidently dated 1530 (first folio of ms.), which states (folio 16 verso — 17 verso): Item in scē lauwerens kercke buten der stat daer ligghen scē Lauwerens eñ Scē steuens lichamen onder den hoeghen altaer is een stat onder der eerden daer Scē lauwerens Eñ Scē steuens graue staen daer sy ierst ghegrauen waren Daer syn alle daghe XLVIII iaer aflaets eñ alsoe voel carenē Ite wie dat mit devocien indien kerckhof onder der eerden gaet eñ visenteert die ontelike graue der martelarē die daer gegrauen syn Eñ visenteert den steē daer Scē lauwerens op gebradē waert Die heuet alle dage. VII M. iaer aflaets Een mensche die daer in wil gaen die moet groet licht mit hem draghē Eñ gaēr dat starck is eñ maken dat vaste inden beghinsel vandē kerckhoue daer hi in gaet eñ loepen alsoe mitter coerden inwaert hy sal vynden X of XII weghe den ene den enen wech den anderen den anderen wech. waert dat hi gheen coerde mit hem en hadde hi en solde nîmermeer uut comē Daer isser menych in gestoruen van hongher die niet weder uut en conden comē Eñ en sal anders niet vynden dan graue eñ steden daer graue in ghestaen hebben. Mer dat meste deel der heilighen syn uutgenomen eñ syn alre weghē in die kercken gelecht. Men vynt oec menych graft daer steen op ligghē lichtēmen die op als menych duet die daer in gaet. mē vonder noch die lichmen soe bescheidelic in ligghen sonder vleische of sy daer mer vyf of VI iaer geleghen en hadden. Mer alsmense roert soe synse soe weeck dat se al van een vallen Die holen hebben die heylighen laten maken om ōtsich der heyden eñ der paganen dat si daer in vloen ... (folio 20:) Item in Scē sebastianus kerke onder den hoeghen altaer lecht scē Sebastianus lichaem ... (folio 20 verso:) Item onder dese kerke steet oec enen kerckhof gelyc dat tot Scē lauwerēs steet mer ten is niet lanck daer plaghen die heilighen in te wonen als sy vanden romeynen ghepersequeert worden soe vloen sy daer ...Eñ heit Calixtus kerckhof ... (folio 21:) Item catabondus is een stat of een put daer laghen die lichamen van Scē peter eñ sinte pouwels IIIc iaer ... (There are variant descriptions of St. Sebastian's and of the catacombs as temporary resting place of the bodies of SS. Peter and Paul in Capgrave and other books.) For the discovery of the catacombs outside Rome, May 31, 1578, see *Enciclopedia Universale dell'Arte*, Venice, 1960, III, 207. That the catacombs had not been lost was noticed by Hoogewerff, "De Romeinse Catacomben," *Nederlands Archief voor Kerkgeschiedenis*, XLIV, 1960, 193-230.

65. The text and illustrations of the *Hynerotomachia* confirm this. Dacos states that no clue can be found for the iconological explanation of grotesque decorations (Dacos, *Domus Aurea*, vii) and that they were constructed through the free play of the imagination, not according to erudite programs. In her opinion when inscriptions or symbols appear in grotesque ornament the placement is capricious. This is contradicted in one case by the frieze in the Room of the Saints, Appartamenta Borgia, Vatican (see Yates, *Giordano Bruno*, 115-116, ill. 6 (b)). It is at variance with the coordinated program of grotesque ornament and symbols derived from *Horapollo*, astrological systems of hierarchies, the *Hypnerotomachia,* and other sources in the facades, stair, courtyard, and ceiling decoration of the University of Salamanca. (See S. Sebastian and L. Cortes, *Symbolismo de Los Programas Humanisticos de la Universidad de Salamanca*, Salamanca 1973.)

66. See Yates, *Giordano Bruno*, 67-68, 73, 90-91, 112-113, 119, 121-122, 161, and 191; see also Gombrich, *Symbolic Images,* 148 and f. (without connecting the form of theology described with its sources in Aristotelianism and Scholasticism, as modified by neo-platonism). The congruence with what E. Panofsky called "Disguised Symbolism" is apparent, and it is significant that the *Arnolfini Wedding Portrait* of Jan van Eyck was painted before the great theological and philosophical controversies which were derived ultimately from opposition to Aquinas and Aristotelianism, as given a new twist by the light of the re-discovered neo-platonic texts. (See E. Panofsky, "Jan van Eyck's Arnolfini Portrait," reprinted in *Renaissance Art* (ed. C. Gilbert), New York, 1970, 1-20.) I should like to note that a good deal of Panofsky's correct observations could have been condensed if the the words (p. 3) *"worden ghetrouwt van Fides, die se t'samengaf"* had been correctly translated into English in the alternative form, "are being married in Faith which they gave each other" (or: with a pledge of Fidelity, or: with a pledge of Trust). This translation is consistent with the grammatical constructions commonly found in Leiden documents (where the final *en* of plural verbs is frequently omitted or abbreviated with a point or period; *f* and *v* were interchangeable). It is also consistent with the marriage ceremony as described in the references above to the two marriages of Marytgen van Dam; and as described by Panofsky. The translation of *"van"* can be given as "in" or "though" or "by means of." Moreover,

"*Tesamengeven*" is not a particularly technical term (p. 4), although it naturally occurs frequently in marriage documents. Thus, it is evident that what Panofsky proposes, as a hypothetical original Latin sentence from which a misunderstood Dutch translation was derived, is, in fact, a correct translation by Panofsky *into* Latin, of what is stated in Dutch, while the translation into German by von Sandrart is incorrect and could have misled Panofsky.

67. That Augustine was the only Early Church Father to oppose Hermes Trismegistus strongly is based inferrentially on the absence of any long discussion of the point in Yates, *Giordano Bruno*, or Pelikan, *The Emergence of the Catholic Tradition (100-600)*; but compare Walker, *Ancient Theology*, 9-10. I am not sufficiently conversant with Patristics to be sure. Luther an Augustinian must have been aware that Augustine contrasted Hermes Trismegistus' "prophesy" with that of Is. 19 : 1 ("An oracle concerning Egypt. Behold, the Lord is riding on a swift cloud and comes to Egypt; and the idols of Egypt will tremble at his presence, and the hearts of the Egyptians will melt within them." (R. S. V.)). Yates partially quotes this verse from the King James Version.

68. See E. G. Rupp, "Luther," *Encyclopedia Britannica*, Chicago, 1967, XIV, 439, etc. The term "glory of the incorruptible God" is found in Romans 1: 22-27, but this may not have been what Luther had in mind. See Yates, *Giordano Bruno*, 9-12 and 132; further, compare the references to Aquinas in Yates, *Giordano Bruno*, given above in note 66. Thomas Aquinas, although explicitly condemning the magic in Hermes' (?) *Asclepius*, by which the Egyptians were said to have animated their idols, provided a natural revelation based on Aristotle which allowed for a bypassing of the condemnation, by claiming that no demonic power was involved. See further, Hans Holbein the Younger's 1524 woodcut *Christ as the True Light* (illustrated in *Erasmus en zijn tijd*, exhibition catalog. Museum Boymans-van Beuningen, Rotterdam, 1969, II, 85, cat. no. 447), where Aristotle leads pope, cardinals, bishops, monks, and theologians to hell.

69. Gombrich, *Symbolic Images*, 107-108.

70. Luther's Works, Weimar, 1888, VI, 329.

71. A further inspiration may have been Is. 43: 14, "Thus says the Lord, your Redeemer, the Holy One of Israel: 'For your sake I will send to Babylon and break down all the bars and the shoutings of the Chaldeans will be turned to Lamentations.' "

72. Luther's Works, Weimar, 1888, VI, 497-573. For Luther's relation to tradition, considered without reference to the new extra-ecclesiastical tradition (recently taken into the church) of hieroglyphic transmission, see W. Pauck, *The Heritage of the Reformation*, 1950, revised ed. Oxford, 1968, 3-59, especially 40; Pelikan, *Obedient Rebels*, New York, 1969, 42-53; and numerous other discussions of Luther.

73. Luther's Works, Weimar, 1888, VI, 523. Cf. Gal. 1:8.

74. For Biel, see the reference in note 59 to Oberman's work. See also Trinkaus' comments on Oberman's thesis in his work cited in note 26.

75. Luther's Works, Weimar, 1888, VI, 500.

76. Luther's Works, Weimar, 1888, VI, 550.

77. Luther's Works, Weimar, 1888, VI, 521-522.

78. See Gombrich, *Symbolic Images*, 105; see also Walker's brief discussions of aspects of Fideism (indexed under "scepticism and fideism"), where the garden, however, is not discussed (in Walker, *Ancient Theology*). For the Vatican Belvedere, see H. H. Brummer, *The Statue Court in the Vatican Belvedere*, Stockholm, 1970.

79. See M. Geisberg, *The German Single-Leaf Woodcut: 1500-1550* (ed. W. Strauss), New York, 1974, III, 861, G. 972. The English title omitting "Egyptian" and referring to the depiction of Luther is Strauss.' Further, for "Master H," see U. Thieme and F. Becker, *Allgemeines Lexikon der Bildenden Künstler*, Leipzig, 1907, XXXVII, 400; H. Zimmerman, *Beiträge zur Bibelillustration des 16. Jahrhunderts*, Strassburg, 1924, 57 and f.; H. Zimmerman, *Archiv für Reformationgeschichte*, XXIII, 1926, 107.

80. This rentention is clear and explanatory of the "pre-Reformation" programs of the Reformation altarpieces of the Cranach family, except for minor alterations. See H. C. von Haebler, *Das Bild in der evangelischen Kirche*, Berlin, 1957; O. Thulin, *Cranach-Altäre der Reformation*, Berlin, 1955; D. Koepplin and T. Falk, *Lucas Cranach, Gemälde, Zeichnungen, Drukgraphic*, Basel (exhibition catalog), 1974, I, 421 and f., where Lucas Cranach the Elder is discussed in relation to the rediscovered antiquities and the *Hypnerotomachia* is rejected as a source (vol. II has not appeared at the time of

writing this); and Schade, *Die Malerfamilie Cranach*, which is the best produced study as regards illustrations. Schade's illustration on page 76, the woodcut *The Fall of Babylon*, shows a city with the Castel Sant Angelo recognizable, together with the Capitol. Also noteworthy are the memorial panels, such as ill. 224, 232, 256, 229, 249, and 250, which continue medieval compositional arrangements and typologies. Luther's seal, while explained somewhat emblematically, does not depart significantly from pre-Renaissance seal designs used by Leiden area clerics (found among the *bijlagen* of the Leiden treasury records). Yate's suggestion that an increase in magic invoked in connection with statues may have led to iconoclasm (Yates, *Giordano Bruno*, 143) is incorrect. Iconoclasm is a logical consequence of the rejection of the doctrine of the real presence in the Eucharist, and once the displayed host was trampled, other destruction could follow against all visible "idols." The philosophical presuppositions of hieroglyphic and emblematic literature did not lead to incantations over ecclesiastical statuary, as far as I can tell. Nor did Dutch Calvinists, who, incidentally, had frequently attempted to preserve artworks from the destruction received by the displayed host wafers, refrain from the composition of emblem books.

81. See Kronenberg, "Werken van Cornelius Aurelius," 72.
82. See F. Secret, *Les Kabbalistes Chrétiens de la Renaissance*, Paris, 1964, 11, 123, 274-275.
83. See Secret (ed. and trs.), *Johann Reuchlin, La Kabbale (de arte cabalistica)*, Paris, 1973, 51, 63, 113 (referring to a letter of February 22, 1518).

8. Notes on Leiden Artists mentioned between 1475 and 1480

Although occupations are mentioned rarely in civil documents before 1500, the following painters are named with occupation between 1475 (the year arbitrarily chosen as the starting date for research) and 1480: Jacop Clementsz., Symon Jansz., Jan Jacopsz., Pieter (Henricxz.?) the painter, Michiel Claesz., and Clais Oliviersz. (Ecclesiastical records mention others.)

Of the foregoing six names, practically nothing is said of the last three. Clais Oliviersz. received a standard fine for causing trouble on the street after curfew, May 16, 1478.[1] Michiel Claesz. is named in an unimportant lawsuit against Ewout Willemsz. van Berendrecht on January 20, 1477.[2] Pieter the painter, probably the same as Pieter Hendricxz. associated with the monastery Hieronymusdal, is mentioned on July 10, 1475;[3] and he was paid for painting some statues in the Abbey of Rijnsburg in 1479-1480.[4] More is known of the other three painters.

Jacop Clementsz. and Symon Jansz. were commissioned in 1462-1465 by the city of Leiden to paint a series of portraits of the Counts of Holland as decoration in the city hall. This commission was published by Rammelman Elsevier.[5] Gibson makes passing reference to the commission, doubting that the painters were local, suggesting that they were called in specially for the occasion (despite published information to the contrary), in the presumed absence of local painters.[6] Jacop Clementsz. is mentioned again in 1479, when he was among the militia members named on July 5.[7] His commission in 1463 for a painting of *The Last Judgement*, which hung in the city hall's court room, is mentioned by Rammelman Elsevier.[8] See Overvoorde's article, noted above, for further information about Jacop Clementsz., whose activities are documented mostly or entirely before 1480.[9]

Symon Jansz. is mentioned after his collaboration on the series of the *Counts of Holland*, in 1497-1498, 1500, 1501, and 1502. In the 1497-1498 tax list discussed concerning Cornelis Engebrechtsz.'s houses, Symon Jansz. is listed in the Maersman's Steeg, but his occupation is not identified,[10] resulting in his omission from Posthumus' statistics about painters. That this is the correct Symon Jansz. of the several in the tax list is proven by identification with occupation and house location in other documents, concerning the house and Symon Jansz.'s debts.[11] Symon Jansz.'s wife was Alyt, widow of Cornelis Pietersz.

Jan Jacopsz. may be described as Jacop Clementsz.'s successor as official painter of Leiden, although that was not a salaried office and is only evident from the uniformity of commissions. In 1474-1475 Jan Jacopsz. received payment for painting the city's official barge, renovated that year.[12] In the same year an unnamed painter was paid

for twelve small paintings of the arms of Leiden done on paper and used on the torches in the annual Holy Sacrament's Day procession.[13] Repetition of the payment for twelve paper heraldic paintings took place annually. Jan Jacopsz. is mentioned by complete name with patronymic in 1475-1476 and 1486-1487.[14] Payment in 1483-1484, 1484-1485, 1485-1486, 1487-1488, 1490-1491, and 1493-1494 was to "Jan the painter," who can be assumed to have been Jan Jacopsz.; just as it can be assumed that he provided the shields in other years, where the records are either missing or do not list the painter's name, as in 1474-1475, where his name is given for the barge but not for the shields.[15] From 1496-1497 onwards payment was to the painter Jan Jansz. for a number of years.[16] Other painters received the commissions in later years. Among them was Pieter Cornelisz. Kunst, who did it on a fairly regular basis. That the paintings were on paper was not known by writers who thought that the single published payment record (1527) was for a commission to Pieter Cornelisz. Kunst for stained glass. Jan Jacopsz. was paid by the city for painting other small shields in 1485-1486, when they were hung over the wine presented to the Emperor Frederick III during his visit to Leiden.[17] He was paid again in 1486-1487, when four small shields were used for the torches of the guild of St. George (militia), a commission which was probably repeated annually, but for which the expenses are usually not listed separately.[18] Renovation and decoration apparently connected with the visit of Frederick III was carried out by Jan (Jacopsz.). He cleaned and repainted three old banners for the city trumpetters and oversaw the commission of four new banners for the trumpetters and *claroen* players, on which he painted the arms of Leiden. He was also paid for painting the windows of the city hall's large chamber green, gilding the window frames, and painting coats of arms on shields, seemingly carved in the woodwork, in the room. These could have been corbels. Such corbels are preserved in the Leiden Municipal Museum "De Lakenhal" taken from the demolished Jerusalems Chapel, and another is preserved in the former house of Johanna van Swieten, Vrouwe tot Upmeer (the person who had the van Swieten Memorial painting renovated), now the Prentenkabinet of the Rijksuniversiteit Leiden, Rapenburg 65.[19]

These civic commissions to Jan Jacopsz. do not imply a painter of minor gifts. Cornelis Engebrechtsz. was given similar commissions, as were Dirck Hugenz. and Jacop Clementsz. But like Dirck Hugenz. and Jacop Clementsz., Jan Jacopsz. is known from documents only, and the quality of his painting is unrecorded. Like Jacop Clementsz., he was also commissioned to touch up dulled gilding, such as the face of the city clock on the tower of the city hall.[20] The foregoing commissions suggest that the unnamed painter commissioned in 1476-1477 to paint ten square banners and two standards to be used on the two new warships constructed by the city was probably Jan Jacopsz.[21]

In 1484-1485 Jan Jacopsz. was paid the high sum of £ 53/13/4 by the Abbey of Rijnsburg for painting a tomb in the chapel of the Counts of Holland in the abbey church.[22] These payments imply the existence of a sarcophagal, above-ground tomb, presumably of stone, similar to those in the Onse Lieve Vrouwe Kerk of Bruges (and to that at Assendelft depicted by Saenredam), and in which the Counts of Holland had evidently been reinterred. The bodies recently discovered underground at

Rijnsburg are, therefore, probably not those of Counts of Holland, but of other local nobles buried in the church.

Jan Jacopsz. was involved in legal matters of no art historical interest on July 26, 1479;[23] April 5, 1505;[24] February 16, 1509;[25] February 3, 1511;[26] and January 24, 1513.[27] Jan Jacopsz. appears in the militia lists of 1518-1520, the last reference to him now known.

Several other lawsuits about him contain information of more or less art historical interest. Two dated June 2, 1488, seem to refer to an apprentice of his, Andries Dircxz., son of Dirck Jansz.[28] The dispute concerned wages and, evidently, fees. Details of the obligation papers on the house on the Breestraat sold by Jan Jacopsz. on February 15, 1496, suggest that the painter Willem Jansz. may have been his son.[29] Jan Jacopsz. was joint arbiter with Phillips van der Laen of a dispute between Cornelis Vinck and Adriaen Moeyt. This led to litigation naming him on December 12, 1511; December 19, 1511; and May 7, 1512.[30] Cornelis Vinck was the father of the painter Geryt Cornelisz. Vinck. Jan Jacopsz. was subpoenaed on July 24, 1514, in a more interesting case.[31] Dieloff Claesz., a stained-glass painter who collaborated with Pieter Cornelisz. Kunst and Phillips Claesz. van Zeyst, subpoenaed not only Jan Jacopsz., but also the cloth shearer Jan Pietersz. and the sculptor Pieter Pouwelsz., about a dispute between Dieloff and a baker of pipeclay statues named Jan.[32]

Two more lawsuits attract attention, dated January 8, 1515.[33] The painter Adriaen Ysbrantsz. sued Jan Jacopsz. for payment of a debt of 45 placken. Jan Jacopsz. acknowledged the debt. On the same date Jan sued the Leiden painter Reyer Garbrantsz. to be freed from the debt to Adriaen Ysbrantsz. In case of refusal, Jan Jacopsz. demanded 3 Ryns guldens. This litigation is the only known reference in the Leiden archives to a painter named Adriaen Ysbrantsz., possibly identical with the painter of that name (usually spelled Adriaen Ysenbrant), who settled in Bruges, having come from an unknown city. Constant commerce between Leiden and Bruges, already mentioned in connection with possible travel by Cornelis Engebrechtsz., could account for this litigation.

The documentation about the painter Jan Jacopsz. is exceptionally complete for a Leiden painter mentioned before 1480. There is no indication, of course, that he was Cornelis Engebrechtsz.'s teacher. Nor does it follow from the extensive documentation that he was Leiden's best painter in the time.

The foregoing information has been given in detail to indicate the presence of active painters in Leiden whose names first occur early enough for them to have had Cornelis Engebrechtsz. as a pupil. It may be remarked that Leiden's painters, besides those mentioned above, numbered an additional twenty or so, contemporaries of Cornelis Engebrechtsz., not counting those whose names are first recorded shortly after 1527, but who were presumably active before then, too. Cornelis Engebrechtsz., Huych Jacopsz., Lucas van Leyden, and Cornelis' sons did not work in a vacuum. This information contradicts Boon's statement that Leiden, in contrast to such cities as Delft and Haarlem, indubitably had no artistic tradition, and that, therefore, Cornelis Engebrechtsz. must have had to study somewhere else like Antwerp.[34]

Notes

1. R. A. 4, 1477-1489, folio 14 verso.
2. R. A. 40, 1476-1481, as dated.
3. R. A. 51, 1466-1482, as dated.
4. A. R. A., The Hague, Abdij van Rijnsburg, inv. no. 168, 1479-1480, folio 61 verso; published in M. Hüffer, *Bronnen voor de Geschiedenis der Abdij Rijnsburg*, The Hague, 1951 (= *Rijks Geschiedkundige Publicatiën, Kleine Serie*, XXXI and XXXII), II, 877.
5. See *De Navorscher*, II, 1852, 251. Rammelman Elsevier was followed by Blok, Overvoorde, and Hoogewerff. See Blok, *Geschiedenis eener Hollandsche Stad*, The Hague, 1910, I, 204-205; Overvoorde, "De Portretten der Hollandsche Graven in het Stadhuis te Leiden," *Feest-Bundel Dr. Abraham Bredius aangeboden*, Amsterdam, 1915, 221-229; Hoogewerff, *Noord Nederlandsche Schilderkunst*, II, 397-398.
6. Gibson, diss., 36-37.
7. S. A. 84, folio 180 verso.
8. See *De Navorscher*, V, 1855, 334. The documentary source for this, omitted in *De Navorscher*, is S. A. 528, 1462-1463, third folio from the end of the volume.
9. See also Pelinck, "De Heilige-Grafkapel van het Jerusalemshofje," *Jaarboekje voor Geschiedenis en Oudheidkunde van Leiden en Omstreken*, LI, 1959, 91-94.
10. S. A. 578, folio 66.
11. See R. A. 41, 1497-1505, folio 145 verso (October 23, 1500 – March 12, 1501); R. A. 50, 1494-1509, folios 67 verso, 68, 68 verso, 69, and 69 verso (details of the sale of the house, uninventoried, for the settlement of specified debts without apparent art historical interest, August 23, 1501); R. A. 41, 1497-1505, folios 180 and 180 verso, May 30, 1502.
12. S. A. 551 (Burgemeesters Rekeningen 1474-1475), folio 141.
13. S. A. 551, folio 87.
14. S. A. 552 (Burgemeesters Rekeningen 1475-1476), folio 77; S. A. 560 (Burgemeesters Rekeningen 1486-1487), folio 158 verso.
15. See S. A. 557 (Burgemeesters Rekeningen 1483-1484), folio 124 verso; S. A. 558 (Burgemeesters Rekeningen 1484-1485), folio 126; S. A. 559 (Burgemeesters Rekeningen 1485-1486), folio 174; S. A. 561 (Burgemeesters Rekeningen 1487-1488), folio 112; S. A. 562 (Burgemeesters Rekeningen 1490-1491), folio 187; and S. A. 576 (Thesauriers Rekeningen 1493-1494), folio 50 verso.
16. For example, S. A. 577 (Thesauriers Rekeningen 1496-1497), folio 98; S. A. 578 (Thesauriers Rekeningen 1497-1498), folio 132; S. A. 579 (Thesauriers Rekeningen 1498-1499), folio 97.
17. S. A. 559 (Burgemeesters Rekeningen 1485-1486), folio 208.
18. See S. A. 560 (Burgemeesters Rekeningen 1486-1487), folio 230.
19. See S. A. 559 (Burgemeesters Rekeningen 1485-1486), folios 204, 205, and 208; see also folio 202, a payment to Jacop van Bosschuysen, father of Elysabeth van Bosschuysen, who was later Lucas van Leyden's wife, for the "*wit taftas*" used for the banners.
20. S. A. 560 (Burgemeesters Rekeningen 1486-1487), folio 218.
21. S. A. 556 (Burgemeesters Rekeningen 1476-1477), folio 163 verso: pigment, oil, and other painting equiment are specified ("*van verwe van olye ende van andere gerescip dienende totter scilderye*").
22. See A. R. A., The Hague, Abdij van Rijnsburg, inv. no. 174, 1484-1485, folio 65 verso; published in Hüffer, *Bronnen*, II, 916; see also A. R. A., The Hague, Abdij van Rijnsburg, inv. no. 173, 1483-1484, folio 49 verso; published in Hüffer, *Bronnen*, II, 906.
23. R. A. 40, 1476-1481, as dated.
24. R. A. 6, folio 7.
25. R. A. 42.
26. R. A. 42.
27. R. A. 42.
28. R. A. 42.
29. See R. A. 50, 1494-1509, folio 29 verso.
30. R. A. 42.
31. R. A. 42.
32. That the production of such statues also occurred in Leiden is unknown in J. Leeuwenberg, "Die

Ausstrahlung Utrechter Tonplastik," *Geschichte der Europäischen Plastik, Festschrift Theodor Müller,* Munich, 1965, 151-166.

33. R. A. 42.
34. K. G. Boon, "De Eerste Bloei van de Noord-Nederlandse Kunst," *Middeleeuwse Kunst der Noordelijke Nederlanden,* exhibition catalog, Rijksmuseum, Amsterdam, 1958, 35. Cornelis Engebrechtsz.'s name is, however, not listed in the published Antwerp guild records (see P. Rombouts and T. Lerius, *De Liggeren en ander historische archieven der Antwerpsche Sint Lucasgilde,* Antwerp, 1872). That Delft had, in contrast to Leiden, an artistic tradition is an idea which returns the art historian to interesting aspects of art historical presupposition in Friedländer's system of masters, schools, and local styles, when brought to bear on the "Master of Delft." Friedländer begins his style analysis for the "Master of Delft" with a work which he carefully describes and which is probably from Delft, because it is provided with an inscription identifying the donors, one of whom was a burgomaster of Delft (Friedländer, *Lucas van Leyden and Other Dutch Masters,* 30). Friedländer assures the reader that it may be assumed that a local master was hired for the triptych. This assurance contrasts with the later commission in Delft from a municipal official given to Jan van Scorel for a similar memorial painting, and with the earlier commissions from Delft, Alkmaar, Gouda, and other towns for paintings from Hieronymusdal, discussed below. The starting painting for style critical study, however, turns out to be an inferior work, so Friedländer relegates it to the category of workshop production, thus making it a painting in search of a master of an atelier that has been hypothesized. The works of this master are found in various places and without documentation. The localization of the "Master of Delft" rests on the workshop triptych; against this is the depiction of the Breda church tower in the background of the *Crucifixion* triptych (National Gallery, London), ascribed by Friedländer to the "Master of Delft" (Friedländer, *Lucas van Leyden and Other Dutch Masters,* no. 60, plate 43). For a depiction of the Breda tower before restoration, see F. A. Brekelmans, "De Stedelijke Ontwikkeling van Breda," *Bulletin van de Koninklijke Nederlandse Oudheidkundige Bond,* LXVIII, 1969, 51-65, pl. 3. An addition to the work of the "Delft School" was made by the recognition by D. P. Oosterbaan, who noticed that the inscription on the back of a portrait ascribed by Friedländer to Simon Marmion (active in Valenciennes and Doornik, d. 1489) was what had been recorded as having been on the gravestone of Canon Hugo de Groot (d. 1509) in The Hague. (Hugo de Groot was from Delft.) The portrait, clearly a memorial, was then seen to display the characteristics of painting in the "Northern Netherlands" and was included in the 1958 Rijksmuseum exhibition. It can be hoped that more of the work of the "Delft School" will turn up, to give a clearer and more comprehensive view of what precisely distinguishes North from South, Leiden from Delft, Haarlem, Amsterdam, and so on, especially since the "Delft School" has also suffered a partial loss. An indirect attribution of the *Spes Nostra* painting to Huych Jacopsz. is given by J. Q. van Regteren Altena, "Huych Jacopsz.," *Nederlands Kunsthistorisch Jaarboek,* VI, 1955, 144; although Friedländer thought that the background figures are typical of the "Master of Delft" (Friedländer, *Lucas van Leyden and Other Dutch Masters,* 76, no. 66 (I)). Van Regteren Altena notes at the beginning of his article that the information about Huych Jacopsz. is scanty, but enough to stimulate research. The article was unfortunately completed before the research. See also Friedländer, *Lucas van Leyden and Other Dutch Masters,* 99, note 63.

9. Hieronymusdal and the Early Years of Huych Jacopsz.

Ill. 43, The monastery Hieronymusdal is of major importance in the Leiden artistic background. It is presently most famous for its monk Cornelius Aurelius, author of the *Cronycke van Hollandt 1517* and friend of Erasmus, Hoen, van der Haer, and Servatius Rogerii, the rector of Marienpoel from 1525-1526 until 1538, who had earlier been Erasmus' superior.[1]

Overvoorde published the information that *"Huge Jacobsz. de schilder"* was briefly a renter of a house belonging to Hieronymusdal in 1480.[2] In 1480 the house was rented to his successor in it. Huych Jacopsz. was in fact trained by one of Hieronymusdal's monks, Brother Tymanus. His connection with his teacher appears with reasonable clarity in the monastery archives. In 1480 several loans were made to "Hughe Jacobsz.," including a half-year's house rent.[3] Payment of various loans had evidently been done gradually, because in 1478 the monastery received various amounts of money from "Hughe Jacobsz.," the first being £ 6/−/− (Flemish), of which "Tyman" kept £ 2/−/−.[4] Instead of loans, however, payment for painting(s) sold by Huych Jacopsz., but partially owed to the monastery where he had been trained and partially owed directly to his teacher, could be the origin of the accounting. This is less likely than simple loan arrangements, because it would imply that as a finished student he was still not at the stage of making a profit from his work by 1478 (a situation similar to the third year of apprenticeship arrangements). Huych Jacopsz.'s student period was rather earlier (1469-1471).[5] In this time he is called *"Hughe Tymans knecht."*

It is beyond doubt that the only person in the monastery records named Tyman is Brother Tymanus of the monastery, whose major activity was painting. His name appears consistently as a painter in the records for commissions and travels from 1446 on. He is still named as late as 1482. Another more complete study of his work and that of the other painters, sculptors, and illuminators of Hieronymusdal is required to elucidate their activity. For the moment it may be noted that his connections with the van Naeldwyck family suggest that Tyman may have been the artist of the series of portraits ascribed by Friedländer to the "Master of Alkmaar (?)."[6] The earliest connection with this family is in 1448.[7] Further, the St. Anthonis Guild of Alkmaar commissioned an expensive painting from Hieronymusdal in 1469 or 1470,[8] which also suggests that the monastery may have provided the artist called the "Master of Alkmaar." The Hieronymusdal records after 1500 unfortunately do not specify the art payments, so the 1504 Alkmaar paintings, if from Leiden, cannot be identified as

such. Beets suggested Huych Jacopsz. as the painter of these panels, in 1914, without any stated reason.[9]

Besides Alkmaar, Delft, Leiden, Gouda (an altarpiece of St. Jacob), Warmond, Voorhout, Naeldwyck, Noordwyck, Enkhuizen, and Medemblik commissioned or received paintings from Hieronymusdal. Hieronymusdal received commissions for sculpture in Leiden and its immediate vicinity, while commissions for illuminated manuscripts came from a larger area. (Some of the manuscripts are preserved and are being studied by Obbema.) Hieronymusdal clearly played a major role in the production of art used throughout present North and South Holland (counties). It is impossible to determine to what extent travels made by monks who were painters imply commissions at the places they visited. Brother Tymanus was a frequent visitor to places like Delft, Haarlem and Utrecht. It is notable that in 1444 a trip to Antwerp was made to buy painting materials.[10] In the light of the commissions carried out at Hieronymusdal for churches and families in towns other than Leiden, the concept of local schools based on the assumption that a painting from a known place was probably by a local painter becomes untenable.[11]

Also connected with Brother Tymanus is a painter named Pieter Heyndricxz. of Delft, who in 1471 repaid money to Hieronymusdal, half of which was kept by Tyman. The monastery also had dealings with him in 1469, and with another painter named Heynrick, who may have been his father (because of the patronymic, merely conjecture).[12] In 1474 the monastery paid Heynrick the painter for travel to Kampen.[13] This painter may have been "*Heynrick de beeldeverwer*" (mentioned below), who owned the house Huych Jacopsz. later bought.

As remarked above, Hieronymusdal made a payment to Cornelis Engebrechtsz. in 1482.[13] Eight stuvers and additional payments for pigments and oil were given.[14] In the same year, payment was made to Huych Jacopsz. He is described as "Hugoni pictori nostro," to whom 6 Ryns guldens were given. The description "our painter" seems to indicate regular commissions, a supposition supported by the existing records. The reference may additionally bear on Huych Jacopsz.'s having lived in one of the monastery's houses. The house to which he later moved was encumbered by the St. Catherine's Hospital, and as discovered by Leverland, Huych bought it in 1485 from Heynrick the painter or statue polychromist.[15] The designation "our painter" presumably indicates a layman in more or less regular employment as a painter by the monastery. The only other person to be called this was "*Alberto quondam pictore nostro*" ("Albert, formerly our painter"), who is so named in 1444.[16] He was paid 6 scuten for his work. He may have been Albert van Ouwater (Oudewater, near Gouda), presumably having worked at Hieronymusdal before moving to Haarlem, then accepting a commission from Hieronymusdal after having left Leiden. This is, however, strictly hypothetical and awaits the discovery of another contemporary painter named Albert associated with the monastery to be replaced by a different hypothesis.

It will be seen below that in the period between 1480 (when he left the house rented from Hieronymusdal) and 1485 (when he bought the Breestraat house in Leiden where he lived until he died) Huych Jacopsz. may have lived for a time in Koudekerk, a village on the Rijn east of Leiden, family seat of the van Poelgeests. Before going

into the details for this suggestion, which of course would provide an easier reason for accepting the idea that Lucas van Leyden's precocity could have attracted the Leiden *schout* Adriaen van Poelgeest, it is worth while to examine the marriages and children of Huych Jacopsz.

Dirck Hugenz. and the Birth Date of Lucas van Leyden

To describe Dirck Hugenz. as Lucas van Leyden's brother requires a brief explanation. Dülberg was the first to mention Lucas van Leyden's brother Dirck, and Dülberg's reference was the source of subsequent remarks until the publication in 1959 of D. Koning's opinion that Dirck Hugenz. was Lucas' half-brother.[17] Koning's version is based on a document dated December 23, 1500, which he had discovered. In it Huych Jacopsz. and his previously unknown first wife, Marie Heynricxdr., are mentioned as the parents of the following minor children, Lucas, Katrijn, Marie, Griet, and Barbar.[18] From the omission of Dirck Hugenz.'s name, Koning concluded that he must have been born by Huych's second wife, Beatrix Dircxdr. Another document led Koning to the conclusion that the second marriage had taken place by September 29, 1498.[19]

Despite the extraordinarily long time that passed before the guaranteeing of the inheritance in 1500,[20] another document, which I have found, shows that the second marriage had already taken place during the twelve months preceding December 8, 1495, if not earlier.[21] The document is an inheritance lawsuit, started on December 8, 1495; there was a statute of limitations on inheritance cases, of one year and six weeks.[22] It follows that Huych Jacopsz.'s second marriage occurred in the end of October, 1494, at the earliest, or shortly before the case started, at the latest.

That the second marriage was so early reduces the chances that Lucas van Leyden was born in 1494 (the date given by van Mander). He could have been born then only if he were the last child of the first marriage and if his mother died in childbirth or shortly afterwards, and if his father quickly remarried. Any of Lucas' sisters, however, could have been the last child of the first marriage. The mathematical possibilities that Lucas was the last in the order of five births suggest that van Mander may have been wrong again.

Dirck Hugenz., on the other hand, must have been born ca. 1475. He could have been omitted from the document of December 23, 1500, if he had already married or if he had already reached majority (age twenty-five). Dirck is mentioned in a document of 1495[23] and he was appointed by the court as an expert in a lawsuit about a commission for artwork on August 20, 1507.[24] He was clearly already known as an independent painter of note. When he married is not certain. His wife, Katryn Jansdr., is mentioned first on May 28, 1512.[25] A daughter old enough to receive wages for working as a purse or bag maker is mentioned earlier, on February 8, 1510.[26] These documents prove that Dirck Hugenz. must have been born ca. 1475 and that he was Lucas van Leyden's full brother. (The possibility that he was a bastard is excluded by later inheritance litigation.)

The St. Nicasius Altarpiece of Huych Jacopsz.

In 1488 the fullers' guild of St. Nicasius moved its chapel from the St. Pancraeskerk to the St. Pieterskerk in Leiden. The new chapel received completely new furnishings, whose construction was completed by 1496. The altar itself was stone, carved, and with carved stone around it. The altarpiece was commissioned from "Meester Huge Jacopsz. van Koudekerck wonende ter Goude," and it cost 775 Rijns guldens, a price decided by two people chosen by Huych Jacopsz. and the guild, Adriaen van Poelgeest the *schout* of Leiden, and Claes Jan Claesz.'sz. The altar had a canopy which cost 4½ Rijns guldens and 1 stuver. Candlesticks, altarcloths and other items were acquired, including a painting of the *Mass of St. Gregory* ("*dat bort van sinte Gregorius oflaet*"). Brass columns were made by "Meester Ian van Tienen" and they were supported by stone lions carved by Meester Joest. At the same time the guild donated a stained-glass window to the convent on the Rapenburg which has become the Academie-Gebouw of the University of Leiden.[27]

This commission indicates that Huych Jacopsz. may have lived in Koudekerk in the years between his renting from Hieronymusdal and his owning a house in Leiden. Further, it is possible that he came from a family originally established in Koudekerk, although his membership in the Leiden archery guilds suggests that he himself was born in Leiden (he did not buy citizenship). Further, Huych Jacopsz. was temporarily residing in Gouda, and this may be presumed to indicate a commission there, since he was already a master painter. In a tiny village like Koudekerk the likelihood of talent attracting the attention of the local nobility was far greater than in Leiden, however small Leiden may have been. This gives credence to the legend that Lucas van Leyden was rewarded at a very early age for a painting of St. Hubert. It has been shown above that Adriaen van Poelgeest was the possessor of Huis Lochorst in Leiden, which may account for confusion regarding the "Heer van Lochorst" for whom Lucas was supposed to have painted his picture.

Notes

1. See Kronenberg, "Werken van Cornelius Aurelius," 69-79; Obbema, "A Dutch Monastery Library of c. 1495;" Reedijk, *Poems of Erasmus*. Obbema describes the monastery library collection with reserve, "But despite the incontestible paucity of books of certain categories, the library still contained over 200 volumes, which is many times the number known to us even from the best preserved libraries of the time in Holland," (Obbema, "A Dutch Monastery Library of c. 1495," 224). Obbema does not speculate on the contents of Cornelius Aurelius' own library, mentioned by Kronenberg. The contrast of the number of books in this library inventory with the personal library of Jan Dircxz. van der Haer is striking.

2. Overvoorde, *Archieven van de Kloosters*, Leiden, 1917, 110, folio 64, regest 1640; mentioned in Leverland, research on Huych Jacopsz., 1968.

3. Kl. Arch. 121[II], folios 56 and 59.

4. Kl. Arch. 121[II], folio 60 verso.

5. See Kl. Arch. 121[I], folio 48 verso, 1471, where the monastery is listed as having owed 8½ Rijns guldens to "Hughe Tymans knecht;" see also Kl. Arch. 119[a] (unfoliated), 1469; and Kl. Arch. 121[I], folio 71 verso, 1471, where Tyman was paid money which he then paid to Huych. The "Meester Cornelis" noted on the last folio cited is Cornelius Aurelius, not Cornelis Engebrechtsz. These records were used

by H. E. van Gelder in establishing the patronymic (Gerytsz.) of Cornelius Aurelius; this has led to the unnecessary use of the name Cornelius Gerard in many references to him.

6. Friedländer, *Lucas van Leyden and Other Dutch Masters*, no. 59, plate 40.

7. See Kl. Arch. 111, folio 13 (1448); and Kl. Arch. 111, folio 7 verso (1446?).

8. See Kl. Arch. 112, folio 17, artist not named.

9. Beets, "De Tentoonstelling van Noord-Nederlandsche Schilder-en Beeldhouwkunst vóór 1575 (Utrecht, 3 September – 3 October, 1913), I. – De Meester der Virgo inter Virgines; Geertgen tot St. Jans; de Leidsche School," *Onze Kunst, voortzetting van de Vlaamsche School*, XXV, 1914, 60.

10. See Kl. Arch. 111, folio 66.

11. This applies particularly to the "Master of Delft."

12. See Kl. Arch. 121I, folio 34 verso; Kl. Arch. 119a (unfoliated), 1469.

13. Kl. Arch. 121I, folio 64, 1474.

14. The 1482 payments are found in Kl. Arch. 112, folio 49.

15. See Leverland, research on Huych Jacopsz., 1968.

16. Kl. Arch. 111, folio 60 verso.

17. See Dülberg, "Lucas van Leyden," 69; and Koning, "Geboortejaar," 83.

18. The document is W. A. 113, Gr. Bew. A, no. 480, December 23, 1500; in it Huych Jacopsz. guarantees the inheritance due to his minor children by his first wife.

19. Koning, "Geboortejaar," 84-85.

20. See Leverland, research on Huych Jacopsz., 1968.

21. The document is R. A. 51, 1482-1519, folio 11 verso of the first 48 folios of the volume. These 48 folios are from the *Kenningen* of 1495-1496 (R. A. 41), but they have been bound incorrectly for centuries with R. A. 51, preceding the properly foliated volume, 1482-1519.

22. Invoked in R. A. 41, 1477-1486, folio 201 verso, December 14, 1484.

23. R. A. 2, 1435-1500, folio 225 verso, September 28, 1495.

24. R. A. 42.

25. R. A. 42.

26. R. A. 42.

27. The preceding information is taken from a short book recording the costs involved in the establishment of the new chapel: Gilde Archieven 1270. The text of the payment note for Huych Jacopsz. is as follows. Item Meester huge Jacopsz. van koudekerck wonende ter goude heeft anghenomen sinte Nycasius outair(stricken out) tafel te maken by prys van meester ende dattet also ghesciet is so heeft dat ambocht ende huge Jacobsz. ghecoren heer Adriaen van poelgheest ridder ende scout tot leiden ende claes ian claesz. als middelaers ende hebben hem toegheseit by die prys van meesters VIIc rijnsguldens ende LXXV van die tafel. ende betaelt. This note, without reference to location, is extracted and found pasted in Dozy's miscellaneous notes preserved in the Leiden Municipal Archives. For Reynier van Thienen, the famous Brussels coppersmith, and Jan Borman, see (among other places) R. J. Dubois-van Veen, *Koperen en bronzen voorwerpen uit de collectie Mr. J. W. Frederiks*, separately available issue of parts 2 and 3 of *Bulletin Museum Boymans-van Beuningen*, XXI, 1971, with bibliography.

10. Tapestry Weaving in Leiden, 1500-1540

That there were tapestry weavers in Leiden before 1540 contradicts a generally accepted version of the history of tapestry weaving just as much as the fact that Leiden was an important center of tapestry production, using wool, silk, and gold metallic thread, in the period from 1540-1575. I have dealt with this problem at some length in a study of Leiden tapestry weaving between 1500 and 1575,[1] so for the purposes of this chapter my remarks will be limited to a recapitulation of the main information about tapestry weaving in the period roughly approximating that of Cornelis Engebrechtsz. (which marks an apparent division within the development of Leiden tapestry weaving with the arrival of Willem Andriesz. de Raet ca. 1540). The significant point concerning the question of the cultural situation in Leiden is that there were tapestry weavers active then and that they were able to find a market for their products.

Documentary proof for the use of gold thread in Leiden occurs later, but there is no reason to suppose that it was not used in the beginning of the century also, when documentary information is much less complete about such matters. There was ample supply of the materials from local embroiderers; and the *placaat* of October 7, 1531, which, in order to extirpate heresy, regulated many items including apparel, mentions a variety of ways to use gold and silver thread on clothing, henceforth forbidden, but evidently previously in fashion. The edict was publicly read in Leiden.[2]

The present Netherlands had not been considered in tapestry study for the first third of the sixteenth century for two reasons. First is the repeated assertion that no tapestry weavers were active in the area now forming The Netherlands before the middle of the century (more precisely, one in 1540, Willem Andriesz. de Raet, whose production was known only after 1550). Second, tapestry activity has been thought not to have been an *industry* there, comparable in organization to tapestry weaving in Flanders and Brabant, before the end of the century, when political and religious refugees supposedly transplanted tapestry weaving northwards in full bloom, or perhaps slightly wilting, from Brussels and other southern towns.[3] The image of the wandering refugee weaver as founder of the northern tapestry industry was most imaginatively set down by G. T. van Ysselsteyn; and it has since held the fancy of writers on the subject.[4] Of course the idea that tapestry weaving was only possible in the wealthy south before the political and religious wars sent refugees north has seemed reasonable to people who presumed that the north was culturally and economically backward before its so-called "Golden Age," which has from time to time been ascribed to an influx of southern cultural stimulus and money. In the first third of the sixteenth century, however, there is documentary information about the

tapestry weaving activities of several masters, chief of whom seems to have been Jacop Jacopsz. the Elder.[5]

Tapestry Commissions of Jacop Jacopsz. the Elder and his son Jan Jacopsz.

The series for the Jonckvrouw van Arenberch

A lawsuit of July 27, 1526, gives important information about the monetary value of the work carried out by Jacop Jacopsz. the Elder, as well as about his clientele.[6] *"Machtelt dochter tot Montfoert, Jonffrou van Arenberch, Vrouwe van Naeldwyck"* sued Jacop Jacopsz. the Elder for damages substained by her in connection with certain works of tapestry. The nature of the case ensures that the tapestries had been commissioned from him and that the "damages" (a standard legal term) were probably considered to have arisen through late delivery.[7] The amount of the damages was to be determined by court-appointed experts, which implies the presence of other tapestry weavers, lawyers, and perhaps painters (to discuss cartoons, if that was at issue), who could be considered independent arbiters, or whose prejudices could be considered to balance each other out, or who were acceptable to both plaintiff and defendant, as in the non-court case decision on price for Huych Jacopsz.'s St. Nicasius Altarpiece. The few references to the other weavers implied by this case is not strange, because the lawsuit is still within a period of relatively rare occupational specification in most documents. Moreover, it was quite possible to stay out of court. If not mentioned in this particular case, caused only by late delivery or some such minor problem, this major commission would not be recorded at all. That would leave practically no information about Jacop Jacopsz. the Elder's work for private people, and it may be assumed that whoever else was weaving at this time had little controversy over commissions — almost certainly nothing which was not settled out of court.[8]

The monetary value of the commission is indicated in a general way, and possibly specifically, by the sum demanded as an alternative if the court decided not to allow the case to be decided by outside experts: 100 Rijns guldens. However, the court absolved Jacop Jacopsz. the Elder from the demands on August 13, 1526; so there are no further comments by experts or court officials or by the litigants to give any more details on the commission. On comparison with similar lawsuits which did run into further developments, it seems reasonable to presume that the absence of further litigation or developments indicates that delivery took place. The lawsuit serves, at any rate, to prove the existence of what must have been large tapestries in a period long before the previously supposed transplantation of the industry to the "Northern Netherlands" as a result of political and religious troubles.

Magteld van Montfoort Jansdr. was the daughter of the Viscount of Montfoort (Jan), who had married Wilhelmina, Vrouwe van Naeldwyck. Magteld married Robbert van der Marck, heer van Aremberg, July 14, 1495. He was the son of Everart van der Marck and Margriete van Bouchout.[9] Magteld died at an old age in 1550. Her granddaughter was Margaretha, Countess van der Marck, Princess (since 1570) van Arenberg, who married Jean de Ligne (d. 1568 at the battle of Heiligerlee).

98

The series of tapestries made by Jacop Jacopsz. the Elder for the Jonckvrouwe van Arenberch in 1526 is apparently not preserved or cannot be recognized. The *Staten van Holland* (Estates of Holland, the county) did acquire a series of ten tapestries in 1574 from the Countess of Arenberg, and the two series could very well have been identical.[10] Depictions of the tapestries acquired in 1574 provide no clear information about them, but they were evidently sufficient to satisfy the habits of the *Staten van Holland*, not a particularly uncultured lot. Two engravings show the tapestries. One, however, sketchily indicates large figures (anonymous, in Commelin), while the other sketchily indicates large verdures (Frisius, in Baudius).[11] In both engravings the tapestries are so generalized that they cannot be considered depictions of specific tapestries. They merely show that tapestries were in the room. Clearly no judgement about the work of Jacop Jacopsz. the Elder can be made on the basis of these engravings; and, just as clearly, the engravings do not provide the link sought between 1526 and 1574, however likely such a connection might be. It is unknown whether the granddaughter inherited her grandmother's estate; or, if so, whether the same tapestries were in it.

Possible Commission from Heer Willem van Alcmade, Knight

Jacop Jacopsz. the Elder was sued on November 11, 1528, for repayment of 10 Rijns guldens he had borrowed from Heer Willem van Alcmade, knight.[12] Willem van Alcmade has been mentioned above in connection with his sale of a tapestry to the convent of Marienpoel in 1522-1523. This connection with a tapestry suggests that the 1528 lawsuit could refer to a loan for materials and wages paid before delivery of the finished product. In such a situation repayment of the loan would mean delivery of the work. A definite example of this situation is found in the activities of Willem Andriesz. de Raet.[13] But in the brief lawsuit of Willem van Alcmade no details are given about the purpose of the loan.

Unclear References to Jan Jacopsz.

Jacop Jacopsz. the Elder's son, Jan Jacopsz., is mentioned for the first time in a lawsuit not directly concerning him. He was one of two people in possession of goods belonging to Jacop van Nyn of Rotterdam, which were attached on January 8, 1529, by someone from Delft for recovery of a small debt.[14] Similar cases raise the possibility that the unspecified goods were tapestries, since tapestries ordered but not yet delivered would be legally considered "goods" belonging to Jacop van Nyn; and that is the sort of goods most imaginable as being in the possession of Jan Jacopsz. in Leiden, while belonging to Jacop van Nyn of Rotterdam. (Other "goods" are, of course, possible on the face of it.) A comparable case occurred on May 9, 1569,[15] when a glasspainter brought claims against twelve tapestry cushion covers and a tapestry dresser cover in possession of de Raet but considered the property of Pieter Phillipsz. van Noorde, who had commissioned them but had not received them. These unfinished tapestry works were legally part of van Noorde's estate when he died. The details are discussed more fully elsewhere,[16] but it indicates the legality of laying claims on unfinished commissions for recovery of funds from the person ordering the artworks, and not directly involving the tapestry weaver.

Jan Jacopsz. was similarly in possession of "goods" belonging to Willem Ghysbrechtsz. when they were attached for the recovery of 6 Rijns guldens rent on October 22, 1529.[17]

On May 2, 1530, Jan Jacopsz. himself sued a baker, Jan Louwerisz., for 16 Karolus guldens and 9 stuvers, a fairly large sum, but there is no indication what it is about.[18]

Jacop Jacopsz. the Elder in Dordrecht, ca. 1531-1533; Jan Jacopsz. Continuing the Leiden Business

Several mortgage suits about Jacop Jacopsz. the Elder's premises in the Noordeinde in Leiden (later the premises of de Raet) state that he had himself moved temporarily to Dordrecht, where his son Jan Jacopsz. travelled to inform him of the various legal developments. Several suits for small fees due annually to the Leiden St. Anthony Hospital mention that the house was mortgaged for payment of a mere 48 placken; these are dated March 10, 1531; January 12, 1532; February 23, 1532; May 17, 1532; and June 21, 1532.[19] Each time arrangements were made to prevent further proceedings of real importance, in another legal stage, such as sale of the house. Jan Jacopsz. agreed to serve court notices to his father on the first two cases, as well as on that of May 17, 1532. He was paid a standard reimbursement from the court for this. The St. Anothony Hospital sued again on May 22, 1534, but by that time Jacop Jacopsz. the Elder had already returned to Leiden.[20]

Without documents from Dordrecht it is impossible to do more than speculate what Jacop Jacopsz. the Elder was doing there. That he was there as a tapestry weaver is stated in a Leiden lawsuit, in which he sued his son Jan for rent payment on the Noordeinde house (October 23, 1531),[21] more specifically bringing suit against his son's sequestered goods. In Dordrecht a resonable speculation would be tapestries for the Grote Kerk, but proof is missing and other reasons could also explain the absence — commissions from some other source, for example, or a simple expansion of the business to operation from two locations with more than a single commission in the area of Dordrecht.

That the Leiden activity was continued by his son is evident from the lawsuits which also probably explain the sequestration of Jan Jacopsz.'s goods (the contents of the Noordeinde house, not the house itself, as made legally clear by the lawsuit between father and son for rent). Jan Jacopsz. was sued on August 28, 1531, for return of 3½ Karolus guldens worth of yarn which he had been given by Kerstyn Pietersdr. from Alkmaar to be made up into cushions.[22] She had presumably commissioned the cushions. Partially worked-up yarn could have been sequestered in that state to guarantee completion, but no note mentions the progress of the commission. Someone else also started mortgage proceedings on Jacop Jacopsz. the Elder's house in the Noordeinde a week later.[23] Usually the entire contents of the house was sequestered in such proceedings, here meaning the combined possessions of father and son, including Jan Jacopsz.'s tapestry work and materials.[24] And it was undoubtedly against the goods personally belonging to Jan Jacopsz. that Jacop Jacopsz. the Elder brought his claims for rent from his son.

A mortgage on Jan Jacopsz.'s possessions (as dintinct from his father's) led to legal action on January 12, 1532, brought by a woman named Meyntgen Heynricxdr.[25]

Some kind of agreement was evidently reached, such as refinancing, so nothing came of it further legally. The capital necessary for materials and assistants' wages required tapestry weavers to mortgage their possessions for loans, because such expenses had to be paid before delivery of the completed products. For that reason it is no indication of poverty to find that tapestry weavers seem constantly to have mortgaged their houses and other goods. The same financial procedure was common among all the richer merchants of Leiden, including many artists and craftsmen, and similar mortgage lawsuits can be found against the wealthiest entrepreneurs of Leiden in the same legal records. Having something with mortgagable value was, in fact, a sign of some wealth, and not the other way round. Only court-enforced sale of mortgaged property indicates a financially insecure operation, although the system obviously depended on lack of disturbance of orderly payment.[26] Sometimes the lender of money and possessor of the mortgage was also the person who had commissioned the work of art. That was not always true, so it cannot be assumed unless what was lent was the materials themselves, as in the example of the yarn provided by Kerstyn Pietersdr. from Alkmaar.[27]

Regardless of mortgage lawsuits, tapestry activity continued. Jan Jacopsz. was sued by Meester Phillips van Henegouwen on August 19, 1532, for return of a tapestry cushion cover which Jan Jacopsz. had borrowed.[28] The value of the cover is given by the alternative sum of 6 Rijns guldens. Jan Jacopsz. agreed to return the cover before the middle of September, which suggests that he was using it in some way, probably as a pattern. He could, for example, have copied the heraldic design surrounding the actual shield; or he could have borrowed it in connection with a commission to make more just like it.

Jacop Jacopsz. the Elder's Return and the Altarfrontal Commission(s)

By April 22, 1534, Jacop Jacopsz. the Elder had returned to Leiden, and on that date he sued the officers of the guild of SS. Joest and Ewout held in the Pieterskerk.[29] They had commissioned an altarfrontal from him, which he had made and delivered. He demanded payment as in the original agreement, or 10 Karolus guldens instead. The case received several postponements, the last of which was on June 15, 1534. Unfortunately the decision is not recorded. Presumably Jacop Jacopsz. the Elder received other guild commissions about which no dispute arose. Without such a dispute, and in the absence of guild accounts, these commissions remain postulates.

Jacop Jacopsz. the Elder died before ca. March 10, 1535, and after June 15, 1534 (he must have been alive during the court actions on his case against the guild of SS. Joest and Ewout). On April 19, 1535, his widow, Cornelia Heynricxdr., instigated a suit for payment for an altarfrontal made and delivered by her late husband to Maertyn Mathysz.[30] The value of the altarfrontal was to be determined by "master tapestry weavers," which has the significance of proving that there were some available. Payment of 10 Karolus guldens plus court costs was an acceptable alternative. This could obviously be a continuation of the earlier case against the guild of SS. Joest and Ewout. That case was supposed to have been decided on the next morning after its last postponement. If Jacop Jacopsz. the Elder had become ill and did not appear (or send a legal representative), perhaps no decision would have been given. The case would

then have remained undecided until reopened by his widow. Frequently, however, the court clerks did not record decisions. Connecting the two lawsuits about altar-frontal(s) cannot be done with certainty. Jacop Jacopsz. the Elder's widow could just as easily have sued a different guild or similar body, which had not paid at the time of the death of Jacop Jacopsz. the Elder.

Tapestry Weavers Mentioned before 1540

After the arrival of Willem Andriesz. de Raet ca. 1540 there is both a change in the extensiveness of documentation and related increased clarity about the activity of tapestry weavers in Leiden and their relation to each other. Before 1540 the information is meagre, and only brief, haphazard biographical notices can be given about a few weavers. Jacop Jacopsz. the Elder and his son Jan Jacopsz. are most clearly seen, but there are others as well. Moreover, the records referring to Jacop Jacopsz. the Elder and his son are not confined to documents which can be considered to be connected in some way with tapestries.

Jacop Jacopsz. the Elder: Further Biographical Notes[31]

Jacop Jacopsz. the Elder is first mentioned on May 30, 1510, in an unimportant subpoena. He was caught with ten other people in 1512, drinking out of bounds (that is to say, beyond the city's taxation area, within which Leiden residents were required to do their drinking). He was living at this time near the Onse Lieve Vrouwe Kerk, and the bond for his fine was his mother-in-law, Lysbet Pietersdr. (which indicates that he was already married, 1512). In 1519 he is described as living outside the Rijnsburg gate. Around 1530 he had acquired the location in the Noordeinde (Breestraat) which was to remain the major tapestry studio in Leiden. He also rented three small fields from the properties of Hieronymusdal in the years from 1523 to 1531.[32] By 1525 he was able to rent space. He sued his tenant for unpaid rent of £ 7/10/– on January 12, 1526. This lawsuit seems to have continued with modifications into 1528. After Jacop Jacopsz. the Elder's death and before 1540 his widow continued to live in the house in the Noordeinde, which she had retiled in 1538.

Jacoba Jacopsdr.

Jacoba Jacopsdr. also seems to have been a family member. She is mentioned from 1533 (living directly behind Jacop Jacopsz. the Elder's house) on into the period of Willem Andriesz. de Raet.

Andries Jacopsz.

Andries Jacopsz. is mentioned as a tapestry weaver from The Hague who married Gerytgen Marcks, daughter of the wealthy Leiden burgher Aernt Gerytsz. Marcks and his wife Katryn.

Jan Thomasz. Blanck

Jan Thomasz. Blanck was required to post bond for the usual beerdrinking mis-

demeanor in 1521. In 1533 he was sued by Joost "The Bastard of Brederoede," for return of a cushion cover on which the arms of van Mathenes and van Assendelft were depicted.

Huybrecht Jansz.

A tapestry weaver mentioned only a few times, but who bridges the periods of Jacop Jacopsz. the Elder and Willem Andriesz. de Raet, is Huybrecht Jansz., first mentioned on November 11, 1536, but clearly active before then. On that date Master Richard Petyt attached an altarfrontal belonging to Huybrecht Jansz. in possession of Cornelis Mathysz. van Bancken. Richard Petyt was an Englishman resident in Leiden, who represented the legal interests of various English cloth traders located at Calais. In 1537 Huybrecht Jansz.'s residence is given as St. Steven's Cloister (an almshouse on the Haarlemmerstraat). Huybrecht Jansz. brought claims against someone from Brabant in 1544. The last reference to him is a subpoena, in which he is named with another tapestry weaver, Jan Moeyns (first mentioned in 1542), requiring his testimony in 1551 on unspecified matters. The documentation of Huybrecht Jansz. spans fifteen years, but nothing is known of his work.

Anonymous Tapestries in Leiden Documents

In the period before 1540, however, references to tapestries do appear without naming their weavers. Presumably the tapestries were mostly local products. A local tapestry is probably at issue in the lawsuit of September 30, 1521, when the sculptor Jan Pietersz. van Dam[33] sued Frans Willem Engelsz.'sz. for restitution of whatever money he had received from sale of a verdure tapestry or payment of 6 Rijns guldens instead.

A criminal case evidently referring to tapestry cushion covers is recorded on January 13, 1531 (the coats of arms had to be removed to make the cushions unrecognizable).

Another tapestry is mentioned in 1535, when a timber merchant demanded that a tapestry wordth £ 7/—/— be returned to him. The tapestry is not further described.

The most expensive anonymous tapestry is mentioned on February 28, 1539, when Jan Heynricxz. van Beveren sued Anthony Carlier, resident of Leiden and Master of the Mint at Dordrecht, for payment of 27 gold Karolus guldens for a tapestry. Van Beveren claimed payment was to be made a year after the sale, while Carlier claimed already to have paid. The court found in favor of Carlier, whose marriage connections have been mentioned above in connection with the families represented by the people portrayed on the *van der Does-van Poelgeest Panels* of Cornelis Engebrechtsz.

The Significance of Leiden Tapestry Weaving, 1500-1540

It is impossible to be very definite about what was produced in the studios of Jacop Jacopsz. the Elder and his Leiden contemporaries. No marks exist to help in identification. Moreover, the precise relation of Leiden's tapestry weavers to their coun-

terparts in Brussels in this period is impossible to determine (in contrast to the period of de Raet, who came from Brussels). The court tapestry weavers visited Leiden in 1508 and 1515 as part of the entourage in the Joyous Entries of Maximilian and the future Charles V. The court tapestry weavers are not personally named, but references to the entourage of Charles V at one of the other cities on the route of the 1515 Joyous Entries state that the leader of the tapestry weavers on tour was Pieter van Aelst, the most important tapestry weaver of the time.[34] These visits must have included the display of some of the best Brussels tapestries of the time, so that Leiden's tapestry weavers could not have been unaware of the possibilities of their craft, whether or not they themselves ever reached qualitative heights.

Despite the difficulty of not knowing what was produced in Leiden (although it was good enough for the daughter-in-law of Everart van der Marck), the very existence of active tapestry workshops in Leiden in the first four decades of the sixteenth century is of great importance, because it throws doubt on the many easy attributions of anonymous tapestries from that period to places of manufacture in present Belgium. Some of them, certainly, could have been made in Leiden. That de Raet is recorded using gold thread in Leiden probably indicates that it was used by earlier tapestry weavers, too. Every excellent tapestry of that period, and every tapestry containing metallic thread (regardless of the quality of the design), becomes, therefore, a candidate for ascription to Leiden, unless explicit proof exists to locate the tapestry's origin in some other particular place. The result is that many tapestries become anonymous, both as regards place of origin and as regards designer; when previously high quality of design and metallic thread have been considered certain indications of Brussels origin. Leiden artists like Cornelis Engebrechtsz. and Lucas van Leyden could very well have designed tapestries.[35]

Finally, the existence of Leiden's tapestry weavers in the first four decades of the sixteenth century requires rejection in its entirety of the misconception that tapestry weaving was an activity transplanted from the "Southern Netherlands" to the "Northern Netherlands" as a result of the political and religious controversies and war at the end of the sixteenth century. As far as the early sixteenth century is concerned, tapestry weaving was well established in the area which has become The Netherlands and it did not require any change of cultural climate to gain a foothold and find a market. Underscoring this is the city government's order to inhabitants of all the Leiden neighborhoods to decorate their houses with "maypoles, garlands, tapestries, and other things" as part of the celebrations of the 1540 triumphal entry of Charles V.[36] The assumption that some of each neighborhood's houses could thus be hung with tapestries by decree of the city government comes twenty years after the city had voted to lend Jacop Jacopsz. the Elder 100 Rijns guldens (= £ 133/6/8 Hollands) "to provide himself with workmen and equipment for tapestry weaving in order to expand that industry within this city" ("omme hem te voirsien van wercluyden ende gerescap dienende tot legwerckerye omme die selve neeringe binnen deser stede te verbreeden"), a sum repaid in full four years later.[37] Tapestry weaving was the only industry to receive such civic support between 1500 and 1540. Other industries received various alternative forms of support, but not outright loans from the city treasury.

Notes

1. See J. D. Bangs, *Documentary Studies in Leiden Art and Crafts, 1475-1575*, Leiden, 1976, 1-181 (= Rijksuniversiteit Leiden diss., published privately in an edition of 199 copies; a copy can be found in many major libraries, such as the Library of Congress, The British Library, Bibliothèque Nationale, and specialized libraries like that of the Metropolitan Museum of Art or the Victoria and Albert Museum). Additional background material placing Leiden's tapestry weaving in the context of present scholarship is found in the diss., as well as a detailed discussion of the activities of Willem Andriesz. de Raet and his contemporaries, active in Leiden after ca. 1540.
2. S. A. 1205 A, no. 62.
3. Not mentioned in my diss. is the Leiden publication of the 1544 ordinance regulating the tapestry industry in Flanders and Brabant. This was published in Holland and Zeeland in 1551, which indicates government recognition of the existence of tapestry weaving in these provinces; see S. A. 1205 A, no. 195 (my attention was called to this by P. de Baar).
4. See G. T. van Ysselsteyn, *Tapijtweverijen in de Noordelijke Nederlanden*, Leiden, 1936, I, 46-54; and I, 36-45 (= Rijksuniversiteit Leiden diss.).
5. Besides tapestry weavers identified as "legwerckers" or "tapijtwevers," there are also cushionmakers, some of whom clearly provided tapestry cushion covers. These are omitted from the present discussion (although references to them are in my diss.). Their activities date from before 1475. The word *cushionmaker* has been found to be synonymous with *tapestry weaver*, although in this discussion only weavers identified with the specific terms definitely indicating tapestry works are considered.
6. R. A. 42.
7. Similar cases about non-completion of commissioned paintings, couched in the same legal language, were brought against the painter Robbrecht Robbrechtsz. by Pieter Heynricxz. Buys (see appendix 2, genealogical tables, no. 176) on September 6, 1512, and September 19, 1513; and also against Robbrecht Robbrechtsz. by Lambrecht Pietersz. on September 20, 1512 (R. A. 42).
8. The records for R. A. 42 are missing for the years 1492-1505; 1515-1518 (September); and end 1521-end 1525. This legal series is the proper place for cases of a minor nature about commissions. Major cases would be recorded in R. A. 41, which has no gaps between 1500 and 1540.
9. Arch. van de Heeren van Montfoort, inv. nr. 254; information provided by P. de Baar.
10. Van Ysselsteyn, *Tapijtweverijen in de Noordelijke Nederlanden*, I, 194; II, 32, document 59.
11. See (1) S. Frisius, *De Vergadering over het Twaalfjarig Bestand* [February 6, 1608] in D. Baudius, *Van 't Bestant des Nederlandtschen Oorlogs*, Amsterdam, 1616, bound between pages 66 and 67; and (2) anonymous, *Afbeeldinge Hoe de Nieuwe Stadhouder Frederick Hendrick, Prince van Orangie aen de G. M. Staten van Hollandt den Eedt doet en ter Rolle gaet Sitten* [September 5, 1625] in I. Commelyn, *Frederick Hendrick van Nassauw, Prince van Orangien Zyn Leven en Bedrijf*, Amsterdam, 1651, bound between pages 6 and 7.
12. R. A. 42.
13. See Bangs, *Documentary Studies*, 52-54.
14. R. A. 42.
15. R. A. 43.
16. See Bangs, *Documentary Studies*, 58-59.
17. R. A. 42.
18. R. A. 40, 1519-1535, folio 48 verso.
19. R. A. 42.
20. R. A. 42.
21. R. A. 42.
22. R. A. 42.
23. R. A. 42.
24. An example of such complete sequestration from a complicated series of mortgage actions between the painter Cornelis Cornelisz. Kunst and the carpenter Adriaen Pietersz. is found on January 9, 1534 (R. A. 42). The carpenter was not identical with Cornelis Cornelisz. Kunst's nephew; see appendix 2, genealogical tables, no. 16.
25. R. A. 42.

26. For this reason, as well as jurisdictional reasons, there are many contemporary indications of anta-gonism towards people without fixed residences; and sudden migration such as that to Münster by Anabaptists could cause disruptions in the orderly payment system affecting many more people than those who left.

27. A likely example of a loan connected with a painting comission is seen in the litigation brought against Lucas van Leyden's widow by Aernt Cornelisz. of Delft, who had inherited annuity papers from his wife's brother, Jacop Heynrick Joestenz.'sz. of Delft, worth £ 3/−/− at an interest rate of 6¼ %, which Lucas and his heirs owed to the holder of the papers. The original obligation papers burned in the fire of Delft in 1536, but the Leiden magistrates required Jan van Ryswyck (Elysabeth van Bosschuysen's third husband) to deliver new papers on Lucas' widow's behalf (R. A. 42, March 9, 1537). The loan to Lucas van Leyden was supposed to have been either 450 Karolus guldens (according to the plaintiff) or 288 Karolus guldens (according to Elysabeth van Bosschuysen); see R. A. 42, April 5, 1538.

28. R. A. 42.

29. R. A. 42.

30. R. A. 42. The page is badly damaged by water, possibly obscuring other details about the case. Maertyn Mathysz. may be identical with the husband of Jacoba Jacopsdr., who had the same name; see R. A. 50, 1533-1563, folio 7, August 14, 1553 (by which time Jacoba Jacopsdr. was a widow).

31. The information which follows in the text is slightly abbreviated from that found in Bangs, *Documentary Studies*, where the archival references for these statements are given. For relatives of Aernt Marcxz., father-in-law of Andries Jacopsz., see R. A. 42, March 16, 1509.

32. See Kl. Arch. 117 (Lopsen, Register van inkomsten uit bezittingen, 1523-1539); Kl. Arch 118 (Maen-boek van den convent van Lopsen, 1529-1531). This information is omitted from Bangs, *Documentary Studies*.

33. See J. D. Bangs, "Rijnsburg Abbey: Additional Documentation on Furniture, Artists, Musicians, and Buildings, 1500-1570," *Bulletin van de Koninklijke Nederlandse Oudheidkundige Bond*, LXXIV, 1975, 184 (article reprinted in Bangs, *Documentary Studies*).

34. S. Schneebalg-Perelman, "Un grand Tapissier Bruxellois: Pierre d'Enghien dit Pierre van Aelst," *De Bloeitijd van de Vlaamse Tapijtkunst*, Brussels, 1969, 294.

35. See, however, E. Duverger, "Lucas van Leyden en de Tapijtkunst," *Artes Textiles*, IV, 1957-1958, 38. He may be counted among the art historians who have given Lucas van Leyden too small a role, since he does not raise the possibility that Lucas van Leyden could have made tapestry cartoons.

36. S. A. 387, 1528-1570, folio 84 verso (not mentioned in my diss.).

37. S. A. 601 (TR 1520-1521), folio 69 verso; S. A. 605 (TR 1524-1525), folio 24 (not mentioned in my diss.).

11. The "Joyous Entries" of Maximilian and Charles

Maximilian entered Leiden triumphally in 1508 and the city paid for the festivities.[1] Ill. 44
C. Harbison mentions the 1508 visit and correctly, I think, associates Lucas van
Leyden's engraving *Mahomet* with it.[2] His suggestion that Lucas might have had an
audience with Maximilian is, however, made unlikely by the presence of a high
number of dignitaries accompanying Maximilian, by the necessary assumption that
most audiences with Maximilian had to do with the dealings with the city government
and its numerous officials which were the basic reason for the visit, and by the absence
of any indication that Lucas van Leyden had more than a local reputation in or before
1508. (Sale of engravings to the visitors may have helped spread his fame, but that is a
different hypothesis than Harbison's.) The treasury records, unknown to Harbison,
list forty-two accompanying nobles and other government officials, besides
representatives of the towns of Dordrecht, Haarlem, Delft, Amsterdam, Gouda,
Gorinchem, and 's Hertogenbosch, and the court's tapestry weavers. The *Mahomet*
engraving could certainly have had the topical significance assigned to it by Harbison,
while still having functioned as a sort of souvenir sold to people comparable to those
who bought engravings from Dürer during his visit to the Netherlands (Brabant,
Flanders, and Zeeland) in 1520-1521, and without any implication of an audience
with or patronage from Maximilian.[3]

In 1515 Duke Charles, Prince of Spain, Count of Holland, etc. (who became
Emperor Charles V in 1519), was sent by his grandfather Maximilian on state visits to
the more important cities in the Netherlands, marking (in Holland) his accession to
the title of Count of Holland. He was accompanied by many servants, personal
tradesmen, and nobles on the tour, which generally marked his coming of age as Duke
of Burgundy at fifteen. Leiden's treasury accounts record payments connected with
the "joyous entry" of Charles on June 14, 1515.[4]

Preparations for the entry of Charles occupied the attention of most of the in- Ill. 45
habitants of Leiden. Wine which was to be given to the visitors at city expense had to
be supplied.[5] Businessmen not directly employed in the preparations were taxed to
help pay for the decorations. The main street of Leiden, the Breestraat, was decorated
in several ways, some emphasizing the town's cloth production.[6] A wooden entrance
arch, painted to look like masonry, and provided with a stage, was built at St.
Anthony's Bridge at the beginning of the long, wide, curving street. A picket fence was
built down both sides of the street and banners of Leiden wool were hung all along the
fence. "Little May poles" were placed on top of the fences, while torches were set in
front of the banners on the fences, in a zig-zag pattern down both sides of the street.

The banners were provided by the travelling cloth sellers, dyers, fullers, etc., who also did the work of hanging them. The torches were paid for by the guilds and by people operating businesses not included under the guild laws. The Breestraat was decorated this way from the wooden arch by St. Anthony's Bridge past the *Blauwe Steen*[7] and the city hall, midway down the street, all the way to the far end of the street at the Hogewoerd's Bridge. The same kind of decorations continued from there around to the right along the wealthy canal, the Steenschuur and Rapenburg, and marked the procession route to the Pieterskerk, next to which Charles lodged in Huis Lochorst.

The procession which went out from Leiden beyond the *Hage Poert* (Hague Gate) in the city walls to meet Charles, present him the city's keys, and bring him into the city included the officers of the court, the *schout*, the four burgomasters, the magistrates, and the civil servants, all in official uniforms, together with the richly dressed members of the city council. In addition the militia appeared in their uniforms carrying fifty-six torches.

As has already been mentioned, Cornelis Engebrechtsz. and Pieter Cornelisz. Kunst were militia members at this time. Lucas van Leyden was also a member of the militia. In 1515 he was a crossbowman.[8] Cornelis Engebrechtsz., Pieter Cornelisz. Kunst, Lucas van Leyden, and several other painters took part in the procession welcoming Charles into Leiden.

The Breestraat was also the scene of entertainment during the stay of Charles and his retinue.[9] Three stages were erected, one at the wooden entry arch, one by the *Blauwe Steen*, and one by the Hogewoerd's Bridge. The city commissioned heraldic decorations, to be hung on the city gates and the city hall, from the painter Pieter Jansz. Heraldic banners for the city trumpeters were commissioned from Lucas van Leyden's older brother Dirck Hugenz.[10] Although he did not receive a commission from the city for decorations, Lucas van Leyden was involved with Cornelis Engebrechtsz. and the other painters in the production of one of the three plays performed, through his membership in the painters' guild. The treasury accounts note that the play performed on the stage by the *Blauwe Steen* was paid for and acted by the painters. The accounts note further that the play at the Hogewoerd's Bridge was paid for and acted by the tailors. The city, in contrast, paid the Rhetoricians to compose and perform the play on the stage of the entry arch at the St. Anthony's Bridge. All three plays were comedies, and that of the Rhetoricians, at least, was mimed, with the presumable use of a narrator.[11] The subject of the Rhetoricians' play was "The Story of David and Abigail." (The other two plays are described only as the other two mime comedies.)

The story of David and Abigail (I Samuel 25: 2-43) may have been considered an analogy referring to Charles, a supposition fully in keeping with the contemporary habit of allegorizing and analogy. In the time of the story David was second under Saul. David is moved to be merciful to Abigail and her people when she presents food and wine in large quantities to him while he is on his way to slaughter her family and servants. Finishing a rather long plea for mercy, Abigail says (verses 30-31):

> And it shall come to pass, when Jehovah shall have done to my lord according to all the good that he hath spoken concerning thee, and shall have appointed thee prince over Israel, that this mercy shall be no grief unto thee, nor offence of heart

unto my lord, either that thou hast shed blood without cause, or that my lord hath avenged himself. And when Jehovah shall have dealt well with my lord, then remember thy handmaid.

The story continues (verse 32):

And David said to Abigail, Blessed be Jehovah, the God of Israel, who sent thee this day to meet me...

Charles could have been considered analogous to David, while the city itself could have been considered analogous to Abigail. The presentation of the keys of the city may be seen as analogous to the gifts brought by Abigail to David, not to mention the parallel gifts of wine and food, and the city's exchange of continued support for confirmation of its charters. Considering the small number of Bible stories dealing with honor given to, or to be given to, someone who is second under a living king, the analogous reference is not too strained.

The Leiden Rhetoricians' Chamber was no stranger to major dramatic performances, having been host to the "*landjuweel*" dramatic competition held in Leiden on March 24, 1493. Rhetoricians' Chambers from the cities of Holland, Brabant, and Flanders visited Leiden to compete for a valuable prize made by the Leiden goldsmith Willem Jansz.[12] The prize was worth about as much as two months' salary of the city secretary, a highly-paid official.[13] The Leiden competition must have been part of a series of dramatic contests, because the "jewels" ("*Juwelen*") had to be brought to Leiden for this particular competition from Brabant. The Leiden 1493 *landjuweel* contest contradicts, incidentally, the presently accepted opinion that a *landjuweel* took place exclusively between the Rhetoricians' Chambers of Brabant and not before the sixteenth century.[14] 1493 was a time of financial difficulties for the city government of Leiden because of war debts and problems with the drapery industry.[15] Evidently the financial problems did not directly affect cultural life, in so far as the highest levels of society were concerned.

The visit of Frederick III in 1485-1486, mentioned in connection with the city's commissions for decorations provided by Jan Jacopsz., can also be considered a "joyous entry," although it is not mentioned in the published literature on the subject.[16] Perhaps the unreliability of published literature for drawing conclusions about differences between "Northern" and "Southern " Netherlandish culture is indicated. Such differences are presupposed by D. P. Snoep. For example, the visits to Leiden in 1508 and 1515, where the court brought along its tapestries and choir, while the city paid for various decorations and commissioned a new play, do not permit the simple statement that, "The extent of these decorations remained far behind those which were provided in the Southern Netherlands, however."[17] Leiden's tapestry work from the time may be unknown, but Leiden's music is not.[18] The Pieterskerk choir books contain music by Josquin des Prez, Clemens non Papa, Adriaen Willaert, Cristobal Morales, and others, some of whom were choir masters in Leiden. It may be assumed that the court choir sang well in the service for Charles V in 1515; but it cannot be supposed that it presented a form of musical quality unimagined in culturally impoverished and uneventful Leiden, as it has been described within the last hundred years (when such music has been unavailable in the Pieterskerk).

I should like to suggest a hypothetical connection of an engraving by Lucas van Ill. 46

Leyden with the 1515 entry (as a sort of parallel to Harbison's suggestion for 1508). Lucas' *Triumph of Mordecai*[19] can be seen as an allusion to Charles' entry into Leiden.

The Triumph of Mordecai is dated 1515 on the plate. The engraving depicts Mordecai on a horse, seen as having entered a sixteenth-century town through a masonry gate and surrounded by people dressed in early sixteenth-century clothing. The spearbearer walking beside the horse of Mordecai wears the clothing decorated with slashings characteristic of the militia clothing of that time. Further indication of the allusion to Charles may be sought in the story of Mordecai itself. The engraving illustrates part of the book of Esther, 5: 6-11.

> So Haman came in. And the king said unto him, What shall be done unto the man whom the king delighteth to honor? Now Haman said in his heart, To whom would the king delight to do honor more than to myself? And Haman said unto the king, For the man whom the king delighteth to honor let royal apparel be brought which the king useth to wear, and the horse that the king rideth upon, and on the head of which a crown royal is set: and let the apparel and the horse be delivered to the hand of one of the king's most noble princes, that they may array the man therewith whom the king delighteth to honor, and cause him to ride on horseback through the street of the city, and proclaim before him, Thus shall it be done to the man whom the king delighteth to honor.
>
> Then the king said to Haman, Make haste, and take the apparel and the horse, as thou hast said, and do even so to Mordecai the Jew, that sitteth at the king's gate: let nothing fail of all that thou hast spoken. Then took Haman the apparel and the horse, and arrayed Mordecai, and caused him to ride through the street of the city, and proclaimed before him, Thus shall it be done unto the man whom the king delighteth to honor.

An analogy can be drawn between the procession of Mordecai and Haman, and the procession of Charles and his nobles, because both Mordecai and Charles were sent by kings who wanted honor done to them. The Netherlandish practice of using analogies has been discussed with reference to the depiction of contemporary history (1500-1800) by van de Waal.[20] The analogy between Mordecai and Charles, who was heir to Maximilian, and, thus, second most important person in the government, is supported in Esther 10:3.

> For Mordecai the Jew was next unto the king Ahasuerus, and great among the Jews, and accepted of the multitude of his brethren, seeking the good of his people, and speaking peace to all his seed.

As H. de la Fontaine Verwey remarks in connection with "Joyous Entries," Erasmus hoped, in his advice to Charles V in 1516, that the Christian prince would maintain peace and be accepted by his subjects through respect for their institutions.[21] These institutions were contained in the charters and liberties which were confirmed for each of the cities on the route of the "Joyous Entries" as the people in return accepted their new sovereign.

Besides "Joyous Entries," the city received official visitors lavishly. In 1539, for example the city was host to Joris van Egmont, Bishop of Utrecht, and Jean II Carondelet, Archbishop of Palermo, on a joint visit, as well as to Margaret of Austria, regent of the Low Countries ("deze landen van harwairts over").[22] It is conceivable

that the wine presentations at these visits led to the necessity of complete renovation of the city's large pewter wine tankards, carried out in November that year by Mathys (Engebrechtsz.).[23] These tankards (now in the Leiden Municipal Museum "De Lakenhal") were undoubtedly used the following year for presentations during the "Joyous Entry" of Charles V, 1540. Leiden spent a total of £ 588/17/8 (Flemish; = ca. £ 4630 Hollands) on the visit. The details of the expenses were specified in a separate notebook, now lost. With costs for food and drink subtracted, Leiden paid ca. £ 2400 Hollands for plays, decorations, etc. [24] This may be compared with the supposed extraordinarily expensive show put on by Utrecht in the same series of entries, which cost "ca. 2300 pounds" for such items.[25]

Notes

1. S. A. 588 (Thesauriers Rekeningen 1507-1508), folios 55 and f.
2. C. Harbison, "The Problem of Patronage in a Work by Lucas van Leyden," *Oud Holland*, LXXXIII, 1968, 211-216.
3. The existence of documentation indicating that early artistic competence was at that time equated through the word "prodigy" with such things as two-headed pigs and other natural oddities might strengthen Harbison's argument for an audience. Such documents do not seem to be preserved in Leiden.
4. S. A. 595 (Thesauriers Rekeningen 1514-1515), folio 76 and f.
5. The following people received gifts of wine: the Ambassador of Spain, the Ambassador of England, the Count Palatine, the Count of Nassau, the Lord of Ravesteyn, the Lord of Cheviers, the Lord of Reulx, the Lord of Ysselsteyn (who was Stadholder of Holland), the Lord of Montigny, the Lord of Arenberch, the Lord of Lalaing, the Lord of Wassenaer, the Prince of Symay, the Lord of Brederode, the Lord of Sevenbergen, the Lord of Gaesbeecke, the Lord of Vaulx, Don Pietro de Poertecariere, the Lord of Mingebal (?), the Chancellor of Charles, the President of Holland, the Dean of Besançon, Mr. Loeys Boussenaey, M. du Marques, Mr. Jan Auxtruyes, the Audiencer, the Procuror General, Mr. Charles de Verde Rue (secretary), the treasurer general, the Marshall of Lodgings, the President of Burgundy, the provisioner of the corps Cortenille, the provisioner of the corps Amensdorf, M. the provost *d'hôtel*, the *hofmr.* Danelu, the *hofmr.* Moukeron, the *hofmr.* Bouton, the guard of the regalia, the chapel of Charles (including the chaplains, priests, choristers, and others), the two surgeons, the two doctors of Charles, the thirty-seven personal archers of Charles, the *hofmr.* Hesdin, the *hofmr.* Alart, the *hofmr.* Brezellis, the Almoner, Mr. Pieter Picot, Mr. Loeys Barengier and Jehan de Marnicx (secretaries), Vredrick van Baden (Bishop of Utrecht), the Bishop of Baderoesse, the Abbot of St. Martin's, the Provost of St. Salvator's, the suffragen bishop of Utrecht, the Guardian of the *Observanten* or Friars Minor of Bruges, the Friars Minor outside Leiden (who participated in the welcoming procession). Gifts of other sorts were given to other members of Charles' party, including his tapestry weavers. A similar group is listed for the entry of 1508; these entries were not little parades brought in by the local brass bands.
6. S. A. 595, folios 86 and f.
7. The *Blauwe Steen* (Blue Stone), lying in the middle of the Breestraat near the city hall, marks the junction of the original quarters of the city. It is at the junction of the Breestraat with the Marsmanssteeg, which continues over the Hoochstraat (which had the *Witte Steen*, White Stone, and is at the head of the island forming the St. Pancraes parish), and further to the present Haarlemmerstraat, where the *Roode Steen* (Red Stone) was located in the Parish of Onse Lieve Vrouwe. (The *Blauwe Steen* lies in the St. Pieters Parish.)
8. S. A. 84, folio 198.
9. S. A. 595, folios 86 and f.
10. S. A. 595, folio 87: Item gegeven/Dirck Hugez. schilder/vyf Ryns gulden/ ter cause/ dat hij gemaect

heeft die frangen ende die sloetelen (= keys, the arms of Leyden) die zyn aen die wimpelen/ hangende aender stede tropetten ende claroenen/ facit £ 6/13/4.

11. The term used for the mimed play is "*stomme personnaige*," while the other two are described as "die andere twee batamenten" (comedies).

12. S. A. 563 (Thesauriers Rekeningen 1492-1493), folio 118.

13. See S. A. 563, folio 134 verso.

14. See G. J. Steenbergen, "De betekenis van de benaming Landjuweel," *Leuvense Bijdragen*, XXXIX, 1949, 10-20, an article with remarkable presuppositions of cultural backwardness in the area which has become the present Netherlands: see also G. P. M. Knuvelder, *Handboek tot de Geschiedenis der Nederlandse Letterkunde*, 's Hertogenbosch, 1970, I, 363,

15. See S. A. 382, 1465-1504, folio 399, August 6, 1493, for example, as well as other notes for that year on adjacent folios.

16. See D. P. Snoep, *Praal en Propaganda, Triumfalia in de Noordelijke Nederlanden in de 16de en 17de eeuw*, Alphen aan den Rijn, 1975. Snoep mentions only a visit to Haarlem in 1478 and another to Amsterdam in 1497 as being the earliest princely visits on record.

17. Snoep, *Triumfalia in de Noordelijke Nederlanden*, 14.

18. Among other places, for a description of the contents of Leiden's choir books, see A. Annegarn, *Floris en Cornelis Schuyt, Muziek in Leiden van de vijftiende tot het begin van de zeventiende eeuw*, Utrecht, 1973, 15-18. (= Rijksuniversiteit Utrecht diss.; = *Muziekhistorische Monografieën uitgegeven door de Vereniging voor Nederlandse Muziekgeschiedenis*, no. 5).

19. B. VII. 355. 32.

20. Van de Waal, *Drie Eeuwen Vaderlandsche Geschied-Uitbeelding*, Lucas' engraving should be compared with the woodcut of "Maximilien I" in *NAT*, Anvers, Jan de Gheet, I, no. 1: MAXIMILIEN I. Gravures sur bois, chansons, musique en son honneur, 1515.

21. H. de la Fontaine Verwey, "De Blijde Inkomst en de opstand tegen Phillips II," *Uit de wereld van het boek, I, Humanisten, Dwepers en Rebellen in de Zestiende Eeuw*, Amsterdam, 1975, 115-116.

22. S. A. 621 (TR 1538-1539), fol. 38 and fol. 53 verso. The presence of Jean II Carondelet together with Joris van Egmont in this year is a contact missing in the description of Jan van Scorel's contacts and his opinion about a medal of Carondelet, in Snoep, "Jan van Scorels activiteiten," *Jan van Scorel in Utrecht* (exhibition catalog, Centraal Museum Utrecht; Musee de la Chartreuse, Douai), 1977, 41. The implication of a later possible date for Jan van Scorel's portrait of Jean II Carondelet has been suggested to me by M. A. Faries (oral communication, April, 1977).

23. S. A. 621 (TR 1538-1539), fol. 53 verso.

24. S. A. 622 (TR 1539-1540), fol. 39 verso.

25. A. M. C. van Asch van Wyck, *Plegtige Intrede van Kaiser Karel den Vijfden in den jare 1540*, Utrecht, 1838, 34 cited in Snoep, *Triumfalia in de Noordelijke Nederlanden*, 161.

12. Pieter Cornelisz. Kunst and the Pieterskerk Pulpit

Before the Reformation Leiden had three parish churches, the St. Pieterskerk, the St. Pancraeskerk, and the Onse Lieve Vrouwe Kerk.[1] Oldest and chief among the three is the Pieterskerk, consecrated in 1121 in honor of SS. Peter and Paul.[2] A study of pre-Reformation furniture of this church, which had more than thirty-five altars before the Reformation, would provide important information about its appearance in the sixteenth century and about the changes which occurred at the Reformation (1572) and into the seventeenth century.[3] No such complete study, like J. Mosman's for the St. Janskerk (Cathedral) of 's Hertogenbosch[4] or D. P. Oosterbaan's admirable history of the Oude Kerk (St. Hypolitus) of Delft, seen in all its pre-Reformation social relations,[5] will be given here. The Pieterskerk retains only three major pre-Reformation items of furniture, the pulpit, the choir screen, and the organ: items like the 1565 choir stalls and the large transept windows made by Geryt Boels in Leuven (donated by Bishop Joris van Egmont of Utrecht) and by Willem Tybout in Haarlem (donated by heer Jan Wit) have long since disappeared.[6] I have given a brief account of the mid-sixteenth century Niehoff organ of the Pieterskerk elsewhere,[7] so that here the pulpit and near contemporary choir screen frieze can receive attention, as examples of Leiden's cabinetmaking, sculpture, and familiarity with Renaissance design in the first third of the sixteenth century.

The extent of familiarity with the "antique" decorative elements which differentiate Renaissance woodcarving from "modern" gothic work in the first half of the sixteenth century provides an approach to the problem of comparing Leiden's artistic and cultural level with that of other cities. The Leiden work to be studied is the Pieterskerk pulpit, for which Pieter Cornelisz. Kunst was paid for designs in 1532. It is his only documented work presently recognized and it will be compared with representative works of the same year or close to it commissioned in other parts of Europe, including present Belgium (the cultured "Southern Netherlands"), as well as with a similar, anonymous work in the province of Utrecht. Pieter Cornelisz. Kunst's designs were carried out by three other people (the nature of the design required this devision according to guild regulations; the statement is not based on some sort of recognition of three separate "hands"). One of them is named in the documents, the cabinetmaker who carried out the bulk of the work, and who, according to custom must have subcontracted the parts he was not allowed to make himself. Another can be identified with reasonable certainty through occupational descriptions in the documents which indicate that he (or one other person in Leiden) was named as qualified to do the sculptural carving. Much of this sculpture, however, has disap-

Ill. 47,48

Ill. 49,50

peared, but a few parts remaining on the pulpit were required to have been carved by a sculptor, not the cabinetmaker. The stonework of the pulpit's base was also carved by a sculptor, but it may have been another, a stonecutter without the guild qualifications to carve figures. The pulpit, thus, is a piece designed by Pieter Cornelisz. Kunst and carried out by other people.[8] It does not provide grounds for recognizing personal aberrations which might be considered the stylistic characteristics of the designer himself. Instead it is a joint product of a group of people from Leiden, in a year in which Leiden was supposed to have been artistically declining and sinking into a period of inactivity; and in a year when, according to presently published information, its designer was probably inactive or even deranged.[9]

The Documents

Four documents refer to the pulpit in the year of construction.[10] The payment notes name the designer, Pieter Cornelisz. Kunst, the son of Cornelis Engebrechtsz. Daniel Willemsz. the cabinetmaker is named as the pulpit's carver in another payment note, whose interpretation is open to some question. He received 6 schellingen for travelling to The Hague to make a design or construction drawing connected with the Pieterskerk pulpit. Presumably the drawing was based on the pulpit in the St. Jacobskerk in The Hague, whose interior was destroyed by fire in 1539.[11] The document, however, does not specify where he went in The Hague, and while the Grote Kerk is most likely, there were several chapels also possible. In addition to these two payments two others refer to the wood used in the pulpit and its canopy, thereby establishing that the two date from the same commission and that pulpit and canopy were conceived as a unity.[12]

The Pulpit

How much freedom for variation from Pieter Cornelisz. Kunst's design was left to Daniel Willemsz. is impossible to know. The total conception must without doubt be attributed to Pieter Cornelisz. Kunst. The closeness to the design drawings for the pulpit of Strassbourg, preserved in the Cathedral Museum, to the work carried out on the actual pulpit suggests that Daniel Willemsz. and the other craftsmen kept fairly closely to what was set out, but there are not enough preserved drawings connected with preserved works for generalization.

The apparent base (nineteenth-century floorboards may hide some further complication at floor level) develops from an octagon through various levels of intersecting stone squares to varied octagonal forms which become the bases of niches. These then expand to the octagonal level which includes the stone pendants which are the bases of the corner columns and the pedestals in the niches of the wooden section of the pulpit. (The pedestals and the capitals of the columns, which serve as small pedestals, are now empty.) Such a unity of conception through various materials could not be the product of a woodcarver and a stonecarver independently

114

designing their sections and then trying to devise a means of junction. Moreover, photographs from before the first "restoration" in 1860 (when the pulpit was moved one pillar westward to its present location) show that the stone pendants forming the base of the wooden pedestals were painted to look like wood.[13] It is also reasonable to assume that the remnants of paint on the wooden band at the base of the pulpit's door show it was painted to look like the stone parts of the rest of the octagon of stone which it continues. D. Bierens de Haan, writing without documentation, thought that the design was the work of a stonecutter, who started with the base and kept on going.[14]

The dominating seventeenth-century sounding board should be momentarily ignored and the sixteenth-century canopy mentally lowered to the position now occupied by its present successor.[15] The octagonal basic design, which within the pulpit proper had divided into a sixteen-sided form, can be seen to continue up into various squares which finally shift through curves and a kind of erased square or nascent octagon into a circle. This was originally the base of a statue. It now supports the weighty shape of a seventeenth-century obelisk.[16] All the parts are evidently planned so that the fineness of detail is related to the visibility of the decorated piece within the original design. The present invisibility of almost every detail of the sixteenth-century canopy is caused by the seventeenth-century sounding board, which is just large enough to block every close view of the fine carving above it.

Full design drawings for the pulpit, if preserved, have not been recognized. Such Ill. 53, 54, 55
drawings would have been of several sorts. There must have been sketches for the whole design. There must have been drawings showing the precise working out of details like the intersecting squares in the base (a possible candidate for this is discussed below). There must have been general plans for every repeated section of ornament on the wooden parts. The pulpit's tracery was probably also set out in a drawing by Pieter Cornelisz. Kunst; it is repeated with only minor variation on all sides. Smaller generally repeated elements which show differences in carved decoration among themselves, like the carved vaulting of the niches in the pulpit, may have been left to the ingenuity of Daniel Willemsz.

Design Sources: a Drawing and some Prints

The *Basler Goldschmiederiss* includes a drawing[17] which looks remarkably similar to Ill. 51, 52
the lower part of the base of the Pieterskerk pulpit, up to the expanding stone octagon. The simplicity of this part of the design of the pulpit, however, precludes stating that there is necessarily a connection between the drawing and the pulpit. Nevertheless, the points of similarity must be enumerated, together with the differences; and the various possibilities of connection explored.

The lower half of the drawing is fairly similar to the pulpit base. The central sequence of rising squares in the pulpit photograph can be seen to have the details of those center and side sequences in the drawing, where at the sides the sequence is shown to connect with the base. The shorter intersecting squares of the pulpit find parallels in the drawing also, but with the problem of a drawn form of a curved

triangle which cannot be resolved three dimensionally. A similar problem appears on the drawing directly above, where at the lower level of the top half of the drawing a transition is drawn with curved triangles and two semicircles. While the first inconsistency can be explained as a technical problem for the draughtman which might have been understood as a formalized indication of what is on the pulpit, the second problem, with its semicircles, is far more complicated. I suggest that its problems were avoided and that the simpler octagon of the pulpit was substituted from that part upwards, with relatively free use of the projecting profiles suggested by the drawing.

The differences involve two types of problematical visualization. The first is that photographic conception was not known, so that a short-hand indication then understood may appear incomprehensible as a three-dimensional shape now. Other examples of such incomprehensible lines can be found easily enough, such as in the Basel drawings illustrated with this particular one by O. von Simpson,[18] or in the earlier drawings of the ambulatory chapels of Rheims by Villard de Honnecourt. A second type of problematical visualization is where it may be assumed that the draughtsman left the working out of his drawing to the carver, and one of the most detailed examples where this seems to have been the case is the famous drawing of the choir of San Juan de los Reyes, Toledo, by Juan Guas (Prado), illustrated by A. L. Mayer.[19] The detail of the drawing shown in Mayer's fig. 62 includes curved lines, similar to those in the Basel drawing, at the left base, absent from the right base, although both bases are clearly intended to be the same in construction. More details of the same sort are seen on the drawing in close inspection.[20]

There are several ways to imagine a possible relation of the Basel drawing to the Leiden pulpit without immediately calling it a design for Leiden. It may be a design for another pulpit, later copied in part at Leiden.[21] It may be the copy made for Leiden (perhaps by Daniel Willemsz.). It could be merely similar, although the absence of most pre-Reformation pulpits in the Low Countries and northern France makes further speculation wasted effort.

Ornament prints can be connected with several parts of the Leiden pulpit canopy, but the double row of pierced foliate ornament at the top of the pulpit proper seems to be the only item there with any general correspondence with prints.[22] However, this device of of a circular cross-section of two rows had been common in sculpture during the preceding two hundred years, and required no introduction through prints.[23] That engravings were used as examples for pulpit carving is shown by P. Poscharsky, who, however, is concerned only with the iconographic scenes, not ornamental panels or sections.[24]

Ill. 54 An ornament print which seems to have provided some inspiration for the design of the pierced carving of the pulpit is one of Lucas van Leyden's engravings.[25] The lower design in the engraving can be traced, minus the axial stick, from the left side of the lower section of pierced carving in the front of the pulpit. The upper design in Lucas van Leyden's engraving seems to have served as the basis for the carving to the left of the section of carving based on the lower half of the engraving. It can easily be traced from right to left.[26]

While other sections of the pierced carving of the pulpit may be derived directly or indirectly from this or other ornament prints, no close connections have been dis-

covered.[27] The carving of the parts evidently based on the print just mentioned is simplified from what is depicted. The other sides of the pulpit may represent nothing more than further developments of the ideas found in the print recognized here as a possible source.

The design of the stalks beside the central skull in Lucas van Leyden's 1527 ornament engraving[28] is reminiscent of the general design of the four wooden pillars on the left side of the pulpit. The general ideas, however, were not invented by Lucas van Leyden; they indicate the use in the pulpit of decorative themes seen throughout Europe.

The comparison of parts of the pulpit with possible sources in ornament prints is severely complicated by the general use of similar designs. The pulpit's canopy gives several examples of design elements which may have been derived from ornament prints. The major source for the pendant boss in the center of the lowest (sixteenth-century) canopy level seems to have been an ornament print by the monogramist NWM, dated 1534 on the plate.[29] If the print was indeed used, it indicates that the canopy was still under construction after 1534 and that the details of the general design of the pulpit and canopy remained subject to change during the work. Such progressive alteration, however, is inconsistent with the usual legal stipulation that commissioned work be carried out according to a design drawing given to the contracting craftsman by the group commissioning the work, and which served as the legal standard for judging whether the work had been carried out according to contract. *Ill. 56,57,59*

The spokes of the octagon in the pulpit's canopy have the same design as the center post between the octagon and the square above it. The design is inverted with the pendant boss as the base of the spokes and the shell motif marking their tops, as the same motif marks the top of the center post.[30]

The octagon of the canopy is divided by the spokes into eight fields. Four are filled with a repeated carving of a foliate man; the other four, arranged alternately, are filled with a repeated carving of a branching foliate central post. The design of the foliate man is very much like the one in an ornament print by H. S. Beham.[31] The branching foliate central post (carved in relief) is less specific. It could easily be a new invention or a mixture of ideas from various sources. The tops of the four central foliate posts and the crossed stems and leaves reappear in one of Aldergrever's prints dated 1529 on the plate.[32] *Ill. 61,62*

The complicated and repeated variations on common themes raise the possibility that Pieter Cornelisz. Kunst arrived at his design without reference to the prints which came closest to it. He must have been aware, nonetheless, of the variations being played in the ornament print business. This evident awareness is what attracts attention, because it goes against the idea of occasional outside contact providing barely comprehended inspiration for Leiden art and in contrast shows an up to date consciousness of current Renaissance art.

The vertical edge of the canopy's octagon has sides with alternating patterns of decoration. The decoration may be generally compared with the woodcut ascribed by Beets in 1907 to Dirck Vellert.[33] The triple leaf form seen in the top row of carving on the rim is both typical of the time and an item which draws attention to the similarity *Ill. 58,60*

of the canopy to the cupola construction depicted at the top in the woodcut *Maximilian's Triumphal Arch* (dated 1515, first published 1518), by Dürer and others.[34] Such cupolas are often seen on contemporary organs, for example that of Amiens.

Ill. 63 The four outside pillars which support the square canopy do not seem to be derived from any particular ornament prints. The circular medallions are typical for the period 1500-1550 and are similar to those seen on other furniture from the time as well as in prints and drawings.[35] These columns have bases like the bases of the pillars on the pulpit proper.

Ill. 57 The underside of the top section is a combination of shell and plant ornament which does not seem to be based on any particular design source. Between this square and the smaller square which is the base of the obelisked pedestal is a small vertical section with the painted inscription: Ick Ben/ Die Wech Die Wareheyt/Ende Dat Leven/Sint Jan II XIIII.[36] The inscription was probably altered during repairs in 1860 (the verse is in fact John 14: 6). The inscription must pre-date the raising of the canopy in 1604, because after that the inscription was hidden from view. The square curved top leading to the pedestal shows carving like the design on a simple ornament print by NW.[37] The design in the print is seen upside down, split at the center and applied along two sides of the square at each use.

The quotation of John 14:6 leads naturally to questions connected with the Cranach-program Lutheran pulpits discussed and helpfully schematized by Poscharsky.[38] Its presence raises the question of Reformation overtones, since it appears (from letter forms and the later removal from view) to pre-date the Leiden Reformation. The verse is not cited by Poscharsky as being on pre-Reformation or post-Reformation pulpits in Germany or other areas he covers.[39] The interpretation of the verse is also unclear with respect to possible indications of Protestant sympathy or tendencies towards reform within the church. The problem is that exclusivity of use and exegesis could not be claimed by any church group. Lutherans or Luther sympathizers within the church (as they remained in Leiden)[40] might have seen in the verse an unequivocal statement in which Christ is indicated as the Way, etc., in contrast to the ways of Rome; and later the same sentiments might be projected on the verse by the Reformed group. Alternatively the verse could be used by anti-Lutheran, anti-Reformed, Roman Catholics as a statement about the Church as exemplifying the Body of Christ.[41]

Poscharsky has demonstrated that pulpit iconography was transformed through the Lutheran Reformation under the direct influence of Lucas Cranach's *Old and New Testaments* (1529) and its immediate variants.[42] The transformation was the application to pulpits of the existing tradition in painting and other two dimensional art, of connecting Old and New Testament parallels and of using them as analogies to the Crucifixion and Redemption, combined with the pictorial traditions related to the Last Judgement. An earlier habit on pulpits had been to depict the four evangelists with a central depiction of some other figure, for example, the church's patron saint, Christ Crucified, or, in at least one case, Christ among the Doctors (Naumburg, 1466). An alternative to the four evangelists was provided by the four Doctors of the Church (as being great preachers), SS. Jerome, Gregory, Augustine, and Ambrose.[43] These

groups of four could be combined, as in the pulpit of Aranda de Duero in Spain, from Ill. 65,66,67 the same year as the Leiden Pieterskerk pulpit, 1532.[44] The earlier programs were not suddenly replaced in all Lutheran or Reformed churches, but the Leiden inscription is clearly in line with the Cranach program as studied by Poscharsky. The inscription, therefore, has some significance for any guesses which could be made about the sculpture which once stood in the five major niches on the Leiden pulpit. That these sculpture pieces must have been carefully removed is indicated by the excellent Ill. 54,55 preservation of the rest of the delicately carved and fragile pulpit. The careful removal occurred after the Reformation at the command of the city government; in itself the removal does not indicate what program was present (for example, the Four Fathers), it indicates only that all "*beelden*" (statues) were removed. These statues could just as easily have followed the Cranach program, in no way capable of exclusivity of use by Lutherans, which was spread through woodcuts. And the statues could have depicted Ill. 68 the four evangelists, as on the lectern of the church of Brou, Bourg-en-Bresse, also from 1532. Such statues were easily removable, because they merely rested on their pedestals or in their niches, attached at most with glue of some sort. (This form of attachment is visible at Brou, Aranda de Duero, and even on some stone altarpices in France; it is obviously a solution to the division of labor imposed by guild regulations.)

Also depicting the four evangelists, with *The Baptism of Christ* as center panel, is Ill. 72,74 the undated pre-Reformation, sixteenth-century pulpit of the parish church of Abcoude (province of Utrecht). This pulpit is in a church now Reformed and its carvings are preserved, almost certainly for no other reason that that they are reliefs instead of the more complicated free-standing figures once in Leiden and still at Brou. To have removed the Abcoude reliefs would have meant dismantling the whole pulpit. *The Baptism of Christ* is a scene comparable to *John the Baptist pointing to the Lamb of God,* the central panel of the pulpit in Aranda de Duero. Both refer to the sacrificial death of Christ[45] or, in other words, to Man's redemption.

It is in the different ways of naming the reference that a problem of interpretation occurs. According to Poscharsky,[46] it is possible to identify a theme on a pulpit of 1550 (Borna bei Oschatz) as demonstrating that the teaching of Christ had been made immediately accessible to the congregation by Luther's translation of the Bible into the people's language. The three scenes are centered on a depiction of *Christ among the Doctors.* To one side is a monk carrying a heavy book, presumed to be Luther. To the other side is a praying woman together with a man whom she points to the central depiction of Christ. The couple are considered representatives of the congregation as such. The dissociation of the central theme from its earlier accompaniment, the Four Doctors, is considered to indicate the immediacy granted by Luther's translation. This seems reasonable.

But if it is accepted, the Abcoude pulpit is open to similar interpretation, without any aid from a presumed depiction of Luther. The central scene is available to the congregation through the words of the evangelists. At Aranda de Duero, however, the more or less identical central theme is available to the congregation through the four evangelists and the Four Doctors. Moreover, the canopy there includes the apostles and is surmounted by the Virgin Mary. How far interpretation can be read into the

Abcoude pulpit is difficult to decide, especially in the absence of nearby comparisons. The four evangelists were traditional on pulpits. The central theme appears at Abcoude and at Aranda de Duero and some others, but not as a central theme in the pulpits studied by Poscharsky. What was said from these pulpits probably had more importance for most of the congregation than what was carved on them (good at most for only a few sermons a year, and visually not all that inspiring).

The possibilities can, nevertheless, be studied further. The pulpit of the Oude Kerk, Delft (carved date: 1548) has *The Baptism of Christ* as central panel with the four evangelists on the sides, as at Abcoude. This is also now Reformed. (The canopy is a recent addition.)[47] The pulpit of the St. Janskerk of 's Hertogenbosch (made a cathedral in 1559), which is undated but was built between 1541 and 1566, is more complicated. The pulpit proper shows five scenes of preaching: (center) Christ preaching the Sermon on the Mount, (left to right) SS. Peter, John the Baptist, Paul, and Andrew. The canopy, not considered to have been originally part of a coherent design with the pulpit, but an addition made soon after the pulpit (an opinion I doubt), has the symbols of the four evangelists, statues of Christ and the apostles, statues of the Four Doctors, and it is surmounted by a modern cross. It also has figures of Moses, the Four Great Prophets, and St. Joseph. What might seem a mild indication of Reformation tendencies in the pulpits of Abcoude and Delft can, through comparison with this collection, also be interpreted as the result of removal of hypothetical further symbolism once found on the canopies.[48] This reasoning results in the hypothesis that what remains is what could be accepted by a post-Reformation church in Abcoude and Delft.[49]

Ill. 60

The question is returned to Leiden and its empty niches. The most easily filled space is that of the surmounting figure at the top of the canopy. Presumably the present obelisk takes the place of a statue of Mary, although a figure of Christ as *Salvator Mundi* is also possible (although generally a later iconographical idea) or a figure of St. Peter as the church's patron. Against the idea of St. Peter as patron is the double patronage of the church, as mentioned above, and the placement of a scene of the martyrdom of St. John on the panel between pulpit and canopy in the St. Janskerk in 's Hertogenbosch. The Leiden panel for that location is missing. My opinion is that Mary is the most likely figure for the pulpit's top.

The niches of the pulpit proper may be given one or another of the following possible programs. (1) Centering on *The Baptism of Christ*, or *John the Baptist pointing to the Lamb of God*, could be the four evangelists and in groups of two, the Four Doctors. Variations of this could include reversal of the positions of evangelists and doctors, or the replacement of one or another set of four, at the sides near the pillar against which the pulpit stands, with single figures of the church's two patron saints, and the four single figures centered on the front could be the Four Doctors, each depicted with their attributes (such as St. Gregory's tiara) together with one of the symbols of the evangelists. (2) The scenes of preaching could be depicted, as at 's Hertogenbosch. (3) An alternative for the central scene would be the *Crucifixion*, as at Strassbourg (1486). (4) The central figure at Leiden could have been *Christ Teaching*, as at St. Goar and Mosselweiss, cited by Poscharsky.[50] (5) The central scene could have depicted the twelve-year-old Jesus in the Temple, although Poscharsky knows of

120

only one example of this theme not produced by the Torgau studio of Simon Schröter the Elder.[51]

There is no documentary evidence presently known to indicate Lutheran sentiments in Leiden strong enough to have led to a pulpit whose decoration was based on the Cranach scheme discussed by Poscharsky despite the presence of the text John 14: 6. For that reason traditional iconography is here assumed for the pulpit, regardless of what the program was in detail.

Finding the statues themselves is probably impossible, but still a few hints are valuable. According to guild regulations, statues of the sort had to be carved by a sculptor, while the canopy and pulpit structure was made by the contracting cabinetmaker.[52] There are, however, two existing parts which required subcontracting, also. The columns had to be turned (in the rough) by a turner (*"stoeldraeyer"*) and the medallions had to be carved by a sculptor. These medallions, then, give an idea of the work of the sculptor who collaborated with Daniel Willemsz. on the pulpit. Their type, circular medal-like heads, indicates that they were carved not by just any Leiden sculptor in the records, but by one who is recognized as an *"Antijquesnijder"* (carver of deep relief "antique" or Renaissance ornament). Two Leiden sculptors of the time are called this, Cornelis Mercelisz.[53] and Pieter Claesz. van Balen (also a book printer). In the absence of others in the time of the pulpit's construction I consider it permissible to ascribe the medallions and the missing sculpture to "Cornelis Mercelisz. or Pieter Claesz. van Balen," until documentary evidence can be found to indicate with certainty who did the work.

An idea of the appearance of these missing statues can be obtained by considering Ill. 64 them probably to have looked rather like the *Madonna and Child* now in Haarlem (Bisschoppelijk Museum) donated from the village of Katwijk near Leiden; and the *Madonna and Child* with fragments of a niche, now in Beverwijk (donated to the St. Agatha Church, 1574, by the parish priest, who had come from Haarlem).[54]

The pilasters of the Beverwijk niche recall the upper pillars of the Leiden pulpit canopy.

With the Leiden Pieterskerk pulpit firmly ascribed to Pieter Cornelisz. Kunst, it might be tempting to cast about for other things to which his name could be attached without documentation. This art critical game produces one suggestion from the mass of anonymous paintings: the painting now in separate fragments depicting SS. Boniface, Gregory, Adelbert and Jeroen of Noordwijk; and Gertrude, Scholastica, Walburg, and Kunegund.[55] The painting, dated 1530, has designs in its architectural details which recur in the Leiden pulpit. However, the painter may have come upon these ideas independently; or the painting may have been the source of ideas for Pieter Cornelisz. Kunst two years later. A possible connection with the Abbey of Egmond is of no significance in locating the painter, since, as I have demonstrated in studying the commissions received by the Leiden tapestry weaver Willem Andriesz. de Raet, the Abbey of Egmond commissioned tapestries with gold thread to be made in Leiden.[56] A painting of the Holy Kinship is supposed to have been painted by the "Master of 1518," already mentioned for a painting of the *Last Supper* with a donor whose arms were those of Lucas van Leyden's step-mother's family.[57] In the *Holy Kinship* "gothic" tracery panels form the back of a chair like the sides of the Pieters-

kerk pulpit; and the "Renaissance" ornament above and at the sides of the chair is very much like things be seen in the canopy of the pulpit. But these details may have been common property, so that the present attributions to the "Master of 1518" and "Jan Joesten van Hillegom?" could remain believable — on the premise that the art of the "Northern Netherlands" is not distinguishable from contemporary art in the "Southern Netherlands." And an attribution to anyone, Jan Joesten van Hillegom? included, will have to wait for documentation.

Comparisons

Ill. 73,75,76, 77,78,79 The Leiden pulpit decoration should first be compared with the carved frieze of the Leiden Pieterskerk choir screen. That the two are probably part of a joint commission, for which the documentary evidence on the frieze is lost, is suggested in two ways. First, two dated ornament prints only can be connected with the frieze, one of 1527 and the other of 1532.[58] The designs have nothing that points to inspiration from later work. Second, there is a parallel at Abcoude for a jointly commissioned pulpit and choir screen, undocumented, but proven by the presence of identical design segments in both. These are repeated sections including a diamond containing a foliate man's face. This is worth attention, because the Abcoude pulpit's original placement was against the center south pillar of the nave, just as at Leiden. The pulpit was thus equally distant from the related choir screen.[59]

Ill. 80,81, 82,83,84, 85,86,87, 88,89,90,91 The Leiden frieze is work which had to be done by a sculptor. It may be assigned to Cornelis Mercelisz. or Pieter Claesz. van Balen for the same reasons as are connected with the pulpit medallions. The medallions on the choir screen naturally show similarity (as do many medallions of the period). The design may be presumed to be from Pieter Cornelisz. Kunst, although documentary evidence may in the future alter this presumption.

Ill. 68,69, 70,71 Taking the Leiden pulpit together with the Leiden frieze it can be seen through a few simple photographic comparisons that Leiden's design work, cabinetmaking, and sculpture ca. 1532 was on a level which cannot be considered backward for non-Italian Europe. The items chosen for comparison are the following. The lectern of 1532 at Brou, which combines antique and modern design elements just as in the Leiden pulpit and which represents the work most prized by the Brussels court. As mentioned above, it retains its corner statues of the evangelists. The apsidal choir screen of Chartres has sections dated 1529 in which minor bands of "antique" ornament are what fills screens of "modern" tracery. Similar combination as in Leiden is seen in the near contemporary altarpiece of St. Crispinus in the parish church of St. Nicolas, Kalkar; in the screens from Augerolles (Puy de Dome, Paris, Cluny Museum); and in the stalls and screens from the church of Palluan, Indre (now in the Museum of Decorative Arts, Paris, Legs. Peyre Pe 1051-1). Antique ornament of comparable quality to that on the Leiden frieze is seen in the pulpit of Aranda de Duero of 1532. And among the many other similar works in Spain the choir stalls now in the National Museum of Sculpture, Valladolid, deserve attention, since they evidently represent the anonymous collaboration of some of the best available

sculptors and carvers in Spain at the time. In England, the closest comparison is with the sixteenth-century parts of the screen and stalls of King's College Chapel, Cambridge, constructed between 1533 and 1536.

The Pieterskerk choir screen friezes are not parts belonging to a screen contemporary with them; they are later additions. The frame of the screen is considered to be the oldest in the present Netherlands, and it may be presumed to have been complete when the rebuilt church was consecrated in 1425.[60] Above it was the Calvary group from 1412. The original form of the screen included wooden or bronze tracery posts placed at closer intervals than the present bronze posts. The old sockets are visible, filled with wooden plugs. On top the screen has sockets which could have supported statues or a tracery cresting, like that of the choir screen of Alkmaar[61] or that of Haarlem.[62] The present brass posts are from the late fifteenth of early sixteenth century.[63]

The horizontal beam now carrying the frieze was decorated with inscriptions reported in 1903 to have said *"Ghebenedijt Sij Die Soete/Name Ons Heren Jhesu Christ Ende/ Di Naem Der Soete Maget Maria Inder Ewicheyt"*[64] This is a short form of the closing prayer for the *Souter* of the Brotherhood of the Sweet Name of Jesus, whose altar was in the center of the choir screen, beneath this inscription, as mentioned above. A second inscription was reported in 1915, on the choir side of the screen, to have read, *"Dum Cantor Populum mulcet Suis vocibus Deum Irritat paravis Moribus D(ivu)s Bernardus."*[65]

The present arrangement of the panels of the frieze results in a composition whose medallion heads look away from the central medallion face. The central panels on nave and choir sides are full-face. The next pairs are three-quarters faces; while the outer medallions contain profiles. The panels are in sections of different widths, restricting the possible arrangements. The most likely correct arrangement would seem to be one centering on the central panel. There is, however, no proof that this was necessarily the case, despite the large number of examples where such symmetry is found, especially in Spanish screens, many of which contain similar decoration. An exception to the symmetrical centrality is found on the choir screen of the Capilla Real, Granada, where the medallion heads are not centrally arranged, although here there may have been clumsy restoration, just as clumsy restoration is possible to explain the Leiden arrangement. The problem of central arrangement was obscured by A. Mulder's reasoning that the frieze was post-Reformation and placed on the screen to cover the older Papist inscriptions.[66]

Aside from the removal of crucifix and statues and possible cresting, the removal of the ornately framed panel at the top, on which the Ten Commandments were painted after the Reformation, the screen has remained mostly intact. A major loss has been the pilasters mentioned in a receipt for gilding, and which presumably were stylistically related to the present frieze, giving the choir screen a more completely Renaissance appearance, like that presented by the beautiful small choir screen in the parish church of remote Enkhuizen (where, if the "Nothern Netherlands" had been truly backward in the sixteenth century, such fine carving should never have been found).[67]

Notes

1. The longest serious attempt at giving the history of the Pieterskerk is A. Mulder, "Iets over de Leidsche St. Pieterskerk, hare gescheidenis en architectuur," *Bulletin uitgegeven door den Nederlandschen Oudheidkundigen Bond*, V, 1903-1904, 54-87. Further, see E. H. ter Kuile, *De Nederlandsche Monumenten van Geschiedenis en Kunst, VII, de Provincie Zuidholland 1: Leiden en Westelijk Rijnland*, The Hague, 1944, for references to all three churches; W. J. Berghuis, *Langs de Oude Zuid Hollandse Kerken, Kustrook en Rijnland*, Baarn, 1972, 8-12 (short, inaccurate notices on the Pieterskerk and Hooglandsekerk); and van Oerle, *Leiden*, I, 99-102. For the St. Pancraeskerk, see Leverland, "Het kapittel van St. Pancras te Leiden," *Jaarboekje voor Geschiedenis en Oudheidkunde van Leiden en Omstreken*, LVIII, 1966, 69-86; Leverland, "De Pastoors van de St. Pancras te Leiden," *Jaarboekje voor Geschiedenis en Oudheidkunde van Leiden en Omstreken*, LXIX, 1977, 62-84; van Oerle, *Leiden*, I, 146 and f. For the Onse Lieve Vrouwe Kerk, see Leverland, "Cornelis Jansz., de laatste pastoor van de O. L. Vrouwekerk," *Jaarboekje voor Geschiedenis en Oudheidkunde van Leiden en Omstreken*, LI, 1959, 55-68; and van Oerle, *Leiden*, 165. See also the introduction to Overvoorde, *Archieven van de Kerken*, Leiden, 1915.

2. Overvoorde mentions the document which refers to the original consecration in his *Archieven van de Kerken*, iii; I have checked the accuracy of the reference.

3. Although I have collected the information for such a study, to include it in this examination of Leiden of the late-fifteenth and early sixteenth century would be extraneous.

4. J. Mosmans, *De St. Janskerk te 's Hertogenbosch*, 's Hertogenbosch, 1931.

5. D. P. Oosterbaan, *De Oude Kerk te Delft gedurende de middeleeuwen*, The Hague, 1973.

6. See Herv. Gem. III B IIa (Le Poole); 2034 (Pelinck), 1565.

7. J. D. Bangs, "The Sixteenth-Century Organ of the Pieterskerk Leiden," *Oud Holland*, LXXXVIII, 1974, 220-231 (reprinted in Bangs, *Documentary Studies*).

8. Compare de la Fontaine Verwey, "Pieter Coecke van Aelst en zijn boeken over Architectuur," *Uit de wereld van het boek*, I, 58-59.

9. For Leiden's decline and Pieter Cornelisz. Kunst's inactivity, see Bruyn, "Lucas van Leyden en zijn Leidse tijdgenoten in hun relatie tot Zuid-Nederland," 44; Gibson, diss., 18 and 210; Ekkart, "Leidse Schilders," 171-172.

10. Herv. Gem. III B II 2a (Le Poole); 2034 (Pelinck), a fragment of the accounts for the period February 22, 1532 – February 21, 1533, more of which is preserved under Kerk. Arch. 323, fragment 1532. The payment to Pieter Cornelisz. Kunst states: Item betaelt Pieter Cornelis van patronen te maken van die preekstoel – VIII sch. The payment to Daniel Willemsz. states: Item ghegeven Daniel die scriwercker dat hy in den hage gherest heeft om een patroen te maken van die precstoel VI sch. The unclear part of the second payment is the word *van*. If considered to mean the same as in the payment to Pieter Cornelisz. Kunst, "for," in the sense of belonging to the Pieterskerk pulpit, the word is simply used to show the connection of the payment with its purpose. If, on the other hand, the word in this case means "from," which it cannot mean in the payment to Pieter Cornelisz. Kunst, then the drawing made by the cabinetmaker could have been made *of* or *from* a pulpit in The Hague, without doubt. The first meaning is more likely, because of the more frequent use of *naer* or *na* to mean "from" in the second sense, distinguishing it from "for," in the sense of "in connection with."

11. See J. J. F. W. van Agt, "De Sint Jacobskerk te 's-Gravenhage," *Bulletin van de Koninklijke Nederlandse Oudheidkundige Bond*, LX, 1961, 152-180; further, see J. S. Witsen Elias, "Een Voorbeeld van Haarlemsch Beeldhouwkunst uit de eerste helft van de XVe eeuw," *Oud-Holland*, LVIII, 1940, 222-227, where the sixteenth-century documents cited are misunderstood favoring the early dating. The documents refer to two separate jobs of cleaning and repair of the Haarlem pulpit and its canopy, in 1535 and again in 1538. This is an important point, since from early drawings, it appears that the Haarlem pulpit looked something like that in Leiden (see *Pieter Jansz. Saenredam* (exhibition catalog Centraal Museum), Utrecht, 1961, ill. 216 and 217, cat. nos. 227 and 226), and thus, presumbaly, also like whichever pulpit in The Hague was visited by Daniel Willemsz.

12. See note 10 for the inventory references.

13. See H. E. van Gelder, "Jhr. Mr. Victor de Steurs, 1843 – 20 October, 1943," *Oudheidkundig Jaarboek*,

vierde serie van het Bulletin van den Nederlandschen Oudheidkundigen Bond, XII, 1943, 5 (quotation from "Iteretur Decoctum," *De Gids,* 1874).

14. D. Bierens de Haan, *Het Houtsnijwerk in Nederland tijdens de Gothiek en de Renaissance,* The Hague, 1921, 72.

15. The addition dates from 1604. Compare Mosmans, *St. Janskerk,* 480 and ill. 279, 280.

16. From the beginning of the sixteenth century to the beginning of the seventeenth, the obelisk had increasingly taken a place as witness to important events, a progression which can be followed in the decorations of triumphal entries and funeral procession and monuments, like that of William the Silent in Delft. By 1604 the pagan witness to extra-biblical revelation merely replaced a statue of someone in the Bible lest an "idol" distract the congregation, while forming a decorative reminder that something important was supposedly occurring in the pulpit. The obelisk had lost its specific conscious meaning and was just a gesture in the direction of revived learning.

17. U. XIII. 39.

18. O. von Simpson, *The Gothic Cathedral,* New York, 1956, 15, fig. 2.

19. A. L. Mayer, *El Estilo Gótico en España,* Madrid, 1960, 133-137.

20. This was made possible during a special research trip granted by the Netherlands Organization for the Advancement of Pure Research, Z. W. O.

21. See L. Devliegher, *Kunstpatrimonium van West-Vlaanderen, I, Beeld van het Kunstbezit, Inleiding tot een Inventarisatie,* Tielt, 1965, 94 and ill. 162, for a description of similar copying.

22. The general double row device is seen in an engraving by Daniel Hopffer, B. VIII. 501. 112. This engraving desplays the contrasting leaf forms in top and bottom rows seen also in the pulpit carving.

23. As random examples on pulpits, see P. Poscharsky, *Die Kanzel, Erscheinungsform im Protestantismus bis zum Ende des Barocks,* Gütersloh, 1963, ill. 5 (1462), ill. 11 (1516), and ill. 15 (1486). The device is seen frequently in late fifteenth and early sixteenth century Spanish churches.

24. Poscharsky, *Die Kanzel,* 109-110.

25. B. VII. 427. 163.

26. Compare F. Ludewich's measured drawing published in *De Architect,* 1896, as "Oude Kunst," 218, 219. A copy is present in the Leiden Municipal Archives, Prentenverz. 2258.

27. Besides the standard works on ornament prints, I have consulted the illustrated Bartsch photograph cards, arranged iconographically.

28. B. VIII. 427. 161.

29. B. VIII. 548. 13.

30. Similar things are seen on all three cup designs in the engraving by Ieronimus Hopffer (B. VIII. 523. 67.).

31. B. VIII. 216. 234.

32. B. VIII. 423. 230. The Aldegrever print is, in turn a close variant on H. S. Beham's print (B. VIII. 218. 238.) dated 1526 on the plate. The H. S. Beham 1526 print is fairly closely followed, although with additions, in B. Beham's engraving (B. VIII. 107. 56.). The B. Beham print also includes other details in an H. S. Beham print dated on the plate 1528 (B. VIII. 220. 245.). In the Aldegrever print of 1532 (B. VIII. 436. 246.) a child at the top seems to be the backside of one whose front is in the H. S. Beham print of 1528.

33. See N. Beets, "Dirick Jacobsz. Vellert: Houtsneden en Koperprenten," *Onze Kunst,* XI, 1907, upper illustration on page between 112 and 113.

34. Reproduced in *Maximilian's Triumphal Arch, Woodcuts by Albrecht Dürer and Others,* New York, 1972; see especially pl. 30.

35. Two of the many ornament prints with medallions are by NW, dated 1534 (B. VIII. 549. 14.); and by D. Hopffer (B. VIII. 498. 100.). Furniture using the decorative device can be found throughout Europe, along with architecture and wall painting. (A variant, in squares, is seen in the ceiling painting dated 1543 at Gripsholm, depicted in B. von Malmborg, *Gripsholm, Ett slott och dess konstskatter,* Stockholm, 1956, 15.) A book whose pages each contained a portrait of a famous Roman or other person in a medallion together with grotesque border ornament is Andreas Fulvius, *Illustrium Imagines* (ed. J. Sadoletus), Rome (J. Mazochius), 1517 (202 cicular woodcut portraits by H. de Carpi), and there are other books of the period where the ornamental device appears. Hind depicts what is supposedly a tarot card with grotesque ornament surrounding the portrait of Julius Caesar; see A. M. Hind, *Early*

Italian Engraving, London, 1938, VI, pl. 698, "Nicoletto da Modena? From a Pack of Tarocchi Cards." The early date of these possible pattern sources contrasts with M. D. Ozinga, "De strenge Renaissance-stijl in de Nederlanden naar de stand van onze tegenwoordige kennis," *Bulletin van de Koninklijke Nederlandsche Oudheidkundige Bond*, LXI, 1962, 22, note 36, where pattern books for medallions are considered unknown ca. 1530, and where an example from 1606 is mentioned.

36. "I am the way, the truth, and the life."

37. B. VIII. 547. 9.

38. Poscharsky, *Die Kanzel*, 104 and f., particularly 135, 138-139, 153 and f., and 167: inscription, "Ego sum R(essurectio) et Vita Q(ui) In Me Cr(edidit) S(alvabitur) etsi M(ortuus) fuerit. Joh. XI," from the 1538 pulpit of Schloss Chemnitz.

39. The Netherlands is not mentioned in the analyses of pulpits except for an innovation in placement. For pre-Reformation inscriptions, see Poscharsky, *Die Kanzel*, 28-29, 39, 42, 55.

40. The anti-transubstantiation notices posted in 1526 by the *Sacramentshuis* (Ostensory) of the Pieters-kerk do not indicate Lutheranism and cannot be the basis for generalizations on popular opinion. Some of the recorded rhymed notices are simply difficult to interpret as to what the precise object of grievance was. See Knappert, *Opkomst*, 96. Knappert's still standard history of the rise of Leiden Protestantism attempts to locate a "Sacramentarian" movement on very little evidence. He assumes that the clergy was so degenerate that a reforming movement is an unavoidable postulate. The major example of Leiden degeneracy is the 1522 case against Jan Velleman, canon of St. Pancraes. Knappert mentions that Velleman was accused of having raped two small girls in a confessional. The plaintiffs (parents of one of the girls, who was eleven) lost. Knappert grants this, but he maintains that the case is nevertheless significant and that the defense was weak (Knappert, *Opkomst*, 50-51). He mentions that the court decided that the alleged time was too short for the rapes. See R. A. 4, 1519-1528, folio 62.

41. According to Mosmans, *St. Janskerk*, 431, F. X. Smits considered that ca. 1570 the Catholics emphasized that only Christ, the apostles, evangelists, and prophets were legitimate preachers, interesting in the context of the Council of Trent.

42. Poscharsky, *Die Kanzel*, 153 and f. See also J.-K. Steppe, "*De Overgang van het Mensdom van het Oude Verbond naar het Nieuwe*: Een Brussels Wandtapijt uit de 16e Eeuw ontstaan onder Invloed van de Lutherse Ikonografie en Prentkunst," *De Gulden Passer, Bulletin van de "Vereeniging der Antwerpsche Bibliophielen"*, LIII, 1975, 326-359; and Bangs, *Documentary Studies*, 85.

43. See Poscharsky, *Die Kanzel*, 37 and f.

44. See also Poscharsky, *Die Kanzel*, 42-44, for examples of combination in ca. 1470-1480, 1498, 1513-1514, 1523, etc. For Aranda de Duero, sec. J. M. Azcárate, *Ars Hispaniae, Historia Universal del Arte Hispánico, XIII, Escultura del Siglo XVI*, Madrid 1958, 186-187 and pl. 164 and 165. "Juan de Cambray," one of the two sculptors named, was apparently a Netherlander and he collaborated with Cornelis de Hollanda ca. 1530.

45. See Poscharsky, *Die Kanzel*, 48-49, for reference to this theme in a German pulpit ca. 1400, ill. 13 and 14.

46. Poscharsky, *Die Kanzel*, 151-153.

47. Oosterbaan, *Oude Kerk*, 82.

48. The Abcoude canopy has in all probability been reduced to its present sounding-board rudiment. The removal of an architectural structure above the flat remainder must be assumed in the absence of any pre-Reformation parallels for a flat sounding-board in the Low Countries taking the form of a suspended canopy.

49. The town of 's Hertogenbosch became Protestant under military force in the late date 1629. The furnishings of the St. Janskerk were considered carefully at that time in discussions of what was to be saved or removed and a statue of Mary above the reredos of the former high altar was allowed to remain until the replacement of the whole altarpiece in 1869-1873 by the neo-gothic reredos still present. (The church had been returned to Catholics in the beginning of the nineteenth century.) See Mosman, *St. Janskerk*, 457-461; *Zingende Kathedraal. . . 700 Jaar Koorzang in de St. Janskathedraal* (program exhibition catalog), 's Hertogenbosch, 1974; and *De Kathedrale Basiliek van St. Jan te 's Hertogenbosch* (guide book), 1973. The illustrations provide valuable comparisons. See further, C. Peeters, "De Sint Jan van den Bosch in de Negentiende Eeuw, Een Gescheidenis van Goede Be-doelingen," *Bulletin van de Koninklijke Nederlandse Oudheidkundige Bond*, LXXII, 1973, 144.

50. Poscharsky, *Die Kanzel*, 39-40.

51. Poscharsky, *Die Kanzel*, 150.

52. See R. A. 42, May 30, 1533; August 28, 1553; February 17, 1548; and especially May 2, 1547.

53. See R. A. 42, February 16, 1537; July 11, 1550. For Pieter Claesz. van Balen, see NK index.

54. For illustrations, see H. L. M. Defoer, "De madonna inv. nr. 1530 in het Bisschoppelijk Museum te Haarlem, een voorbeeld van Jan Gossaerts invloed op de beeldhouwkunst der Noordelijke Neder-landen," *Oud Holland*, LXXXV, 1970, 49-53, pl. 1 and 2. It is self-evident that the attribution to Utrecht is unnecessary; moreover, the sculptures discussed have no more connection with Jan Gossaert than, say, did Lucas van Leyden, who presumably did not work for the "Master of the Utrecht Stone Female Head," but did travel with the "uitheemse kunstenaar" Gossaert (according to van Mander).

55. Illustrated in J. Bruyn, "De Abdij van Egmond als opdrachtgeefster van kunstwerken in het begin van de zestiende eeuw," *Oud Holland*, LXXXV, 1970, ill. 24, 25, 26, 27.

56. See Bangs, *Documentary Studies*, 38-42.

57. See Bruyn, "Egmond als opdrachtgeefster," ill. 5.

58. Lucas van Leyden, B. VII. 427. 161.; H. Aldegrever, B. VIII. 436. 242.

59. The original placement is visible from marks analogous to those on the Leiden pillar which was the original position before movement of the Leiden pulpit in 1860. At Abcoude the pulpit is now placed in front of the center of the screen, which although underscoring the stylistic unity, makes a peculiar impression both liturgically and esthetically.

60. Overvoorde, "Rekeningen uit de bouwperiode van de St. Pieterskerk te Leiden," 137.

61. Illustrated in E. Elzinga, *Nederlandse monumenten in beeld*, Baarn, 1975, 112.

62. The famous Haarlem work is cast bronze, while that at Alkmaar is wood, painted (presumably in the nineteenth century) to look like oxidized copper (as also occurred at Leiden, according to de Steurs; see note 13).

63. They have clearly stamped Arabic numbers running from north to south.

64. Mulder, "St. Pieterskerk," 69.

65. A. H. L. Hensen reported that he found this inscription in Dozy's miscellaneous notes, dating from 1894 (Hensen, in *Bulletin van den Nederlandschen Oudheidkundigen Bond*, XIV, 1915, 136). It is in the volume "Kerkwezen" of Dozy's notes. It is curious that Mulder did not mention having seen this inscription when he removed the panels in 1903.

66. Mulder, "St Pieterskerk," 70.

67. See Witsen Elias, *De Schoonheid van ons Land, Beeldhouwkunst, Koorbanken, Koorhekken en Kansels*, Amsterdam, 1946, ill. 148, 153, 154.

13. Cornelis Engebrechtsz.'s Problem Pupil:
The Idea of Aertgen van Leyden and the enigmatic Rijksmuseum
*Preaching of the Lord's Prayer**

Ill. 92,93, The van Montfoort *Last Judgement* triptych, which Carel van Mander saw at the
94,96 house of Jan Dircxz. van Montfoort, has recently been rediscovered and is now in the
Musée des Beaux-Arts, Valenciennes.[1] This triptych is presently unique as the only
indisputable work by Aertgen van Leyden. Particularly important is that it does not
look much like the many other paintings, drawings, prints, and stained-glass panels
which have been attributed to him in the past. This paradox calls attention to basic
problems affecting attributions to Aertgen van Leyden generally and to specific
problems connected with his purported authorship of some famous disputed paint-
ings, chief examples being *The Preaching of the Lord's Prayer* (Rijksmuseum,
presently labelled *The Calling of St. Anthony*) and *The Nativity* (examples in the
Wallraf-Richartz-Museum, The Louvre, The Hermitage, and The North Carolina
Museum of Art).

Attributions have been founded mostly on van Mander's remarks that Aertgen van
Leyden imitated first Cornelis Engebrechtsz., then Jan van Scorel, then Maerten van
Heemskerck.[2] A corresponding body of work was collected, divided chronologically
into imitations of what has been considered the "Leiden School" of the time of
Cornelis Engebrechtsz., imitations of Jan van Scorel, and imitations of Maerten van
Heemskerck. All these works were seen to be properly unpleasant and sloppy, as van
Mander had said all of Aertgen's works were.[3]

Contemporary with Aertgen van Leyden and also working in Leiden were ca. fifty
other painters, besides Cornelis Engebrechtsz. and Lucas van Leyden. These painters
might just as easily have been imitators of Cornelis Engebrechtsz., Jan van Scorel, or
Maerten van Heemskerck. Other imitators may have been active in other towns. Van
Mander's remarks are, therefore, insufficient for identifying works by Aertgen van
Leyden. A logical problem is inherent in the mere statistics of unsigned paintings by
artists who are forgotten except by name. Any of the unsigned "Aertgen" paintings, if
indeed from Leiden, could be the work of the Leiden painter Jan Jansz. or one of his
forgotten friends instead.

* See J. G. van Gelder, "De 'Kerkprediking' van 'Lucas van Leyden'," *Oud Holland*, LXI, 1946, 101-106. I
am indebted to J. Bruyn's review of H. van de Waal's *Steps towards Rembrandt* (*Tijdschrift voor
Geschiedenis*, LXXXVII, 1974, 466-467) for several concepts used here. Bruyn refers to the dangers of
self-identification with the object of study, to the distinction between the eccentric and the more eccentric
aspects of an art historian's work, and to the existence of usual Dutch standards of art history. As N.
Freeling has warned, deviation from usual Dutch standards can delay or prevent otherwise expectable
promotion and acceptance of research methods.

A problem essential to style criticism is reasoning by analogy. Analogy suppresses differences while stressing similarities. No doubt it is trite to remark that it is impossible to verify which similarities and differences are important in the problem of distinguishing between the works of artists who did not employ overwhelmingly divergent techniques and conceptions. Similarities may be common to imitators of the same person, especially if the imitators were that person's pupils. Differences ignored in the analogy may be what distinguishes imitators from each other as well as from their teacher. Experience in looking at the pictures does not resolve the basic logical problem — that reasoning by analogy is so far from providing proof of anything that in many disciplines it is identified as a variety of fallacious argument.

The statistical problem and the problem of analogical reasoning affect the idea of Aertgen van Leyden's work in general. Other problems of reasoning affect the attribution to him of specific key works, which have been the sources of analogical comparisons. A few of these works can be examined here, with major emphasis on the Rijksmuseum painting *The Preaching of the Lord's Prayer*.

J. Bruyn's major contribution to the discussion is attribution to Aertgen of the Rijksmuseum painting he maintains depicts *The Calling of St. Anthony* (formerly attributed to Lucas van Leyden by M. J. Friedländer and others).[4] Bruyn connects the Rijksmuseum painting with the painting *The Temptation of St. Anthony* (Brussels) and with the *Portrait of a Man* (Schloss Rohoncz).[5] Bruyn thinks all were originally part of a single triptych.[6] Creating hypothetical arrangements of separate paintings can, of course, bring any art critic personally close to unperceived mingling in and self-identification with the actual creative processes of the artist whose work is the object of the critic's study.[7] K. Boon finds Bruyn's combination hard to believe, because according to Bruyn's own arguments it includes donors from two social classes.[8] Bruyn's opinions can be discussed first concentrating on the subject of the Amsterdam painting (which I think J. G. van Gelder had correctly identified in 1946 as *The Preaching of the Lord's Prayer*) and then on the presumed identification of portraits in that painting.

Two observations are brought forth by Bruyn to support the claim that the painting depicts *The Calling of St. Anthony*. The first is that the composition of the Amsterdam painting is like that of a painting of *The Calling of St. Anthony* in The Metropolitan Museum of Art, New York.[9] Each painting contains a church interior on the left side, opened to view by means of a cross section. Each painting also contains a scene on the right side in which a richly-clad man distributes something to poor people, who are seen in the middle distance in front of a city view with a round tower, behind which is a rocky and hilly landscape. The second observation is that the man seen at the right in the foreground of the Amsterdam painting wears a Tau-cross and pendant bell on a ribbon around his neck.

The following compositional differences between the Amsterdam painting and the New York painting are also noted by Bruyn. The Amsterdam painting depicts a preacher giving a sermon to ca. forty people, while the New York painting, like others depicting *The Calling of St. Anthony*, has no preacher or congregation; instead mass is being said and it is heard by one person, St. Anthony. The Amsterdam painting depicts the distribution of bread, while the New York painting depicts the distribution

of money to the poor, in accordance with the life of St. Anthony.[10]

Bruyn recognizes that the Amsterdam painting is derivative not only of the New York painting but also of an illustration to Erasmus's 1523 publication of the Lord's Prayer, an engraving by Hans Holbein the Younger on the theme, "Give us this day our daily bread."[11] As Bruyn admits, van Gelder had discovered other versions of the same theme with similar compositional arrangements, which led van Gelder to conclude that the Amsterdam painting also depicts that theme from the Lord's Prayer.[12] A drawing and an engraving of 1571 by Maerten van Heemskerck, depicting the theme "Give us this day our daily bread," was evidently based on acquaintance with the Amsterdam painting, a point noted by both van Gelder and Bruyn.[13] Van Heemskerck must, therefore, have been able to recognize an iconographic composition associated with the subject of the *Lord's Prayer* in the Amsterdam painting. Subsequently Boon mentioned still another painting, ascribed to Pieter Cornelisz. Kunst and approximately contemporary with the Amsterdam painting, which is not only similar in composition but is moreover labelled "Give us this day our daily bread" on the panel itself.[14] These depictions suggest a commonly recognized iconographic reference to the Lord's Prayer. The common points which the Amsterdam painting shares with the Lord's Prayer compositions are the preacher giving a sermon to a congregation in the foreground set in a church seen through a cross section. In the background, bread is distributed. The Amsterdam painting refers to the mass by the presence of mass equipment on an altar with burning candles, located in front of the choir screen. The Holbein engraving more simply depicts a priest distributing the host.[15] The Holbein version shows distribution of bread to people seated around a table, unlike the Amsterdam painting.

Ill. 95 The Amsterdam painting has been dated in the past between ca. 1520 and 1535 on stylistic grounds.[16] The 1523 date of the Holbein illustration gives a *datum post quem*; another illustration gives an even later one. While the Holbein has been shown by Bruyn to be the source of such items as the hat of the woman in the lower center of the painting, together with general compositional relations, both the group of seated figures with one child and the group of standing men in the painting are closely dependent on the Lutheran side (left) of Georg Pencz's 1530 broadside *Inhalt zweierly predig* (Lutheran and Catholic Preaching).[17] It is most noteworthy that the group of men at the right in the foreground of the painting comes from such a source, since these have often been identified as Leiden portraits. The derivation from this print gives the painting a date of 1530 or later. A woman at the right in the engraving may also be seen in the painting.

The question of Lutheran tendency in the painting is raised by the 1530 source, which is outspokenly Lutheran. The painting, however, gives no answer to the question. It combines reference to an illustration to Erasmus's commentaries on the Lord's Prayer with reference to Lutheran preaching as true preaching, but the painting does not necessarily provide grounds for claiming more than Erasmian sentiments. (Erasmian sentiments were, of course, serious enough after his death in 1536.) The altar in the Amsterdam painting's background is prepared for the mass, just as mass in shown in the Holbein illustration. It is impossible to claim that the painting suggests a denial of the mass whose preparation it shows, despite the painter's evident familiarity with

130

the Lutheran broadside. The painting is thus one of those enigmatic depictions where attempts to provide clear-cut proof that it represents a choice between Erasmian and Lutheran tendencies can only lead to arguments. That the painting is connected with both tendencies must have made it politically controversial soon after it was painted, raising questions about its original purpose and owner which cannot at the moment be answered.

The painting's subject, on the other hand, can be conceded beyond doubt as being what van Gelder recognized in 1946. With the iconographic continuity already mentioned kept in mind as strong enough indication of the Lord's Prayer subject, it remains to examine Bruyn's reasons for rejecting that in favor of *The Calling of St. Anthony*. The key to this break with previous and later iconography is the Tau-cross and bell pendant worn on a ribbon around the neck of the man in the painting's right foreground.

The presence of the Tau-cross leads Bruyn to two conclusions. First, the Tau-cross singles the man out from the other portraits and identifies him as St. Anthony, and as such the equivalent of the single figure of St. Anthony seen in depictions of *The Calling of St. Anthony*.[18] Second, the man is not only St. Anthony; he is also the donor of the picture portrayed in the role of his patron saint, St. Anthony.

The possibility of the second identification is closely connected with the acceptance of the idea that St. Anthony is really depicted. Examples of donor portraits in the roles of their patron saints are rare in Netherlandish art, if they exist at all. Bruyn supports the possibility by reference to a painting he identifies for the first time as *The Holy Family with the Tiburtine Sibyl and (Hendrik III van Nassau as) Keizer Augustus, and St. John on Patmos*.[19] It is difficult to believe Bruyn's opinion that the depiction of *The Holy Family* in this triptych represents the Apocalyptic Woman, against which St. John had to shield his eyes.[20] Rev. 12: 1-2 describes: "a woman clothed with the sun, with the moon under her feet and on her head a crown of twelve stars; she was with child and she cried out in the pangs of birth in anguish for delivery." This is quite a contrast with the placid depiction of the Holy Family.

The depiction of the Apocalyptic Woman largely inspired by Dürer's 1498 woodcut,[21] and continued by Holbein's 1523 New Testament illustrations, was again spread without significant variation in the illustration to Rev. 12: 1-5 in Vorsterman's Bible published in Antwerp in 1528.[22] To see a depiction of the Holy Family as representing the Apocalyptic Woman would indeed be, as Bruyn describes it himself, iconographically remarkable. The identification of this iconography is important because it is Bruyn's only evidence for the claim that it was not unusual in Netherlandish court circles for donors to be depicted not only as donors but also as iconographically active figures — in this case Hendrik III van Nassau as Keizer Augustus, while in the Amsterdam painting the donor is supposed to represent St. Anthony.[23]

Bruyn says that some explanation must be found for the ermine cloak of Hendrik III van Nassau in the *Holy Family* triptych, as well as for the "scepter" in front of him. This staff of office (baton) is not a "scepter" and various sixteenth-century officials had the right and obligation to be in possession of an official staff. It therefore has no imperial connotations. That the ermine cloak was unusual and indicates the garb of an emperor is probably incorrect, since Hendrik III van Nassau wears an ermine cloak

in another painting where he cannot through any interpretation be identified as an emperor: the panel of the Breda Sacraments Procession.[24] Moreover, if Hendrik III van Nassau had wanted to be identified as a Roman emperor, he could have ordered his portrait painter to pay more attention to the antique costumes of the Roman soldiers and emperors, as seen, for example, on the four Romans bearing the grave monument of Engelbert II van Nassau, erected in the Grote Kerk of Breda between 1526 and 1538.[25]

The idea of the donor portrait conjoined with iconographic activity is dubious but can be disregarded momentarily in considering the first conclusion, whether the person at the right foreground of the Amsterdam painting is necessarily either St. Anothony or the only donor. Bruyn describes the man as being ca. thirty years old; wearing an unusally fashionable costume which indicates a leading nobleman who, therefore, must have been in contact with the major fashion centers of the time, Mechelen and Brussels; and wearing his tabbard draped with a peculiarly Italian or Spanish gesture, rather than according to local custom.[26] The Tau-cross pendant indicates to Bruyn that the man was a member of the knightly order of St. Anthony-en-Barbefosse in Henegouwe.[27] Who fulfills the necessary requirements for identification, asks Bruyn. He answers: the Viscount of Leiden, Jacques de Ligne.[28] (That St. Anthony would be the patron saint of a man named Jacques is inconsistent with the usual pattern of name-saints, by which the patron saint of Jacques would be a St. James.)

Bruyn sees confirmation of his identification in a comparison of the beardless three-quarter-view portrait in the Amsterdam painting with a nearly straight-on portrait of Jacques de Ligne in full-bearded maturity ca. 1550, which he thinks looks strikingly similar to the Amsterdam portrait.[29] Even more eccentric is his opinion that Jacques de Ligne's wife Maria van Wassenaar is portrayed in the center of the group in the left foreground of the Amsterdam painting. A stylized portrait of Maria van Wassenaar is shown for comparison.[30] The evident derivation of the woman in the painting from an engraving ("school of Leonardo da Vinci") is explained as an indication that Maria van Wassenaar was possibly intended to be seen as a kind of connection with Italy, or perhaps simply in a costume of exotic finery.[31] The Amsterdam painting contains no definite indications that the woman seen by Bruyn as Maria van Wassenaar is intended to be a portrait, nor is there any compositional relation between the married couple's hypothetical portraits.

The special characteristics of the portrayed man can be taken in order. First, the Tau-cross. This is rare on portraits, according to Bruyn, who mentions two (in fact portraits of the same person).[32] He does not mention the twelve members (out of seventeen) of the Leiden family van Swieten who are depicted with the Tau-cross in the *van Swieten Memorial* painting in the Leiden Municipal Museum "De Lakenhal."[33] He does not mention several other occurences of the Tau-cross and he omits to note the order's required silver-gilt and silver chains for members. Nothing proves that the Tau-cross automatically indicates a member of the Order of St. Anthony-en-Barbefosse (especially considering that the husband of the woman whose portrait Bruyn *does* mention does not wear the decoration worn by his wife; see note 32). Alternative candidates for wearing such decorations could be the officers of the Guild

of St. Anthony, whose existence in Leiden is mentioned by Bruyn. These officers were regents of the St. Anthony's Hospital outside Leiden. The only painter among them was Huych Jacopsz., father of Lucas van Leyden and Dirck Hugenz., both esteemed painters in their day.[34]

The second point is that the man's clothing is thought to be so unusually fashionable and wealthy that only a leading nobleman could have owned it. The clothing is specified as consisting of a pleated shirt with a vertical collar and ruffed cuffs, a low tunic with slashings, and a short broad tabbard trimmed with a wide band of fox fur, whose sleeves are broad and gathered and are fastened at the elbow with buttons closing a transverse opening. Also, the shoes are described as having a wide, but not deep, toe covering.[35] According to Bruyn, such a worldly appearance can scarcely be duplicated in these years in the "Northern Netherlands." To determine "these years" together with the difficulty of duplicating the clothing, Bruyn refers to a popularizing book on the dating of clothing styles in the Netherlands in the sixteenth century, in which the Rijksmuseum painting here discussed is dated 1530 without question.[36]

As a distinguishing worldly feature the pleated shirt with its collar and cuffs is not very useful, because the same kind of shirt is worn by each of the five people standing in the group with the man in question.[37] Similar shirts are also worn by men in the painting *The Card Players* attributed to Lucas van Leyden.[38] The tunic with slashings differs in its colors from the tunic worn by the man standing second from the left in the group in the Amsterdam painting, but the neck line is the same. Here, however, the sleeve ends are not shown, so slashings are not visible. Tunic sleeves with similar slashings are, however, seen in the painting *The Card Players*, just mentioned. In *The Card Players* the card player holding the money wears a fur-decorated cloak like that in the Amsterdam painting. Another cloak of the same type is seen on the judge in the painting *Susanna before the Judge* attributed to Lucas van Leyden.[39] In *The Card Players* and *Susanna before the Judge* the sleeves are depicted open at the transverse openings, whose presence made it possible to use half-sleeve length with the remainder dangling.[40] Such sleeves are a common detail in the engravings of Lucas van Leyden, for example, the *Man with a skull*.[41] It seems a difficult problem to determine the Southern European origins of the gesture of the man in the Amsterdam painting and to exclude it from gestures more usual in Leiden, but it is at least worth noting that the cloak of the judge in *Susanna before the Judge* is attached at the side, like the draping of the cloak in the Amsterdam painting.[42] Moreover, the fur-lined cloak of the tax collector in *The Calling of St. Matthew*, a painting attributed to Cornelis Engebrechtsz., is similarly draped and has a fur collar of the same cut as that seen in the Amsterdam painting.[43] That fur-lined cloaks actually existed in Leiden is attested by their being specified in numerous lawsuits about the division of estates,[44] as well as being depicted in several Leiden portraits.[45] The importance of such items in inheritance suits is a warning that dating by costume may be risky.[46] Finally, the shoes in the Amsterdam painting must be considered. Shoes of this sort are seen in Lucas van Leyden's painting *Christ Healing the Blind Man* (shield bearer, left side)[47] and in Lucas van Leyden's engravings, such as *Virgil in the Basket* (1525).[48]

To summarize, none of the clothing details selected by Bruyn to support the identification of the man in the Amsterdam painting as Jacques de Ligne was unusual

in Leiden. Strikingly, the wealthiest item, the fur-lined cloak, was commonly found in the wardrobe of Leiden's richer burghers. The premise that such finery was unusual in Leiden and the corollary that the man depicted was, therefore, in contact with the fashion centers Mechelen and Brussels imply further that the ordinary rich man in Leiden was *not* in contact with those places. Bruyn mistakenly presupposes that Leiden was more or less isolated from the centers of culture at this time.[49] In fact, most rich burghers of Leiden had contact with Mechelen, Brussels, Antwerp, and other cultural centers.[50] Clearly there is no need to search for a leading nobleman as the donor of the Amsterdam painting. The donor (or donors, if the portrait group are all donors) could easily have been (a) Leiden citizen(s). The Tau-cross does not point necessarily to connections unavailable to various Leiden burghers. The absentee Viscount Jacques de Ligne is unnecessary for this painting.

Among the portraits in the Amsterdam painting various art historians have seen self-portraits by Lucas van Leyden and Aertgen van Leyden, as well as portraits of Dirck Hugenz., Cornelis Engebrechtsz., and his three sons, Pieter Cornelisz. Kunst, Cornelis Cornelisz. Kunst, and Lucas Cornelisz. Cock.[51]

Bruyn mentions the altar of the St. Anthony's Guild in the Leiden Pieterskerk.[52] That this altarpiece was probably carved and may have had painted doors can be inferred from the presence in the Pieterskerk of other altarpieces of that type and from the annual references to the city's payments to St. Anthony's *"casse"* for keeping St. Anthony's pigs off the streets of Leiden.[53] The word *"casse"* probably refers here to a carved altarpiece, in contrast to other references to payments to a saint's *"outaer"* (altar), where a carved altarpiece is not implied, although possibly present.[54] The annual payments contradict Bruyn's statement that St. Anthony's pigs could be seen daily on Leiden's streets.[55] This deserves mention because the image of pigs wallowing freely in the streets supports by implication the presupposition of provincial uneventfulness.

Bruyn's relatively recent study of the Amsterdam painting may not be based on a systematic study of the available historical sources,[56] but it is by no means unique in the literature about Aertgen van Leyden.[57] Four other works attributed to Aertgen will be considered to indicate that Bruyn's historical method is unexceptional.

Bruyn attributes to Aertgen van Leyden a painting of *St. Jerome by Candlelight* (Rijksmuseum, Amsterdam) bearing a monogram consisting of I and C.[58] This monogram is not mentioned by Bruyn; E. Pelinck, however, interprets it as the mark of Jan Cornelisz. Vermeyen, who because of this monogram is then postulated as having learned to paint in Leiden, without further evidence in support of the hypothesis.[59] The only Leiden painter known from Leiden documents between 1475 and 1575 with the correct initials was Jeronimus Cornelisz.; and no painter with initials C. I. is recorded. If in fact a Leiden painting, then attribution to Jeronimus Cornelisz., active ca. 1510-1540, seems more reasonable than attribution to Aertgen van Leyden or to Jan Cornelisz. Vermeyen.

Bruyn built his study on earlier attributions made by I. Q. van Regteren Altena, who considered a drawing, on which the name "A V LEYDEN" appears, to have been signed that way by Aertgen van Leyden.[60] To explain this signature instead of a mere "Aert Claesz.," van Regteren Altena suggests that Aertgen van Leyden wanted

134

to distinguish himself from Allaert Claesz., the Amsterdam painter.[61] The suggestion is unlikely. "Aert," "Aernt," and "Aertgen" are diminutives of the names Adriaen or Arnold. "Allaert" is different and unrelated, connected with the name Adelaart.[62] To distinguish himself from Allaert Claesz., Aert Claesz. had only to sign his name. Other considerations indicate that "A V LEYDEN" is improbable as a signature. Nothing indicates that the painter Aert Claesz. was related to the Leiden family named "van Leyden." "From Leiden" in his case is a later sobriquet, just as it was in the case of Lucas Hugenz., also a native of Leiden not known to have been a member of the van Leyden family.

Noting that van Regteren Altena had attributed a painting of *Christ and the Adulteress* to Aertgen van Leyden, J. G. van Gelder published a drawing by Jan de Bisschop of a painting of the same general composition.[63] Jan de Bisschop's drawing is clearly marked "L" and he must have been convinced that the painting he was copying had been painted by Lucas van Leyden.[64] Van Gelder mentions that de Bisschop's copies are accurate and faithful rather than inaccurate and at variance with the originals.[65] It is therefore important to remark that the de Bisschop drawing does not depict the painting attributed to Aertgen van Leyden.[66] While the foreground figures in drawing and painting are as good as identical, around fifteen figures in the background of the drawing are omitted from the painting. The architecture differs significantly, the drawing being rather more complicated. The space in the background of the drawing is accordingly more complex than that in the painting. The lunette sculpture in the drawing clearly depicts Cain and Abel, but in the painting the altar which establishes the identity of the scene is missing.[67] The hanging garlands and globe in the central arch in the painting are not found in the drawing. It may be concluded from these differences that the drawing is a copy of another painting, not the one attributed to Aertgen van Leyden. Conceivably Jan de Bisschop copied a painting in fact by Lucas van Leyden, and that painting by Lucas had served another artist earlier as the inspiration for the close copy attributed to Aertgen van Leyden. This is a hypothetical explanation for the available evidence. Nothing, however, has been found to warrant the attribution to Aertgen van Leyden.[68]

Van Regteren Altena attributed the painting *Christ and the Adulteress* to Aertgen on the basis of a supposed analogy with a painting of *The Nativity*, known in four examples.[69] Van Regteren Altena's analogical source was attributed by him to Aertgen van Leyden also, on the following questionable grounds.

The estate of the painter Frans Francken the Elder contained a painting of *The Nativity* attributed in the 1617 estate inventory to "Artus van Leyden."[70] A painting by one of his sons, Frans Francken the Younger, depicting *A Collector's Cabinet*, includes among other works of art the painting of *The Nativity* known in four examples.[71] For van Regteren Altena it follows that the painting seen in *A Collector's Cabinet* was identical with the painting attributed to Aertgen van Leyden in the inventory of the estate of Frans Francken the Younger's father (an estate to which Frans Francken the Younger was not sole heir).[72] Other items mentioned in the inventory, however, do not appear in the painting *A Collector's Cabinet*.[73] Frans Francken the Younger painted other *Collector's Cabinet* pictures, such as the one in Antwerp dated 1619, where the painting *The Nativity* is not seen.[74] Nothing compels

the art critic to assume that Frans Francken the Younger was depicting his own possessions in the *Collector's Cabinet* picture which shows the *Nativity* painting known in four examples. Moreover, nothing indicates that that picture was the same as the *Nativity* of the 1617 inventory. The 1617 attribution was made more than fifty years after the death of Aertgen van Leyden, so even its accuracy is not above doubt, despite the impossibility of connecting inventory with depictions. The attribution of the *Nativity* painting known in four examples is the basis for the analogical expansion of Aertgen's oeuvre, and the basic attribution involves the fallacy of the undistributed middle.

The Search for the Documented Aertgen

It may be asked in conclusion what archival records do say about Aertgen van Leyden. The information is extremely scanty and entirely inadequate for biographical purposes. The presence in Leiden at the same time of several namesakes makes it impossible to know without the specification "painter" that the correct Aertgen is named.[75]

Aertgen van Leyden is mentioned with certainty in only five documents, so far as I know. On August 19, 1521, "Aernt Claesz. scilder" (Aernt Claesz., painter) stood bond for a minor fine.[76] "Aernt die schilder" was sued for payment of 15 *placken* to the Guild of St. Luke, probably owed as dues.[77] In 1536 the Guild of St. Job in the Pieterskerk acquired for its altar two standing columns with a "crest" on which were three statues, all carved by Jan Pietersz. (van Dam).[78] In the series of legal cases surrounding the delivery of the commissioned work four impartial people were named as receivers of various financial papers pending the judicial decision. Two of them were the painters Aernt Claesz. and Jacop Adriaensz.[79] Aertgen van Leyden's association with Jacop Adriaensz., a much better documented painter who received commissions in The Hague and Delft as well as Leiden, suggests that Aernt was also a respected member in the painters' guild. Finally, the Tenth Penny tax lists of 1561 and 1564 name "Aertgen schilder" as living in a house on the Zydegracht, the location mentioned by van Mander.[80] In 1557, however, Aernt Claesz. did not live there. The house was empty.[81] Failure to give the occupations of the various Aernt Claesz. listings in other tax years makes it impossible to find him except in 1561 and 1564.

Van Mander's story that Aertgen van Leyden was first trained as a fuller may represent confusion with the painter Baernt Claesz. (mentioned in 1518-1520 and in 1534) and his namesake the fuller Baernt Claesz.[82] Van Mander's story that Aertgen closed contracts in inns is undoubtedly accurate, because that was the normal legal practice for relatively minor contracts in Leiden: everyone present was given a drink and could be called on later to serve as a witness if necessary.

Ill. 97 None of this information supports the massive attempts at oeuvre construction. It is possible then to return to van Mander, taking statistical problems into consideration, and suggest very tentatively a single painting as perhaps van Mander's basis for claiming that Aertgen worked in imitation of Jan van Scorel. The St. Anna Hof in Leiden possesses a portrait of its priest Cornelis Willemsz. dated 1552, whose back-

136

ground is a copy of the so-called Wezelaar triptych by Jan can Scorel, which in 1552 was to be seen in Delft. The reuse of van Scorel's work, consistent with the borrowing in the van Montfoort triptych by Aertgen, may be what van Mander meant by "working in the manner of," but it unfortunately does not add "Aertgen" as a signature to exclude the possibility of "Jan Jansz."[83]

It is necessary to return to the van Montfoort triptych to see what was considered important by van Mander and, presumably, to see what was esteemed in Leiden in 1555. As mentioned in note one, large dependence on van Heemskerck is immediately visible. Further, the long, thin figures, painted in what van Mander must have considered a sloppy way, attract attention through their similarity to the elongated and contorted figures in sixteenth-century Italian paintings now considered Mannerist and the technical sketchiness recalls some Fontainebleau work. It must be admitted that the recollection of the works of painters such as Pontormo and Parmigianino does not help Aertgen's reputation now. Nevertheless, Aertgen van Leyden was evidently up to date on a European scale in 1555, regardless of his derivativeness. There are technical aspects of the actual background figures which, especially in the heavenly hosts, distantly call to mind Roman fresco paintings from the Domus Aurea and the sixteenth-century imitations inspired by them.[84] The idea that Aertgen painted sloppily must be firmly assigned to van Mander, in whose time Aernt Claesz. van Leyden, active half a century earlier, was still recalled with a reputation of greatness in imitation, when imitation of antiquity was still more novelty than an academic study according to rules to be formulated in the codified canons van Mander was propagating by the end of the century.

Ill. 93

Notes

1. Illustrated in J. Foucart, "Tableaux et Dessins des Écoles du Nord, XVIe et XVIIe Siècles," and A. Hardy, "Musée des Beaux-Arts de Valenciennes, II. Peintures du XVIe au XIXe Siècle," *La Revue du Louvre et des Musées de France,* XXII, 1972, 283-284 and 301. Although the name Aertgen van Leyden is omitted from these articles, the complete congruence of the triptych with van Mander's description had been noted by several people, including J. G. van Gelder, and it would be incorrect to imply that it is a discovery of mine. My thanks are due to T. H. Lunsingh Scheurleer for informing me of the rediscovery of the painting. It had been auctioned in 1900 without being recognized as by Aertgen. The central depiction, *The Last Judgement* helps explain van Mander's statement that Aertgen van Leyden painted in the manner of Maerten van Heemskerck. The upper part of the composition, as well as numerous figures in the lower part, are based on van Heemskerck's engraving *The Last Judgement* (Leiden, Prentenkabinet der Rijksuniversiteit, temporarily lost, but presumably equivalent to Hollstein, *Dutch and Flemish Etchings, Engravings, and Woodcuts,* VIII, 248, no. 562 or no. 563); or, less likely I think, they are based on first-hand acquaintance with van Heemskerck's painting *The Last Judgement* dated 1554 (Turin). Foucart mentions the strong resemblance to the Turin painting (illustrated in G. J. Hoogewerff, *De Noord Nederlandsche Schilderkunst,* The Hague, 1939, IV, 369, ill. 175). Some details of the painting by Aertgen not appearing in van Heemskerck's works, such as the group of four figures in the left foreground, vaguely recall similar figures in Lucas van Leyden's *Last Judgement* triptych (Leiden Municipal Museum "De Lakenhal"). Also reminiscent of Lucas' work are the figures on the outsides of the wings, holding the coats of arms. They recall the shield-bearers on Lucas' painting *Christ Healing the Blind Man* (Hermitage), commissioned by the same family. Comparison of Aertgen's triptych with the compositional source in van Heemskerck reveals a large amount of copying. This may well be the meaning of van Mander's reference to working in the manner of another artist, almost direct copying of particular works, not of more generalized characteristics of

137

laying on paint, of drawing, or of composition. This hypothesis would greatly restrict the art critic's practiced eyesight.

2. C. van Mander, *Het Schilder-Boek*, Haarlem, 1604 (reprint, Utrecht, 1969), folios 236 verso – 238.

3. Van Mander, *Schilderboek*, folio 237: "... zijn dingen wat slordich en onplaysant geschildert stonden:..."

4. J. Bruyn, "Twee St. Antonius-Panelen en Andere Werken van Aertgen van Leyden," *Nederlands Kunsthistorisch Jaarboek*, XI, 1960, 36, ill. 1. See also M. J. Friedländer, *From van Eyck to Bruegel*, London, 1969 (edited F. Grossmann), II, 126 and ill. 252.

5. Bruyn, "Werken van Aertgen," 65, ill. 16; 106, ill. 41. The evident connection of the first painting with the drawing in the Prentenkabinet, Rijksuniversiteit Leiden (Bruyn, "Werken van Aertgen," 70, ill. 19), which is divided as if to provide for the outside doors of an altarpiece, as Bruyn notes, suggests that the Brussels painting *The Temptation of St. Anthony* was originally part of an altarpiece. Private ownership was, however, also possible. The altar of the Guild of St. Anthony in the Leiden Pieterskerk, mentioned below, seems to have had a carved center. Another St. Anthony altar was located in the hospital of St. Anthony outside the walls of Leiden; and a place of special veneration of St. Anthony, with an altarpiece, was the parish church of Boscoop, between Leiden and Gouda, which fell under the jurisdiction of the Abbess of Rijnsburg, a village near Leiden (see M. Hüffer, *Bronnen voor de Geschiedenis der Abdij Rijnsburg*, The Hague, 1951, I, 510, no. 1098, April 11, 1510, for regulation about connected artworks; = *Rijks Geschiedkundige Publicatiën, Kleine Serie*, XXXI).

6. Bruyn, "Werken van Aertgen," 73, ill. 20, and preceding pages.

7. In Bruyn's opinion van de Waal's vision of Rembrandt developed to a position bordering on such self-identification (see Bruyn, "Visie op Rembrandt," the review mentioned above). For T. S. Eliot's comments on such criticism, see Eliot, *Selected Essays*, London, 1951 (third edition), "Hamlet," 141, second sentence and f. Bruyn's proposed reconstruction (Bruyn, "Werken van Aertgen," 73, ill. 20) uses a photograph of the Lugano portrait too small to show how extraordinarily long and out of joint the man's arms would have had to have been to meet the hands in the Brussels portrait. This can be seen, however, in the illustration given by Bruyn, "Werken van Aertgen," 106, ill. 41.

8. K. G. Boon, "Rondom Aertgen," *Miscellanea I. Q. van Regteren Altena*, Amsterdam, 1969, 59.

9. Bruyn, "Werken van Aertgen," 40-43, ill. 4.

10. Bruyn, "Werken van Aertgen," 43.

11. *Die Malerfamilie Holbein in Basel*, Kunstmuseum Basel, 1960, 315, no. 397, one of eight illustrations to the Lord's Prayer; also illustrated in Bruyn, "Werken van Aertgen," 49, ill. 8; and *Erasmus en zijn Tijd*, Museum Boymans-van Beuningen, Rotterdam, 1969, II, 141, no. 370.

12. Van Gelder, "De 'Kerkprediking'," 101-106. The other versions are ill. 2, by Jean II Penicaud; ill. 3, attributed to Jan van Amstel; and ill. 4, by Maerten van Heemskerck. The van Heemskerck version was reused with the inscription "Give us this day our daily bread" in *Biblia Sacra, dat is de geheele heylige Schrifture*, P. J. Paets, Leiden, 1657 (N. T. 1646), not mentioned by van Gelder. Also not mentioned in connection with the painting are Hans Holbein the Younger's *The Preacher* (from the *Dance of Death*) and John Bewick's copy illustrated in A. M. Hind, *An Introduction to the History of Woodcut with a Detailed Survey of Work done in the Fifteenth Century*, New York, 1935 (reprint, New York, 1963), I, 21 fig. 13 and fig. 14. The origin of the composition of the crowd may be partially derived from Hans Fries's *St. Anthony of Padua Preaching and the Miracle of his Grave*, 1506 (Freiburg, Franciscan Church), where, however, the rest of the painting serves well to indicate the extreme iconographic differences from the Amsterdam *Preaching of the Lord's Prayer*. See P. L. Ganz, *Die Malerei des Mittelalters und des XVI Jahrhunderts in der Schweiz*, Basel, 1950, color plate between pp. 124 and 125. See further, *NAT*, Anvers, Joannes Steels, II, no. 6. Servilus, Joh. (Knapius), Lexicon Graeco-Latinum 1559, border biblical scene of preaching with "VERBUM DEI" on pulpit antependium; the alterpiece of Thorslundekirke near Roskilde, 1561 (color plate 1 in *Nationalmuseets Vejledninger, Danmark, 1530-1660*, Copenhagen, 1968); and P. Schmidt, *Die Illustration der Lutherbibel, 1522-1700*, Basel, 1962, 224 and 336, pl. 250, "Ich bin das Brot des Levens", woodcut of Hans Brosamer, ca. 1548-1550, reused in the *Wustbibel*, Frankfurt, 1671.

13. Bruyn, "Werken van Aertgen," 64; van Gelder, "De 'Kerkprediking'," 105, ill. 4. The engraving is based on a drawing signed and dated 1571, not mentioned by van Gelder or Bruyn (Copenhagen,

Statens Museum for Kunst, neg. no. 8470; J. Garff, *Tegninger af Maerten van Heemskerck*, Statens Museum for Kunst, 1971, no. 113).

14. Boon, "Rondom Aertgen," 59.
15. Van Gelder, "De 'Kerkprediking'," 106.
16. Van Gelder, "De 'Kerkprediking'," 101.
17. Illustrated in *Erasmus en zijn Tijd*, II, 84, no. 451; and M. Geisberg, *The German Single-leaf Woodcut* (ed. W. Strauss), New York, 1974, III, 953, G. 997. For the date, see *Albrecht Dürer in de Nederlanden, zijn reis (1520-1521) en invloed* (exhibition catalog, Paleis voor Schone Kunsten), Brussels, 1977, 25-26, no. 28.
18. Bruyn, "Werken van Aertgen," 38-40.
19. Bruyn, "Werken van Aertgen," 39.
20. Bruyn, "Werken van Aertgen," 99-100, ill. 36; see also E. Panofsky, *Studies in Iconology*, New York, 1972 (originally published 1939), 7, on whether or not a figure is St. Bartholomew.
21. See W. Kurth, *The Complete Woodcuts of Albrecht Dürer*, New York, 1963, no. 115.
22. See N. Beets, *De Houtsneden in Vorsterman's Bijbel van 1528*, Amsterdam, 1915, no. 96, and page 26 of the critical commentary.
23. For French and German examples, however, see Bruyn, "Werken van Aertgen," 54-55.
24. See D. Enklaar, "Portretten van Bredasche Nassau's en hun Gevolg," *Oud-Holland*, LVI, 1939, 140. See also Boon, "Rondom Aertgen," 57.
25. See H. van de Waal, *Drie Eeuwen Vaderlandsche Geschied-Uitbeelding*, The Hague, 1952, I, 117; II, ill. 39; also illustrated elsewhere, for example, *Kunstreisboek voor Nederland in Beeld*, Amsterdam, 1972, 54.
26. Bruyn, "Werken van Aertgen," 50-51.
27. Bruyn, "Werken van Aertgen," 51-52.
28. Bruyn, "Werken van Aertgen," 52-53.
29. See Bruyn, "Werken van Aertgen," 53 and 51, ill. 9 and 10.
30. Bruyn, "Werken van Aertgen," 52-53 and 54-55, ill. 11, 12, and 13.
31. Bruyn, "Werken van Aertgen," 53. That the outmoded Italian fashion was perhaps used merely to give an exotic and vaguely historical appearance to the presumed portrait is at variance with the information in van de Waal, *Drie Eeuwen Vaderlandsche Geschied-Uitbeelding*, I, 60; II, ill. 24, 1 and 2.
32. See Bruyn, "Werken van Aertgen," 52; M. J. Friedländer, *Early Netherlandsih Painting*, X, *Lucas van Leyden and Other Dutch Masters of his Time*, no. 152 and 153, ill. 116 and 117; *Middeleeuwse Kunst der Noordelijke Nederlanden*, Rijksmuseum, Amsterdam, 1958, no. 45 and 46. Bruyn considers the woman portrayed in Friedländer's no. 152 to be unidentified (Bruyn, "Werken van Aertgen," 52). He therefore apparently rejects the identification in the Amsterdam catalog of the portrait as that of Maria Snellenberg, the same woman depicted in Friedländer's no. 153, the other painting Bruyn mentions. That one portrait is a slightly altered copy of the other is seen from Friedländer's illustrations (ill. 116 and 117), which are on facing pages. Only the hands have been altered. Bruyn's two portraits of people with Tau-crosses are thus reduced to one person. Even with the addition of the van Swieten relatives (note 33 below), the significance of rarity of the appearance of the Tau-cross on portraits is decreased; and its interpretation is not self-evident. Certainly there is no indication that the Tau-cross was limited to members of the Order of St. Anthony — en — Barbefosse. Maria Snellenberg's husband does not wear it; see Friedländer's no. 153. Two pendant Tau-crosses not from that Order are displayed in the National Museum, Copenhagen.
33. E. Pelinck, *Stedelijk Museum "De Lakenhal" Leiden, Beschrijvende Catalogus van de Schilderijen en Tekeningen*, Leiden, 1949, 97-100, no. 250.
34. S. A. 74, 1515-1564 (earlier years are missing), folio 1 verso, 1515: Willem Pietersz. den Dedens (?), Andries Hugez., Huge Jacopsz. scilder, Ghysbrecht Kerstantz. upte Hogewoert; and subsequent years, in which no painters are listed (the "Meester Dirck Hugenz." in 1521 was Dirck Huych Aelwynsz.'sz., a surgeon). The officers were rich.
35. Bruyn, "Werken van Aertgen," 50.
36. J. H. der Kinderen Bessier, *Mode-Metamorphosen, De Kleedij onzer Voorouders in de Zestiende eeuw*, Amsterdam, 1933. On page 6 the the author claims more popularizing intentions based on the work of C. H. de Jonge, partly published in her "Bijdrage tot de Kennis van de Kleederdracht in de Neder-

landen in de XVIe eeuw, . . ." *Oud-Holland*, XXXVI, 1918, 133-169, and *Oud-Holland*, XXXVII, 1919, 1-70, 129-168, 193-214. For this particular costume, see especially de Jonge, Type A, variatie III, on page 210. Neither author pretends to be exhaustive.

37. See Bruyn, "Werken van Aertgen," 46, ill. 6; 47, ill. 7; and 48. Bruyn prefers not to include the portrait he thinks is Jacques de Ligne in the group of portraits at the right. Instead he sees a single portrait apart, supposedly de Ligne, behind which is a group of four other portraits.

38. Friedländer, *Lucas van Leyden and Other Dutch Masters,* no. 141, ill. 109.

39. Friedländer, *Lucas van Leyden and Other Dutch Masters,* no. 118, ill. 94.

40. The sleeve design was common throughout northern Europe.

41. Bartsch VII. 433. 174.

42. The attachment, however, is on the opposite side, the judge's left, the cloaks may have been closable on either side; or compositional reasons may have determined the choice of closure side in the paintings. Which side seems unimportant in distinguishing the style of cloak from others in the area.

43. Friedländer, *Lucas van Leyden and Other Dutch Masters,* no. 80. The coat of arms of the city of Leiden appears on this painting.

44. Besides the lawsuits, recorded in R. A. 42/43, a fur-decorated cassock is mentioned in the will of the Leiden priest Meester Jan Gherytsz. ca. 1500 (Kl. Arch. 350). The will also instructs his executors to commission a memorial painting depicting Jan Gherytsz. standing on one side with his father, and Jan Gherytsz.'s mother standing on the other side with his three sisters. The only further specification is that the painting should not be too large and that it should be displayed on the grave of Jan Gherytsz. No preference for any particular artist is expressed nor are patron saints named or any other details. The mention of two sides suggests a triptych, but no middle is mentioned. Most interesting is that the donor would not have appeared as necessarily the most important figure in the painting.

45. Willem Jan Kerstantsz.'sz. Stoop wears one in Cornelis Engebrechtsz.'s *van der Does- van Poelgeest* panels (Friedländer, *Lucas van Leyden and other Dutch Masters,* no. 75); as does a leading male member of the family depicted in the so-called Paedts — Pynssen or Paedts — van Raephorst triptych, attributed to Cornelis Engebrechtsz. (Friedländer, *Lucas van Leyden and Other Dutch Masters,* no. 69). Although the painting is inferior, an equally fine coat is seen in the supposed portrait of Dirck van Brouchoven (Pelinck, *Leiden Municipal Museum "De Lakenhal" Catalog of Paintings*, 96, no. 248, ill. 7).

46. On inheritance the cloaks may have been sent out for alteration, but no documents support this idea for Leiden. The continuity of such cloaks in paintings of several decades suggests the contrary.

47. Friedländer, *Lucas van Leyden and Other Dutch Masters.* no. 111, ill. 85.

48. Bartsch VII. 409. 136.

49. Another example is Bruyn's "Lucas van Leyden en zijn tijdgenoten in hun relatie tot de Zuidelijke Nederlanden." See also his "Werken van Aertgen," 71 (with exclamation point).

50. Leiden was a center for the production and export of cloth, bricks, fish, dairy products, and pewter at this time.

51. Van Gelder, "De 'Kerkprediking',"102. Bruyn's comment that consciousness of difference in social rank in 1530 renders it unthinkable that a painter might be depicted among the notables in the group at the right side of the Amsterdam painting points to a lack of understanding of the social rank of painters at that time (Bruyn, "Werken van Aertgen," 50).

52. Bruyn, "Werken van Aertgen," 63.

53. For an apparent example of this kind of altarpiece in dispute, see R. A. 42, December 11, 1514. An example of payment of pig protection money can be found in S. A. 594 (Thesauriers Rekeningen, 1514-1515), folio 63 verso. The city's payments to the "Procurator van Sint Anthonis Casse" had been at some time delegated to the verger of the Church of Our Lady (Onze Lieve Vrouwe Kerk), but references to them continued to be entered in the city's annual accounts.

54. Payment to the "altar" is also synonymous with payment to the guild attached to or maintaining the altar. The phrase occurs this way in guild dues lawsuits in R. A. 42/43. A description of a "casse" containing a statue is found in the van Berendrecht inventory, R. A. 102, folios 37 verso — 38: "Een schoone casse met een Magdaleenen beelt." This was valued at four guldens, far more than the usual valuation of the many paintings in the inventory.

55. Bruyn, "Werken van Aertgen," 67.

56. The Dutch historian A. E. Cohen has described this as the prime prerequisite of modern historical scholarship; see his "Ten Geleide" (preceding Table of Contents), *Leiden University in the Seventeenth Century, An Exchange of Learning* (essays edited by T. H. Lunsingh Scheurleer and G. H. M. Posthumus Meyjes and others), Leiden, 1975.

57. It evidently may be considered normal according to what Bruyn identifies as the usual Dutch standards in art historical writing in "Visie op Rembrandt," the review of van de Waal's *Steps towards Rembrandt* mentioned above.

58. Bruyn, "Werken van Aertgen," 93 and 92, ill. 33. The attribution to Aertgen van Leyden is found in the caption to the illustration (too small to show the monogram); the attribution is implicit in the single sentence referring to the painting. Pelinck gives the monogram correctly in his "Een Heilige Hieronymus van Jan Cornelisz. Vermeyen," *Bulletin Rijksmuseum*, VIII, 1960, 135. The monogram can be seen fairly clearly (on the small pendant above the candle) in van de Waal, *Steps towards Rembrandt*, Amsterdam, 1974, 179, ill. 42. Van de Waal, however, misreads the monogram as G. I. or I. G., although the serifs at the top and bottom of the C are exactly equal (van de Waal, *Steps towards Rembrandt*, 159). Van de Waal provides a full-page illustration of this picture as being "typically Leiden" work and the earliest example of a group of pictures illuminating side issues raised by Rembrandt's Faust etching in the article considered by Bruyn to be an example of eccentricity against which the "more eccentric" work of van de Waal can be measured.

59. Pelinck, "Een Heilige Hieronymus," 135-139.

60. J. Q. van Regteren Altena, "Aertgen van Leyden," *Oud-Holland*, LVI, 1939, 129, drawing in Darmstadt.

61. Van Regteren Altena, "Aertgen van Leyden," 130.

62. J. J. Graaf, *Nederlandsche Doopnamen naar Oorsprong en Gebruik*, Bussum, 1915, III and VII, names no. 23 and 60; II, no. 19. The information in this book is consistent with the sixteenth-century practices recorded in Leiden archival records; Aertgen appears also as Aert and Aernt, names which in Aertgen van Leyden's namesakes also appear as Adriaen and Arnoldus.

63. J. G. van Gelder, "Verloren Werken van Lucas van Leyden," *Miscellanea Prof. Dr. D. Roggen*, Antwerp, 1957, 94, no. 5. The drawing is in the National Gallery of Scotland, Edinburgh. For one additional de Bisschop drawing of a lost work by Lucas van Leyden, see van Gelder, "Jan de Bisschop 1628-1671," *Oud-Holland*, LXXXVI, 1971, ill. 44.

64. See van Gelder, "Verloren Werken van Lucas van Leyden," ill. 7.

65. Van Gelder, "Verloren Werken van Lucas van Leyden," 92.

66. Bruyn noted that the Edinburgh drawing could depict the published painting or another unknown version (Bruyn, "Werken van Aertgen," 95). There is, however, no possibility that the published painting is depicted in the drawing.

67. Another depiction of Cain and Abel with two altars is seen in the right roundel in the background of Pieter Coecke van Aelst's painting *The Last Supper*. See G. Marlier, *La Renaissance flamande, Pierre Coeck d'Alost*, Brussels, 1966, 94, ill. 28, and 103, ill. 32.

68. De Bisschop's opinion about the painter may have been wrong, if the signature was not in fact on the painting he copied; see van Gelder, "Verloren Werken van Lucas van Leyden," 92. Similar considerations apply to many of the works listed by van Regteren Altena in his catalog of Aertgen's works: van Regteren Altena, "Aertgen van Leyden," 226-235. The problem of old inscriptions is noticed by Bruyn in "Some Drawings by Pieter Aertsen," *Master Drawings*, III, 1965, 365, no. 5.

69. See P. Wescher, "Aertgen van Leyden: Some Additions," *Wallraf-Richartz-Jahrbuch, Westdeutsches Jahrbuch für Kunstgeschichte*, XXX, 1968, 215-222. The four examples are in the Wallraf-Richartz-Museum, The Louvre, The Hermitage, and The North Carolina Museum of Art. See I. Hiller and H. Vey, *Katalog der deutschen und niederländischen Gemälde bis 1550 ... Wallraf-Richartz-Museum/ Kunstgewerbmuseum der Stadt Köln*, Cologne, 1969, 35-37, ill. 38; van Regteren Altena, "Aertgen van Leyden," 222-223, where he calls attention to the similarities between the *Nativity* painting known in four examples and a *Nativity* of 1520 by Hans Baldung Grien. (See *Alte Pinakothek München, Katalog II, Altdeutschen Malerei*, Munich, 1963, no. 6280, ill. page 267.) Van Regteren Altena suggested that Aertgen had probably travelled to the South via Strassbourg and Basel. Bruyn, "Werken van Aertgen," 93, agrees with the connection of the two *Nativity* paintings and also connects to them a drawing (Bruyn, "Werken van Aertgen," ill. 31). Through this drawing he proceeds to connect another

dissimilar painting of *The Nativity* with Aertgen van Leyden (Bruyn, "Werken van Aertgen," ill. 32). The two paintings and the drawing of *The Nativity* which have been attributed to Aertgen van Leyden are derivative of Hans Holbein the Younger's *Nativity* in the Oberried Altar left wing, which itself has been connected with the painting by Hans Baldung Grien (see *Die Malerfamilie Holbein in Basel*, 184-186, no. 156, ill. 59).

70. F. J. van den Branden, *Geschiedenis der Antwerpsche Schilderschool*, Antwerp, 1883, 350. This is cited by van Regteren Altena, "Aertgen van Leyden," 23, who, however, confused Frans Francken the Elder, whose estate was inventoried, with the painter Frans Francken the Younger, whose *Collector's Cabinet* shows the *Nativity* known in four examples. See van Regteren Altena, "Aertgen van Leyden," 20, ill. 2. This error is not made in Hoogewerff, *Noord Nederlandsche Schilderkunst*, III, 400, where it is also noted that no certainty exists that Frans Francken the Younger inherited his father's painting.

71. Van Regteren Altena also shows a painting supposed to be by D. Teniers, a *Collector's Cabinet* containing another copy of the painting in four examples, but with other proportions and format (van Regteren Altena, "Aertgen van Leyden," 21, ill. 3). Hoogewerff, however, attributed this painting also to Frans Francken the Younger, which might have strengthened the supposition that he had inherited the painting in his father's estate, and that it was, additionally, the painting now attributed to Aertgen van Leyden by van Regteren Altena, Hoogewerff, Wescher, Bruyn, and others.

72. Van Regteren Altena, "Aertgen van Leyden," 23-24. Van Regteren Altena states that the conception of the painting is so different from that of Lucas van Leyden that an attribution to Lucas van Leyden needs no refutation. E. Michel, *Catalogue Raisonné des Peintures du Moyen-Age, de la Renaissance et de Temps Modernes, Peintures Flamandes du XVe et du XVIe Siècle*, Paris, 1953, 157, maintains that the Louvre's example of *The Nativity* is either an original work of Lucas van Leyden or, possibly, a studio copy of a beautiful original work of Lucas van Leyden. Michel mentions the attribution to Aertgen van Leyden by Hoogewerff, but he does not mention van Regteren Altena.

73. See van den Branden, *Antwerpsche Schilderschool*, 349-351. Thirty-two original paintings are apparently named by subject (a few may be repetitiously listed), and it is further said that there were numerous copies of other paintings, in addition.

74. A. J. J. Delen, *Koninklijk Museum voor Schone Kunsten. Antwerpen. Beschrijvende Catalogus I. — Oude Meesters*, Antwerp, 1948, 115, no. 816.

75. The Tenth Penny tax records of 1544 (A. R. A., The Hague, Staten van Holland vóór 1572, 275) list seven people of the name; those of 1557 (A. R. A., The Hague, Staten van Holland vóór 1572, 1011) list eleven, one of whom (a brewer) is listed as deceased; those of 1559 (S. A. 992) list the name on seventeen different pages. Aert Claes Aertsz.'sz., an example of a namesake, died before March 11, 1555 (R. A. 42). Another person, however, had the same name, patronymic, and father's patronymic; and he continues to be mentioned, for example, on March 20, 1556 (R. A. 42). Aernt Claesz., boatbuilder, was married to Erm Dircxdr.; he died before January 24, 1564 (R. A. 42). Further, there is a lawsuit between the widow of one Aernt Claesz. and another person named Aernt Claesz. (see R. A. 42, March 2, 1562, and March 16, 1562). It will probably remain impossible to identify the painter Aernt Claesz. without clear occupational specification or reference to his residence in the house belonging to Cornelis Vranckenz. ca. 1560-1564.

76. R. A. 6, folio 40 verso, August 19, 1521.

77. R. A. 42. Five other members of the St. Lucas Guild were sued for similarly small amounts in the same series of lawsuits on the same date. The others were all glassmakers and stained-glass painters: Oeloff Reyersz., Dirck Jansz. (den Abt), Pieter (Huygenz.) van Cloetinge, David Eggertsz (van Dulmenhorst), and Michiel (Gerytsz.).

78. R. A. 42, August 7, 1536; August 21, 1536; September 11, 1536; October 6, 1536; two cases on October 9, 1536.

79. R. A. 42, October 9, 1536. In the first case reference is to "Aernt Schilder;" in the second, reference is to "Aernt Claeszoen schilder."

80. A. R. A., The Hague, Staten van Holland vóór 1572, 1330, Leiden Tenth Penny tax records for 1561, not foliated, section: *Sytgraft* in *Bon Levendeel*; S. A. 993, Tenth Penny tax records of Leiden for 1564, folio 110, *Zytgraft*. In both lists the name is given as *Aertgen schilder*, the only contemporary references to his name in this diminutive form which has become the most commonly used version of his name.

81. S. A. 992, Tenth Penny tax records, Leiden, 1559, folio 54, *die Ziedtghraft*: "*Cornelies Vranckenz. een*

Lech erf eygenair" (no tax on this empty house). That the house is identical with Aertgen's later is determined by the ownership listing of adjoining properties. That Frans Florysz. met Aertgen by visiting this particular house, a story given by van Mander, is probably incorrect. Hoogewerff identified the story as having been applied to other artists earlier (see his *Noord Nederlandsche Schilderkunst*, III, 389).

82. S. A. 1176, folio 21 verso; R. A. 42, March 27, 1534. The painter Baernt Claesz.'s house is named in the lawsuit. It was located by the Wittepoort and was called "In Patmos." The case was delayed until April 17, 1534, to await the arrival of the painter's wife. Reference to the fuller Baernt Claesz. is found relatively frequently in R. A. 42, for example, see October 30, 1531.

83. The Leiden painter Jan Jansz. received civic commissions from ca. 1497 onwards. The portrait of Cornelis Willemsz. originally hung in the St. Pancraeskerk.

84. Possibly related figures are seen on the choir stalls of the Onze Lieve Vrouwe Kerk (Grote Kerk) Dordrecht; see J. S. Witsen Elias, *De Schoonheid van Ons Land, Beeldhouwkunst, Koorbanken Koorhekken en Kansels*, Amsterdam, 1946, ill. 122-131.

Appendix 1. Selected Documents

1. R. A. 42, November 14, 1477
Allairt Aelbrechte z. heeft verwonnen Heynric tasschemaker van XVI placken
soe hy hem hadde doen besetten by Heynrick van Aken ende V grooten van beset gelt
dair Cornelis die scilder borge voir is/ als Heynric seyt Actum XIIII dagen In
novembri anno LXXVII scepenen Daniel Reynersz./ Dirc Dircxz. Pieter van Noor-
tich Pieter Reymbrandtsz. Pieter Grebber.

2. R. A. 42, June 10, 1513
Jan Zeversz. printer beclaecht Cornelis die figuersnyder om leveringe van seker
figueren hem besteet off XII Rijns guldens dair voir.

3. R. A. 42, June 15, 1520
Dirck Mast beclaecht Cornelis Ghysbrechtsz. om hem te voldoen by Cornelis
Engebrechtsz. van dat hy zyn zoon heeft leeren schilderen of III £ groot dair voir

4. R. A. 42, August 12, 1521
Baltasar gemachticht van Katryn Jansdr. beclaecht Cornelis Engebrechtsz. om
tonderteykenen zulcken obligacie als hy beloeft heeft tonderteykene of III £ groot dair
voir

5. S. A. 602 (Thesauriers Rekeningen, 1521-1522), folio 102
Item opten XVIIen dach van Julio Anno XVcXXII betaelt Pieter Corneliszoon
schilder van een kaerte die hy mit Cornelis Engebrechtsz. zyn vader gemaict heeft
omme dair by te verificeren trecht dat die stede heeft totte vischerye van de maeren
poel die somme van V £

6. S. A. 663 (Bijlagen Thesauriers Rekeningen, 1525)
Ick Cornelis Enghebrechtsz. kenne ende lije ontfangen te hebben vier schellijng
groet flaes ter cause van die trompetters vanen ende noch drie stuivers an die frange
voer die bagijn [signed:] Bouwen Willemsz. Florys Jacopsz.

7. R. A. 42, February 11, 1527
Balthazar gemachticht van Matheeus van Berendrecht beclaecht Cornelis En-
gebrechtsz. ende Frans Pieter Mouwerynsz.'sz. om tuychnisse der wairheyt tusschen
hem ende Roeloff Gerytsz. of elcx vier £ groot dair voir

144

8. R. A. 42, October 7, 1527

Jacop Jansz. Cock als man ende voicht van Meynsgen Cornelisdochter zyn wyf beclaecht Lysbet Pietersdr. Cornelis Engebrechtsz.'s wedue om hem betaelinge te doen van der voirn. Meynsgens vaders erve of X £ groot dair voir

9. R. A. 42, November 15, 1527

Jacop Jansz. Cock beclaecht Lysbet Pietersdr. Cornelis Engebrechtsz.'s wedue mit hoir voicht om hem te voldoen van alzulcken voirwairde als sy mit hem gemaect heeft In presentie van alle hoer kinderen of X £ groot dair voir

10. R. A. 42, September 19, 1530

Idem [Balthazar] gemachticht van Lieven Jacopsz. voirs. [van ZZe. = Sassenheim] beclaecht Lysbeth Cornelis Engelbrechtsz. schilders weduwe om 11 Ryns guldens ter cause van zekere werck dat Cornelis voirs. In zyn leven van voirn. Lieven angenomen hadde te maecken ende nyet gelevert en heeft/ Is gewesen alzoe deysscher zynen eyssche nyet en bewyst zulcx dat scepenen dunct genouch te wesen dat dair omme die verweerster vry ende quyt zel wesen van de voirs. eyssche ende ansprake actum ut supra [In the case preceding this, Lieven Jacopsz. van Sassenheim had been acting on behalf of Lieven van Bosschuysen, whose guardian he was. The connection with Lieven van Bosschuysen is, however, not mentioned in the case against Cornelis Engebrechtsz.'s widow.]

11. R. A. 42, November 17, 1533

Pieter Jansz. gemachticht van Lysbet Pietersdochter als boelhoudster van Cornelis Engebrechtsz.'s boel beclaecht Claes Cornelisz. zeggende dat by schuldich zal wesen Inden voirs. boel alsulcke goeden als hy mit Lucie Cornelisdr. zyn eere wyf gehadt heeft om alsoe den voirs. boel ghelickelick elcx Int zyn te schyften ende te scheyden of hondert Karolus guldens daer voer/ ende Is deze saicke nae de gestedinge boven getogen up dynsdage naestcomende actum den XXVIIIen novembris

12. R. A. 42, November 17, 1533

Claes Cornelisz. beclaecht Lysbet Cornelis Engebrechtsz.'s weduwe als boelhoudster van den gemeenen boel van Cornelis Engebrechtsz. zyn huysvrouwen vader was/ om hem te leveren een doechdelicke ende souffisante Inventaris van alle die naegelaten goeden die Cornelis voirs, aftergelaten ende mitter doot geruymt heeft of hondert Ryns guldens daer voer/ Uutgestelt tot den naesten Rechtdage om dair en binnen by deysscher gevisiteert te worden den Inventarys die de verweerder hem overgelevert heeft actum den XXVIIIen novembris boven getogen up dynsdage naestcomende actum den XXVIIIen novembris Upten IIIIen decembris Is by scepenen gewesen dat die verweerster volstaen zal mits ten naesten Rechtdage doende den behoirlicken eedt up den Inventaris by haer overgelevert/ Upten XIIen decembris zo dair an volgende zoe Is die voers. zaicke by pertyen weder gecontinueert tot den eersten Rechtdage nae kersmisse toecomende

13. R. A. 42, October 13, 1536

Lysbeth Engebrechtsdochter als erfgename van Otto Dircxz. van der Goude saliger memorien beclaecht Lysbeth Pietersdochter weduwe van wylen Cornelis Engebrechtsz. saliger gedachten mit Jacop Jansz. als man ende voicht van Clemeynse Cornelisdochter zyn huysvrouwe/ Pieter Cornelisz. mit zyn voechden/ ende Beatris Cornelisdochter als erfgenamen van Cornelis Engebrechtsz. voirs. Ende seyt dat sekeren Jaeren geleden Otto Dircxz. deser werlt overleet achterlaetende zekere goeden/ onder andere een huys ende erve gelegen binnen der Goude/ daer van die helft/ de weduwe van den voors. Otto competeerde/ ende die voors. Cornelis Engebrechtsz., Lysbeth Engebrechtsdochter eysschersse voornoemd mit haer consoerten die ander helfte/ ende alzoe die voirs. Lysbeth Engebrechtsdochter zekere deelen ant voors. halve huys heeft/ ende zy een oude vrouwe Is/ zoude daer omme gaerne haer portie tot gelde maken/ mits tzelve een ander te vercopen ende transpoert daer van te doen/ waer toe zy niet en can geraecken/ alzoe men seyt dat die voors. Lysbet Pietersdr. ofte haer voors. kinderen tzelve halve huys vercoft hebben — gheen anschou noch Regardt te nemen dat die voors. Lysbeth Engebrechtsdochter daer zekere deelen an heeft/ of oeck sonder eenich consent van der voornoemden Lysbeth Engebrechtsdochter te hebbene Concludeert daer omme die vooirs. Lysbeth Engebrechtsdochter dat by vonnisse van U myn heeren die voors. verweerders gecondempneert zullen wesen van de voirs. coepe voer U myn heeren te Renunchieren up dat die voors. Lysbeth Engebrechtsdochter die Renunchiatie thonende haer wille mit hoer goet mach doen mits betalende die costen van den eyssche gedaen ende noch gedaen zullen worden of elcx drie ponden groten Vlaems daer voer te geven Protesterende nyettemin van schaden ende Interesten omme In tyden ende wylen die te Intenteren alst deysscherse goet duncken zal/ Angaende Pieter Cornelisz. mit zyn voechden off/ ende voirt Is de saicke uutgestelt VIIIe dagen actum den XXen dach In octobri

14. R. A. 42, March 15, 1538

Jan Pietersz. gemachticht van Cornelis Woutersz. beclaecht Elysabeth Cornelis Engebrechtsz.'s weduwe mit haer voecht Seggende dat Inden Jaere XVᶜXXVIII upten XXVIIIen martii Elysabeth voors. mit hoer voecht vercoft heeft Cornelis Woutersz. voirn. drie morgen lants twelck gemengender voer zoude leggen In acht morghen behoerende die leprosen buyten Leyden Ende alsoe Cornelis Woutersz. voors. gaerne zyn wille mit die voors. drie morgen zoude doen mit vercopen off anders ende die voors. meesters van den leprosen Inden zelve weer lants zeggen te hebben VI½ morgen lants/ wair doer Cornelis Woutersz. voors. tzynre meninge niet en mach commen Soe zeyt ende concludeert Jan Pietersz. voors. Inden name als boven dat by vonnisse van U myn heeren de voors. Elysabeth mit haer voecht gecondempneert zullen wesen den voirnoemden Cornelis Woutersz. leveringe van de voors. drie morgen lants te doene ende bewysene of drie hondert gouden Karolus guldens daer voer te geven maickende eysch van costen schade ende Interesten// Uuytgestelt van manendage toecomende ende achte dagen actum den XXIIen martii

Appendix 2 Genealogical Notes

The Family of Cornelis Engebrechtsz.

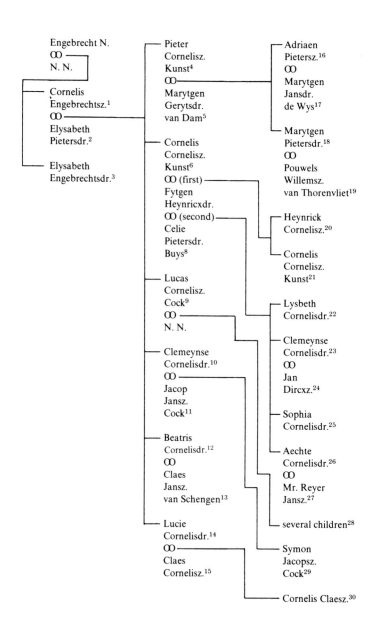

Engebrecht N.
∞
N. N.

Cornelis
Engebrechtsz.[1]
∞
Elysabeth
Pietersdr.[2]

Elysabeth
Engebrechtsdr.[3]

Pieter
Cornelisz.
Kunst[4]
∞
Marytgen
Gerytsdr.
van Dam[5]

Cornelis
Cornelisz.
Kunst[6]
∞ (first)
Fytgen
Heynricxdr.
∞ (second)
Celie
Pietersdr.
Buys[8]

Lucas
Cornelisz.
Cock[9]
∞
N. N.

Clemeynse
Cornelisdr.[10]
∞
Jacop
Jansz.
Cock[11]

Beatris
Cornelisdr.[12]
∞
Claes
Jansz.
van Schengen[13]

Lucie
Cornelisdr.[14]
∞
Claes
Cornelisz.[15]

Adriaen
Pietersz.[16]
∞
Marytgen
Jansdr.
de Wys[17]

Marytgen
Pietersdr.[18]
∞
Pouwels
Willemsz.
van Thorenvliet[19]

Heynrick
Cornelisz.[20]

Cornelis
Cornelisz.
Kunst[21]

Lysbeth
Cornelisdr.[22]

Clemeynse
Cornelisdr.[23]
∞
Jan
Dircxz.[24]

Sophia
Cornelisdr.[25]

Aechte
Cornelisdr.[26]
∞
Mr. Reyer
Jansz.[27]

several children[28]

Symon
Jacopsz.
Cock[29]

Cornelis Claesz.[30]

147

Relatives of Pieter Cornelisz. Kunst's wife, Marytgen Gerytsdr. van Dam

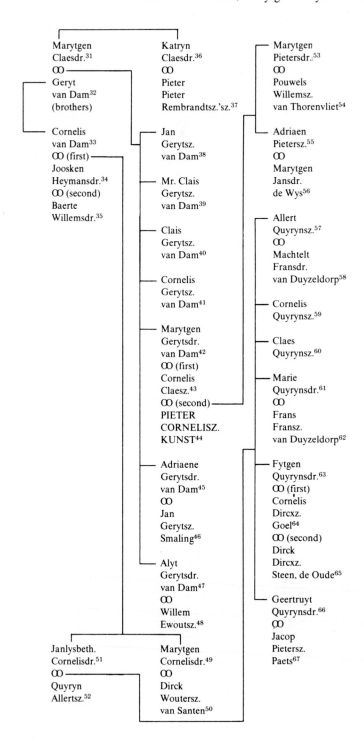

Relatives of Quyryn Allertsz., whose wife Janlysbeth Cornelisdr. was a cousin of Marytgen Gerytsdr. van Dam (wife of Pieter Cornelisz. Kunst)

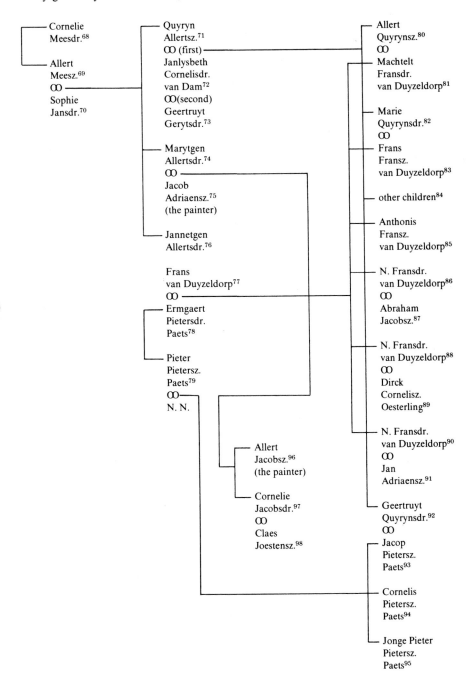

Relatives of Pouwels Willemsz. van Thorenvliet, son-in-law of Pieter Cornelisz. Kunst (list of descendents of founders of Annahofje)

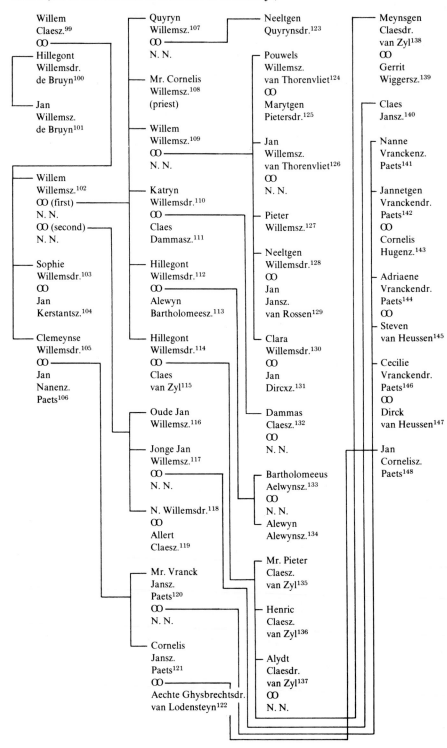

Relatives of Marytgen Jansdr. de Wys, daughter-in-law of Pieter Cornelisz. Kunst

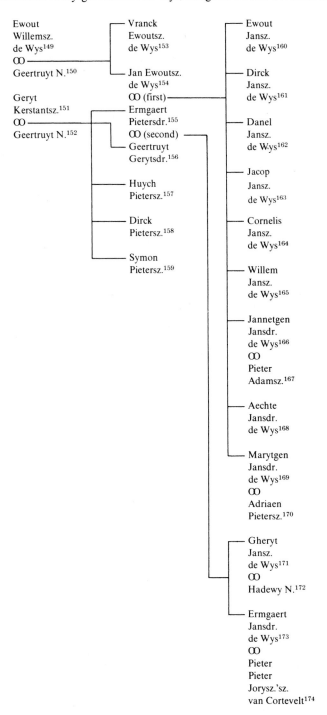

Ewout
Willemsz.
de Wys[149]
∞
Geertruyt N.[150]

Geryt
Kerstantsz.[151]
∞
Geertruyt N.[152]

Vranck
Ewoutsz.
de Wys[153]

Jan Ewoutsz.
de Wys[154]
∞ (first)

Ermgaert
Pietersdr.[155]
∞ (second)

Geertruyt
Gerytsdr.[156]

Huych
Pietersz.[157]

Dirck
Pietersz.[158]

Symon
Pietersz.[159]

Ewout
Jansz.
de Wys[160]

Dirck
Jansz.
de Wys[161]

Danel
Jansz.
de Wys[162]

Jacop
Jansz.
de Wys[163]

Cornelis
Jansz.
de Wys[164]

Willem
Jansz.
de Wys[165]

Jannetgen
Jansdr.
de Wys[166]
∞
Pieter
Adamsz.[167]

Aechte
Jansdr.
de Wys[168]

Marytgen
Jansdr.
de Wys[169]
∞
Adriaen
Pietersz.[170]

Gheryt
Jansz.
de Wys[171]
∞
Hadewy N.[172]

Ermgaert
Jansdr.
de Wys[173]
∞
Pieter
Pieter
Jorysz.'sz.
van Cortevelt[174]

151

Relatives of Celie Pietersdr. Buys, second wife of Cornelis Cornelisz. Kunst, her second husband

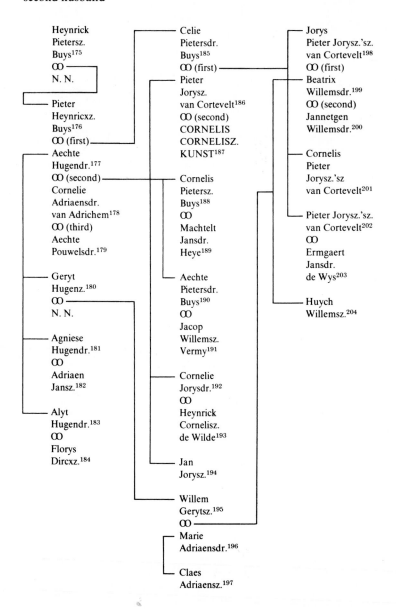

Notes

1. See text.
2. See text.
3. R. A. 42, October 13, 1536.
4. Pieter Cornelisz. Kunst birth date is discussed in the text. His marriage to Marytgen Gerytsdr. van Dam took place within the year preceding January 7, 1510 (R. A. 42). The marriage contract is R. A. 76, B^1, no. 36, July 1, 15—— (thus, 1509). Pieter Cornelisz. Kunst died between October 31, 1560 and the first week in July, 1561 (R. A. 42, October 31, 1560 and August 8, 1561).
5. Marytgen Gerytsdr. van Dam died within the year before March 5, 1548 (R. A. 42).
6. The marriage contract for Cornelis Cornelisz. Kunst's first marriage is not preserved. That for the second is R. A. 76, B^1, no. 82, January 24, 1530. It is mentioned in Bruyn, "Lucas van Leyden en zijn tijdgenoten," 44, with thanks to Koning. Cornelis Cornelisz. Kunst died between January 29, 1546, and November 8, 1546, probably in the third week of August, 1546 (R. A. 42). Besides being a painter, he was a wealthy investor in the drapery industry.
7. Fytgen Heynricxdr. died before January 19, 1530 (see W. A. 113, Gr. Bew. B, folio 123 verso). She had a brother, Ghysbrecht Heynricxz. who was a priest; and she had a sister, Jannetgen Heynricxdr., who married Geryt Jansz. Onderwater, a man of importance in Leiderdorp. Jannetgen Heynricxdr. died in the year preceding June 22, 1527 (R. A. 42).
8. Celie Pietersdr. Buys died in the year before February 27, 1568 (R.A. 43). Her activities will be discussed in connection with the separation of her drapery interests from those of her second husband, Cornelis Cornelisz. Kunst, in a separate study. See also no. 186 below.
9. Lucas Cornelisz. Cock was still in Leiden on June 16, 1542 (R. A. 42). He died somewhere else before June 27, 1552 (R. A. 42).
10. R. A. 42, October 7, 1527.
11. Jacops Jansz. Cock was possibly the son of Jan Dircxz. Cock, with whom he was co-owner of a house (see R. A. 42, September 27, 1518).
12. Beatris Cornelisdr. died in the year preceding April 8, 1552 (R. A. 42).
13. Claes Jansz. van Schengen died before January 29, 1535 (R. A. 42). His parents were Jan van Schengen and Geertruyt N; Jan van Schengen died befor July 19, 1504 (W. A. 113, Gr. Bew. A, no. 490). Claes Jansz. van Schengen had a brother Cornelis, who married Katryn Adriaensdr. She died before May 4, 1527, when Cornelis Jansz. van Schengen made arrangements for guaranteeing his children's inheritance (W. A. 113, Gr. Bew. B, folio 65). His bond was Pieter Heynricxz. Buys (see no. 176 below). His children were named Jan, Pieter, Wyburch, Maritgen, Celi, and Fytgen.
14. Lucie Cornelisdr. died before August 12, 1533 (see W. A. 113, Gr. Bew. B, folio 146 verso).
15. Claes Cornelisz. was a "*droechsheryer*" (cloth shearer). He remarried before November 17, 1533 (R. A. 42).
16. Adriaen Pietersz. was a stained-glass painter. The marriage of Adriaen Pietersz. and Marytgen Jansdr. de Wys took place after October 23, 1539 (see W. A. 113, Gr. Bew. B, folio 195). Adriaen Pietersz. died between July 26, 1557, and November 22, 1557 (R. A. 42). He probably was one of the stained-glass painters who carried out his father's designs
17. See W. A. 113, Gr. Bew. B, folio 322 verso, April 5, 1559. The son of Adriaen Pietersz. and Marytgen Jansdr. de Wys was Cornelis Adraensz.
18. The marriage contract of Marytgen Pietersdr. and Pouwels Willemsz. van Thorenvliet is R. A. 76, B^1, no. 147, January 17, 1541. Their children were Willem, Pouwels, Janneken, and Maritgen. Willem Pouwelsz. van Thorenvliet married Pietergen Jansdr. Nachtegael. Their children were Jan and Clara. See Archieven der Hofjes, 131 and 132; see also W. A. 113, Gr. Bew. F, folio 299, April 23, 1614; and W. A. 113, Gr. Bew. G, folio 28 verso, October 14, 1627.
19. Pouwels Willemsz. van Thorenvliet died between November 4, 1575, and October 5, 1576 (R. A. 43). He was survived by his widow. He was an important cabinetmaker, investor, and political figure in Leiden, where he acted as deputy sheriff for many years preceding the Reformation and was one of the earliest churchmasters of the Pieterskerk (and conjoined parishes) after the Reformation. See R. A. 43, August 1, 1575; the other churchmasters of that date were Bouwen Jansz. Paedts, Jacop Allertsz. de Haes, and Allert Willemsz.
20. W. A. 113, Gr. Bew. B, folio 123 verso, January 19, 1530.
21. Cornelis Cornelis Cornelisz.'sz. Kunst was a draper with international trading connections, which

will receive attention in a discussion of that aspect of his father's activities. For example, see R. A. 43, November 17, 1572.

22. Lysbeth Cornelisdr. is mentioned several times in archival documents without any definite proof that she was the daughter of Cornelis Cornelisz. Kunst. On January 28, 1558, for example, she sued Cornelis Vranckenz. van Delft (a Leiden lawyer) for payment of 5 shillings (Flemish) for a painting delivered to him (R. A. 42).

23. Clemeynse Cornelisdr. was sued by Claes Ysaack Claesz.'sz. on November 18, 1547, about various things, including seven small pictures (R. A. 42). Although Claes Ysaack Claesz.'sz. was related to, and associated with, Pieter Cornelisz. Kunst, it is not proven that Clemeynse was the daughter of Cornelis Cornelisz. Kunst. A possibility exists that there is a clerical error in the lawsuit of November 18, 1547, and that her husband should be identified as Jacop Jansz. Cock (co-owner of a house with Jan Dircxz.; see no. 11). If so, the reference would be to Cornelis Cornelisz. Kunst's sister.

24. See no. 23.

25. Sophia Cornelisdr. is mentioned as a child of Celie Pietersdr. Buys in an inheritance case of March 12, 1568 (R. A. 43).

26. See. W. A. 113, Gr. Bew. B, folio 393 verso, January 25, 1575.

27. See citation in no. 26. He was an important Leiden surgeon and also owned the inn "*In de Meereminne*".

28. The interests of Lucas Cornelisz. Cock's children, described as living in a foreign land, were represented in the inheritance case of June 27, 1552 (R. A. 42), mentioned above in no. 9.

29. Jacop Jansz. Cock is named as the father of Symon Jacopsz. Cock on March 19, 1551 (R. A. 2). On May 10, 1551, Symon Jacopsz. Cock was banned from Leiden for fifteen years and fined 20 Karolus guldens for having caused great violence on the street, wounding someone severely (R. A. 3, 1533-1584, no. 65).

30. See W. A. 113, Gr. Bew. B, folio 146 verso, August 12, 1533.

31. Marytgen Claesdr. van Dam died sometime before May 17, 1527 (R. A. 42), leaving a considerable estate. Her will was made in 1521 (see R. A. 76, B¹, no. 203, February 8, 1549). That she was the sister of Katryn Claesdr. is noted in various places including R. A. 42, May 17, 1527; R. A. 41, 1504-1521, folio 43 verso, ca. September 26, 1507; and R. A. 41, 1504-1521, folio 156, February 20, 1511.

32. Geryt van Dam died before June 17, 1487 (R. A. 41, 1486-1492, folio 46). That he was the brother of Cornelis van Dam is implicit in the relationships mentioned in R. A. 42, 1535-1536, after April 26, 1535.

33. See R. A. 42, 1535-1536, folio 46.

34. As no. 33.

35. As no. 33. After the death of Cornelis van Dam. Baerte Willemsdr. married Geryt Boeckelsz. Buytewech. She died in the year before July 26, 1538 (R. A. 42).

36. See no. 31. Katryn Claesdr. had previously been married to Geryt Claisz. (van) Raephorst (R. A. 41, 1497-1505, folio 165, March 14, 1501). She should not be confused with Katryn Claesdr. van Keeten, who was the first wife of Pieter Pieter Rembrandtsz.'sz. (see no. 37).

37. Pieter Pieter Rembrandtsz.'sz. was a very wealthy draper and official of the municipal government. He appears to have been one of the two or three most important drapers of Leiden. Pieter Heynricxz. Buys was another; see no. 176. Pieter Pieter Rembrandtsz.'sz. died in the year before October 14, 1504 (R. A. 41, 1497-1505, folio 275). His first wife had been Katryn Claesdr. van Keeten, who died in the year before July 10, 1493 (R. A. 41, 1491-1497, folios 130 and 130 verso).

38. R. A. 41, 1497-1505, folio 52 verso, December 3, 1498.

39. As no. 38.

40. As no. 38.

41. As no. 38.

42. As no. 38. See also nos. 4 and 5. The marriage contract of Marytgen Gerytsdr. van Dam to Cornelis Claesz. was witnessed by his brother Claes Claesz. and Ysaack Claesz. at the house of Katryn Claesdr., widow of Pieter Pieter Rembrandtsz.'sz. See R. A. 41, 1504-1521, folio 127, February 18, 1510.

43. R. A. 41, 1504-1521, folio 127.

44. See no. 4.

45. Adriaene Gerytsdr. van Dam died before July 6, 1551 (R. A. 42). Various estate inheritance cases followed, for example, August 3, 1551 (R. A. 42). In these cases the following children are mentioned: Marytgen, Clara, Margriete, Geryt, Aechte, and Lysbet. Clara Jansdr. Smaling married Jan Kerstansz. Heye (see R. A. 42, April 18, 1547); Margriete Jansdr. Smaling married Jan Pietersz. van Rossen (see R. A. 42, July 6, 1551). Geryt Jansz. Smaling married Katryn Dircxdr. (see W. A. 113, Gr. Bew. B, folio 82 verso, December 4, 1526). Aechte Jansdr. Smaling married Jacop Huygenz., brewer and schoolmaster (see R. A. 42, July 6, 1551). Lysbet Jansdr. Smaling married Govert Jacopsz. (see W. A. 113, Gr. Bew. B. folio 84 verso, July 23, 1527).

46. Jan Gerytsz. Smaling died before March 1, 1538 (R. A. 42). See no. 45.

47. See R. A. 41. 1497-1505, folio 52 verso, December 3, 1498; R. A. 42, 1535-1536, folio 46, after April 26, 1535.

48. R. A. 41, 1497-1505, folio 52 verso; his name is apparently given incorrectly as Geryt Ewoutsz. in R. A. 42, 1535-1536, folio 46.

49. R. A. 42, 1535-1536, folio 46.

50. As no. 49. He was the brother of the goldsmith Cornelis Woutersz. van Santen. He was himself a business associate of Pieter Heynricxz. Buys (see no. 176); see R. A. 42, February 3, 1528.

51. See R. A. 42, May 17, 1527; July 1, 1527; and December 12, 1530; see also no. 71.

52. As no. 51.

53. See no. 18.

54. See nos. 18 and 19.

55. See no. 16.

56. See no. 17.

57. See no. 80.

58. See no. 81.

59. W. A. 113, Gr. Bew. B, folio 193, August 23, 1539.

60. As no. 59.

61. See no. 82.

62. See no. 83.

63. The marriage contract of Fytgen Quyrynsdr. and Cornelis Dircxz. Goel is R. A. 76, B[2], no. 232, January 30, 1555. The marriage contract of Fytgen Quyrynsdr. and Dirck Dircxz. Steen de Oude is R. A. 76, B[2], no. 403, July 6, 1576.

64. See no. 63.

65. See no. 63.

66. See no. 92.

67. See no. 93.

68. R. A. 42, September 11, 1536.

69. That Cornelie Meesdr. was Quyryn Allertsz.'s aunt, while his mother was Sophie Jansdr., gives the name of his father as Allert Meesz. Quyryn Allertsz.'s father may be assumed to have been the important Leiden brewer of that name, since Quyryn Allerstz. was also a brewer.

70. R. A. 42, June 13, 1530.

71. W. A. 113, Gr. Bew. B. folio 193, August 23, 1539, gives the names of the minor children of Quyryn Allertsz. and his first wife, Janlysbeth Cornelisdr. Quyryn Allertsz.'s second marriage took place before August 23, 1539, because Janlysbeth Cornelisdr. is described there as his former wife. Geertruyt Gerytsdr. is named as his wife on September 1, 1539 (R. A. 42). Quyryn Allertsz., a wealthy brewer, was closely associated with Pieter Cornelisz. Kunst. Quyryn Allertsz.'s birth was in 1500, but the precise date is not given (see S. A. 976, loose deposition dated January 2, 1545).

72. See nos. 51 and 71.

73. Geertrutyt Gerytsdr. was first married to Jan Ewoutsz. de Wys. See no. 156.

74. R. A. 42, October 15, 1546, and November 10, 1565.

75. As no. 74. Jacop Adriaensz is a painter who will be studied elsewhere.

76. R. A. 76, B[2], no. 274, February 6, 1560.

77. See R. A. 76, B[1], no. 203, February 8, 1549; R. A. 76, B[2], no. 215, May 15, 1553.

78. See no. 77. Ermgaert Pietersdr. Paets later remarried with Jacop Gerytsz. (see R. A. 76, B[1], no. 203, February 8, 1549).

79. See R. A. 76, B², no. 271, December 15, 1559. Frans Pietersz. Paets, who married Marie Willemsdr., may have been a brother of Pieter and Ermgaert (see R. A. 42, April 1, 1538).
80. The marriage contract of Allert Quyrynsz. and Machtelt Fransdr. van Duyzeldorp is R. A. 76, B², no. 215, May 15, 1553.
81. See no. 80.
82. The marriage contract of Marie Quyrynsdr. and Frans Fransz. van Duyzeldorp is R. A. 76, B¹, no. 203, February 8, 1549. He was also called Frans *Jansz.* van Duyzeldorp, according to the marriage contract. Their son was Franciscus Dusseldorp, the author.
83. Frans van Duyzeldorp was a brewer (see R. A. 76, B², no. 215, May 15, 1553) and political official.
84. See nos. 59, 60, and 63.
85. See R. A. 76, B², no. 215, May 15, 1553. He was a brewer.
86. As citation in no. 85.
87. As no. 86.
88. As no. 86.
89. As no. 86. He was the brother of Pieter Cornelisz. (den) Oosterling. They were apparently born in Leiden. The surname probably refers to antecedents who came from the eastern provinces of the present Netherlands or from present Germany.
90. As no. 86.
91. As no. 86.
92. The marriage contract of Geertruyt Quyrynsdr. and Jacop Pietersz. Paets is R. A. 76, B², no. 271, December 15, 1559.
93. As no. 92.
94. As no. 92.
95. As no. 92.
96. See R. A. 42, February 1, 1563. Material has been collected for a separate study on Allert Jacopsz.
97. As no. 96.
98. As no. 96.
99. Willem Claesz.'s great-grandsons used the surname van Thorenvliet; therefore, he was probably also named that. Willem Claesz. and his wife Hillegont Willemsdr. de Bruyn founded the St. Annahof on the Hooygracht in Leiden, an almshouse with chapel. They and their descendents, as well as Hillegont's brother Jan Willemsz. de Bruyn, are shown on two genealogical charts from which this chart has been copied – Archieven der Hofjes, no. 131 and no. 132. The first of these charts dates from the third quarter of the sixteenth century. The other is dated 1604 and is a copy of the first annotated by Jan van Hout.
100. As no. 99.
101. As no. 99. Jan Willemsz. de Bruyn was a relative also of the painter Cornelis Engebrechtsz. and appeared with him and with Cornelis Mast representing the paternal side as witnesses to the marriage contract of Pieter Cornelisz. Kunst and Marytgen Gerytsdr. van Dam (see R. A. 76, B¹, no. 36, July 1, 150(9)).
102. Archieven der Hofjes, 131 and 132. Willem Willemsz. van Thorenvliet was a brewer.
103. As citation in no. 99.
104. As no. 103. He was the brother of Jan Kerstantsz. Stoop. The location of his house is given in the St. Annahof charter (Archieven der Hofjes, 132, a copy by Jan van Hout), and it coincides with that of the house of Jan Kerstantsz. Stoop's brother, mentioned in Gasthuis Archieven 303.
105. Archieven der Hofjes, 131 and 132.
106. As no. 105.
107. As no. 105.
108. Archieven der Hofjes 132. He was chaplain of the St. Annahof. His portrait, discussed above, is preserved in the chapel.
109. Archieven der Hofjes, 131 and 132. Willem Willemsz. van Thorenvliet, son of the brewer Willem Willemsz. van Thorenvliet, was nick-named Willem Claisz.
110. As citation in no. 109.
111. As no. 110.
112. As no. 110. She was nick-named "Oude Hillegont."

156

113. As no. 110.
114. As no. 110. She was nick-named "Jonge Hillegont."
115. As no. 110.
116. As no. 110.
117. As no. 110.
118. As no. 110.
119. As no. 110.
120. As no. 110.
121. As no. 110.
122. Archieven der Hofjes, 132.
123. As no. 110.
124. As no. 110. See also no. 19. The identification as Pouwels Willemsz. *van Thorenvliet* is not on these lists; it is evident, however, from the names of his wife and children, which are confirmed in various other sources. Further, one of Pouwels Willemsz. van Thorenvliet's uncles, who witnessed the marriage contract (see no. 18), was Jan Willem Willemsz.'sz. (see no. 116. and no. 117).
125. Archieven der Hofjes, 132. See also no. 18.
126. As no. 110. His children were Pieter Jansz. van Thorenvliet and Clartgen Jansdr. van Thorenvliet.
127. Archieven der Hofjes, 132.
128. As no. 110. The children of Neeltgen Willemsdr. and Jan Jansz. van Rossen were Pieter Jansz. van Rossen and Willem Jansz. van Rossen.
129. As no. 110. He was a wealthy Leiden butcher.
130. As no. 110.
131. As no. 110.
132. As no. 110. Dammas Claesz.'s daughter was Katryn Dammasdr. This Dammas Claesz. was the wealthy draper, not the painter Dammas Claesz., who was Lucas van Leyden's son-in-law. That the draper Dammas Claesz. was a cousin of Pouwels Willemsz. van Thorenvliet may partly explain the selection of van Thorenvliet to be one of the three curators of the finances of Dammas Claesz. around 1553 or 1554. The other two were Jeroen Jansz. and the tapestry weaver Willem Andriesz. de Raet. This appointment and legal cases connected with it are mentioned in my study of Leiden tapestry weaving, 1500-1575.
133. As no. 110. His son was Aelwyn Bartholomeeusz.
134. As no. 110.
135. As no. 110.
135. As no. 110.
136. As no. 110.
137. As no. 110.
138. As no. 110.
139. As no. 110.
140. As no. 110.
141. As no. 110.
142. As no. 110. The children of Jannetgen Vranckendr. Paets and Cornelis Hugenz. were Andries Cornelisz., Vranck Cornelisz., and N. Cornelisdr.
143. As no. 110.
144. As no. 110.
145. As no. 110.
146. As no. 110.
147. As no. 110.
148. As no. 110.
149. See W. A. 113, Gr. Bew. B, folio 91 verso, April 19, 1529.
150. As no. 149.
151. See W. A. 113, Gr. Bew. B, folio 194 verso, October 23, 1539. (He may be the Geryt Kerstantsz. in no. 64.)
152. As no. 151.
153. As no. 151.

154. W. A. 113, Gr. Bew. B, folios 91 verso, April 19, 1529; 194 verso and 195, October 23, 1539. Jan Ewoutsz. de Wys died before June 9, 1539 (R. A. 42).

155. W. A. 113, Gr. Bew. B, folios 91 verso, April 19, 1529; and 195, October 23, 1539. Ermgaert Pietersdr. died before April 19, 1539. Apparently a sister of hers married Dirck Aelbrechtsz., and a close relative of hers was Frans Gerytsz. Goel (see also no. 63).

156. W. A. 113, Gr. Bew. B, folio 194 verso. Gheertruyt Gerytsdr. remarried with Quyryn Allertsz. (see no. 71).

157. W. A. 113, Gr. Bew. B, folio 91 verso, April 19, 1529.

158. As no. 157.

159. As no. 157.

160. As no. 157.

161. As no. 157.

162. As no. 157.

163. As no. 157.

164. As no. 157.

165. As no. 157.

166. As no. 157; see also no. 167.

167. R. A. 42, March 21, 1541.

168. As no. 157.

169. As no. 157; see also no. 17.

170. See no. 16.

171. W. A. 113, Gr. Bew. B, folio 194 verso, October 23, 1539.

172. R. A. 43, February 18, 1569.

173. W. A. 113, Gr. Bew, B, folio 194 verso, October 23, 1539. The marriage contract of Ermgaert Jansdr. de Wys and Pieter Pieter Jorysz.'sz. van Cortevelt is R. A. 76, B², no. 212, August 26, 1551.

174. See no. 202.

175. R. A. 76, B¹, no. 62, November 9, 1521.

176. As no. 175; See also W. A. 113, Gr. Bew. B, folio 34 verso March 10, 1522. Pieter Heynricxz. Buys died before May 5, 1544 (R. A. 42). See nos. 177, 178, and 179.

177. R. A. 41, 1504-1521, folios 443 verso, 434, and 434 verso, April 15, 1519. Aechte Hugendr. was married to Pieter Heynricxz. Buys for fifteen years. She had two sisters, Agnies Hugendr., who married Adriaen Jansz., and Alyt Hugendr., who married Florys Dircxz. She may have had a brother, Geryt Hugenz. (see no. 180). Their father was Huych Clementsz., son of Clement Willemsz. Their mother was N. Jansdr., who was the sister of Katryn Jansdr., wife of the draper Geryt Roelofsz. (van der Mye), probably the brother of Martyn Roelofsz., also an important draper; see R. A. 41, 1520-1529, folio 74 verso, October 21, 1521. The two children of Geryt Roelofsz. and Katryn Jansdr. were Roelof Gerytsz. and Balich Gerytsdr., wife of Anthonis Paets. Aechte Hugendr., first wife of Pieter Heynricxz. Buys, died before April 15, 1519, by which time he had already remarried.

178. Cornelie Adriaensdr. van Adrichem died before November 9, 1521, the date of the marriage contract of Pieter Heynricxz. Buys and Aechte Pouwelsdr. Her brothers were Meester Jan van Adrichem, licentiate in civil and canon laws, canon of St. Pancraes Collegiate Church in Leiden; and Florys van Adrichem. See W. A. 113, Gr. Bew. B, folio 34 verso, March 10, 1522. See further the tombstone in the Academie Gebouw, Rijksuniversiteit Leiden.

179. The marriage contract of Pieter Heynricxz. Buys and Aechte Pouwelsdr. is R. A. 76, B¹, no. 62, November 9, 1521. Present as witnesses from her side were her mother, Alyt Pouwels Pietersz.'s widow, and her brother, Cornelis Pouwelsz.

180. See W. A. 113, Gr. Bew. B, folio 330, May 2, 1561; R. A. 76, B¹, no. 179, February 9, 1546.

181. See no. 177.

182. See no. 177.

183. See no. 177.

184. See no. 177.

185. See no. 6 and no. 8.

186. The marriage of Celie Pietersdr. Buys and Pieter Jorysz. van Cortevelt took place in January, 1523

158

(see R. A. 42, June 20, 1544). Pieter Jorysz. van Cortevelt, an important draper, died before October 25, 1526 (see W. A. 113, Gr. Bew. B, folio 57 verso).

187. See no. 6.

188. W. A. 113, Gr. Bew. B, folio 34 verso, March 10, 1522. The marriage contract of Cornelis Pietersz. Buys and Machtelt Jansdr. Heye is R. A. 76, B[1], no. 131, January 26, 1539.

189. See no. 188. Machtelt Jansdr. Heye's father was Jan Gerytsz. Heye, brother of Meester Pieter Gerytsz. Heye, canon of St. Pancraes Collegiate Church, Leiden. Her mother was N. Wittendr., sister of Meester Heynrick Wittenz., priest, and of Govert Wittenz. They were children of Witte Govertz. and Jannetgen Sas. Jannetgen Sas, grandmother of Machtelt Jansdr. Heye, was the sister of Meester Ghysbrecht Sas, priest. Machtelt Jansdr. Heye had four minor siblings at this time, named Geryt Jansz. Heye, Heynrick Jansz. Sas, Witte Jansz., and Gerburch Jansdr. Presumably the painter Nanninck Jansz. Sas and his son Warnaer Nannenz. Sas (also a painter) were relatives.

190. W. A. 113, Gr. Bew. B, folio 34 verso, March 10, 1522.

191. R. A. 42, March 14, 1547.

192. See R. A. 76, B[2], no 212, August 26, 1551.

193. As no. 192.

194. W. A. 113, Gr. Bew. B, folio 57 verso, October 25, 1526.

195. W. A. 113, Gr. Bew. B, folio 330, May 2, 1561; R. A. 76, B[1], no. 179, February 9, 1546.

196. W. A. 113, Gr. Bew. B, folio 330, May 2, 1561.

197. As no. 196.

198. Jorys Pieter Jorysz.'sz. van Cortevelt was a dealer in silk cloth. The marriage contract of Jorys Pieter Jorysz.'sz. van Cortevelt and Beatrix Willemsdr. is R. A. 76, B[1], no. 179, February 9, 1546. Their children were Pieter Jorysz. and Aechte Jorysdr. Aechte Jorysdr. married Pieter Maertynsz. (marriage contract: R. A. 76. B[2], no. 382, September 1, 1571), a nephew of Claes Jansz. de Goede. See also no. 200.

199. Beatricx Willemsdr. died before May 2, 1561 (W. A. 113, Gr. Bew. B, folio 330). See no. 198.

200. The marriage contract of Jorys Pieter Jorysz.'sz. van Cortevelt and Jannetgen Willemsdr. is R. A. 76, B[2], no. 288, November 1, 1561. Her "*neef*" ("cousin" or "nephew") was Pieter Jansz. Paets.

201. W. A. 113, Gr. Bew. B, folio 57 verso, October 25, 1526.

202. As no. 201. The wealthy draper Pieter Pieter Jorysz.'sz. van Cortevelt was the holder of an obligation on the cabinetmaker Bruyn Claesz. (who made the reredos of the Pieterskerk, now gone). Bruyn Claesz.'s bonds were Cornelis Pietersz. Buys (see no. 188) and Heynrick Jansz. Sas (see no. 189). See also no. 173.

203. See no. 173.

204. W. A. 113, Gr. Bew. B, folio 330, May 2, 1561. Huych Willemsz. was a brewer.

Inventories, Abbreviations, Remarks on the Documents

Inventories and other basic works not cited in notes:

J. C. Overvoorde, *Archieven van de Gasthuizen*, Leiden, 1913.
Overvoorde, *Archieven van de Kerken*, Leiden, 1915.
Overvoorde, *Archieven van de Kloosters*, Leiden, 1917.
Overvoorde, *Archieven van de Gilden, de Beurzen en van de Rederijkerskamers*, Leiden, 1921.
Overvoorde and J. C. Verbrught, *Archief der Secretarie van de Stad Leiden, 1253-1575*, Leiden, 1937.
Het Oude Rechterlijke Archief van Leiden (= *Verslagen 's Rijks Ander Archieven*, 1921, I, XLIV), The Hague, 1922 (anon.).

P. J. Blok, *Oud Vaderlandsche Rechtsbronnen, Leidsche Rechtsbronnen uit de Middeleeuwen*, The Hague, 1884.
H. G. Hamaker, *De Middeleeuwsche Keurboeken van de Stad Leiden*, Leiden, 1873 (with a useful glossary of legal terms).
M. Kaser and F. B. J. Wubbe, *Romeins privaatrecht* (2nd ed.), Zwolle, 1971 (a simple introduction to general legal structures).
C. Ligtenberg, *De Armezorg te Leiden tot het Einde van de 16e Eeuw*, The Hague, 1908.
J. J. Orlers, *Beschrijvinghe der Stad Leyden*, Leiden, 1614.

Abbreviations:

A. R. A.	Algemeen Rijks Archief
G. A.	Gemeente Archief
K. B.	Koninklijke Bibliotheek (manuscripts)

The following abbreviations refer to current inventories of separate archival collections in the Leiden Municipal Archives:

R. A.	Rechterlijk Archief
W. A.	Weeskamer Archief
Gr. Bew.	Grote Bewijsboek
S. A.	Archief der Secretarie, 1253-1575
Kl. Arch.	Archieven van de Kloosters
Kerk. Arch.	Archieven van de Kerken
Not. Arch.	Notarieel Archief
Herv. Gem.	Archives of the Leiden congregation of the Dutch Reformed Church, deposited at the Leiden Municipal Archives.

Other abbreviations:

inv. no.	inventory number (usually not used; if used, it precedes the number which oridnarily follows the abbreviation for the archival collection)
Ned. Herv.	Nederlands Hervormd
B.	A. Bartsch, *Le Peintre Graveur*, Vienna, 1803-1821.

160

NAT	W. Nijhoff, *L'Art Typographique dans les Pays-Bas pendant les années 1500-1540.*
NK	W. Nijhoff and M. E. Kronenberg, *Nederlandsche Bibliographie van 1500-1540.*
—dr.	—dochter (daughter)
—sz.; —z.	—zoon (son)
—sz.'sdr.	—zoonsdochter (son's daughter, grand daughter indicated through patronymics
—sz.'sz.	—zoonszoon (son's son, grandson, indicated through patronymics)

(Patronymic abbreviations should be spoken full out to avoid confusion with surnames; for that reason I have retained the abbreviation signs as indicated, in contrast to the spellings which give names as if unabbreviated, e. g. Cornelis Engebrechtsz and Celie Cornelis Cornelis Kunsten, the latter of which means Celie, Cornelis Corneliszoon Kunstens vrouw (wife)/ wedue (widow) and involves a grammatical alteration to the surname with a possessive.)

Remarks on the documents and their use:

The Leiden documents from between 1475 and 1575 show a general tendency to include more and more details of litigation and other activities being registered. For example, earlier documents rarely give the occupations of the people named. Before ca. 1515 occupations seem to have been noted at random. Later they were recorded in legal cases where failure to specify might cause later legal confusion about two or more people with the same first name and patronymic and even sometimes the same surname. Around 1530 it became usual to note the occupation or some other identifying characteristic of the person, although throughout the period there are unspecified references to people who had contemporary namesakes. A similar pattern is seen in the registration of the subjects of legal disputes and the registration of which party won.

I have read all legal records of civil and criminal cases which are preserved for the period. In the series R. A. 42/43, which includes notes on ca. 350,000 minor cases, and which proved to be the most important single series, I read the volumes at least three times to try to avoid falling asleep on the same page each time. I have read the other legal series at least once from cover to cover; when subsequent information made re-reading appear useful I have done so. It is, nevertheless, obvious that more information may be preserved in the records, overlooked or unrecognized by me.

I have read all the city treasury records for the period, with the exception of the lists of payments of annuities. On these I have read numerous sample listings of the annually recurrent names. The records of personal travel expenses of the city officials seemed less important that the payments where commissions normally appear; the travel records might therefore contain information missed in my hasty reading. I have carefully read all the loose receipts connected with the treasury records.

Further, in the Archief der Secretarie, I have read every item from the period which seemed in any way to have possible bearing on artists or craftsmen or their secondary occupations. The *Vroedschapsresolutien*, however, follow a pattern of listing major political and taxation interests before local issues which means that further information of significance to cultural history is almost certainly to be found in them, if studied in entirety as a register of what most concerned the government at the time. For this study I have looked only for items directly connected with art.

I have also read the apparently relevant items in the Archieven van de Kloosters, the Archieven van de Kerken, and the Gasthuis Archieven, as well as the archives of the Leiden congregation of the Dutch Reformed Church and the early documents in possession of the Dutch Reformed Diaconie of Leiden, now deposited in the Leiden Municipal Archives.

Several series of Documents have been provided with alphabetical indexing, which I have used. These include the Weeskamer Archief Grote Bewijsboeken; the records of marriage contracts; and the Notarieel Archief. Using indexing by name has the drawback that subsidiary figures are not named in the indexes. It is very likely that artists and craftsmen appear as witnesses, unindexed, and not noted in my research because I did not have time to read these volumes systematically cover to cover. For the Tenth Penny tax records, for which an alphabetical index on the Leiden copies exists, I decided to read the volumes cover to

cover, because the volumes in The Hague covering Leiden, but not duplicated, are not indexed. There was some advantage to this procedure, because the lists are arranged household by household for all of Leiden. The Tenth Penny tax lists start in 1544, in contrast to the recent pronouncement that they begin in 1570 (see A. Deblaere, s. j., "Bruegel and the Religious Problems of his Time," *Apollo*, CV, 1977, 176-180).

A category of documents which seemed least important had to do with land transactions and can be identified in reading the various inventories. Unless there was an immediately evident reason for reading these I did not. They could provide information on housing location through the general practice of describing land as bordering on land owned by another person (perhaps an artist, etc.).

I have attempted to give the most precise possible documentary references. In some series, however, this means that the reference is by date. Such references indicate that the volume has no pagination or foliation, or that the series generally does not, or that the volume is provided with merely partial foliation or with more than one set of numerical sequences. For R. A. 42/43 there is generally one volume per year, with court sessions two or three times a week; the notes for each session do not usually exceed twenty-five folios. If accidentally a date is given which appears incorrectly in my notes, it is possible that the citation is from the next court session. I have rechecked the documentary notes to try to clear them of mis-references.

The foregoing description of the documentary sources and their use applies equally to the town records of other Netherlandish cities. The results obtained from a relatively thorough approach to what is preserved, some of which I have attempted to explain in this book, suggest that a similar approach is well worth the effort in studying that art and culture of other towns. Such study has not generally preceded art historical opinion and I wish to call attention to F. J. Dubiez's book, *Cornelis Anthoniszoon van Amsterdam, 1507-1553*, Amsterdam, 1969, which is an exception. Required to take note of the same secondary art historical sources as are also mentioned by me regarding Leiden at many points, Dubiez must be given the credit for having written a pioneering, non style-critical, historical study of an artist in context. Although not directly associated with Leiden art, the book is to be recommended to anyone studying Netherlandish art and needing a sober assessment of secondary opinion before approaching primary, documentary evidence.

Since completion of this manuscript I have made a few alterations to bring it up to date. It must be remarked that I have not altered page references to the typed dissertation of W. S. Gibson, which, however, has recently appeared with different pagination in print. Its contents are essentially unaltered and its contributions lie generally in a direction which diverges from the path I follow; its illustrations provide a necessary reference for the paintings discussed in style criticism around the name of Cornelis Engebrechtsz. (See W. S. Gibson, *The Paintings of Cornelis Engebrechtsz*, New York/London, 1977 (= *Outstanding Dissertations in the Fine Arts*, Garland Publishing, Inc.). In the same series are C. Harbison's *The Last Judgment in Sixteenth Century Europe: A Study of the Relation between Art and the Reformation*, 1976, which has comparison material of interest for the discussion of Aertgen van Leyden's work (not known at the time of Harbison's dissertation, 1971); and K. P. F. Moxey's *Pieter Aertsen, Joachim Beuckelaer, and the Rise of Secular Painting in the Context of the Reformation*, 1977, which contains a useful bibliography related to iconoclasm and other questions touched on here. The locations of a few paintings discussed by me have changed, for example, the portraits of the van Naeldwyck family still in the Rijksmuseum Amsterdam when vol. X of the English Friedländer appeared, have returned to the less accessible Naeldwyck townhall and the portrait said to be of Dirck van Brouchoven has entered the cellars of the Lakenhal during a museum renovation and rearrangement in Leiden. Such publications and migrations naturally doom citations to datedness and for that reason I make no pretence to having referred the reader to the most recent or largest reproduction of this or that.

Any members of the public who have reached this point will have perceived that the forms required for precise indication of references, as well as for raising tangential but significant material related to the main text, have necessitated experimentation in the category "notes" which may justly be prefaced by the command: *capricioso*. In respect to tradition, this book's index must be forcefully peculiar to readers unaccustomed to the problems presented by archival records in fifteenth and sixteenth-century Dutch. Naturally the book could not be written and cannot be read in a day. However, the index has occupied the author's mind to an extent far less than all the arts brought together in the book. The index has two parts.

Part one lists names from the fifteenth and sixteenth centuries (up to ca. 1575). Part two lists other names, topics, places, and the first note in which full bibliographical information on an author's work appears, information which is sometimes repeated. Each part of the index requires an explanation for use. Letters

162

typify alphabetized indexes, so to use the index the order of the letter in the alphabet should be understood, or at least remembered. Fifteenth and sixteenth-century Dutch names which form part one are arranged according to a system becoming popular in Dutch archives, and non-Dutch names in that section follow the same order: A, B, C (see also K), D, E, F (see also V), G, H, I (IJ, Y), J, C and K, L, M, N, O, P, Q, R, S and Z, T, U, V (see also F), W. The customary alphabetical order is used in part two of the index.)

Part one presents specific problems, some solved by the order of the letters. The names are listed according to given (first) name and surname, if any, but not according to patronymic. Names may appear in different forms. For that reason, variant forms are listed before the first reference to anyone with a name of multiple possibilities, which may help locate other people of the same first name. Examples are: Claes (Nicolas), Bartholomeeus (Mees), Anna (Adriaena, Johanna, Susanna), Agnes (Nietgen). The second, lengthening vowal in Dutch may be a repetition or E or I; such variant second vowals do not affect listing. Particles are not alphabetized. Double or multiple surnames are listed by the first in sequence, with some duplicate listing of final surnames where confusion might arise, providing reference to the first surname in sequence.

Thus, the alphabetization of the names in part one of the index is: first name, surname (if any), patronymic if no surname is used. The patronymic functions alpabetically only to arrange non-surnamed people sharing the same first name. Surnames are listed with the word "family" followed by references to the various people sharing the surname, regardless of first name. Masculine forms of first names are grouped before feminine forms because in general the masculine forms are shorter. Further, the principal index items is the first name and not the other possible modifications to this general organization. Because all names of the period are placed in part one of the index, famous non-Leiden residents are also treated as above. Help is provided by cross-references, e.g. Martin Luther, and Luther, Martin. Not indexed are the names of the courtiers who visited Leiden during the Triumphal Entries (q.v., in the second part of the index). Five Leiden stainedglass painters appearing in a footnote together with someone of text importance have been omitted, pending a study of their trade.

Part two is the result of a brief study of the means by which the author has been frustrated by normal indexes in a random selection of books. Part two does not list every topic in the book. No attempt has been made to provide an exhaustive bibliographical tool, because the source materials for further work are still archival documents and not, for the most part, books from after the period of post-incunabula. Nevertheless, full bibliographical material on cited works is indexed under the author's name, shown by note numbers in italics, with the chapter of the note indicated, e.g. C 12, n.*11*. Part two of the index gives double or multiple surnames in the alphabetical order of the last name in sequence. Belgian names are not alphabetized by particles, despite the practice favored in Belgian telephone books.

In composing the text, notes, appendix material and index, various standard style manuals have been consulted. They do not seem to be intended for the presentation of the particular type of archival material about which this book is concerned. As to language usage, the free-flowing, cheerful breeziness now characterizing the atttempts of scholars in the United States to present complex new material to what is evidently considered a second generation of students raised on television and capable only of learning history orally is not a style useful in presenting the material under consideration here. I find it hard to believe the description by another writer of today's students as illiterate, and hope that somewhere there are some interested in finding the answer to the question of an academic symposium several years ago: what knowledge is most worth having. It probably is not in this index; moreover, I omitted to include a map to show where The Low Countries can be found, and Leiden, in "Northern Europe" during the "Early Modern" period.

Index (1)

A

van den Abeele, family, p. 39.

Adriaen VI, Pope, p. 75.

Adriaen van Bergen, bookprinter, C.7,n.8

Adriaen van der Boeckorst, p. 39; C.2,n.7.

Adriaen van Egmont, p. 37.

Adriaen Fyck, p. 37.

Adriaen Ysbrantsz. (Adriaen Ysenbrandt), painter, p. 89; C.2,n.92.

Adriaen Dirck Ottensz.'sz. van Meerburch, C.4,n.6.

Adriaen Moeyt, p. 89.

Adriaen van der Mye, pp. 39, 40.

Adriaen Pietersz., carpenter, C.10,n.24.

heer Adriaen Jansz. van Poelgeest, knight, sheriff, husband of Machtelt van der Does, pp. 35-38, 94-95; C.3,n.12, 13, 15; C.9,n.27.

Adriaen Stoop, p. 41.

jonckheer Adriaen van Swieten, rentmeester generaal, C.4,n.28.

Adriaen Boudewijnsz. van Swieten, p. 18.

Adriaen Jansz. van Swieten, husband of Otte van Egmont, C.2,n.38, 41.

Adriaen Willaert, composer, p. 109.

Adriaen van Zonnevelt, p. 39.

Adriana Willemsdr. van der Does, pp. 36, 37, 39; C.3,n.13.

Adriana Hugensdr. van Swieten, p. 39.

granddaughter of Adriaena Hugensdr. van Swieten, p. 39.

Aernt = Adriaen, Arnoldus, Arendt, Aert, Aertgen: Aernt Heerman, p. 39.

Aernt Claesz. (Aertgen van Leyden), painter, pp. 50, 128-129, 134-137; C.4,n.21; C.13,n.1, 58, 62, 68, 69, 71, 72, 75, 79, 80, 81.

namesakes of Aernt Claesz. the painter, C.13,n.62, 75.

Aernt Cornelisz. of Delft, C.10,n.27.

Aernt Gerytsz. Marcks, p. 102; C 10,n.31.

Agniet = Agnes, Agnietgen, Nietgen, Aachte, Aechtgen (the last two can also be abbreviations for Machteld): Suster Agniet Gielisdr. van Vlaeminckspoerte, C.2,n.5.

Agrippa de Nettesheym, Henricus Cornelius, C.7,n.22, 28.

Alan de Rupe, C.6,n.11.

Albert = Albrecht: Albert (van Ouwater?), painter, p. 93.

Albrecht Dürer, pp. 22, 107, 118, 131; C.1,n.41; C.2,n.80; C.3,n.57; C.7,n.40, 47.

Aelbrecht van Rietwijck, C.2,n.111.

Alciatus, Andrea, p. 72.

Aldus Manutius, bookprinter, p. 72; C.7,n.38, 39.

Alexander VI, Pope, p. 74.

Allaert = Adelart, Allart, Allard, Alardus; Allaert Claesz. of Amsterdam, painter, p. 135.

Allard Gauter, bookprinter, C.7,n.8.

Allart du Hamel (read: Hameel), engraver, architect, p. 51; C.7,n.13.

van Alcmade, family, pp. 20, 50, 99; C.1,n.13, 49; C.2,n5, 112.

Aelwyn = Alyn, Allen: Aelwyn Claes Aelwynsz.'sz. Verhooch, p. 41; C.3,n.89.

Alewyns, family, p. 41; C.2,n.112.

Alyt, widow of Cornelis Pietersz., wife of painter Symon Jansz., p. 87.

Alyt Jan Heermansdr., p. 40.

Alyt Willemsdr. van Leeuwen, wife of Jan Willemsz. Stoop, p. 41.

Alyt, wife of Jan Kerstantsz. Stoop, p. 40.

Alydt Florysdr. van Zyl, p. 39.

Ambrosius Holbein, painter, C.7,n.28, 40.

Andries Dirck Jansz.'sz., apprentice of painter Jan Jansz., p. 89.

Andreas Fulvius, C.12,n.35.

Andries Hugez., C.13,n.34.

Andries Jacopsz., tapestry weaver, husband of Gerytgen Aerntsdr. Marcks, p. 102; C.10,n.31.

Andries Ropier of Haarlem, C.1,n.28.

Anna = Anna, Adriaena, Johanna, Susanna: Anna of Saxony, C.7,n.9.

Anna van der Hooge, C.3,n.57.

Anna Ysbrantsdr. van Rietwijck (or: van Rijck), C.2,n.111.

van Duivenvoorde, family, C.2,n.7, 112.
Duyst, family, p. 39.

E

Eck, Johannes, p. 73.
Eck and Luther, p. 73; C.7,n.*59*.
van Egmont, family, pp. 37, 39, 110, 113; C.2,n.5, 38, 42; C.11,n.22.
van Egmont van Kennenburch, family, p. 37.
van Eyck, Jan, p. 70; C.7,n.18, 66.
Elysabeth = Lysbet: Elysabeth Jacobsdr. van Bosschuysen, wife of (1) Jan van Wena, (2) Lucas van Leyden, (3) Jan van Ryswyck, p. 40; C.8,n.19; C.10,n.27.
Elysabeth Engebrechtsdr., sister of Cornelis Engebrechtsz., see: Cornelis Engebrechtsz.'s sister.
Elysabeth Pietersdr., wife of Cornelis Engebrechtsz., pp. 2, 3, 6, 55-57; C.1,n.13, 22, 24.
Engel, Govert, Hansa factor in Leiden, C.4,n.5.
"Engebrecht Dircxz.", p. 2.
Engelbert II van Nassau, tomb of, p. 132.
Engebrecht Ysbrantsz. Schut, priest, pp. 72-73; C.1,n.20.
Erasmus, pp. 21, 69, 72-73, 92, 110, 130; C.7,n.*16*, 31, 37, 40, 57, *59*.
Erkenraet Dirck Aelbrechtsz.'dr., p. 40.
Erm(gart) Dircxdr., C.8,n.75.
Everart van der marck, husband of Margriete van Bouchout, pp. 98, 104.
Ewout Willemsz. van Berendrecht, p. 87.
Ewout Vos, stained-glass painter, p. 5.

F (see also V)
Ficino, Marsilio, p. 71; C.7,n.26.
Fyck, family, p. 39.
"Fytgen" (Sophia), incorrect name for painter Cornelis Engebrechtsz.'s wife, C.1,n.13, 65.
van Flory, de Fleurie, family, C.1,n.68.
Florys Adriaensz., C.2,n.111.
Florys van der Bouchorst, C.3,n.17, 56.
Florys Ghysbrechtsz., painter, p. 4.
Florys Heerman, p. 39.
Florys Maertensz., relative of family van Rietwijk, C.2,n.9, 111
Florys van Wingaerden, C.2,n.7.
Focula Pietersdr., Marienpoel nun, C.2,n.111.
heer Foye van Zyl, priest and bookprinter, C.1,n.70.
Frans Florysz., C.8,n.81.
Francesco Colonna, p. 72; C.8,n.39, 40, 53.
Francesco Parmigianino, painter, compared to Aertgen van Leyden, p. 137.
Frans Pieter Mouwerynsz.'sz., p. 6.

Frans Willem Engelsz.'sz., p. 103.
Frederick III, Emperor, pp. 36, 88, 109; C.3,n.16.
Frederick van Baden, Bishop of Utrecht, C.2,n.37.
Fulvius, Andreas, C.12,n.*35*.

G

Gabriel van der Boude, cabinetmaker, C.1,n.35.
Gabriel Biel, p. 75; C.7,n.74.
Gasfort, Wessel, p. 73.
Gauter, Allard, bookprinter, C.7,n.8.
Georg = Joris, George: Georg Pencz, p. 130.
George Congre (or: Conget), C.7,n.36.
Gerijt = Gerardus, Gerard, Geertgen: heer Gerijt, brother of Ghysbert N., rector of Marienpoel, priest (at Marienpoel?), C.2,n.7.
Geertgen tot Sint Jans, painter, p. 23; C.1,n.36; C.2,n.
Geryt Boels, stained-glass painter, p. 113.
Gerard David, painter, p. 23; C.2,n.89.
Geryt Dircxz. coman, C.1,n.48.
Geryt Dircxz., rector of Marienpoel, pp. 22, 23, 24; C.2,n.8, 48, 55, 83.
Geryt Jacobsz. Heerman, pp. 37, 39.
Geryt van Hoochtwoude, husband of Machtelt van der Does, C.3,n.13.
Geryt Jan Kerstantsz.'sz., p. 39.
Geryt Jansz. van Lochorst, pp. 35-41; C.1,n.49; c.2,n.5; C.3,n.13.
Geryt Pietersz. (van) Ryswyck, pp. 39-40.
Geryt Roest, C.1,n.49.
Geryt Kerstantsz. (Stoop), p. 40.
Geryt Cornelisz. Vinck, painter, p. 89.
Geryt Woutersz., C.1,n.48.
Gerytgen Aernstsdr. Marcks, wife of Andries Jacopsz., tapestry weaver, p. 102.
Gerritgen Ysbrantsdr. van Rietwijk, Prioress of Marienpoel, C.2,n.9, 111.
Geertruyt = Gertrudis: Geertruyt Adriaensdr., Prioress of Marienpoel, C.2,n.111.
de Gheet, Jan, bookprinter, C.11,n.20.
Gielis van Vlaeminckspoerte, C.2,n.5.
Gysbert = Gisbertus, Ghysbrecht, Ghys, Guus: Gysbert N. (of Donck), rector of Marienpoel, pp. 22, 24; C.2,n.7, 48.
Ghysbrecht van der Bouchorst, husband of Marghritte, p. 69; C.2,n.59; C.7,n.10.
Ghysbrecht Dirrickz., C.2,n.14.
Ghysbrecht Kerstantsz., C.13,n.34.
Ghysbrecht van Swieten, C.2,n.30.
Ghysbrecht van Ysselsteyn, p. 39.
Goes, Hugo van der, painter, Portinari Altarpiece, p. 70; C.7,n.18.
Gorter van Reijgersberch, family, p. 24; C.2,n.110.
Govert Engel, Hansa factor in Leiden, C.4,n.5.

Jan Kerstantsz. Stoop, husband of Alyt and Clara, p. 40; C.3,n.22.

Jan Reynersz. Stoop, p. 41.

Jan Roelofsz. Stoop, p. 41.

Jan Willemsz. Stoop, husband of Alyt Willemsdr. van Leeuwen, p. 41.

Jan van Swieten, heer van Upmeer, C.2,n.42.

Ian van Thienen, bronze sculptor, father of Reynier, p. 95.

Jan Cornelisz. Vermeyen, painter, p. 134; C.13,n.58.

Jan Gielisz. van Vlaeminckspoorte, C.2,n.5.

heer Jan van Wassenaer, C.2,n.5, 8.

Jan van Wena, husband of Elysabeth van Bosschuysen, p. 40.

Ian van de Werf, C.2,n.7.

heer Jan Wit of Haarlem, p. 113.

joncvrouw Janna, widow of Willem van Bosschuysen, C.3,n.39.

Johanna van Swieten, Vrouwe tot Upmeer, p. 88; C.1,n.75; C.2,n.42.

Janlysbet Cornelisdr. van Dam, C.1,n.14.

Jeronimus Cornelisz., painter, pp. 4, 134; C.1,n.26.

Joris van Egmont, Bishop of Utrecht, p. 110; C.11,n.22.

Meester Joest, Leiden sculptor, p. 95.

Joost, Bastard of Brederode, p. 103.

Joest Lankaert, basconter and tapestry weaver of Delft, C.2,n.4.

Josquin des Prez, composer, p. 109.

Joest Willemsz. C.1,n.48.

Josina van Egmont, Vrou van Wassenair, C.2,n.5.

Josina Fransdr. van Leyden van Leeuwen, C.4,n.6.

heer Jonius (Junius), priest of Delft, C.1,n.13.

C and K

Capgrave, John, C.7,n.32.

Carolus V, see: Charles V.

Carlier, family, p. 103; C.3,n.13.

Katryn = Katherina, Katharina, Tryn, Tryngen: Katryn, wife of Aernt Gerytsz. Marcks, p. 102.

Katherine van Bakenes, C.2,n.26.

Katryn Bouwensdr. Fyck, p. 39.

Katrijn Hugensdr., sister of Lucas van Leyden, p. 94.

Katryn Jansdr., wife of Dirck Hugensz., painter, pp. 6, 94 (with daughter); C.1,n.78.

Katrijn Claesdr., Pieter Rembrandtsz.'s widow, C.1,n.7.

Katryn Michielsdr., wife of Vrydach Gerytsz., p. 20; C.2,n.5.

Katryn Jacobsdr. van Ryswyck, pp. 39, 40.

Katryn Ysbrantsdr. van Rietwyck (or: van Ryck), C.2,n.111

Katryn Daniel Roelofsz.'sdr. Stoop, p. 41.

Katryn Hugensdr. van Swieten, p. 39.

Katherina van Swieten, p. 19.

van Kats, family, C.2,n.7.

Vrouwe van Kats, C.2,n.7.

van Kennenburch, family, p. 37.

Kerstant = Christian: Kerstant Boeyenz. (Stoop), p. 40.

Kerstyn = Christina: Kerstyn Pietersdr. of Alkmaar, pp. 100-101.

Claertgen = Clara: Claertgen van Lodensteyn, C.3,n.39.

Clara, wife of Jan Kerstantsz. Stoop, C.3,n.39.

Claes = Nicolas, Niclaes: Claes Adriaensz. Mast, bookprinter, C.1,n.75.

Claes Jacobsz., father of Marytgen van Dam's first husband, C.1,n.7, 8.

Claes Jan Claesz.'sz., p. 95; C.9,n.27.

Claes Cornelisz., husband of Lucie Cornelis Engebrechtsz.'sdr., pp. 55-56.

Claes van Leeuwen, p. 41.

Claes Oliviersz., cabinetmaker, p. 20.

Claes Oliviersz., painter, p. 87.

Claes Pietersz., son of Pieter Pietersz. C.1,n.48.

Claes van Zyl, p. 40.

Claes Jansz. van Schengen, C.1,n.17.

Claes Suycker of Haarlem, C.1,n.30.

Claes Claesz. van Swanenburch, husband of Marytgen, C.1,n.7, 8, 49; C.3,n.39.

Claes Aelewyn Claesz.'sz. Verhooch, p. 41; C.3,n.57.

Claes Vranckensz. C.1,n.65.

Claesgen Gerytsdr. C.3,n.39.

Meester Clement Jansz. of Amsterdam, Leiden surgeon, pp. 37, 38; C.3,n.42.

Clemens non Papa, Jacobus, composer, p. 109.

Clemeynse Cornelisdr., daughter of Cornelis Engebrechtsz., pp. 2, 55-57.

Clemeynse Willemsdr. van Thorenvliet, p. 40.

Clemeynse Dircxdr. van Zyl, p. 39.

Clement IV, Pope, p. 62.

Cleophas Anthonisz., stained-glass painter from Delft, pp. 20, 21.

Coeganck, family, C.2,n.112.

Coecke van Aelst, Pieter, C.13,n.67.

Colyn de Coter, p. 4; C.1,n.40.

Colet, John, C.7,n.57.

Colonna, Francesco, p. 72; C.7,n.39, 40, 53.

Coen = Coenradt, Conrad: Coen van

Luther, Martin, pp. 63, 64, 72-76, 119; C.7,n.1, 31, 67, 68, 72, 79, 80.
Luther and Eck, C.7,n.*59*.
de Luu, family, C.2,n.112.

M

Machtelt van der Does, wife of Adriaen van Poelgeest, pp. 36, 38; C.3,n.13, 15.
Machtelt van der Does, wife of Geryt van Hoochtwoude, C.3,n.13.
daughter of Machtelt van Hoochtwoude-van der Does, wife of Anthonis Carlier, Master of the Mint at Dordrecht, C.3,n.13.
Magteld Jansdr. van Montfoort, joncvrouw van Arenberch, Vrouwe van Naeldwyck, pp. 98-99, 104.
Mair von Landshut, engraver, C.7,n.28.
Manutius, Aldus, bookprinter, p. 72; C.7,n.38, 39.
Grietgen = Margaretha, Marghriet, Griet: Grietgen, daughter of Jan Beuckelsz. (Jan van Leyden), C.6,n.18.
Margaret of Austria, p. 110.
Margaretha, Countess van der Marck, Princess of Arenberch, wife of Jean de Ligne, pp. 98, 99.
Marghritte, wife of Ghysbrecht van der Bouchorst, p. 69; C.2,n.59.
Margriete van Bouchout, wife of Everart van der Marck, p. 98.
Margaretha Willemsdr. van der Does, pp. 36-41; C.3,n.13, 39, 42.
Grietgen Florysdr., C.2,n.111.
Griet Hugensdr., sister of Lucas van Leyden, p. 94.
Margriete Maertensdr., C.2,n.111.
Margriete van Naeldwyck, C.2,n.77.
Margriete Boudewynsdr. van Swieten, p. 39, C.3,n.13.
Marytgen = Marritgen, Maria, Marie: Marytgen, daughter of Pieter Cornelisz. Kunst, p. 40.
Marytgen, wife of Claes Claesz. van Swanenburch, C.3,n.39.
Marytgen Gerytsdr. van Dam, p. 1; C.1,n.7, 8, 10; C.7,n.66.
Marie Heynricxdr., wife of Huych Jacopsz., p. 94.
Marie Hugensdr., sister of Lucas van Leyden, p. 94.
Marie Ysbrantsdr., wife of Jan Beukelsz. (Jan van Leyden), C.6,n.18.
Marytgen Cornelisdr. of Delft, C.1,n.13, 65.
Maria Snellenberg, C.13,n.32.
Marytgen Vrydachsdr., Marienpoel nun, p. 20, C.2,n.5.
Maria van Wassenaar, p. 132.

Marytgen Willemsdr. (van Thorenvliet), Marienpoel nun, C.2,n.112.
de la Marche, see: Olivier de la Marche.
van der Marck, family, pp. 98, 104.
Marcks, family, p. 102; C.10, n.31.
Marsilio Ficino, p. 71; C.7,n.26.
Meester Maerten Florysz., C.2,n.111.
Maerten van Heemskerk, pp. 128, 130, 137; C.13,n.1, 12, 13.
Martin Luther, see: Luther, Martin.
Maertyn Mathysz., p. 102, C.10,n.30.
Mast, family, see: Dirck and Claes Adriaensz. Mast.
Matheeus = Mathys, Mathias, Thys: Matheeus van Berendrecht, pewtersmith, p. 6; C.1,n.75, 79.
Mathys Engebrechtsz., pewtersmith, p. 111; C.1,n.19.
Matheeus Jordansz., rector of Marienpoel, C.2,n.48.
Mathias Willemsz., rector of Marienpoel, p. 21, 22; C.2,n.48.
van Mathenes(se), family, p. 103; C.2,n.112.
Maricisu Yemantsz. van Middelborch, bookprinter of Delft, C.7,n.34.
Maximilian I, Emperor, pp. 4, 104, 107-110, 118; C.7,n.31; C.11,n.20.
de' Medici, Cosimo, p. 71.
van der Meer, family (see also: Lettersnijder), C.7,n.14, 34.
van Meerburch, family, p. 47; C.4,n.6, 7, 8.
Meyntgen = Clemynse or Willemyn: Meyntgen Heynricxdr., p. 100.
Melancthon, Philip, p. 76.
Melchior Sachse, bookprinter, p. 76.
Michiel Claesz., painter, p. 87.
Michiel Michielsz. van Helmondt, C.2,n.14.
van der Mye, family, pp. 39, 40; C.1,n.79.
Moens, family (tapestry weavers), p. 103.
van Montfoirde, family, p. 39, 98-99, 104, 128, 137; C.10,n.9.
Moeyt, family, p. 89.
Morales, Cristobal, composer, p. 109.
Mostaert, family, see: Jan Mostaert.

N

Nachtegael, family, C.1,n.49.
van Naeldwyck, family, pp. 92, 98-99, 104; C.2,n.77.
"Nanne de hoeyckmakere", c.1,n.17, 18.
van Nassau, family, pp. 131-132; see also: William of Orange.
Niehoff, family, organ builders, p. 113.

Index (2)

182

184

Illustration Credits and Copyright

Illustrations

84. Leiden Pieterskerk choirscreen (detail)
85. Leiden Pieterskerk choirscreen (detail)
86. Leiden Pieterskerk choirscreen (detail)
87. Leiden Pieterskerk choirscreen (detail)
88. Leiden Pieterskerk choirscreen (detail)
89. Leiden Pieterskerk choirscreen (detail)
90. Leiden Pieterskerk choirscreen (detail)
91. Leiden Pieterskerk choirscreen (detail)
92. Aertgen van Leyden, *The Van Montfoort Last Judgement*, 1555 (closed) Valenciennes, Musée des Beaux-Arts
93. Aertgen van Leyden, *The Van Montfoort Last Judgement*, 1555 (open), Valenciennes, Musée des Beaux-Arts
94. anon., *The Preaching of the Lord's Prayer*, Rijksmuseum Amsterdam
95. Georg Pencz, *Inhalt zweierley predig*, Kupferstichkabinett, Berlin-Dahlem
96. Aertgen van Leyden, *The Van Montfoort Last Judgement* (central panel), Valenciennes, Musée des Beaux-Arts
97. anon., portrait of Cornelis Willemsz., St. Anna Hof, Leiden

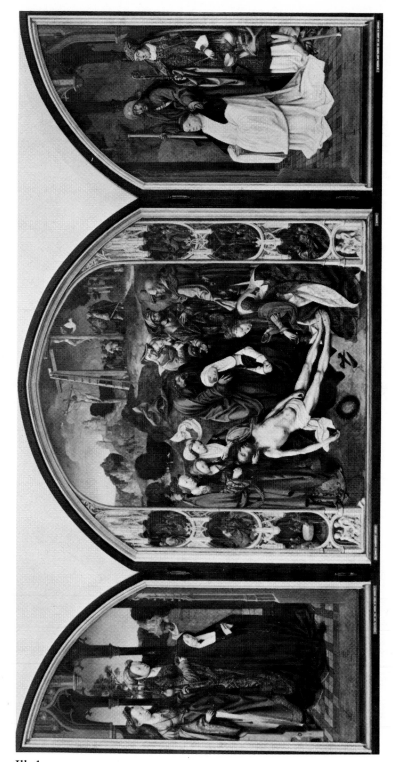

Ill. 1

190

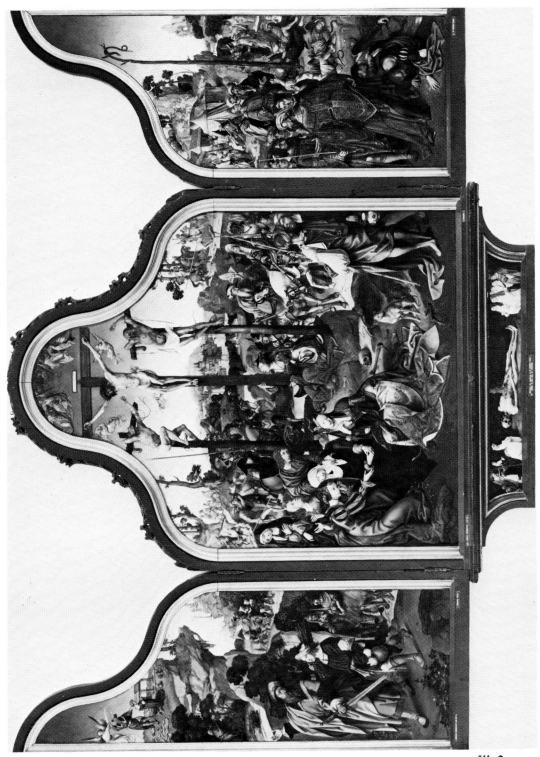

Ill. 2

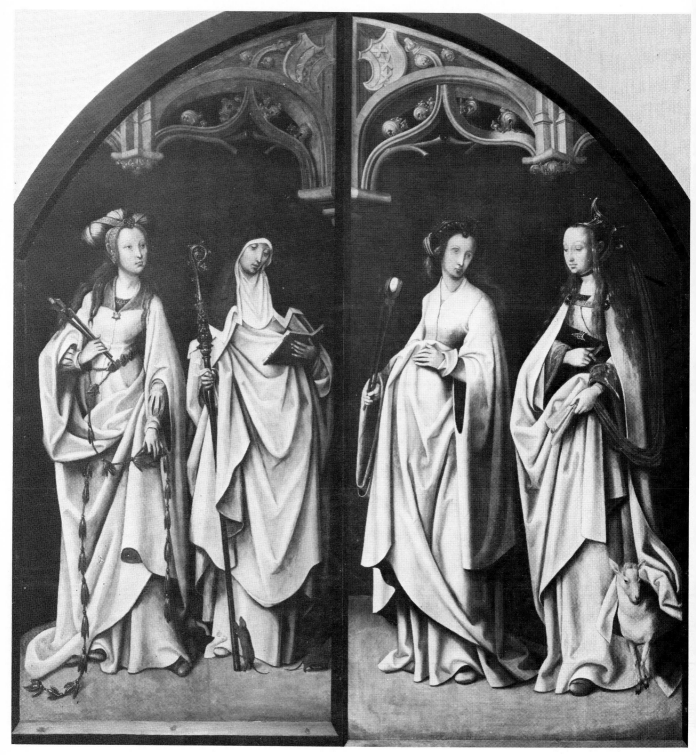

Ill. 3a Ill. 3b

192

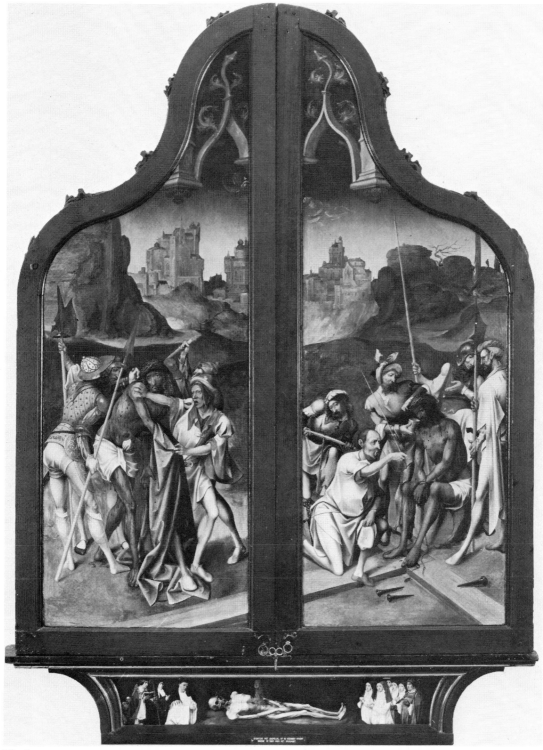

Ill. 4

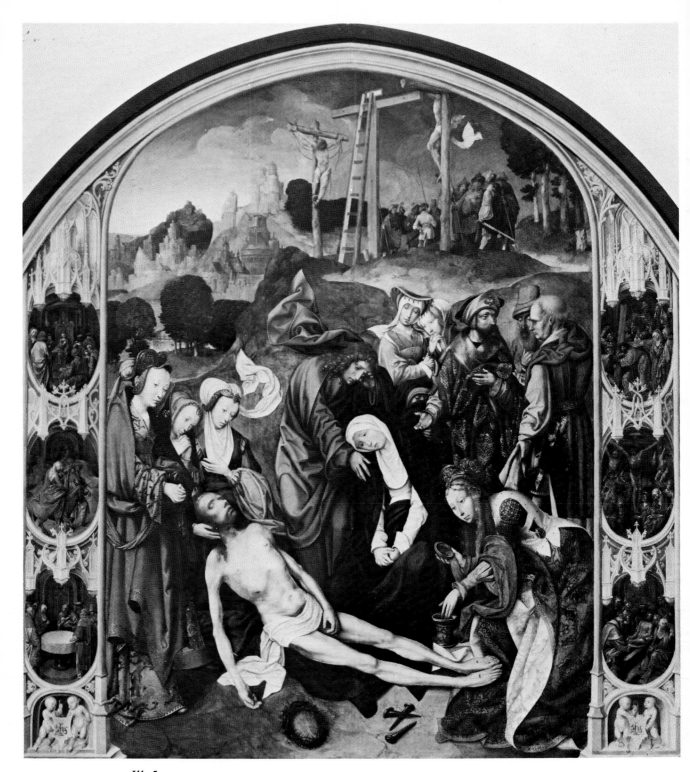

Ill. 5

194

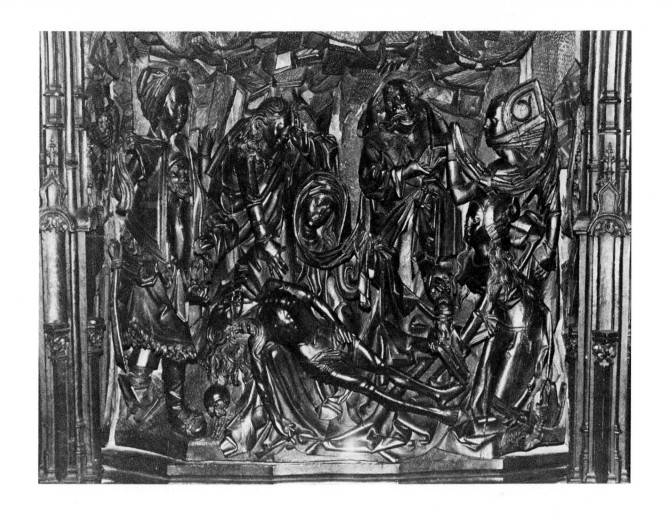

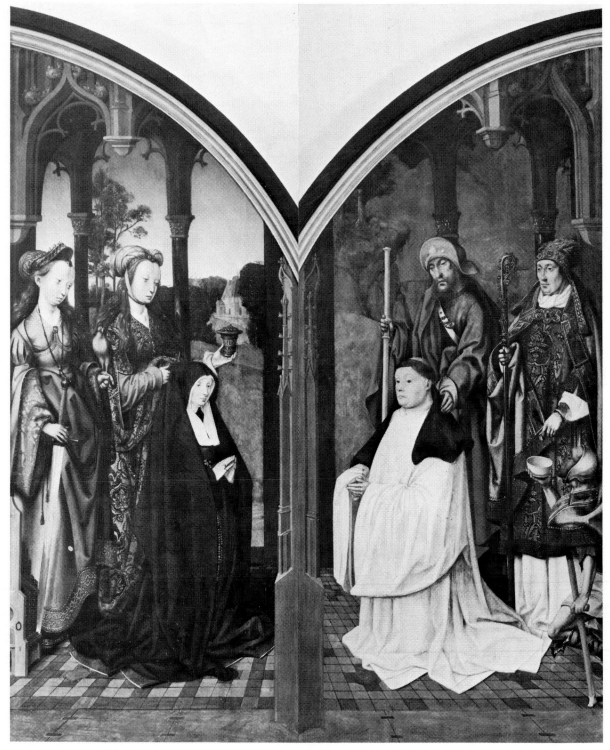

Ill. 7a Ill. 7b

196

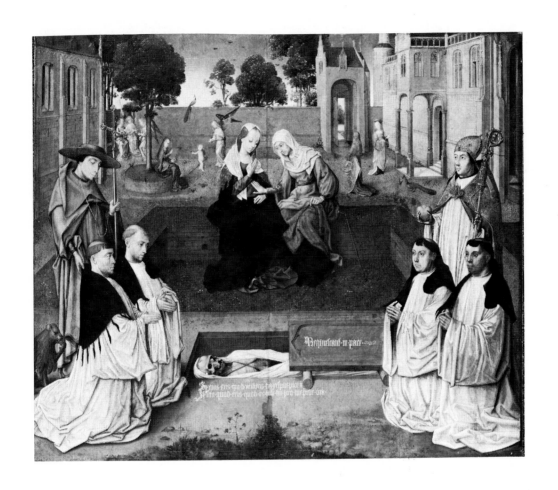

Ill. 8

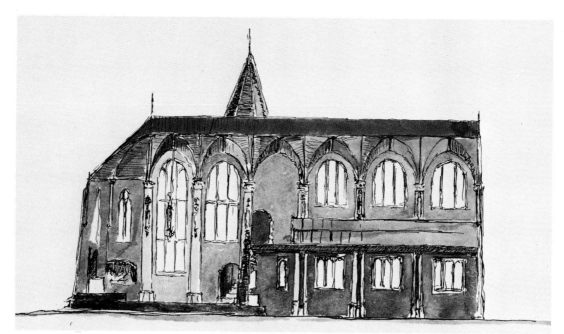

Ill. 9

Ill. 11

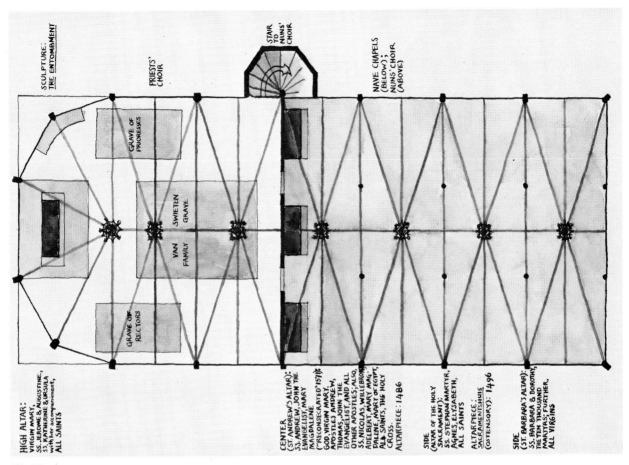

SCULPTURE:
THE ENTOMBMENT

PRIESTS'
CHOIR

STAIR
TO
NUNS'
CHOIR

NAVE CHAPELS
(BELOW);
NUNS' CHOIR
(ABOVE)

GRAVE OF
PRIORESSES

SWIETEN
GRAVE

VAN
FAMILY

GRAVE OF
RECTORS

HIGH ALTAR:
VIRGIN MARY,
SS. JEROME & AUGUSTINE,
SS. KATHERINE & URSULA,
with her accompaniment,
ALL SAINTS

CENTER
(ST. ANDREW'S ALTAR):
SS. ANDREW, JOHN THE
EVANGELIST, MARY
MAGDALENE
("RECONSECRATED"1517);
GOD, VIRGIN MARY,
APOSTLES ANDREW,
THOMAS, JOHN THE
EVANGELIST, AND ALL
OTHER APOSTLES; ALSO,
SS. NICOLAS, WILLEBRORD,
ADELBERT, MARY MAG-
DALENE, MARY OF EGYPT,
ALL SAINTS, THE HOLY
CROSS.
ALTARPIECE: 1486

SIDE
(ALTAR OF THE HOLY
SACRAMENT):
SS. STEPHAN MARTYR,
AGNES, ELYSABETH,
ALL SAINTS

ALTARPIECE:
SACRAMENTSHUIS
(OSTENSORY): 1496

SIDE
(ST. BARBARA'S ALTAR):
SS. BARBARA & DOROTHY,
THE TEN THOUSAND
MARTYRS; FURTHER,
ALL VIRGINS

Ill. 10

Ill. 12

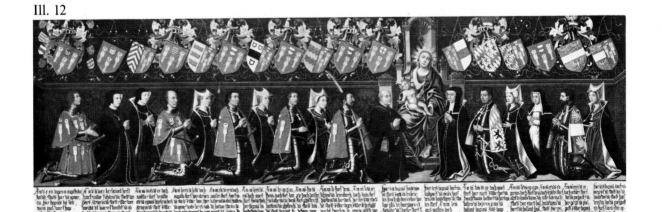

199

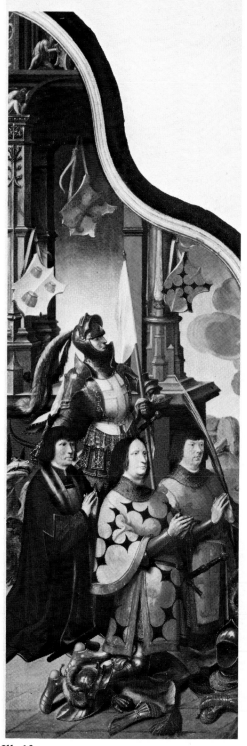

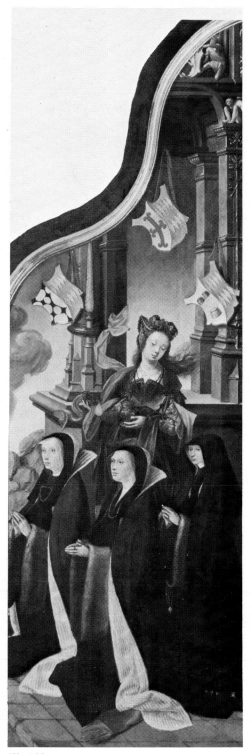

Ill. 13a

Ill. 13b

Ill. 14

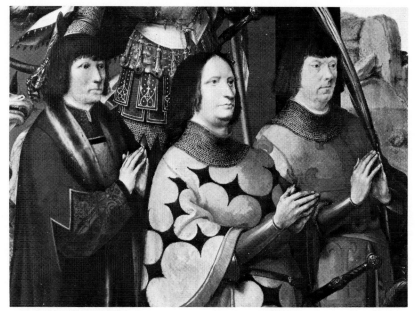

Ill. 15

Ill. 17

202

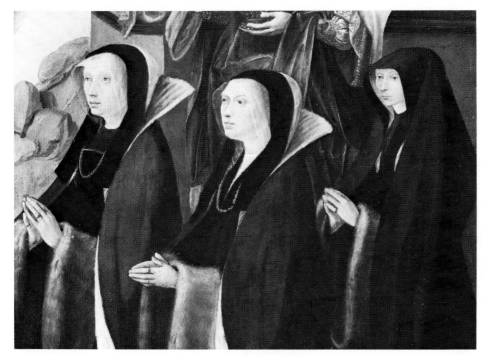

Ill. 16

Ill. 18

Een suuerlic boecxken van onser lieuer vrouwen croon

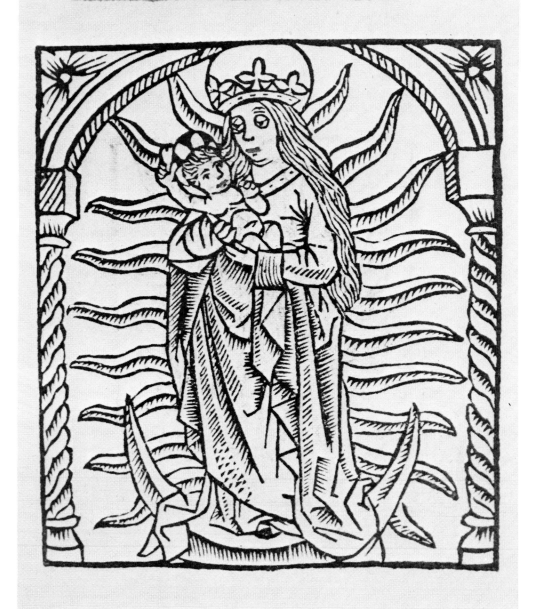

Ill. 19

Die ierſte en principael hooft ker-
ke van allen kercken der ganſer
weerelt is tot ſinte Joannes te Jarrane
binnen Roomen dye Conſtantinus die
keyſere heeft doen timmeren. Ende ſt
is ghewiet vanden heylighē paus Sil-

Ill. 20

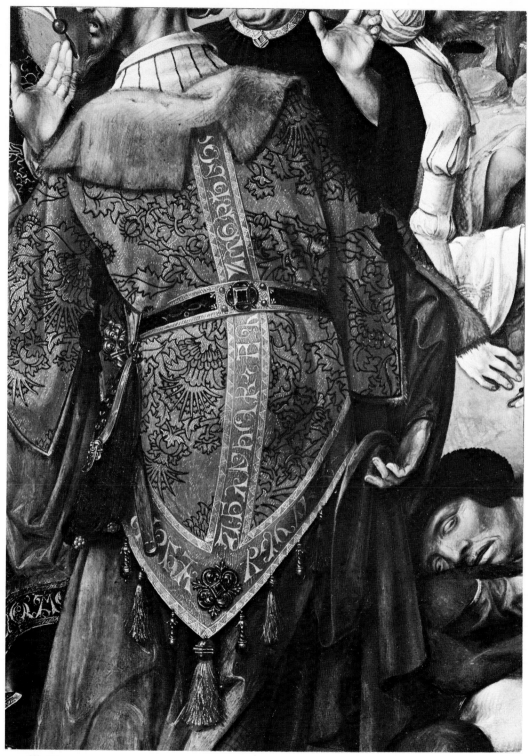

Ill. 21

Ill. 22

Ill. 23

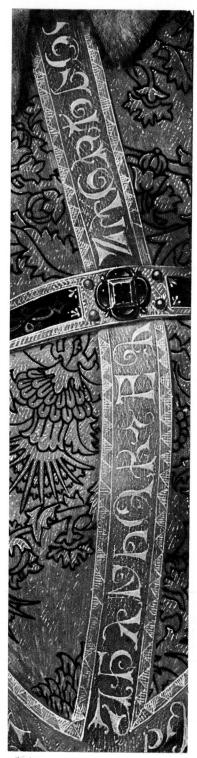

Ill. 24

Ill. 25

Ill. 26

Ill. 27

26. AGRIPPA DE NETTESHEYM, H. C., De occulta philosophia.
1531.

Ill. 28

Scriptura Cœlestis.

Aleph Beth Gimel Daleth He Vau Zain Cheth Theth Jod Caph Lamed Mem Nun Samech Ain Pe Zade Kuph Resch Shin Tau

ADAMÆI ALPHABETI.

Hebraicum Alphabetum antiquius.

Ill. 29 Ill. 30 Ill. 31

Ill. 32

Ill. 33

Ill. 35

Ill. 34

Ill. 36

Ill. 37

Ereipublice cura et sorte principā
tis a reuerēdissima vniuersitate et
felici collegio doctorum ⁊ scolariū
studij Aurelianensis missus illustri et potenti duci wilhelmo de ba
uaria tunc hollandie et zelandie Comiti vicesimo secundo. eius no
minis quinto postmodum ad hannonie comitatum promoto Cla
rissimi Erudissimiꝙ viri domini philippi de Leydē Insignis Acha
demie parrisiorum pōtificij iuris interpretis ac eiusdem illustrissi
mi principis viri consularis nec nō vigilantissimi traiettensis ecle
sie presulis domini Arnoldi de hoern vicarij Tractatus.
Eiusdē de sormis ⁊ semitis reipublice vtilius et facilius gubernāde
De modo et regula Rei familiaris facilius gubernande bernard⁹.

Cum gratia et priuilegio.
Venundantur Leydis in aedibus Johannis Seuerini
qui eos selectis characteribus impressit.
xiiij. Septembris anni dni.
1.5.1.6.

ACADLVGD

Ill. 38

214

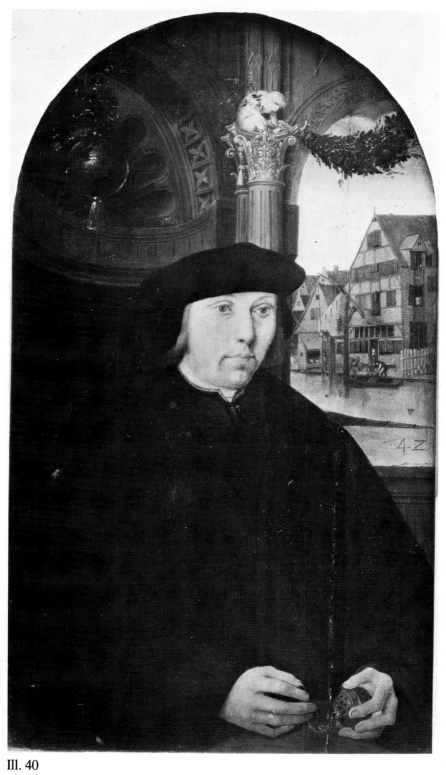

Ill. 40

Ill. 41

Ill. 42

Ill. 43

Ill. 44

218

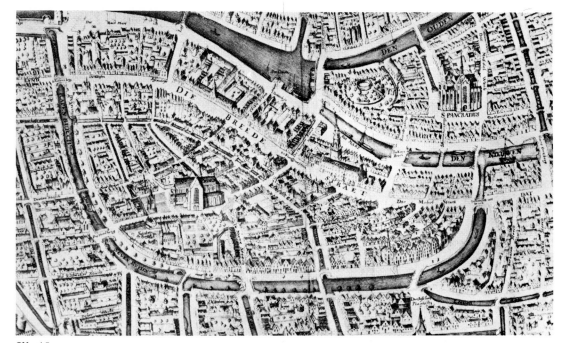

Ill. 45

Ill. 46

219

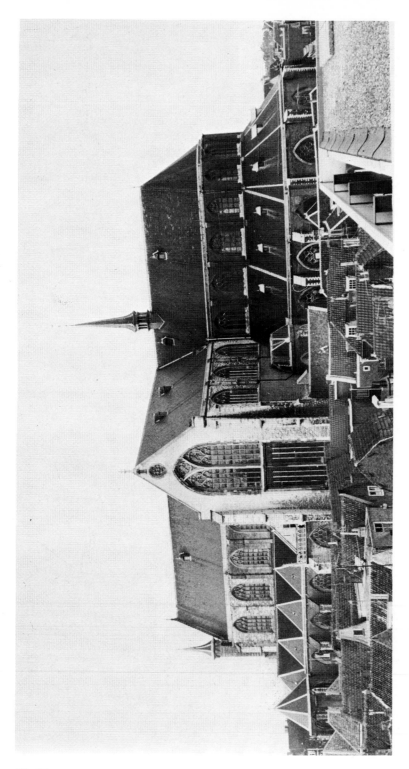

Ill. 47

220

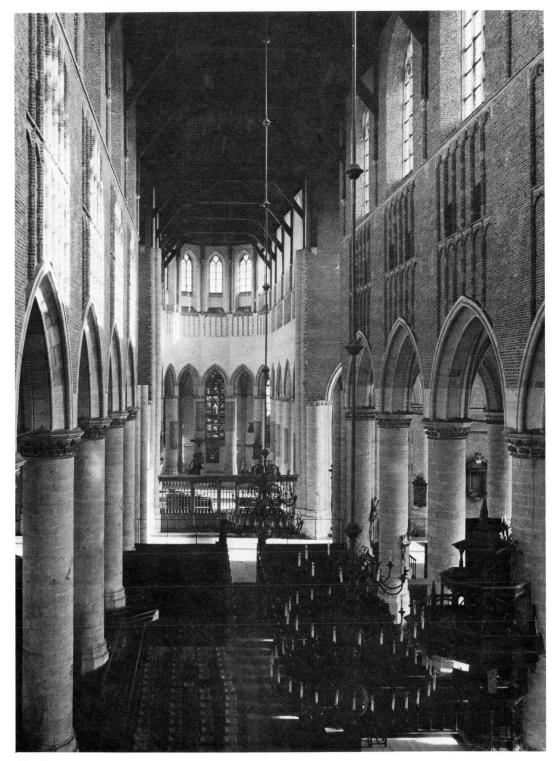

Ill. 48

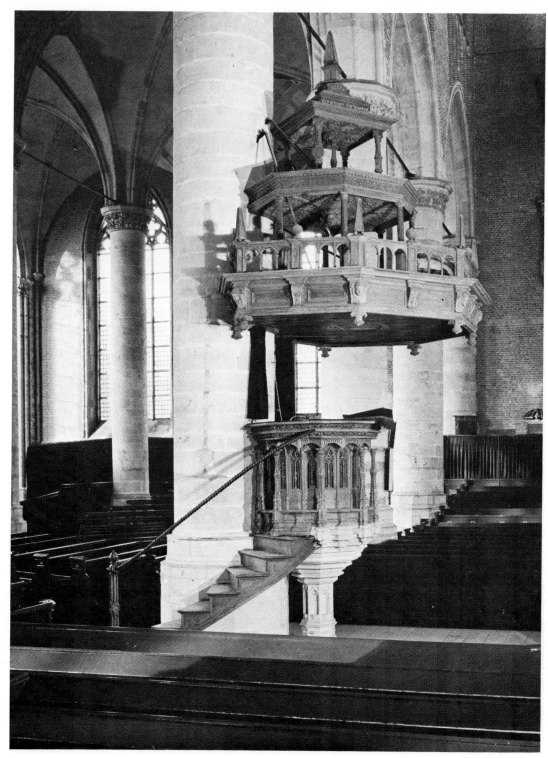

Ill. 49

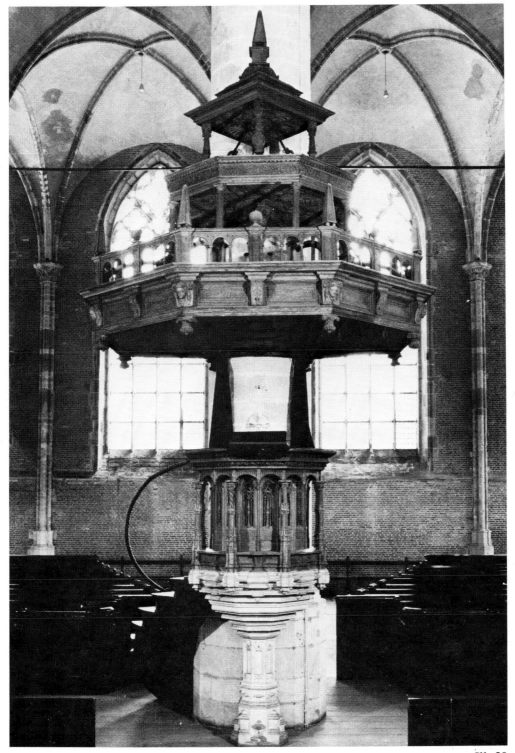

Ill. 52

Ill. 51

Ill. 53

Ill. 54

Ill. 55

Ill. 56

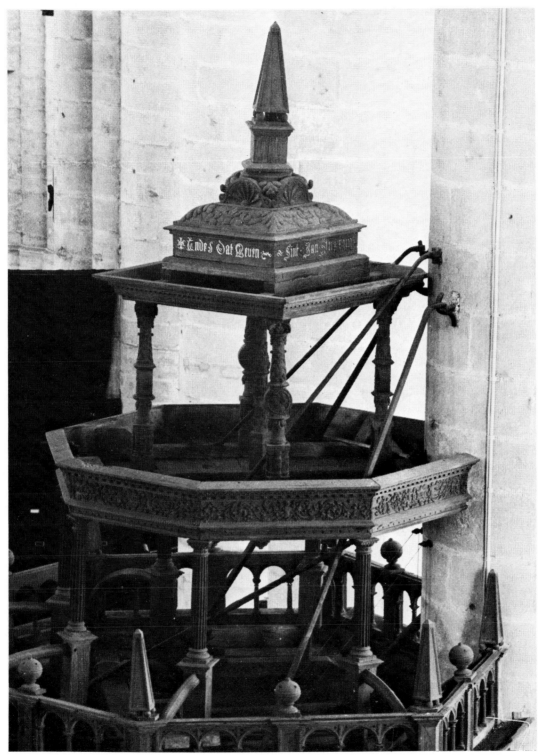

Ill. 57

Ill. 58

Ill. 59

Ill. 60

231

Ill. 61

Ill. 62

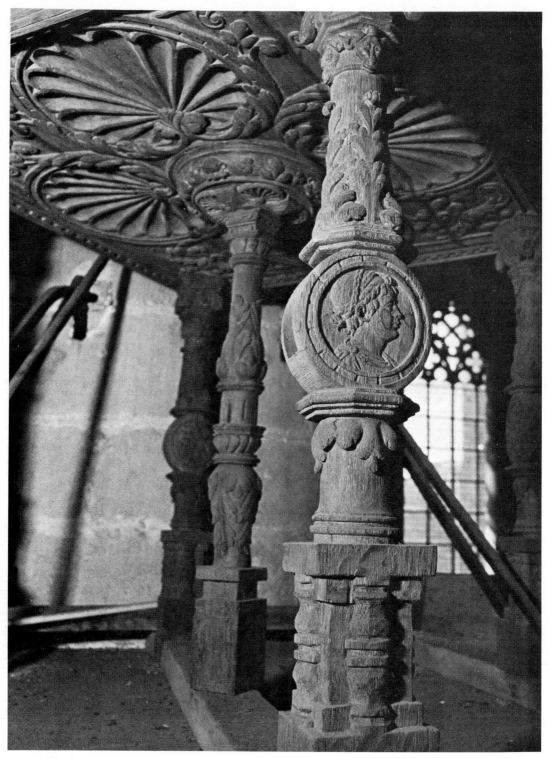

Ill. 63

234

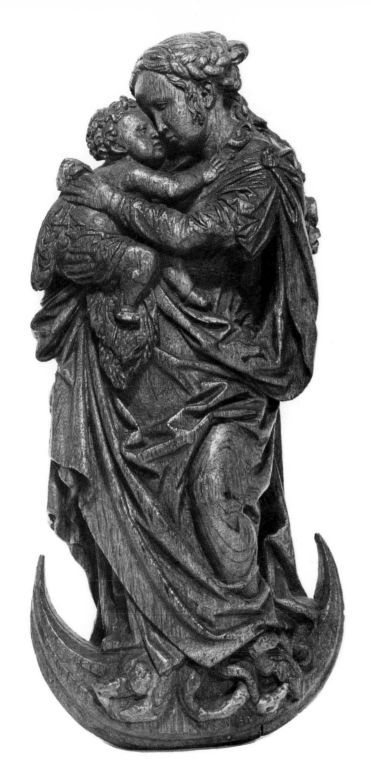

Ill. 64

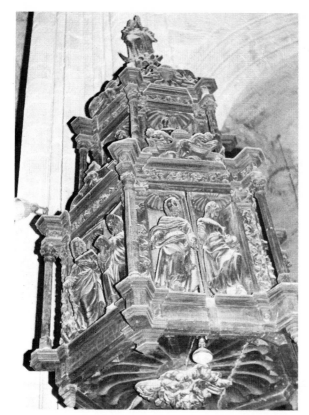

Ill. 65

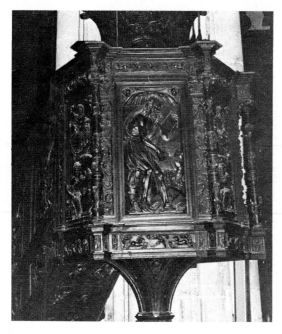

Ill. 66

236

Ill. 67

Ill. 68

Ill. 69

238

Ill. 70

Ill. 71

240

Ill. 72

Ill. 73

242

Ill. 74

Ill. 76

Ill. 75

Ill. 77

Ill. 78

Ill. 79

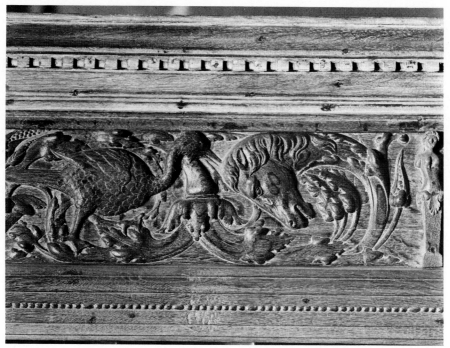

Ill. 80

Ill. 81

Ill. 82

Ill. 83

Ill. 84

Ill. 85

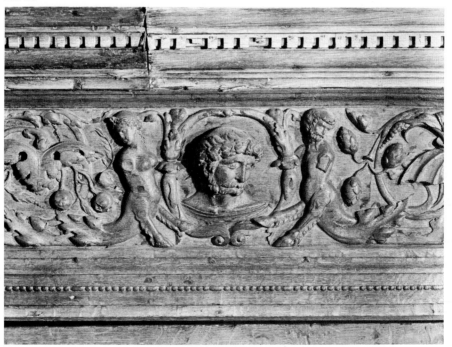

250

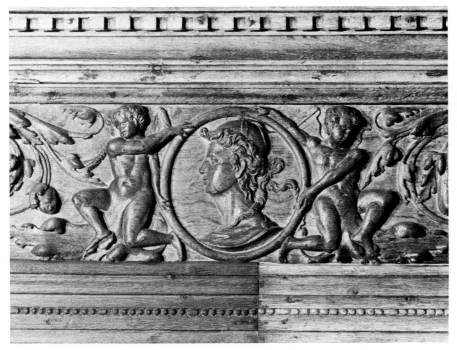

Ill. 86

Ill. 87

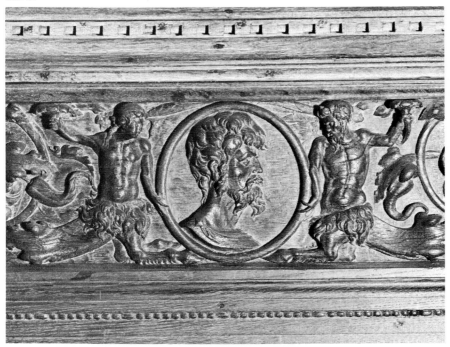

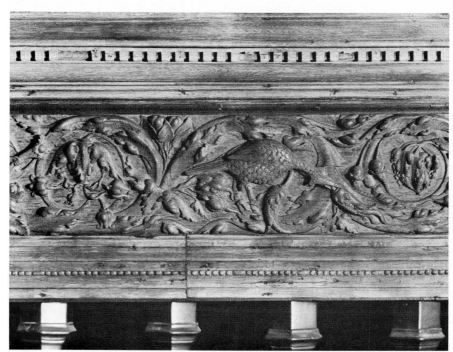

Ill. 88

Ill. 89

Ill. 90

Ill. 91

Ill. 92

254

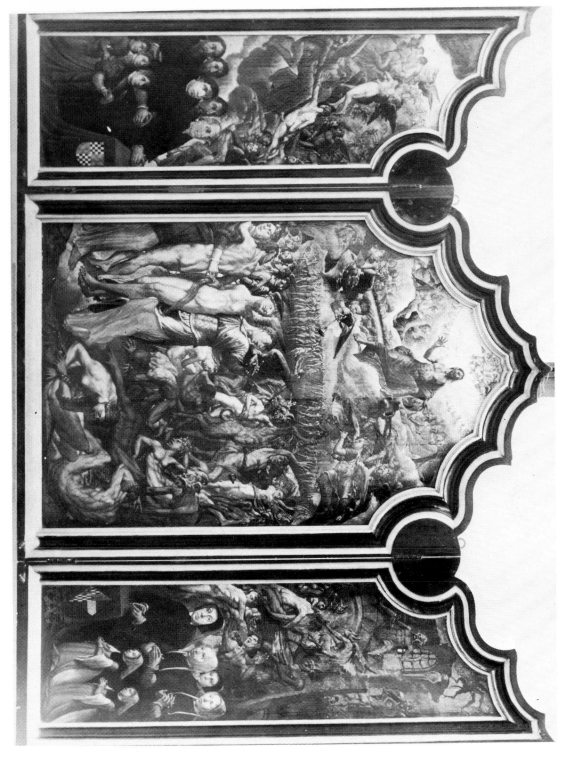

Ill. 93

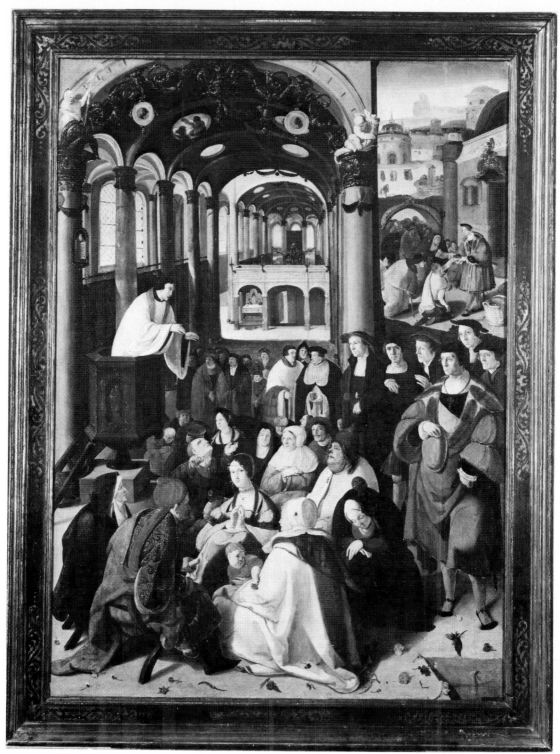

Ill. 94

Ill. 95

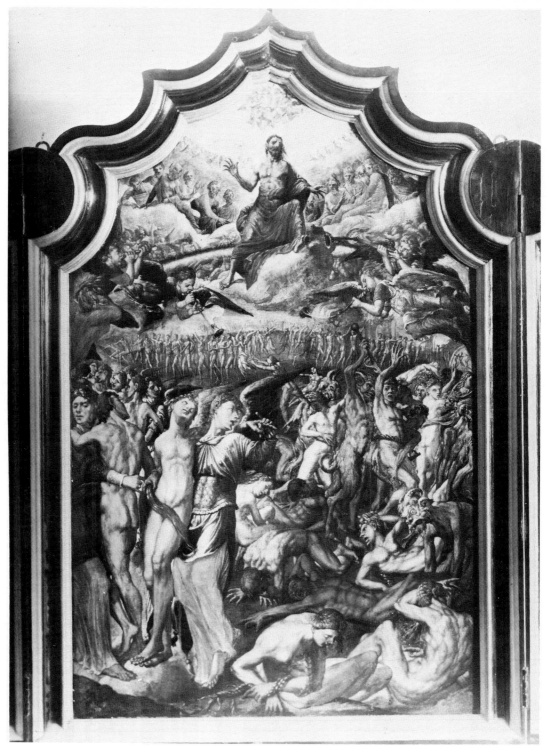

Ill. 96

Ill. 97